Praise

"A lively read. . . . Among many recent books on Pakistan, Mr. Akbar's stands out . . . it is a fine and detailed history of Indian Muslim anger and insecurity, spawned by the eighteenth-century decline of the Mughals. . . . Mr. Akbar is a stylish writer with an excellent eye for a gag."

—*The Economist*

"M. J. Akbar [rediscovers] for the reader a story that had been confined to the footnotes of history."

—*The Telegraph* (UK)

"M. J. Akbar takes an enchanting journey through history to trace the origin and evolution of Pakistan. . . . [A] well-written, clearly argued, and historically grounded work . . . [it] seeks to trace [Pakistan's] peculiar and unorthodox origins to explain the key political choices that its leaders, both civilian and military, have made and to meditate on its endemic as well as current political predicaments."

—*India Today*

"[A] brilliant study. . . . M. J. Akbar embarks on a historical whodunit to trace the journey of an idea, and the events, people, circumstances, and mind-set that divided India. . . . Reading this book should be a must for all policy makers in India."

—*Free Press Journal* (India)

"A finely nuanced book. . . . A riveting account."

—*Indian Express*

Tinderbox

Tinderbox

The Past and Future of Pakistan

M. J. Akbar

HARPER PERENNIAL

NEW YORK • LONDON • TORONTO • SYDNEY • NEW DELHI • AUCKLAND

HARPER ⬤ PERENNIAL

This book was originally published in India in 2011 by HarperCollins Publishers India, a joint venture with The India Today Group.

TINDERBOX. Copyright © 2012 by M. J. Akbar. All rights reserved. Printed in the United States of America. No part of this book may be used or reproduced in any manner whatsoever without written permission except in the case of brief quotations embodied in critical articles and reviews. For information address HarperCollins Publishers, 10 East 53rd Street, New York, NY 10022.

HarperCollins books may be purchased for educational, business, or sales promotional use. For information please write: Special Markets Department, HarperCollins Publishers, 10 East 53rd Street, New York, NY 10022.

FIRST U.S. EDITION

Library of Congress Cataloging-in-Publication Data is available upon request.

ISBN 978-0-06-213179-9

12 13 14 15 16 RRD 10 9 8 7 6 5 4 3 2 1

For Mukulika and Carl Nordenberg,
and their future

Contents

Introduction

It was one of those suggestions that seem perfectly sensible during a spirited conversation at the home of a dear friend in Karachi. Bravado comes easily in the drawing room. A fellow guest, a former dignitary, offered to take me to the Binori mosque and madrasa, founded by Maulana Yusuf Binori soon after independence in 1947; it says something that he had not seen it either. We were not inspired by visions of a local Taj Mahal, but by the widely held belief that this was the sanctuary of Osama bin Laden during the fallow period between the Afghan jihad against the Soviet Union and his declaration of war upon America. In 1998, the then spiritual mentor of Binori, Mufti Nizamuddin Shamzai, had issued a fatwa saying that killing Americans was justified. A little later, Lashkar-e-Tayyiba, which became an international outcast after it organized the Mumbai attacks on 26 November 2008, issued a similar decree. The Taliban in Afghanistan honoured any visitor from Binori as a state guest.

The ride was uneventful, the mosque large rather than imposing. We mounted steps that opened into a spacious, rectangular courtyard surrounded by rooms. A few students loitered around, for it was neither time for study nor prayer, their dress indistinguishable from any Islamic seminary on the subcontinent: white pyjamas ending two inches above the ankle, white kurta, white cap taut over the scalp. As I bent to unlace my shoes, I dismissed a slight tremor of unease, unwilling to accept that I was

afraid. It was impossible, however, not to sense that we were on the threshold of a different world, where a different law and a separate order prevailed. The Karachi police would probably have guffawed at the thought that they needed to do something about an Indian held hostage in the mosque. Fools deserve their fate. Then, without a word, my companion signalled, with a jerk of the head, that it was time to end this stupidity. We returned to the car at a brisk pace, just short of a panic run.

The time for rumination would come later. But surely there was an obvious, immediate question that demanded an answer. Muslims of British India had opted for a separate homeland in 1947, destroying the possibility of a secular India in which Hindus and Muslims would coexist, because they believed that they would be physically safe, and their religion secure, in a new nation called Pakistan. Instead, within six decades, Pakistan had become one of the most violent nations on earth, not because Hindus were killing Muslims but because Muslims were killing Muslims.

Nations are not born across a breakfast table. Their period of gestation is surely one of the more fascinating chapters in the study of history. The indisputable stature of Mohammad Ali Jinnah, a master of the endgame, has led to a notion that Pakistan emerged out of a resolution passed in March 1940 at the Muslim League session in Lahore. The reality is more complicated. Pakistan emerged out of a fear of the future and pride in the past, but this fear began as a mood of anguish set in among the Muslim elite during the long decline of the Mughal Empire in the eighteenth century. The embryo had a long and turbulent existence, particularly during the generations when it remained shapeless.

This book is a history of an idea as it weaved and bobbed its way through dramatic events with rare resilience, sometimes disappearing from sight, but always resurrected either by the will of proponents or the mistakes of opponents. It began hesitantly, in the shadow of the age of decline, in the 1750s, when the collapse of the Mughal Empire and the consequent disintegration of what is called 'Muslim rule' in India could no longer be disguised by explanations, theories or hope of revival.

Pakistan is a successor state to the Mughal Empire, the culmination of a journey that began as a search for 'Muslim space' in a post-Muslim dispensation, nurtured by a dread that became a conviction: that a demographic minority would not be able to protect either itself or its faith unless it established cultural and political distance from an overwhelming majority Hindu presence. Muslims, who had lived in India for five centuries with a superiority complex, suddenly lurched into the consuming doubt of an inferiority complex which became self-perpetuating with every challenge that came up during different phases of turbulent colonial rule.

The infirmities of this idea were never recognized because they could only become evident in practice. An existentialist question was completely ignored: was Islam so weak that it could not survive as a minority presence? There was nothing in its glittering past to suggest this, but those who raised the question, like the brilliant scholar–politician Maulana Abul Kalam Azad, were dismissed, ironically, as traitors to Islam.

The first phase consists of the years between 1739 and 1757. In 1739, a Persian marauder–king, Nadir Shah, entered Delhi as Mughal Emperor Muhammad Shah's 'guest'. Two days later, Nadir Shah, using an untenable excuse, ordered a massacre which did not discriminate between Muslims and Hindus. An estimated 20,000 were killed, women raped and the capital plundered of private and public wealth. After fifty-eight days of terror, Nadir Shah departed with a hoard of invaluable jewels, gold and coins, including the Kohinoor diamond and Shah Jehan's Peacock Throne. The Mughal Empire, a superpower three decades before, never recovered from this humiliation; it had failed in its basic duty, the safety of its subjects.

Shah Waliullah, the premier Sunni theologian and intellectual of his age, read many meanings in the catastrophe. The security that Muslims had taken for granted was over. The disintegrating empire was being replaced by powerful regional dynasties that were largely Hindu. The most important Muslim principality, Awadh, was in the control of Shias, a 'deviant' sect that could not

be trusted with the preservation of Islam, and who were in his eyes even worse than the infidel. Nadir Shah, who broke the bent back of Mughals, was a Shia.

Shah Waliullah proposed a theory of distance and the protection of 'Islamic purity' as his prescription for a community that was threatened by the cultural power and military might of the infidel. While he thanked Allah for keeping the blood in his own veins 'pure' and 'Arab', he recognized that the majority of Indian Muslims were converts from Hinduism; there was enormous cultural overlap in their habits and behaviour. He feared a lapse into Hindu practices among Indian Muslims in the absence of the religious leadership that had been preserved by political power. Islam could survive in India, he argued, only if Muslims maintained physical, ideological and emotional distance from Hindus. He urged Muslims to live so far from Hindus that they would not be able to see the smoke from their kitchens.

Shah Waliullah's seminary would play a vital part in the shaping of the north Indian Muslim mind in the nineteenth century, when British rule moved from a southern enclave and eastern corner to dominate the whole of the subcontinent. British rule originates in a minor but epoch-changing battle in 1757, in a village called Plassey, which ended Mughal rule in the richest trading province of the country, Bengal. The students of Shah Waliullah's seminary, however, were not so easily defeated. One of them, Sayyid Ahmad Barelvi, inspired the long jihad which began in 1825 and continued long after his death in 1831, on the battlefield, at Balakote (today, a principal centre of the Pakistan Taliban).

Mistrust of Hindus, fundamental to the theory of distance, became the catechism of Muslim politics when it sought to find its place in the emerging polity of British rule in the early twentieth century. The very first demand made by Muslim notables, when Indian representation was proposed in the legislature, was unique: that Muslims should be elected only by fellow Muslims. This was the 'separate electorates' scheme which the British happily endorsed into law. A perceptive young man, who would later be honoured as the father of Pakistan, recognized the

implications immediately, even as he dissociated himself from the demand. Jinnah said, as early as in the first decade of the twentieth century, that separate electorates would lead to the destruction of Indian unity; and so they did.

Jinnah was an exceptional product of British India. He loved Shakespeare and fashionably tailored suits, called English his mother tongue, had an upper lip stiffer than an earl's, and had to be dissuaded by his father when he wanted to join the stage in England after a law degree from Lincoln's Inn. He desired freedom as passionately as anyone else, but unlike the father of India, Mahatma Gandhi, he would not break the law in the process, since he considered that incompatible with his professional ethics as a lawyer. Ironically, on the eve of a movement that changed the course of the freedom struggle but left a residual disappointment that alienated Muslims from Gandhi, Jinnah warned Gandhi about the dangers of mixing religion with politics, and indulging Muslim mullah firebrands.

Between 1919 and February 1922, Gandhi became the first non-Muslim to be given leadership of a jihad. Gandhi accepted the 'dictatorship' (a term that clearly had different connotations then), but on one condition: that this jihad against the British would be non-violent. Muslim leaders, including the most important ulema, accepted, and absorbed Gandhi into what is known as the Khilafat movement, or the Caliphate movement, since it was launched in support of the Ottoman caliph of Islam and his suzerainty over the holy cities of Mecca and Medina. The caliph was the last symbol of Muslim power against the sweeping tide of British and European imperialism, which is where it intersected with Gandhi's needs. He saw in this the opportunity to unite Hindus and Muslims against the British Raj, irrespective of their starting points. Having achieved Indian unity, Gandhi promised swaraj within a year. Instead, by February 1922, he realized that he could not contain the violence that was bursting in corners across the country. Gandhi arbitrarily abandoned the movement, to the shock of his Muslim supporters. The bitterness of failure was so deep that Muslims never really returned to

Gandhi's Congress. But this did not take them directly to the Muslim League either; suffice it to say that the search for 'Muslim space' did not catch fire until it was converted into a demand for 'Islamic space', and Gandhi was successfully converted by Muslim League leaders into an insidious Hindu bania whose secularism was nothing but a hypocritical term for Hindu oppression and the consequent destruction of Islam in the subcontinent. Islam was in danger, and Pakistan was the fortress where it could be saved. With an advocate as powerful as Jinnah, enough Muslims were persuaded that the man who had spent his life caring about their welfare and eventually lost it in their cause was actually their sly enemy.

Jinnah's forensic skills were at their finest in the court of public opinion, even when his sarcasm was devoid of finesse, as when he described Gandhi as 'that Hindu revivalist'. Jinnah, who drank alcohol, went to the races for pleasure, never fasted during Ramadan, and could not recite a single ayat of the Quran, created such a hypnotic spell upon some Muslims that they believed he got up before much before dawn for the Tahajjud namaaz, the optional sixth prayer which only the very pious offer.

Jinnah clearly believed that he could exploit a slogan he had once warned against, 'Islam in danger', and then dispatch it to the rubbish bin reserved for the past when it had outlived its utility. In his first speech to the Constituent Assembly of Pakistan, Jinnah made a case for a secular Pakistan that would have been applauded in the Constituent Assembly of India. The kindest interpretation of Jinnah's politics is that he wanted a secular state with a Muslim majority, just as Gandhi wanted a secular state with a Hindu majority. The difference was, however, crucial: Gandhi wanted an inclusive nation, Jinnah an exclusive state. When, on 13 June 1947, Gandhi was asked whether those who called God Rama and Krishna instead of Allah would be turned out of Pakistan, he answered only for India: 'We shall worship God both as Krishna and Karim [one of the names of Allah] and show the world we refuse to go mad.'[1] Gandhi's commitment to religion never meant commitment to a single religion.

Both Jinnah and Gandhi died in 1948, the first a victim of tuberculosis and the second to assassination. India had clarity about the secular ideology of the state, completed work on an independent Constitution by 1950, and held its first free, adult franchise elections in 1952. The debate in Pakistan, about the role of Islam in its polity, began while Jinnah was still alive. The father of Pakistan was challenged by the godfather of Pakistan, Maulana Maududi, founder of the Jamaat-e-Islami, and accurately described as the architect of the Islamist movement in South Asia and the most powerful influence on its development worldwide. Islamism did not, and does not, have much popular support in Pakistan, as elections prove whenever they are held; but its impact on legislation and political life is far stronger than a thin support base would justify. Maududi's disciple, General Zia ul Haq, who ruled Pakistan from 1976 with an autocratic fist for a decade, crippled liberals with a neat question: if Pakistan had not been created for Islam, what was it, just a second-rate India? Zia changed the motto of the Pakistan army to '*Jihad fi sabil Allah*' (Jihad in the name of Allah) and worked to turn governance into 'Nizam-e-Mustafa' (Rule of the Prophet) through a rigorous application of the Sharia law, as interpreted by the most medieval minds in the country. But the 'Islamization' of the Constitution preceded Zia, and efforts to reverse his legacy have not succeeded, because a strain of theocracy runs through the DNA of the idea of Pakistan. The effort to convert Pakistan into a Taliban-style Islamic emirate will continue in one form or the other, at a slow or faster pace.

The challenge before South Asia is the same as anywhere in the post-colonial world: the evolution to a modern state. Economic growth is an aspect of modernity but far from the whole of it. In my view, a modern state has four fundamental commitments: democracy, secularism, gender equality and economic equity. Civil society in Pakistan knows the threat posed by Maududi Islamists and understands that it is an existential battle. As Sir Hilary Synnott, British High Commissioner in Pakistan between 2001 and 2003, and the Coalition Provisional Authority's Regional

Coordinator for South Iraq in 2003 and 2004, points out, 'Pakistan's structural and historical weaknesses are such that nothing short of a transformation of the country's body politic and institutions will be necessary.'[2] This change, he points out sagely, can only be brought about by Pakistanis.

Indians and Pakistanis are the same people; why then have the two nations travelled on such different trajectories? The idea of India is stronger than the Indian; the idea of Pakistan weaker than the Pakistani. Islam, as Maulana Azad repeatedly pointed out, cannot be the basis of nationhood; perhaps it required a scholar of Islam to comprehend what an Anglophile like Jinnah could not. Islam did not save the Pakistan of 1947 from its own partition, and in 1971 the eastern wing separated to form Bangladesh. It is neither coincidental nor irrelevant that the anthem of Bangladesh has been written by the same poet who gave India its national song, Rabindranath Tagore. Bangladeshis, 90 per cent of whom are Muslims, would strongly resent the suggestion that this makes them an associate nation of India; they are as proud and protective of their independence as any free country. Bangladesh is a linguistic, not a religious, state. At the moment of writing, Pakistan displays the characteristics of a 'jelly state'; neither will it achieve stability, nor disintegrate. Its large arsenal of nuclear weapons makes it a toxic jelly state in a region that seems condemned to sectarian, fratricidal and international wars. The thought is not comforting.

Pakistan can become a stable, modern nation, but only if the children of the father of Pakistan, Jinnah, can defeat the ideological heirs of the godfather, Maududi.

Tinderbox

1

The Age of Defeat

—⟨ళ⟩—

At what point in their history of more than a thousand years did Indian Muslims become a minority? The question is clearly rhetorical, because Indian Muslims have never been in a majority.

The last British census, taken in 1941, showed that Muslims constituted 24.3 per cent of the population. Five years later, in 1946, provoked by fears that they and their faith would be destroyed by majority-Hindu aggression after the British left, Indian Muslims voted overwhelmingly for the Muslim League, a party that promised a new Muslim nation on the map of the Indian subcontinent, to be called Pakistan. In August 1947, Pakistan, a concept that had not been considered a serious option even in 1940, became a fact.

Its geography was fantastic: its western and eastern halves were separated by more than a thousand miles of hostile India, and by sharp differences in ethnicity and culture, for the east was Bengali while the west was Punjabi, Pakhtoon, Baloch and Sindhi. Its professed ideology, Islam, was unprecedented as a glue for nationalism, since no nation state had yet been created on the basis of Islam. The great theologian–politician, Maulana Abul Kalam Azad (1888–1958), president of the Indian National

1

Congress between 1940 and 1946, repeatedly pointed this out to fellow Muslims, but to shrinking audiences. In a remarkably prescient interview, given to Shorish Kashmiri for the Lahore-based Urdu magazine *Chattan*, published in April 1946, Azad argued that the division of territory on the basis of religion 'finds no sanction in Islam or the Quran ... Who among the scholars of Islam has divided the dominion of God on this basis? ... Do they realize that if Islam had approved this principle then it would not have permitted its followers to go to non-Muslim lands and many ancestors of the supporters of Pakistan would not have even entered the fold of Islam?' Islam was a value system for the transformation of the human soul, not an instrument of political power.

Nor would a common faith eliminate ethnic tensions. 'The environment of Bengal is such that it disfavours leadership from outside and rises in revolt when it senses danger to its rights and interests ... I feel that it will not be possible for East Pakistan to stay with West Pakistan for any considerable period of time. There is nothing common between the two regions except that they call themselves Muslims. But the fact of being Muslim has never created durable political unity anywhere in the world. The Arab world is before us; they subscribe to a common religion, a common civilization and culture, and speak a common language. In fact, they acknowledge even territorial unity. But there is no political unity among them.' Exactly twenty-five years after Azad made this prediction, in 1971, Pakistan broke into two, and Bengali-speaking East Pakistan reinvented itself as Bangladesh after brutal civil strife and an India–Pakistan war.

The partitions of India divided Indian Muslims, who constituted one-third of the world's Muslim population before 1947, into three nations by 1971. By the turn of the century, Pakistan had reduced non-Muslims to 2 per cent of its population. Ten per cent of Bangladesh, a more secular formation, was Hindu. When the first census of the twenty-first century was taken, in 2001, Muslims were 13.4 per cent of secular India.

—⟨∞⟩—

Muslims of the Indian subcontinent, from the Khyber Pass to the borders of Burma, claim a unique history spanning more than a thousand years in which their political power has been remarkably disproportionate to their demographic limitations. Muslim dynasties were by far the most powerful element within the complex mosaic of a multi-ethnic, multi-religious feudal structure before the slow aggregation of British rule from the middle of the eighteenth century. An Arab invader, Muhammad bin Qasim, established the first Muslim dynasty, in 712, in Sind (now in Pakistan), but it faltered and stagnated. Muslim rule in a substantive sense is more correctly dated to 1192, when Muhammad Ghori, at the head of a Turco-Afghan army, defeated the Rajput king Prithviraj at Tarain, about 150 km from Delhi, near Thaneswar, to establish a dominant centre of Muslim power in the heartland.

Ghori soon returned to Afghanistan, but his successors, Turco-Afghan generals, set up a Delhi Sultanate that became independent of Afghanistan in 1206. By this time, with astonishing rapidity, they held an empire that stretched from Gujarat in the west to Bengal in the east. Delhi, or its alter ego Agra, remained a Muslim capital for over six centuries. The Khiljis (1288–1320), Tughlaqs (1320–1413), Sayyids (1414–51), Lodis (1451–1526), Suris (1540–56) and Mughals (1526–40 and 1556–1857) won or lost power in wars that were as bitter as any other, but the fact that succession never went out of the Islamic fold created a comfort zone that seeped down to even those Muslims who had little to gain from that moveable feast called monarchy. There were powerful Muslim domains even during British rule, the most important being the state of Hyderabad, founded by a Mughal governor who bore the title of nizam ul mulk and who broke away from an already brittle Delhi around 1725; the dynasty survived till 1948, with the seventh and last nizam, Mir Osman, becoming famous as a miser with the most valuable diamond hoard in the world. He ate off a tin plate, smoked cigarette stubs left behind by guests, and was hugely reluctant to serve champagne to so eminent a visitor as the viceroy, Lord

Wavell, but used the 280-carat Jacob diamond as a paperweight. There were only three million Muslims in a population of twenty-three million in his state, but did Muslims consider themselves a minority as long as their ruler was a Muslim? No.

Minority and majority are, therefore, more a measure of empowerment than a function of numbers. For Muslims under shahanshahs, nawabs and nizams, power translated into positive discrimination in employment, within the bureaucracy, judiciary and military; and it ensured that their *aman i awwal* (liberty of religion) was beyond threat.

This changed in 1803, when victorious British troops marched into Delhi. The Mughal emperor, the blind and impotent Shah Alam II, became a British vassal, and centuries of Muslim confidence began to crumble into a melee of reactions ranging from anger, frustration, bombast, lament and self-pity to insurrection and intellectual enquiry.

Indian Muslims entered an age of insecurity for which they sought a range of answers. One question fluctuated at many levels: what would be the geography of what might be called Muslim space in the post-Mughal dispensation? The concept did not begin as a hostile idea, but it certainly had the contours of protectionism, buoyed by an underlying, if unspoken, assumption that Muslims would not be able to hold their own. Political power had made their 'minority' numbers irrelevant; without power, they would be squeezed into irrelevance or subjugation. They sought, therefore, reservations or positive discrimination of all kinds, in the polity, in preferential treatment for their language, in jobs, and eventually in geographical space. Pakistan emerged as the twentieth century's answer to a nineteenth-century defeat. So far, it has merely replaced insecurity with uncertainty.

The last two Muslim empires, Mughal and Ottoman, succumbed to British power in the long nineteenth century, which came to an end in 1918 with the end of the First World War. In south Asia, Pakistan evolved as a kind of successor-state to the Mughal Empire, a comfort zone for Muslims. Turkey survived the collapse of the Ottomans by a remarkable renovation: Mustafa Kemal

Ataturk, who saved his nation from British plans for dismemberment, abandoned Ottoman ideas and values, and turned Turkey into an independent, integrated, modern country. The victors of the First World War, principally Britain and France, picked up the Arab parts of the Ottoman Empire and spun them off into either colonies or neo-colonies.

In 1918, a startling historical coincidence occurred. Every Muslim state in the world, whether in Asia or Africa, came under European rule. Muslim trauma was accentuated by the fact that for the first time since Prophet Muhammad marched into Mecca in 630, the holy cities of Mecca and Medina were under the suzerainty of a Christian power. Jerusalem, the third holy city, had been lost before, during the Crusades, but never Mecca, where the Prophet was born, or Medina, where he established the first Muslim state.

Persian nationalists might argue that their country was technically independent, since their shah was never actually removed by a European power, but the Anglo-Russian Convention of 1907 effectively ended Persian pretensions to sovereignty. The country was divided into Russian and British 'zones of influence' in which Russia took the north and Britain gained control of the south and its ports. Similarly, pedants might suggest that Muslim Central Asian khanates like Bukhara, Kokand and Azerbaijan became independent of Moscow in 1917 after the collapse of the Tsars during the First World War, but their pretensions were quickly snuffed out by Vladimir Lenin, who sent in tanks and bombers to reassert the boundaries of the tsarist empire. The great library of Bukhara was destroyed in this Bolshevik invasion. Lenin may have been blind to irony when, in November 1919, he described Afghanistan – in a letter to King Amanullah, after control of foreign affairs was restored to Kabul following the brief Third Afghan War in 1919 – as the only independent Muslim country in the world.

By 1919, more Muslims lived under British rule than in any other political space. The Ganga and the Nile were linked by Empire; experience in one area was absorbed into institutional memory, enabling London to formulate policy in another. As Britain organized and reorganized her Arab possessions after 1918, she applied lessons learnt, in war and peace, from the conquest and domination of India. Britain had realized – through the crises and conquests of the nineteenth century – that her interests did not always need the heavy hand of colonization. They might be equally well served by the lighter touch of neo-colonization.

Neo-colonization is the grant of independence on condition that you do not exercise it. (The British weekly newspaper, the *Economist*, provided, in its issue of 20 June 2009, an excellent working definition of neo-colonization in its obituary of Omar Bongo, president, for forty-two years, of former French colony Gabon: 'Their bargain [between Bongo and France] too was a neat one. He allowed the French to take his oil and wood; they subsidized and protected him. At various times through his long political career, when opposition elements got brash, or multi-party democracy, which he allowed after 1993, became too lively, the French military base in Libreville would turn out the paratroopers for him.')

Each one of these events – the fall of the Ottoman Empire, the creation of Arab neo-colonies, the reaction of Afghanistan to the Anglo-Russian Convention of 1907 leading to the Third Afghan War – would play some part in the extraordinary drama of the Indian challenge to the British, and influence the domestic politics that gradually separated Indian Muslims from the unique and unifying national movement led by Mahatma Gandhi. The most creative phase of Gandhi's career was not towards the end, but in the beginning, between 1919 and 1922, when he fused Muslim and Hindu sentiment to mould a non-violent revolution. It was popularly called the Khilafat, or Caliphate, Movement. Indian Muslims, who constituted one-third of the world's Muslim population, mobilized under Gandhi to destroy the British Empire because the British had seized Mecca and Medina from the legitimate caliph of Islam.

The Ottoman sultan was also caliph of the Muslim world, in his capacity as heir to a political tradition that began just after the death of Prophet Muhammad in 632. The caliph merged, in his person, temporal and spiritual responsibilities. He was sultan of his realm, as well as a symbol of Islam in his capacity as custodian of the two holy mosques, Kaaba in Mecca and the Prophet's mosque in Medina. The bonds of Islam did not make the Arab an equal of the Turk in the Ottoman Empire, but religion and contiguity did create a harmony of cultural and economic interests that was less abrasive than European colonization, which was perceived as more foreign, intrusive and hostile.

The Ottomans became caliphs much after they became sultans. Their origins lay in the rise of Osman I[1] in 1300 in southern Turkey. They expanded into Europe; Serbia fell in 1389, Bulgaria in 1394. They crushed a pan-European force at the battle of Nicopolis in 1396, and in 1453 became masters of Eurasia when they conquered the Byzantine capital, Constantinople, till then considered impregnable. The sultan became caliph only in 1517, when Selim I defeated the Mamelukes in Cairo, and extended his possessions to Mecca and Medina. Selim believed that it was his mission to conquer both east and west.

The Ottoman rise was matched by the retreat of Arabs in Europe. The resurrection of Christian Spain and Portugal had phenomenal global consequences. The two Catholic powers opened up maritime routes to the west and east, established a chain of possessions in Africa, Asia and Latin America, and launched the age of imperialism that would make Europe master of most of the world.

The Portuguese reached India in 1498, when Vasco da Gama weighed anchor at the southern trading city of Calicut. They established bases in Cochin in 1503, Goa in 1510 and reached Malacca in South East Asia by 1511. With the advantage of hindsight it is possible to visualize a Portuguese Indian empire: the disarray of central authority in the fifteenth century was not very dissimilar to conditions that the British exploited in the

eighteenth. The Portuguese entertained thoughts of moving inland and north, either in alliance with the Hindu kingdom of Vijayanagar, or at its expense.

The year 1526 turned out to be an auspicious one for both the Ottomans and Mughals. Suleiman the Magnificent defeated the Hungarians at Mohacs; in the east, Babur's triumph at Panipat, near Delhi, established a new, and by far the most successful, Muslim dynasty. By the middle of the sixteenth century, Mughal consolidation had precluded the possibility of a Portuguese empire. Portugal was limited to three trading posts on the western coast – Goa, Daman and Diu – and trading rights in the east, at Hooghly in Bengal. It remained content with a string of some fifty well-defended fortresses along the sea routes of the Indian Ocean that protected a lucrative trade, and were often able to command a premium on ships flying other flags. Sporadic Portuguese attacks on Indian pilgrim ships on their way to Jeddah caused continual tension with the Mughals, for haj security was a fundamental responsibility of the Mughal state.

The Ottoman ebb was managed more skilfully than the Mughal, but its élan began to seep out in a slow dribble after the failure to take Vienna in 1683. The fall of Vienna would have, as has been often said, brought Austria into the Ottoman domain, and made it the most powerful force in Europe. Defeat, conversely, punctured its confidence; retreat from the walls of Vienna became the first stage of the long retreat from Europe.

The Mughal collapse, between 1715 and 1725, was more sudden and spectacular. The causes were similar: in essence, an inability to modernize the economy or political and military institutions. There is no satisfactory explanation as to why the Ottomans did not increase the range and mobility of their field guns by adopting the latest advances in metallurgical technology; or why they did not increase the size of their ships to bigger European standards after the naval defeat at Lepanto. Both the Mughals and Ottomans also failed to democratize the educational system with the help of new technologies like printing. There was nothing un-Islamic about printing. But the calligraphers in the

bureaucracy who kept records, and the clergy in the seminary, formed a powerful conservative coalition that resisted instruments of modernity.

———~~~———

Queen Elizabeth granted a royal charter to what came to be known as the East India Company on the last day of the sixteenth century. The first British ambassador, Sir Thomas Roe, an Oxonian who had been knighted for exploring the Amazon, received an audience from Emperor Jahangir in Agra in 1615. Jahangir, used to pearls from the Portuguese, sniffed at Sir Thomas's pedestrian presents and asked, instead, for an English horse.[2] The embarrassed, but patient, Englishman was finally granted a *firman* to trade in 1618. The East India Company was only one of many British enterprises – among them Levant, Muscovy, Royal African, Massachusetts Bay and South Sea – engaged in international commerce; but it was by far the most successful. By 1750, its network extended from Basra to Sumatra.

The most important of its possessions was Calcutta, founded in 1690, on the Hooghly river in Bengal. Maya Jasanoff explains why: 'From their capital at Murshidabad, the nawabs of Bengal presided over the richest province of the Mughal Empire. Cotton cloth, raw silk, saltpeter, sugar, indigo, and opium – the products of the region seemed inexhaustible, and all the European merchant companies set up factories to trade in them. Travelling downriver from Murshidabad was like travelling across a mixed-up map of Europe: there were the Portuguese at Hughli, the Dutch at Chinsura, the Danes at Serampore, the French at Chandernagore, and, of course, the British at Calcutta.'[3] The nawabs of Bengal were among the richest Indian princes until ruined by conspiracy and defeat.

The British began their Bengal trade in 1633, from Balasore and Hooghly, a riverside settlement named after the river. In 1660, they established 'factories' at Kasimbazar and Patna. Since corruption and threats were endemic, they set up a fortification

and began to raise local troops. In 1701, Emperor Aurangzeb sent a recently converted Hindu, Murshid Kuli Khan, as his financial representative to Bengal. In 1704, Kuli Khan established himself at Mokshabad, which he renamed Murshidabad in his own honour, and which he turned into the capital when he was appointed governor in 1713. His line was awarded the title of 'nawab' in 1736. It would be a short line.

The penultimate nawab, Alivardi Khan, was a perceptive man who was fully conscious of the growing strength of the Europeans, and the malpractices used to bolster that strength. He called the British 'Hatmen', literally, men who wore hats rather than turbans. He compared them to bees: Indian rulers could share the honey, but if you disturbed the hive they would sting you to death. He was apprehensive that after his death, 'Hatmen' would possess all the shores of India. His nominated heir Siraj ud Daulah ('Lamp of the State') clearly did not heed such advice. Siraj set out to disturb the hive. Angered by a suspected conspiracy between the English and his aunt Ghasita Begum, who had her own candidate for his job, he attacked the British settlement in Calcutta in 1756.

The man generally credited with turning a trading company into a political behemoth, Robert Clive, was in Madras at the time. He was nineteen when he reached India in 1744, on a starting salary of five pounds a year (plus three pounds for candles and servants; accommodation was free). Robert Harvey notes that Clive's pay was performance-related, his 'job was tedious in the extreme . . . lodgings were plagued with mosquitoes, giant ants and constant coatings of dust from periodic storms . . .'[4] He had three servants but could only afford them with financial help from his father. Clive took up chewing paan and smoking the hookah, but his preferred pleasure remained wine. There is a disputed story that he tried to commit suicide, and when he failed after two attempts began to believe that he had been reserved by destiny for higher tasks. What is beyond doubt is that even in Madras he realized that the British could win India if they but showed the imagination to do so.

Clive had acquired a well-earned reputation for military skill

when, in June 1756, the Calcutta garrison was outnumbered and overwhelmed. That night, one of the hottest of the year, 146 prisoners, including a woman and twelve wounded officers, were stuffed into a cell, 18 feet long and 14 feet wide, called the 'Black Hole',[5] with only two air vents. Only twenty-three survived.

Outrage, not to mention the lucrative trade of Bengal, demanded revenge, and a more pliable ruler. In December 1756, Clive left Madras for Calcutta with a fleet of six ships. On 23 June 1757, exploiting ambitions within the nawab's family, and displaying brilliant battlefield strategy and courage, Clive ended Muslim rule in Bengal near a village called Plassey. Clive had eight guns, 800 Europeans and 2,100 sepoys against an army of 50,000 backed by heavy artillery. Siraj ud Daulah escaped on a fast camel when only some 500 of his troops had died. As Clive wrote in a brief note to the Committee of Fort William after the battle: 'Our loss is trifling, not above twenty Europeans killed and wounded.'

The British built their Indian empire in small, careful steps, choosing one adversary at a time, and using exceptional diplomatic skills to sabotage an enemy alliance to the extent they could. They were brilliant at provoking dissent through the effective expedience of promising power to the rebel. The sequence of military victories encouraged hope in potential rebels and kept potentates off-balance; reputation became a pre-eminent British asset. The British advance was helped by the implosion of the Mughal Empire, and the rise of regional princes who paid nominal homage to the emperor in Delhi. Individually, they could not withstand the discipline, will and competence of British officers, soldiers and the 'native army' they raised, trained and turned into a splendid fighting force.

———⟨⟩———

The vulnerability of Indian Muslim communities increased in direct proportion to the gradual erosion of their empire between 1757 and 1857. As they struggled to find new equations with

fellow Indians and the foreign British, they were squeezed from both sides: Hindus, who had the advantage of numbers, and the British, who had the advantage of power. An assertive Hindu elite claimed preference under British rule after centuries of a sense of feeling denied. The British were also wary of any revival by those they had displaced, the Muslim nobility; unsurprisingly, it was marginalized.

Since the capital of the British Raj was in Bengal, a dominion that included much of eastern India, the politics of Hindu–Muslim relations in this province was always a major factor in the formulation of British policy. The British created a new set of landed and commercial elites in Bengal. In stages, the traditional Muslim establishment of the Gangetic belt between Calcutta and Delhi was either whittled down, as in the case of the old landed nobility, or eliminated, as happened to the military aristocracy. Muslims retreated into a sullen despondency. But one group, the ulema, or the clergy, surprised the British with its determination, ideology and persistence, and shocked them with a newly acquired military skill.

The ulema have always had a special place in Muslim societies, not merely as leaders of prayer but as judicial and educational bureaucracy. Ulema is the plural of *alim*, meaning a wise man. Alim is a derivative of *ilm*, or knowledge. There are three degrees of knowledge: *ain al-yaqin*, certainty derived from sight; *ilm al-yaqin*, certainty from inference or reasoning; and *haqq al-yaqin*, the absolute truth, which is the eternal truth contained in the Quran. As scholars, the ulema extended their expertise to the arts and sciences, and their seminaries became schools that stored and disseminated knowledge to Muslims.

The high status given to knowledge in Islam has been transferred to the keeper of knowledge, the cleric-teacher. Imam Abu Abdullah Muhammad Bukhari (810–70), who culled some 7,000 sayings and stories about Prophet Muhammad from a mass of about 600,000, reports the Prophet as saying that envy is permitted in only two cases: when a wealthy man disposes of his wealth correctly, and when a person of knowledge applies and teaches

it. Another Hadith says that he who goes on a search for knowledge is treated as being on jihad. The first great seminaries were established within seven decades of the Prophet's death.

The Indian clergy energized despondent Muslims across the subcontinent, from Peshawar to Dhaka, and inspired, between 1825 and 1870, what is best described as a people's war. By the time this insurrection was defeated, it had planted seeds of a fierce anti-West, anti-colonial sentiment that prepared the community for the nationalist movement lead by Gandhi. Gandhi recognized the importance of such allies, and wooed Muslims through the ulema.

There was more than one strand in the ideological heritage of nineteenth-century ulema, but the most influential voice belonged to the school of Shah Waliullah (1703–62), the pre-eminent theological intellectual of Delhi. His son, Shah Abdul Aziz (1745–1824), issued the influential fatwa in 1803 that declared India a 'house of war', and his disciple, Sayyid Ahmad Barelvi (1786–1831), launched a jihad in 1825. Barelvi's movement began in eastern India, but he made Balakot in the Malakand division of the North West Frontier his war headquarters: a town that was destined to become famous again as a haven of the Pakistan Taliban. Barelvi's strength lay in the mobilization of subaltern forces. Donations came from the meanest Muslim homes, ferried by an invisible network of clerics: when peasants ate a meal in Bengal or Bihar, they would set aside a handful of uncooked rice as their contribution to the jihad. This long war confirmed in British minds the view that Muslims, when inspired by faith, fought for ideas beyond the conventional dynamic of territory and kingdom; and convinced them that Islam was a faith that inspired permanent war.

Strength, guile, and the exploitation of competing egos had enabled the British to destroy Indian princes. A subaltern war needed other solutions. Their most successful tactic was the slow injection of inter- and intra-communal hostility into the popular discourse.

Lord Charles Canning, the last Governor-General and first

viceroy of India (the transition from East India Company rule to the British Crown took place during his turbulent tenure, 1856–62) wrote candidly to Vernon Smith, president of the Board of Control, on 21 November 1857, at the height of the 'mutiny': 'As we must rule 150 million of people by a handful [of] Englishmen, let us do it in a manner best calculated to leave them divided (as in religion and national feeling they already are) and to inspire them with the greatest possible awe of our power and with the least possible suspicion of our motives'.[6] The instructions to James Bruce, eighth earl of Elgin, Canning's successor, were specific: 'We have maintained our power in India by playing off one party against the other, and we must continue to do so. Do all you can, therefore, to prevent all having a common feeling.'

There were many options available: competition for jobs; the lure of advancement through preferences in language, education and the economy. An unusual provocation for discord was history. Both Hindus and Muslims were tempted by an imagined past. Influential Hindu intellectuals explained centuries of Muslim rule as unrelieved tyranny that had kept a civilized and non-violent people, the Hindus, subservient. Muslim zealots glorified the worst examples of aggression, like the iconoclast and looter Mahmud of Ghazni, and encouraged Muslims to believe that they were superior to Hindus. The upper-caste Hindu resurgence of the nineteenth century was infected by an undercurrent of anti-Muslim bias, in which Muslims had to be punished for real or imagined sins from the past.

The British did not invent fantasy; Muslims and Hindus were quite capable of deluding themselves. But history became a frontline weapon in the armoury of colonial power, particularly when it could be fired with stealth. The potential of Hindu–Muslim strife was always present below, and occasionally above, the surface. Textbook history is rarely the memory of peace. Chronicles of conflict were mutilated by exaggeration and propaganda. Ordinary people, who had gained little from the rule of their elites, basked in the vicarious pleasures of 'triumph' or suffered the 'humiliation' of defeat.

While Muslim self-glorification easily encouraged excess, nineteenth-century Hindu intellectuals had a different dilemma: why were the most powerful Hindu princes unable to replace the feeblest Mughal ruler in Delhi? The alibis extended from a rapacious, barbaric, culture-insensitive Islamic temperament (an image easily extended to the rape of a beautiful wife and the rape of Mother India), to betrayal. Muslim partisans were equally eager to claim superior genes, and taunt Hindus as cowards. As acrimony gravitated towards hatred, the British did not have much to do, except watch, and, when opportunity presented itself, nudge.

A strange alchemy of past superiority and future insecurity shaped the dream of a separate Muslim state in India.

2

A Scimitar at Somanath

‖◦◦◦‖

Pakistan's nuclear missiles are named Ghazni, Ghauri, Babur and Abdali: each name has been turned into a symbol of Muslim victory in a Hindu–Muslim conflict. Modern India has named its nuclear missiles after the elements: Agni, Aakash, Prithvi. Fire, Sky, Earth.

The past, however, is more shaded and complex than a one-dimensional metaphor would suggest. While battlefield conflict between Hindus and Muslims forms most of the text of historical narrative, Indian society developed along a more cooperative axis, even as rulers learnt that the battle cries that had brought them to power would not help them survive it.

Mahmud of Ghazni, the first Muslim to invade central India, is renowned for his wanton destruction of Hindu temples, particularly the revered Shiva shrine at Somanath on the coast of Gujarat. Muhammad of Ghor (hence Ghori) defeated the last Hindu king of Delhi, Prithviraj Chauhan, in 1192; his successors established Muslim rule from Gujarat to Bengal. Zahiruddin Babur revived Muslim rule from near-terminal decline and founded the Mughal Empire in 1526. Ahmad Shah Abdali was the Afghan king whose decisive intervention in the third battle of

Panipat, in 1761, prevented Mughal Delhi from falling to the ascendant Marathas; without Abdali, there would have been a Hindu emperor in Delhi in the middle of the eighteenth century.

History and its manipulated symbols matter in a subcontinent that won freedom from the British in 1947 but has yet to find peace with itself.

A war over symbols began the moment India became free, and it centred around the ruins of Somanath temple, destroyed nine centuries before by Ghazni. A senior Congress leader, K.M. Munshi (1887–1971), demanded that almost the very first thing that the government of free India should do was to restore 'Hindu pride' by rebuilding the temple.

Although Munshi was appointed home minister in the first elected Congress government of Bombay, in 1937, he was always a bit ambivalent, privately, about Mahatma Gandhi's commitment to non-violence. He left the Congress in 1941, arguing that violence might be justified in self-defence. He returned to the Congress in 1946 and served as food minister after 1947. Munshi had the support of the first home minister of India, the redoubtable Sardar Vallabhbhai Patel, but the first prime minister, Jawaharlal Nehru, thought that the state should have nothing to do with religious projects like temple construction. Munshi and his supporters believed that the destruction of Somanath was symbolic of the 'barbarism' that they considered synonymous with Muslim rule in India.

Ghazni, a feared iconoclast and military genius, massacred an estimated 50,000 defenders and plundered the wealth of Somanath in 1026. This was the high point of sixteen undefeated campaigns in which Mahmud looted a string of towns across north India. The scars, their memory revived in the decades of verbal and physical confrontations that preceded the creation of Pakistan, had filled with fresh blood by 1947.

Munshi turned his project into free India's first public–private partnership. He financed the reconstruction through donations from individuals as well as a grant of Rs 5 lakhs (a substantial contribution at the time) from the government of Saurashtra. The

two highest functionaries of the Indian state, President Rajendra Prasad and Prime Minister Jawaharlal Nehru, differed sharply over this project. Prasad was an enthusiastic supporter, and wanted to be present at the inauguration of the rebuilt temple in 1951. Nehru thought that the constitutional head of a secular state had no right to give official legitimacy to such an event by his presence. On 2 May 1951, Nehru wrote a formal letter to chief ministers explaining that 'Government of India as such has nothing to do with it [the reconstruction]. While it is easy to understand a certain measure of public support to this venture we have to remember that we must not do anything which comes in the way of our State being secular. That is the basis of our Constitution and Governments therefore, should refrain from associating themselves with anything which tends to affect the secular character of our State. There are, unfortunately, many communal tendencies at work in India today and we have to be on our guard against them'.[1]

Despite Nehru's objections, Prasad presided over the opening ceremony. They may have found it impolitic to say so publicly, but many Congressmen believed, as Munshi did, that Islam had destroyed the religious and social integrity of India. Munshi lamented, in *Somanath: The Shrine Eternal,* 'For a thousand years Mahmud's destruction of the shrine has been burnt into the collective subconscious of the race as an unforgettable national disaster.'

Pakistan, perhaps inevitably, glorified the destroyer of Somanath. Ghazni has been turned into a forefather of Pakistan in textbooks. He is seated on an even higher pedestal than Muhammad bin Qasim, the Arab who landed on Sind's shores with an Umayyad army in 712 and established the first Muslim kingdom on the subcontinent, which lasted for about a century and a half. Qasim gets credit for bringing the first 'Islamic' army to the subcontinent; Ghazni is celebrated as the fountainhead of Islamic power.

—◦◦◦—

Islam, in fact, came to India long before the armies marching in its name. The first Indian converts to Islam were residents of the southern coastal region of Malabar, in north Kerala, hosts and partners of Arab merchants and seafarers. Malabar is said to be a variation of the Arabic word 'mabar', meaning a place of passage. Its food and culture have been influenced by the Arab connection, and it remains a preponderantly Muslim district to this day.

Qasim brought an Arab army to the northern shores in Sind to establish a bridgehead from where he could clear the sea of pirates who had become a menace to Arab ships on the traditional and lucrative trade routes between Arabia and the Gujarat–Sind coastline. Qasim's Arab kingdom did not last very long – about 140 years – or grow to any significant size. It petered out in the deserts of Sind, and could never penetrate either east or north into the Rajput kingdoms of Gujarat, Rajasthan and Punjab. They held their line against the *mlechha*, the impure, as Hindus termed the invaders.

This line was breached, repeatedly, by Ghazni, ruler of Afghanistan between 999 and 1030. In 1000, Mahmud's cavalry defeated the forces of Jaypal, the second-last king of the Rajput Hindu Shahi dynasty, at Peshawar. Popular lore suggests that the mountains around the battlefield were named the Hindu Kush (Killer of Hindus) because of the numbers slain. Jaypal immolated himself on a funeral pyre; Mahmud extended his domains to roughly the point marking the international border between India and Pakistan today. Muslims ruled this region on either side of the Indus till the rise of the Sikhs under the inspirational leadership of Maharaja Ranjit Singh (1780–1839).

Mahmud's ferocity and avarice were not community-specific. He savaged Muslim principalities like Multan, Mansura, Balkh and Seistan with equal enthusiasm. Abu Raihan Muhammad ibn Ahmad, better known as Alberuni, the scholar who served in Mahmud's court, recalls the plunder that his master brought back, along with prisoners, from the historic Central Asian khanate of Khiva. His booty from Rayy in Persia was said to be

only a little less than that from Somanath. But what might be called the Pakistani memory of Mahmud, passed on to new generations through schoolbooks, does not dwell on this inconvenient truth. Alberuni travelled to India with Mahmud and recorded the economic devastation and the hatred for Mahmud and Muslims it generated.[2] The Hindu heartland's first experience of Muslim conquest shaped a reputation for frenzy, pillage and worse. Muslims became the archetypal uncivilized barbarians who would never permit another faith to coexist with honour. The hangover lingers to this day.

Mahmud laid waste rich pilgrimage cities like Mathura and important provincial centres like Kannauj. He used naptha and fire to level the Krishna temple at Mathura, an architectural masterpiece. Al-Utbi, Mahmud's secretary, quoted his master, in *Tarikh-i-Yamini* (written by 1031), as saying that the temple must have taken two hundred years to build. Propaganda by the victor, and horror of the victim, both tend to exaggerate, but iconoclasm served a dual need: Mahmud could fill his treasury even as he posed as a champion of Islam in an age when Muslims seemed invincible. The most tempting target was Somanath, surrounded by the Indian Ocean on three sides, rich with the offerings of sea-faring merchants and inland pilgrims. According to one account, the loot from Somanath was valued at 20 million dirhams worth of gold, silver and precious gems.

The historian Romila Thapar offers an interesting Islamic explanation for the destruction of the temple.[3] She suggests that it may have been linked to Mahmud's ambitions in the Arab–Persian world, where Abbasid power was in ebb, and claimants to the caliphate were hovering over Baghdad. Thapar suggests a link between Somanath and the famous controversy over the three principal goddesses of pre-Islamic Arabia, Lat, Uzza and Manat, daughters of the supreme deity. Lat's idol had a human shape, Uzza's origin was in a sacred tree, and Manat, goddess of destiny (also known as Ishtar) was manifest in a white stone. Her shrine was in Qudayd, near the sea. The pre-Islamic pilgrimage to Mecca was considered incomplete without a visit to Qudayd.

The Prophet of Islam, Muhammad, challenged this heresy with the message of *tawhid*, or the One God, and was forced to emigrate by his own tribe, the Quraysh, who had turned the mosque at Kaaba into a place of idol worship. In 630, the Prophet returned to Mecca and destroyed the idols inside Kaaba, including those of Lat and Uzza. It is said that a devoted idol-worshipper reached Qudayd before the Muslims and escaped with Manat's image on a trading ship heading to Gujarat, where it was placed in a temple. This temple to Manat came to be known as Su-Manat, and thence Somanath. Mahmud intended, in other words, to complete the objective of the Prophet and thereby raise his stature in the Muslim world, as part of his campaign to become caliph of the Muslim world.

But such theories were of little comfort to Somanath's victims, or those who suffered psychological anguish in its wake. Nor did the fact that Mahmud's armies included Hindu units offer any balm. Thapar notes that 'there were Indians of standing . . . who were willing to support the ventures of Mahmud and to fight in Mahmud's army not merely as mercenary soldiers but also as commanders', among whom was a certain Suvendhray. These Hindu troops 'remained loyal to Mahmud'. They, along with their commander, Sipahsalar-i-Hinduwan (Commander of the Hindus), lived in their own quarters in Ghazni. When a Turkish general rebelled, his command was given to a Hindu, Tilak, who is commended for his loyalty (mentioned in Abul Fazl al-Bayhaqi's *Tarikh al-Sabuktigan*). Complaints are recorded about the severity with which Muslims and Christians were killed by Indian troops fighting for Mahmud in Seistan.

Some of Mahmud's coins were inscribed in both Arabic and Sharda scripts. Others had an image of the Nandi bull, with the legend *Shri Samanta Deva*. One dirham has a line in Sanskrit: *Avyaktam ekam Muhammada avatara nripati Mahmuda*. Roughly translated, it means that Muhammad is the Prophet of the One God, and Mahmud is King.

Temple destruction is hardly unknown in Indian history; a victor signalled change of authority by installing seized idols as

war trophies in his own temples. The Lakshman temple in the famous Khajuraho complex was built around 950 by Raja Yasovarman of the Chandala dynasty to house the image of Vishnu Vaikuntha, originally taken as war booty from the defeated Pratiharas. In the south, Krishnadevaraya, who ruled between 1509 and 1529, took away the image of Balakrishna when he defeated the Gajapati ruler Prataparudra of Udaygiri in what is now Andhra Pradesh. There are numerous such instances. But Mahmud did not divert idols to another capital; he smashed them.

The politics of Hindu–Muslim–British relations rubbed salt into old wounds. The British did not need to invent the past, merely to embellish it. The bravado of some Muslim accounts, like that of a seventeenth-century historian, Ferishta, was useful to their cause. *Tarikh-i-Ferishta* was riddled with inconsistencies; it could not make up its mind whether the idol at Somanath was a lingam, a representation of Shiva's male prowess, or a figure five yards high with a belly stuffed with gems. But the image of this belly being slit by Mahmud's sword suited the Western depiction of Islam as a faith of bigots.

In 1842, Lord Ellenborough, then Governor-General of India, instructed General Nott, head of the British Army in Afghanistan, that were he to return via Ghazni he should bring back the sandalwood gates from the tomb of Ghazni, which, he claimed, had been carried away from Somanath. Their return, Ellenborough argued, would mark a restoration of Indian/Hindu pride. 'However,' writes Thapar, 'there was little reaction from the princes and still less from the Hindus.' The gates were brought back, and found to be of non-Indian origin. But the proclamation served its political purpose. Ghazni became a focal point in the emerging Hindu–Muslim politics. Ellenborough's tactics were criticized in a debate in the House of Commons. He was occasionally surprised by the Hindu reaction as well. When he sought legal opinion from the Hindu lawyer of the raja of Satara, the reply was piquant. Hindus did not want the gates back, he was told, because any object that had been in contact with a dead body, even a tomb, had become polluted.

Such is the power of myth that an 'essential reference guide' published by Penguin in 2000, *The Indian Millennium*, says, with unblinking authority, in its entry for 1026, that Ghazni took away these gates: 'Mahmud of Ghazni sacks Somanath during the reign of Bhimadeva I. Mahmud destroys Somanath temple (January 8) and takes away the sandalwood gates of the city as well.'

———◦◦◦———

Indian historians, and those who made use of history for political purposes, have inhabited three broad camps. One set read history as practical accommodation between elites, in which religion was a secondary factor except when personality flaws led to aberrations, as in the case of Aurangzeb. A second group chose to propagate the view that Hindus and Muslims may have lived on the same land, but as separate social and political nations. And then there were those who fashioned the past through the prism of 'communal nationalism' in which a 'Hindu India' had been consistently violated by Muslim rulers. This ideology found fervent advocacy in historical fiction and sometimes folklore. K.M. Munshi, to give one instance, started his literary career with books in which a glorious Aryan–Hindu culture is vitiated by the arrival of Islam and its savage armies. The starting point of this narrative is the defeat of Prithviraj in 1192.

Early in the twelfth century, a Chahamana, or Chauhan, Rajput prince called Ajayaraja broke away from the Gurjara–Pratihara Empire to form an independent state with a new capital, called Ajayameru (now Ajmer). In the middle of the century, an expansionist successor, Vigraharaja, extended the realm to Delhi and eastern Punjab, where it bordered territory controlled by the Afghans. Vigraharaja added his own inscriptions to an Ashoka pillar (now preserved in Delhi), claiming that his sway had reached the Himalayas, and that he had frequently exterminated the *mlechhas* (Muslims) and made *aryavarta* (land of the Aryan-Hindus) secure for the *arya*.

Relations between the adjoining Afghan and Chauhan states

were the normal mix of trade, travel and skirmish. Muslims did not live only in Afghan territory. There were existing Muslim settlements as far east as in Varanasi. Muslim missionaries from Central Asia had brought the message of Islam to the Punjab and Gangetic belt. The *zuhad* (asceticism) and *taqwa* (piety) of these Sufis from Central Asia made them attractive to a Hindu population weaned on spirituality. Shaikh Ismail of Bukhara reached Lahore in 1005 and lived there till his death in 1056. Lahore was also the home of Shaikh Syed Ali bin Usman Hujwairi, a Persian Sufi and scholar known as Daata Ganjbaksh, who died some time between 1072 and 1079. Unusually, he did not leave behind a *silsila*, or heirs, but his mausoleum remains a Lahore landmark and attracts millions of devotees; Lahore is also known as 'Daata di nagari', or city of the Daata.[4]

The most influential Sufi sage (arguably, of the millennium) was the venerable Khwaja Muinuddin Chishti, the mystic known as 'Gharib Nawaz' (roughly, benefactor of the poor), who settled in Ajmer in 1191, a year before Prithviraj's defeat. By the time he died in 1236, he had become a cult figure for both Hindus and Muslims.

Sufis were indifferent to politics. Kings lived and died on the ebb and flow of power. The Afghan urge to extend their rule into the rich Gangetic plains hovered over the twelfth century. Some Hindu kingdoms imposed a strategic tax to pay for defence, called turuska (the local word for Turk, synonymous with Muslim). John Keay explains that 'This could have been a levy to meet tribute demands from the Ghaznavids, but seems more probably to have been a poll-tax on Muslims resident in India and so a Hindu equivalent of the Muslim *jizya* (poll tax on Hindus).'[5]

The Ghoris were a Tajik dynasty who, from their base in central Afghanistan, swept aside the Ghaznavids and began to probe further east. Muhammad Ghori invited Prithviraj to make common cause against the powerful Solanki state in Gujarat. Prithviraj refused. Ghori was defeated in Gujarat and turned north, securing Lahore by 1187. In 1191, he turned towards Delhi. He was mauled in his first encounter with Prithviraj at Tarain, some

150 km north of Delhi. His retreat was in good order, but the reception he organized for his troops was less than welcoming. They were paraded through the streets with horses' nosebags around their necks, while citizens jeered.

Ghori rearmed and returned in the summer of 1192, with a 120,000-strong cavalry. Prithviraj, his fame fanned by success, assembled what was said to be the largest-ever Rajput alliance, despite the fact that his father-in-law, Jaichand, the formidable king of Kanauj, refused to join his banner. Ghori's battle plan was borrowed from Ghazni. He first caused disarray in the enemy camp with a predawn attack, and followed it with an air assault of arrows. As Prithviraj's elephant-led formations began to move, Afghan cavalry attacked the flanks in sudden bursts, wearing down opposition. Around sundown, Ghori, at the head of 12,000 fresh cavalry, led the decisive charge that won the battle.

Ghori returned to Afghanistan, but his Tajik-Turk generals established themselves in north India with spectacular speed. They opened the route to Rajasthan by taking the massive fort at Ranthambore. Jaichand was defeated in 1194, at Chandwar in Etawah. By 1199, the Turuskas had taken Gujarat. Bakhtiar Khalji conquered Bengal in 1204. In 1206, when Ghori was stabbed to death during a revolt of a Punjabi hill tribe, the Gakkars, his governor in Delhi, Qutbuddin Aibak, declared independence and established what is now known as the sultanate of the 'Slave Dynasty', or Mamluks. 'Slave' is a misnomer. Prisoners of war, whether soldiers or officers, were technically 'slaves' because they could be ransomed. Aibak had once been prisoner of the qazi of Nishapur before being purchased and freed by Ghori, in whose service he rose to high command. The Qutub Minar is his contribution to Delhi's skyline; a third of this unique pillar was constructed during his lifetime.

Distances were forbidding, communication difficult, but a new warrior class had routed the old order and established the first Muslim state from Punjab to Bengal. The strength of Delhi was never consistent, but the primacy of power remained in Muslim hands. Slave sultans (1206–90) were followed by the Khiljis

(1290–1320), Tughlaqs (1320–1413), Sayyids (1414–1451), and the Lodis (1451–1526). The Mughals sat on the throne of Delhi from 1526 (apart from a brief hiccup of fourteen years) till the British arrived in the nineteenth century.

These 'Muslim' armies did not – could not – consist only of Muslims. It is estimated that there were only about 20,000 Turkish families who had stayed in India after Ghori's victory. Ziauddin Barani (c.1280–c.1360) records in *Tarikh-i-Firuzshahi* that Hindu infantry, from both high and low castes, was recruited into the sultanate force. Barani emphasizes that the sultans were respectful of Hindu sentiment. Jalaluddin Khilji, to give one instance, complained about the noise made by Hindu processions passing by the walls of the palace each morning, with drums and trumpets, on their way to worship on the banks of the Jumna, but never stopped them. 'They do not care for our power and magnificence,' said the sultan, according to Barani. The sultan added, not without, it seems, a tinge of regret, 'During our rule the enemies of God and the enemies of the Prophet live under our eyes and in our capital in the most sophisticated and grand manner, in dignity and plenty, enjoying pleasures and abundance, and are held in honour and esteem among the Muslims.' Any regret was private; state policy was more prudent. It did not interfere with local custom and practice.

The co-option of the local Hindu nobility gave the administration depth and stability: Prithviraj's family was also given a place in the new order. Barani reported what he saw: 'The desire for overthrowing infidels and knocking down idolaters does not fill the hearts of the Muslim kings. On the other hand, out of consideration for the fact that infidels and polytheists are payers of taxes and protected persons, these infidels are honoured, distinguished, favoured and made eminent; the kings bestow drums, banners, ornaments, cloaks of brocade and caparisoned horses upon them and appoint them to governorships, high posts and offices.'

The sultans, as good believers, proclaimed Allah as the source of their victories and gave themselves titles such as al-Mujahid fi

Sabilullah (Warrior in the Path of Allah), Nasir-ul Millat wal Muslimin (Helper of Muslims) and Muhyyus Sunnat (Reviver of Sunnat, or the law of the Prophet). But, as Finbarr Flood points out in his essay, 'Islam, Iconoclasm and the Early Indian Mosque', 'Seldom is it noted, for example, that, in their Indian coin issues, the Ghurid Sultans continued pre-existing types featuring Hindu deities such as Lakshmi and Nandi. While it by no means proves that the issue of the image was unproblematic, the minting of such coins certainly reveals a more complex and ambivalent response to figural imagery (even religious imagery) on the part of the Ghurid Sultan than one would suspect from reading contemporary chronicles.'[6]

The sultans, however, kept the ulema out of statecraft, and resisted continual pressure to make forcible conversion a state enterprise. Iqtidar Hussain Siddiqui quotes Barani to affirm that Alauddin Khilji (ruled 1296–1316) 'held firm to the viewpoint that kingship is separate from Sharia (the holy law) and religious tradition. The affairs of the state concern the King while the enforcement of Sharia comes within the jurisdiction of the Qazis and the Muftis (the expounders of the law).'[7] The chronicler lists Khilji's most notable achievements. Cheap grain, cloth and basic necessities for the people are at the top; and although Khilji defeated the feared Mongols and described himself as a second Alexander, his military achievements come afterwards. The repair of mosques is placed eighth, and there is no mention that Khilji earned any earthly or heavenly merit by destroying idols or spreading the faith. He did loot temples and reward converts, but neither was considered worthy of mention. 'They (Turkish Sultans) appear to have realized the need for cooperation between the Sultan and hereditary land chiefs, Hindu and Muslim alike,' writes Siddiqui.

The most famous convert of his time was Alauddin's brilliant general, Malik Kafur Hazardinari,[8] a handsome Rajput Hindu eunuch captured during the conquest of Gujarat. Alauddin, impressed by his talent, appointed him malik-naib (senior commander), and placed him in charge of the southern campaigns

that took the army up to the Pandya kingdom of Madurai, on the southern coast of India. Kafur was as good a politician as a soldier, and exploited local rivalries. The Seunas in the Deccan helped him conquer the Hoysalas, and the Hoysalas to defeat the Pandyas.

It is important to note that a policy of adjustment, rather than permanent war upon the infidel, was practised even by the first Muslim to invade the subcontinent, Muhammad bin Qasim. Siddiqui notes: 'The *Chachnama* (a history of the Arab conquest of Sind) seems to have been translated by Ali bin Hamid al-Kufi with a view to providing the new rulers of the region, Sultan Nasiruddin Qubacha and his officers of foreign birth, with information about the political traditions followed by the early Muslim rulers (the Arab conquerors) since the eighth century AD. The translator brings into greater relief the need for the Muslim rulers not to interfere with the social system of the Hindus in India. For example, Muhammad bin Qasim is said to have sanctioned the privileges of the high castes and the degradation of the low castes. The Brahmans [*sic*] were granted full religious freedom and also appointed to important positions in Sind and Multan regions ... It suggests by implication that the Sultan should foster cordial relations with the hereditary local potentates, for they constituted an important element in Indian polity. Ali bin Hamid al-Kufi seems also to imply that the victorious Muslim ruler should regard his victory over the chiefs as a prelude to a rapprochement and not to their annihilation.' This contrasts sharply with the catechism of Pakistani school texts, which enforce the view that Qasim's arrival liberated Hindus from Hinduism. Qasim also exempted the highest caste, Brahmins, from jiziya, the hated tax on Hindus.

Alauddin Khilji gave priests their due, but no more. The sultan limited his interference in the courts of qazis and muftis to rare emergencies. He might dine with the four leading ulema – Qazi Ziauddin, Maulana Zahir Lung, Maulana Mashayed Kuhrami and Qazi Mughis – but when Qazi Mughis once suggested to the sultan that the wives and sons of rebels could not be held guilty

of a man's crimes, Khilji crisply replied that while the qazi was undoubtedly wise, he had no experience of administration.

To what extent was Sharia, the law of Allah, applicable in a multi-faith state? The sultans took a pragmatic rather than a theological view. Alauddin declared, says Barani, 'I do not know whether such commands are permitted or not in the *Sharia*. I command what I consider to be of benefit to my country and what appears to me opportune under the circumstances. I do not know what God will do with me on the Day of Judgment.'

The scholar M. Mujeeb comments, 'All rulers could not be as frank as Alauddin, because they did not possess as much power. But no ruler could give priority to orthodoxy over reasons of state. If we consider the period of the sultanate and look for the highest common factor in the policies of the kings, it would perhaps be judicious non-interference in matters of religion.'[9] In theory, Muslim rulers have shadow-sovereignty, since the final authority rests with Allah. Islam was the state religion in the sultanate, and the ulema were intellectuals (turban-wearers) as well as the judiciary. The Qadi-i-Mumalik was also the Sadr-us-Sudur. The hierarchy was clearly defined: Shaikh-ul-Islam, Qadi, Mufti, Muhtasib, Imam, Qatib and Ustad, the teacher whose salary was paid by the state. The court ulema, usefully, gave religious protection to the sultan's decisions, and were popularly known as 'ulema-e-duniya' or 'ulema-e-su', the worldly clerics, as distinct from those who did not care for this earth's rewards, like the mystics.

Sultan Iltutmish (ruled 1210–36) wooed religious scholars like Shaikh Bahauddin Zakariya, Khwaja Qutbuddin Bakhtiyar Kaki and Shaykh Fariduddin and went to hear the sermons of Sayyid Nuruddin Mubarak Ghaznavi, but, as Khaliq Ahmad Nizami points out, clerics were not given a role in policy formulation.[10] Ghiyasuddin Balban (ruled 1266–87) inducted Fariduddin Zahid – teacher of Delhi's pre-eminent saint, Nizamuddin Auliya – into state service, but, in Barani's words, Balban made it clear that 'royal commands belong to the king and legal decrees rest upon the judgments of *qadis* and *muftis*'.

The sultans had reason to be apprehensive about Sufis, who fused divine power with mass popularity, placed ethics above the law and made little distinction between Hindu and Muslim devotees. The influential fourteenth-century divine Sheikh Sharf ud Din Ahmad bin Yahya Maneri – a contemporary of Feroz Shah Tughlaq – who was born near Patna in Bihar, ridiculed political zealots who wanted to massacre all infidels. Faith, he argued, was the antonym of conceit, while power was synonymous with it. The Sharia, in his view, had to be interpreted according to the emerging needs of Muslims. The intellectuals of the time could be found as often at the feet of a Sufi as the sultan: Nizamuddin Auliya's disciples included the great poet Amir Khusro and the historian Barani.

Sufis were held in such awe that people ascribed the collapse of the Tughlaqs to Nizamuddin Auliya's death in 1325, and the sudden rise of the Deccan as a power centre to the fact that a disciple, Burhanuddin Gharib, had settled in south India. Both commoner and king believed that God would honour any intercession on their behalf by the penniless Sufis. When a Mongol force of 120,000 under Targhi besieged Delhi in 1303, Alauddin Khilji beseeched Nizamuddin Auliya for help, and the Mongol siege dissipated. He returned to the sage a decade later when he lost touch with his conquering general, Malik Kafur. Kafur returned with booty beyond expectations. People attributed a famine in the time of Jalaluddin Tughlaq to the fact that he had executed a Sufi, Sidi Maula, without trial, on suspicion of conspiracy. When Muhammad bin Tughlaq (ruled 1325–51) was threatened by a Mongol army, he went to pray at the shrine of Muinuddin Chishti in Ajmer. The Mongols were defeated.

Ghiyasuddin Tughlaq (ruled 1321–25), on the other hand, was arrogant enough to order Nizamuddin Auliya to leave Delhi before he reached the capital on his way back from the Tirhut campaign. Nizamuddin's comment has passed into the language: '*Dilli dur ast* (Delhi is still far).' Ghiyasuddin never reached Delhi. He died in an accident. Sensible sultans like Feroz Shah (ruled 1351–88) won applause by repairing and adorning the

tombs of divines like Shaykh Fariduddin Ganj Shakr, Bahauddin Zakariya, Lal Shahbaz Qalandar, Nizamuddin Auliya and Shaykh Nasiruddin Chiraghi-i-Dilli (Lamp of Delhi). Feroz Shah, however, was among the few who emphasized the role of the Sharia in state policy, increasing the role and power of the mushaikh (religious leaders).

At ground level, Hindus and Muslims respected the difference between their faiths and lived with it. Abu Abdullah ibn Battuta (died 1368), the Arab traveller who served for eight years as a qadi in Delhi during the reign of Muhammad bin Tughlaq, has left a fascinating account of Hindu–Muslim relations.[11] On a journey from Sandapur to Quilon in Malabar, in the south, where Muslims had been living since the seventh century, he notes that every half mile there was a wooden resting house for travellers. Hindus were offered water in utensils; Muslims had to cup their hands. If a Muslim used a vessel, it would either be broken or given away to a Muslim. The Muslim elite considered itself superior to the Hindus, but made no effort to impose its mores on those who wanted to be left alone.

Mujeeb describes this complex, evolving relationship: 'Hindu institutions were not interfered with under the Sultanate. Hindus could worship idols openly. There were no restrictions on pilgrims and the observations in regard to bathing etc, on the holy days, continued uninterrupted. Sikandar Lodi's desire to destroy an old temple and to stop the gathering of pilgrims at Kurukshetra could not be fulfilled because he was told that such interference in religious practices was against the Sharia. It seems unhistorical to consider that Muslims followed a straight or distinct course in matters of religion; on the other hand, it is equally unhistorical to hold that Hindus or Hinduism were stifled or suppressed ... Prejudices, exclusiveness, tolerance, understanding, zest for living and detachment all play their part in the creation of a pattern that is complicated but still intelligible.'

Ibn Battuta narrates how Muhammad bin Tughlaq had water from the Ganga carried, on a forty-day journey, for his personal use when he shifted to Daulatabad, his new capital in central

India. Tughlaq was honouring a Hindu tradition in which use of Ganga water gave legitimacy to imperial authority. The later sultans of Bengal would bathe in water brought from Ganga Sagar, where the river emptied into the Bay of Bengal.

Hindu bankers flourished under Muslim rulers, and land grants, called jagirs, were given to Hindu nobility. Inter-community marriages strengthened political alliances. Feroz Shah Tughlaq's mother was the daughter of a Hindu raja. The sultan's palace was often under greater threat from fratricide than outsiders. As a famous aphorism put it, the Turko-Afghan royalty united against the enemy and fragmented when at peace. Succession was a perennial reason for bloodletting; poison and treachery were common. Ghazni's eldest sons might have had good reason to war for succession, since the two were born on the same day from different mothers, but ambition does not need any excuse. Alauddin Khilji invited his ageing uncle Jalaluddin to his camp and had him beheaded. His followers placed the royal canopy over his head while blood was still dripping from the predecessor's severed head. It took ten years of war before a successor could be found after the death of Feroz Tughlaq in 1388. Taimur faced little opposition when he reached Delhi in 1398, as the court was in disarray. He massacred the citizens in any case. Bad habits die hard.

―――⁓∿∾―――

A Pakistani missile named after Taimur might have been more appropriate than one in the name of Babur, founder of the Mughal Empire in 1526 and one of the most cultured men of his age. His name is controversial now because it has been attached to a mosque constructed by one of his generals in Ayodhya, allegedly on the site of a demolished temple at the birthplace of the venerated Hindu god Rama. But Babur does not seem to have had much idea of any such mosque. His candid and comprehensive memoir, *Baburnama* (innumerable editions of Annette Susannah Beveridge's translation from Turkish have been published), makes no mention of it.

This marvellous memoir is evidence that Babur (ruled 1526–30) was equally adept at writing poetry, art criticism, military strategy and piling rebel skulls in the shape of a pyramid. He was not above superstition, and considered a gift of half-ripe mangoes as a favourable omen for an Indian campaign. (The omen was accurate.) His attitude to war was mature: *He who lays his hand on the sword with haste/ Shall lift to his teeth the back hand with regret.* In love, he was honest, and describes his infatuation, as a young man, 'for a boy in the camp's bazaar, his name Baburi being apposite'.

He was a believer: he wrote an exposition of the Sharia in 'Dar Fiqh Mubaiyan', a Turkish poem of 2,000 lines. He sent offerings to Mecca and Medina after the victories that made him master of Delhi, Agra and Punjab in 1526. He prayed five times a day – except when he was drunk. He celebrated the birth of his son Hind-al (meaning, the taking of Hind) with a drunken bout of historic proportions that finally broke up in a brawl. The morning began with *araq* (fermented juice of rice, date palm or aniseed, still enjoyed in the Middle East) and shifted to *maajun* (a mixture of bhang, milk, sugar and spices) when he tired of *araq*. He did not remember riding back to camp on loose-rein gallop, and vomited when he reached his tent. He once invited a woman, Hulhul Aniga, to join his party because 'I never saw a woman drink wine'. When she later tried to accost him he pretended he was drunk.

Babur, then, is a curious role model for an Islamic missile.

He ruled in India for only four years, much of it spent campaigning. His son, Humayun, misplaced a splendid legacy, and then found it with help from Persia. The Mughal Empire that is remembered in books, miniatures, folklore, the Kathak dance, music, cuisine and magnificent architecture is the legacy of Humayun's son, Akbar (ruled 1556–1605), and his heirs Jahangir (ruled 1605–27) and Shah Jehan (ruled 1627–58; died 1666). Akbar, a military genius as well as an idealist, has not been honoured with a missile because he believed in political partnership and cultural harmony between Hindus and Muslims. The century of Akbar, his son and grandson, marks the epitome

of a secular Indo-Muslim state and society. This was the true Mughal Empire whose reputation would be distorted by later ideologues who practised the politics of communal separation.

Akbar was born in the fortress of the Hindu rana of Umarkot in Sind, who had given his father, Humayun, shelter after the latter's defeat by Sher Shah Afghan, whose family ruled Delhi for about fifteen years till the Mughals re-established themselves. He moved as a child to his uncle's court in Kabul, and rejoined his father at twelve, on the campaign to recover Delhi. Akbar's heir, Jahangir, had a Hindu Rajput mother.

Raja Bihar Mal, the Kachwaha ruler of Amer in Rajasthan, was among the nobles who supported Humayun. In 1562, Akbar married his daughter, strengthening an alliance – and entering local folklore. Akbar's name is often mentioned in Rajasthani folk songs as the quintessential husband or lover, in the form of Jalla, Jallal or Jallalo. Bhagwant Das and Man Singh, Bihar Mal's son and grandson, ranked among Akbar's most trusted amirs. Power was largely non-denominational, and structured through a system of alliances with traditional regional dynasties.

The first challenge to Akbar, within ten months of his coronation in 1556, came from an unorthodox maverick rather than a traditional ruling clan. Hemu, a Hindu peddler of saltpeter, raised an army with the help of dispossessed Afghans, and confronted the Mughals at Panipat on 5 November 1556. Akbar, just thirteen, was heavily outnumbered, and his generals advised retreat to Kabul. The teenage ruler held his ground, won the day and went on to build an empire in partnership with traditional Hindu dynasties of the north.

In 1555, a year before Akbar's reign, the Mughal court consisted of fifty-one Muslim families, nearly all of them from Central Asia. By 1580, the court had expanded to 222 nobles, but half the Muslims in that number were of Indian origin, and forty-three were Rajput Hindus. The rulers of Mewar, who had raised a formidable alliance against Babur at Khanwa in 1527, were the only important Rajput principality to hold out, until subdued by Shah Jehan during the reign of Jahangir.

Akbar discovered soon that orthodoxy was the big obstacle to his vision of a more shared culture in court. Or, as that superb, if obsequious, intellectual and historian Abul Fadl (author of *Akbarnama* and *Ain-i-Akbari*) put it: did the religious and worldly tendencies of men have no common ground?

In 1564, Akbar abolished the jiziya, a radical step towards justice, and banned cow slaughter to promote emotional integration. He further mollified Hindu angst by halting interfaith marriages, since Hindus felt that the traffic generally went in one direction; there was rarely an instance of a Muslim girl being wed to a Hindu boy. But social reform affected Hindus as well: child-marriage, a traditional Hindu practice, was banned and the ages sixteen and fourteen were set as the legal age for wedlock for boys and girls. Polygamy was prohibited, unless the wife was barren. Widow remarriage, another taboo among upper-caste Hindus, was permitted, while marriage between cousins, a Muslim practice, became taboo. He stopped short of making sati, in which Hindu widows burnt themselves on their husband's funeral pyre, illegal, because Rajputs, stalwarts of the Akbar court, were partial to this practice. The local police chief, however, was instructed to assure himself that the sati had been voluntary.

Palace practices were eased. The earlier compulsion upon Muslims to pray five times a day was relaxed, and the Shia noble, Mir Fathullah, was permitted to offer namaaz in his sectarian fashion. Akbar began to play Holi and celebrate Diwali. Hindus who claimed that they had been forcibly converted were allowed to return to their faith. The historian Abdul Qadir Badayuni, who was as caustic as Abul Fadl was enamoured, mentions that Raja Man Singh once told the emperor that he would become a Muslim if commanded, but saw no reason to do so (*Muntakhab al-Tawarikh*). Akbar made it clear that he did not consider loyalty synonymous with faith, and Man Singh remained among his most trusted commanders.

The emperor took care, however, not to tip too far away from Muslim sentiment. One of his trusted courtiers, Sheikh Bhawan, was a learned Brahmin from the Deccan who had converted to

Islam. Shabaz Khan, the bakshi, once castigated Birbal, an Akbar favourite, in open court for being disrespectful towards Islam. Akbar was largely unimpressed by Portuguese Jesuits, who thought they had won a divine lottery when they were invited to court, and spread the notion that the emperor was on the verge of becoming a Christian.

'Loyalty, not a distinctive Islamic ideology, held the state together,' explains Barbara Metcalf. 'Under the Mughals, a Hindu Rajput who was loyal was praised; a Muslim who was disloyal was subject to jihad ... Loyalty was a Muslim virtue, but it was also a Rajput virtue. Conversion was not required to be part of the Muslim state.'[12]

The most controversial Akbar innovation was an ideology known as Din-i-Ilahi, literally, Faith of God. But which God was he talking about, or had he invented a new one altogether? Abul Fadl, the careful chronicler, treats it, in *Akbarnama*, as an interfaith dialogue between Sunnis, Shias, Ismailis, Sufis, Shaivites, Vaishnavites, Jains, Sikhs and Portuguese priests, rather than an epiphany.

Badayuni, a conservative Sunni chronicler who viewed Shias with distaste, is the principal proponent of the idea that Akbar had turned apostate: *'Kufr shai shud'* ('Unbelief was propagated'), he claims. Badayuni is, however, deeply impressed by Akbar's profound spirituality, recording that the emperor would often spend the night praising God by repeating His names, Ya Huwa and Ya Hadi; and on many mornings he would sit on a large flat stone in a lonely spot, praising God for granting him success.

An interesting episode illustrates Akbar's attitude to the faith and the faithful. Shaikh Abdun Nabi, scion of a family of scholars and mystics, so entranced Akbar in 1566 that the emperor began to sweep the mosque, give the azaan and lead the namaaz. Once, when someone sprinkled saffron on Shaikh Nabi's robes, he became so incensed that he tore off that part of the cloth and hit the emperor with his stick. Akbar went inside the palace and complained to his mother that the shaikh could have admonished him in private instead of insulting him in public. His mother

offered some wise advice: let him be, for people would remember that the emperor had the humility to accept admonishment from a mystic.

But when Shaikh Nabi, now promoted to Sadr al Sudur, ordered, in 1575, the execution of a Brahmin falsely accused of insulting the Prophet, Akbar was visibly upset. The breaking point came when the shaikh reneged on a manifesto authorizing Akbar to decide in religious disputes. He was exiled to Mecca, but became rather more insufferable on his return from haj, once using such violent language that Akbar hit him in the face. Nabi was found guilty of embezzlement and thrown into prison, where he died.

The controversial manifesto empowering Akbar to intervene in disputes between ulema was drafted by Shaikh Mubarak of Nagor and issued in August–September 1579. It said: 'Whereas Hindustan is now become the centre of security and peace, and the land of justice and benevolence, so that numbers of the higher and lower orders of the people, and especially learned men possessed of divine knowledge, and subtle jurists who are guides to salvation and travellers in the path of the diffusion of learning have immigrated to this land from Arabia and Persia, and have domiciled ourselves here; now we, the principal ulema declare that the King of Islam, the Asylum of Mankind, the Commander of the Faithful, Shadow of God in the world, Abul Fath Jalaluddin Muhammad Akbar, Padishah-i-Ghazi (whose kingdom God perpetuate!) is a most just and wise King, with a knowledge of God, should, therefore, in future, religious questions arise regarding which the opinions of the *mujtahids* are at variance, and His Majesty, in his penetrating understanding and clear wisdom, be inclined to adopt, for the benefit of the nation and in the interests of good order, any of the conflicting opinion which exist on that point, and should he issue a decree to that effect, we do hereby agree that such a decree shall be binding on all his people and all his subjects.'

This manifesto brought the conflict between Akbar and the orthodox ulema to a head. Conservatives, convinced that Akbar was ignorant of the Quran and the Hadith, called him unworthy

of being the shadow of the true God because of his excessive tolerance of infidel practices. The most respected critic, Shaikh Ahmad Sirhindi (1563–1624), known as Mujaddid-i-Alif-i-Thani (Reviver of the First Millennium), described Akbar as a traitor to Islam. He accused the loyal clergy of disobeying Allah in order to please the emperor. There was a schism across the empire, adding an incendiary religious dimension to political upheavals like the 1579–80 Afghan rebellion in Bengal, and the bid for power made by Akbar's brother Mirza Hakim, who was governor in Kabul. The ulema of Jaunpur, in east India, issued a fatwa recognizing Hakim as the true emperor, and his name was taken instead of Akbar's in Friday prayers. Snide references were made to the practice in Akbar's service of responding to the cry Allahu Akbar (Allah is Great!) with Jalle-jalaluhu (Exalted be His glory!). Critics wondered whose glory was being exalted, Allah's or the emperor's.

—◊◊◊—

The tension between Mughal rulers seeking to establish sustainable government and a clergy agitating for an Islamic state existed from the beginning. Abd al-Quddus Gangohi (1456–1537) instructed Babur: 'In the Sharia the subordination of the kafirs is enjoined ... they should be humbled, subordinated and made to pay tax.' In a similar vein, Akbar's contemporary Sirhindi wrote to Shaikh Farid Bukhari, who was among the most important personages at court, 'The honour of Islam lies in insulting Kufr and Kafirs ... ' Sirhindi was aghast that idol-worshippers had places of honour, when they needed to be kept at arm's length, like dogs. Bukhari was a patron of Khwaja Baqibillah (1563–1603), who was Sirhindi's spiritual master.

Bukhari's influence can be gauged from his assignments, whether to quell rebellions in Orissa or supervise famine relief in Bihar, before he was raised to the position of mir bakshi. He was close enough to Akbar to inform him that his son Jahangir had murdered Akbar's favourite intellectual, Abul Fadl; no one else

had the courage to do so. Bukhari also ensured a bloodless succession in 1605, when a strong faction, including Raja Man Singh, preferred Jahangir's son Khusrau as successor. Bukhari pre-empted an inevitable civil war by publicly congratulating Jahangir on the succession. His intervention encouraged other emirs to follow suit, and the Khusrau effort fizzled out. Jahangir received his dying father's blessings.

Jahangir clearly felt that his father's freethinking had exceeded what might be acceptable even to moderates, and asked Sirhindi to nominate four ulema to his court as advisers. Sirhindi, astutely, pointed out that this would mean hiring four men to quarrel with one another, and suggested that one was enough. If he thought he should be the one, his timing was wrong. A letter to Khwaja Baqibillah had surfaced in which Sirhindi told of a dream where he was above the first four caliphs of Islam. Instead of high honour, he got high dudgeon, ending up in Gwalior Fort. Reprieve came within a year: Sirhindi was released, and compensated with a robe and a thousand rupees.

Sirhindi's agenda had not changed. He advised Jahangir to end the practice of prostration before the emperor, since a Muslim could only prostrate himself before Allah; to revive cow slaughter; to check deviation from Sharia; restore the office of qadi; and renovate or rebuild mosques. Sirhindi's excesses were self-defeating. He attacked Hindus, 'deviant' Shias, 'worldly' preachers whose company he called poisonous, and otherworldly Sufis. He does seem to have ascended into fantasy, once claiming he had inherited the combined perfections of the Prophets Muhammad and Abraham, inviting the scorn of contemporaries. His influence would become stronger much after his death, with the collapse of Mughal rule, when his ideological heirs found a cosmological reason for decline: it was Allah's punishment for deviation and *zandaqah* (heresy).

The irony is that this decline followed the reign of Aurangzeb, whose rule is considered the template of the orthodox. Aurangzeb imposed Hanafi law, prohibited intoxicants (both the elitist wine and popular cannabis, or bhang), and introduced a moral police

that, much in the style of Taliban rule in the twentieth century, measured morality by the length of beards. Delhi's sophisticated citizens laughed, while corruption increased. Debtors who could not, or would not, repay their loans accused lenders of 'un-Islamic' usury. There was inevitable social and economic disarray. In the twenty-second year of his reign, Aurangzeb imposed the jiziya, which sealed his reputation as a bigot. He was, however, astute enough not to alienate the Hindu nobility: there were more Hindu nobles and officers in Aurangzeb's court than in any previous Mughal's. In the critical battle for succession between Aurangzeb and his elder brother, Dara Shikoh, twenty-four Hindu nobles supported Aurangzeb and twenty-one Dara Shikoh.

Shivaji, the charismatic Maratha ruler whose challenge to Mughal suzerainty has often been cited as a principal cause for their decline, wrote an extraordinary letter to Aurangzeb protesting against jiziya: 'If you believe in the true Divine Book and the Word of God (the Quran), you will find there *Rabb-ul-Alamin*, the Lord of all men, and not *Rabb-ul-Muslimin*, the Lord of the Muslims only. Islam and Hinduism are terms of contrast. They are (diverse pigments) used by the true Divine Painter for blending the colours and filling in the outlines ... If it be a mosque, the call to prayer is chanted in remembrance of Him. If it be a temple, the bell is rung in yearning for Him only. To show bigotry for any man's own creed and practices is equivalent to altering the words of the Holy Book ... ' It was this philosophy, noted Shivaji, which had impelled Akbar towards *sulh-i-kul* and prevented Jahangir and Shah Jehan from alienating Hindus. 'They too,' wrote Shivaji, 'had the power of levying jiziya, but they did not give place to bigotry in their hearts.'

He was right. Aurangzeb's legacy was a splintered kingdom, in which regional satraps declared virtual independence within two decades of his death in 1707. Impotence was the surest invitation to a marauder. In 1739, the Persian Nadir Shah ravaged Delhi, and looted the most precious Mughal treasures, including the peacock throne, while his soldiers raped and killed for three

horrific days. The security of India had been breached, and the road from Kabul through Khyber was open again. In 1748, Ahmad Shah Abdali, a former general in Nadir Shah's army who set up an independent Afghan kingdom, looted the Mughal capital while the emperor once again did nothing.

By 1761, the political map of India read, from west to east: Afghans held territory up to Sind, Punjab and Kashmir. Adjacent were the Rajput states; and Marathas (Peshwas, Gaikwads, Holkars, Scindias and Bhonsles) controlled the breadth of India from Gujarat to Orissa. Shia nawabs ruled the Gangetic belt across Awadh; with the Rohilla Pathans in a powerful conclave to their west. The British held Bengal and Bihar up to Nepal. In the south, the nizam of Hyderabad was the most important power but Haidar Ali of Mysore was the most potent force.

The Marathas were at their zenith. They had even watered their horses in the Indus, although they could not hold on to their gains in Punjab. They were contemptuous of an enfeebled Mughal Empire, and mobilized to replace the premier symbol of Muslim rule. The ulema's tremors were best expressed by the most important Muslim theologian since Akbar's time, Shah Waliullah (1702–63), who had received permission from his father, Shah Abdur Rahim, to teach at the age of fifteen. He did not make himself popular with the traditionalists when he translated the Quran into Persian, in order to reach a wider audience.

His sons, Shah Abdul Qadir and Shah Rafiuddin, went further: they translated the Quran into Urdu. Shah Waliullah's anxiety to preserve Islamic political power in the subcontinent persuaded him to plead with the Afghans to save the Mughals from the Marathas. Ainslie Embree quotes from a letter Waliullah wrote to Abdali in the 1750s when the Mughals were threatened by two Hindu powers, the Marathas and Jats, collected in *Siyasi Maktubat* (translated by Christopher Brunner): 'There has remained nothing of the sultanate except the name ... In this age there exists no king, apart from His Majesty (Abdali), who is a master of means and power, potent for the smashing of the unbelievers' army ...'[13]

There is no evidence that Waliullah or excessive piety influenced
Abdali. Fraternal feelings had not prevented him from sacking
Delhi more than once, the last time in January 1756. He could
see the obvious. If the Marathas took Delhi, they would threaten
Afghan domination over Punjab and across the Khyber. On 14
January 1761, an alliance of Afghan, Awadh and Mughal soldiers
went into battle against the largest Maratha army ever assembled.
The Marathas were defeated. Abdali had prevented a Hindu king
from becoming emperor in Delhi. The titular Mughal clung on to
a meaningless title, until the British ended the fiction in 1857 and
turned India into a colony of the Crown.

The 'Muslim period' of Indian history (a term coined by British
historians) began to cede space to the age of colonization in
1757, with Robert Clive's famous victory over Bengal's Nawab
Siraj ud Daulah at Plassey.

Defeat was not easy to accept, as much for Muslim partisans in
1757 as it had been for Hindus who treated the defeat of
Prithviraj in 1192 as a millennial setback to their community.
Both sought refuge in an alibi: treachery. The betrayal of Jaichand
served as the rationale for Prithviraj's defeat; Siraj's failure was
camouflaged by a deal that his general, Mir Jafar, had made with
Clive. It was an inadequate excuse. Clive had just 3,000 men
against Siraj ud Daulah's 50,000, and even if half his army had
opted for neutrality, Siraj still had an overwhelming numerical
advantage. He had lost the will to win.

That could be said for most, but certainly not all, the adversaries
the British faced over the next century. Between 1757 and 1857
the British lost an occasional battle, but never a war, against the
most powerful princes of India. They would eventually be defeated,
in 1947, but by a concept that they could never fully comprehend:
non-violence.

British progress was incremental rather than spectacular. The
commercial breakthrough came in 1717, when they obtained a

Mughal firman waiving all customs duties for inland trade in salt, saltpeter (much in demand in Europe for gunpowder), betel nut, opium and tobacco, creating the first generation of East India Company 'nabobs'. After Plassey, in 1757, they became masters of the richest province of India. The British threat was too palpable to ignore. An alliance of Delhi, Awadh and Bengal attempted to reverse Plassey, but it was comprehensively defeated by Major Hector Munro at Buxar on 23 October 1765.

The British could impose their terms after Buxar. They won the right to collect land revenue in Bengal, Bihar and Orissa in 1765, and proceed to convert opportunity into wealth with astonishing avarice. 'Revenue collection,' writes Nick Robins, 'had increased dramatically from just 606,000 pounds the year before the Company took over the *diwani* to a peak of 2,500,000 pounds two years later. Flows of bullion into Bengal fell from 345,000 pounds in 1764 to 54,000 pounds in 1765, and ceased entirely in 1766. Instead, silver started leaving Bengal for the Company's tea trade. By 1769, Richard Becher, the Company's Resident at Murshidabad (Bengal's capital), admitted with some shame that "the condition of the people of this country has been worse than it was before", arguing that "this fine country, which flourished under the most despotic and arbitrary government, is verging towards its ruin while the English have so great a share in the Administration".[14]

An economically devastated Bengal became too weak to fight back the famine of 1769–70; it is estimated that 10 million, out of a population of 30 million, died. 'In fact, British control of India started with a famine in Bengal in 1770 and ended in a famine – again in Bengal – in 1943. Working in the midst of the terrible 1877 famine that he estimated had cost another 10 million lives, Cornelius Walford calculated that in the 120 years of British rule there had been thirty-four famines in India, compared with only seventeen recorded famines in the entire previous two millennia,' writes Robins. The Mughal response to famine had been good governance: embargo on food export, anti-speculation regulation, tax relief and free kitchens. If any merchant

short-changed a peasant during a famine, the punishment was an equivalent weight in flesh from his body. That kept hoarding down.

As the British moved towards Delhi in stages, they destroyed the principal Muslim states of north India along the Ganga: Bengal (which included Bihar), Awadh and then of course Delhi. The impact of their revenue policies fell heavily on the defeated Muslim nobility and the more productive elements of Muslim society. British taxes led to a 'rapid decay of landed aristocracy' in Awadh, reported Colonel W.H. Sleeman, the famous Company administrator.[15] 'A less and less proportion of the annual produce is left to them in our periodical settlements of the land revenue, while family pride makes them spend the same sums in the marriages of their children, in religion and other festivals, personal servants and family retainers. They ... incur heavy debts, and estate after estate is put up to auction,' noted Sleeman. This landed aristocracy was largely Muslim.

The last Muslim ruler capable of challenging the British, Tipu Sultan, was defeated by 1798. Mysore, under Haidar Ali and his son Tipu, held the British at bay in the south through three wars spread across five decades. It needed an unprecedented alliance between the Christian masters of the East India Company, the Muslim nizam of Hyderabad and the Hindu Marathas to defeat Tipu. The Company was also fortunate to obtain the services of British generals of the quality of Arthur Wesley (who changed his surname to Wellesley before reaching India in order to sound a bit more grand) in its endeavour to become the supreme power on the subcontinent.

In 1803, General Gerard Lake entered Delhi and made the Mughal emperor his vassal. Exactly six centuries earlier, the 'slave sultans' had built a tower of victory in Delhi to commemorate their triumph. It was called the Qutub Minar, and rose above the mosque known as Quwat-ul Islam, or the 'Might of Islam'. In 1803, an earthquake felled the topmost cupola of the Qutub Minar. It was the perfect metaphor.

Europe's arrival in India did not suddenly brighten an area of

darkness. John Darwin notes: '... the facile conclusion that Europeans had galvanized a somnolent Asia after Vasco da Gama's arrival in India in 1498 was a travesty of facts ... Whatever their shortcomings, Asian governments were more than the predatory despots of European mythology who crushed trade and agriculture by penal taxation and arbitrary seizure ... Indeed, before 1800 what really stood out was not the sharp economic contrast between Europe and Asia but, on the contrary, a Eurasian world of "surprising resemblances" in which a number of regions, European and Asian, were at least theoretically capable of the great leap forward into the industrial age.'[16]

When India became free in 1947, its leaders were committed to a clear objective: a great leap forward into the industrial and modern age. There was, however, one inhibiting obstacle. The politics of the nineteenth century had divided India along religious lines in the twentieth.

3

A Theory of Distance

O n 10 July 2009, China's English-language newspaper, *Global Times*, published an interview with a second-tier leader of the Taliban in Pakistan, Mullah Mahamud. In the accompanying photograph, he was seen sitting on his haunches, taking aim with a sophisticated gun. Zhou Rong, Islamabad correspondent of the paper, explained: 'Mullah Nageer Mahamud is one of the branch leaders of the Taliban in Pakistan. He agreed to talk to the *Global Times* in [north] Waziristan in April, and was accompanied by six Taliban militants during the interview. After initially insisting the interview not be published immediately, in light of the escalating conflict between the Taliban and Pakistani forces and US aerial bombardments, he has now granted permission.'

Two excerpts are relevant.

GT: When and how did you join the Taliban?
Nageer: I joined the Taliban in Afghanistan and then transferred to Pakistan. I was born in southern Waziristan 35 years ago. A traditional saying of my tribe is 'one should take the sufferings of his brothers as his own and help them out'. In 1995, I attended a madrasa in southern Waziristan,

moved on to Wana and then entered the capital Kabul with Afghan militants. I returned to Pakistan after Afghanistan was taken over by US and NATO forces. I am one of the organizers of the Taliban activities in Pakistan and the Emir here. We hope to establish an Afghanistan Islamic Emirate, a Pakistani Islamic Emirate or a country ruled by an Emir.

GT: Why do some armed tribes participate in military activities led by the Taliban?

Nageer: You know, the Pushtus are nationalists. We have beat [*sic*] the British, the Russians and now we are fighting against the Americans and the Mossad [intelligence agency] of Israel and the Inter-Services Intelligence of Pakistan. The final victory is ours. We Taliban are not born today. We were born in the days of the colonization of India by Britain. We never let them get through easily.

GT: Did you have anything to do with the attacks in Mumbai [in November 2008]? What do you think about the Kashmir and Pakistan issues?

Nageer: My jihad brothers blasted Mumbai, but I can't tell you who did it. We had cooperation with Pakistani Inter-Services Intelligence but they sold us down the river [*sic*]. We are related to the Indian Muslim military, but we are more ambitious and brave than they are. We need to cooperate with the soldiers of the Jihad in India, who are by no means small in number. We do not have much foreign aid and we are isolated in form. But we are strong in spirit and religion. The victory of the jihad will be ours. We rely more on spirit than on weapons. Even though the whole world is against us and ignores us, we will get through the difficulties. I can forecast the US will collapse after 2010 and by then the whole southern Asian area will have a heavier mujahideen presence. In addition, we support the liberation of Pakistan because in fact our war is part of the Jihad, which includes the liberation of Pakistan.

At the top of Mullah Mahamud's presentation of Taliban priorities in the summer of 2009 was the establishment of Islamic emirates in Pakistan and Afghanistan. Some dreams were fuelled by fantasy, but that did not make them less real in his imagination. He was, in any case, only taking the idea of an Islamic state a step further, from an Islamic republic, which Pakistan is, to an Islamic emirate, which the more orthodox desire. The more ambitious among them also see Pakistan as a natural leader of the Islamic world, working in harmony with its brothers in Saudi Arabia. The Americans would be defeated and disappear, but India was in the neighbourhood. India was the ideological antidote of an emirate, and therefore a legitimate enemy. In Mullah Mahamud's breathless time span, this was all going to happen immediately, but most of his colleagues were blessed with an ideologue's patience.

This patience has lasted a while. He was accurate when he asserted that 'We Taliban are not born today. We were born in the days of colonization of India by Britain.'

—◦◦◦—

The pregnancy of this unusual birth extended for over a hundred years, and its many complications could not always be sustained by the logic of events or the evolving nature of the enemy. The vision, however, was determined by an idea with lasting power, the search for 'Islamic space' on the Indian subcontinent. This search began during the ebb of the Mughal Empire, and its formative ideology was shaped by the powerful mind of Shah Waliullah.

Shah Waliullah is successor, in terms of intellectual hierarchy, ideological continuity and influence, to Shaikh Ahmad Sirhindi, the cleric who had charged Emperor Akbar with apostasy because he sought to create a shared Muslim–Hindu culture and ideology. Waliullah built upon Sirhindi's ideas of reform and fashioned a persuasive logic for a jihad to establish a post-Mughal Islamic state on the Indian subcontinent.

He was born four years before the most 'Islamic' of the great

Mughal emperors, Aurangzeb, died in 1707. His father Shah Abdul Rahman was, for a while, a member of the group that compiled the *Fatawa-i-Alamgiri*, a compendium of Hanafi law commissioned by Aurangzeb, which became the theological basis of a regime that sought a strict implementation of the Sharia. By the time, at the age of twenty-eight, Waliullah went for haj and set up his madrasa, near Delhi's Jama Masjid, and turned it into a leading centre of scholarship powered by his own formidable, wide-ranging examination of the Quran and Islamic theology, an impregnable Mughal Empire had sunk into visible decline.

At a theoretical level, he traced Muslim decline to the institution of monarchy, which had usurped the elective principle that nominated the first four caliphs. This was aggravated by the collapse of *ijtihad*, the progressive interpretation of law that kept the spirit of faith beyond the stagnation of dogma. 'Instead of being a revolutionary movement for the emancipation of mankind from various inequities, Islam had become circumscribed to a set of dogmas and ceremonies,' explains Qeyamuddin Ahmad.[1] The ideal Islamic government, argued Shah Waliullah, would be split into 'Khaas' (special) and 'Aam' (common), the former being a spiritual authority with power to regulate the latter, which conducted affairs of state.

His prescription was radical, and intellectually rigorous. The resurgence of Sunni Islam in India needed unity, ethics and military success which could help establish an Islamic state. He attempted to find a median between the four schools of Sunni law in order to promote unity, a brave attempt that did not get much traction. His second initiative had far-reaching impact, and he is justifiably esteemed as *mujtahid*, a theorist of *ijtihad*, or independent reasoning, and a *qutb*, or a radiant intellectual pole where divine thought intersects with the temporal. He fashioned a systematic framework for jihad, the virtuous route towards a theocratic order, within the Indian context. Indian Muslims had to be purged of Hindu influences in order to recover their pristine, and consequently victorious, self, for contact with the infidel undermined the faith. This was essential for a true jihad

against the rising Hindu powers which had usurped space from the Mughals, the Marathas and the Jats.

Jihad, as has been noted often enough, is much more than war. The word for war in the Quran is *harb* or *qitl*. Jihad, which appears forty-one times in the holy book, is strife in the cause of faith, which made it all the more essential at a time when Islam seemed threatened in India. *Jihad fi sabil Allah*, the struggle in the way of God, was therefore essential in both its dimensions, Jihad i Akbari, the greater struggle for internal cleansing, and Jihad i Asghari, the lesser, which was fought on the battlefield; indeed, the two were linked by cause and effect. Islam was perfect because it understood the self-correcting power of jihad, which prevented dispersal of unity or objective, and became the basis of social equilibrium. Jihad had established the Muslim way of life across the world, and the desire to wage war was embedded in the Prophet's people; conversely, those who forgot this were doomed to fall from glory to dust. Jihad was the paramount duty of an Islamic state. While Waliullah opposed rebellion against a Muslim ruler, he reminded his congregations that it was an Islamic duty to remove anyone who undermined Islam.

Abdication of the principles of Islam and flirtation with polytheistic practices explained the collapse of Mughal rule, apart from wasting the people's money on egoistic, grandiose architectural projects rather than on public welfare. The Mughal aristocracy had compounded the betrayal of first principles with near-apostasy in cultural compromise. Delhi was heading for punishment because it had betrayed Islam. A principal duty of the Islamic government would be to eliminate Hindu and deviationist Persian/Shia accretions from the state. Waliullah had watched, with a pain that we can only imagine, the Persian Nadir Shah ravage Delhi in 1739, looting treasure and destroying Mughal credibility beyond repair. And yet Shias, a sect he despised almost as much as non-believers, remained a powerful influence in court along with Hindus. Sunni Muslims had become destitute, while Hindus had become visibly wealthy. He was certain that unless infidels were broken and Shias contained, true Islam

would be absorbed in degree into the larger Hindu presence. His fear of such a calamity took him to the edge of bigotry.

There were four stages of *irtiqadat*, or socio-religious consciousness: natural and instinctive life; family and social cohesion; the establishment of order, as in the city state of Medina during the Prophet's leadership; and the extension of this state to a world order under a caliphate. In its absence, Muslims should be guided by a *qutb*. He urged Muslims, living in an age of discord, to stress the difference with Hindus by giving importance to action over intellect, and promoting the visible over the invisible attributes of Islam. While it was true that God gave greater cognizance to what was in the heart, this was a moment to advertise marks of external identity: this might be the beard and stylized moustache, or ankle-length, namaaz-convenient pyjamas. This unique identity syndrome has degenerated into the contemporary practice of staining the forehead with a black mark to indicate excessive devotion to namaaz. Artifice is a familiar companion of pseudo-piety.

Shah Waliullah's *Hujjat Allah al-Balighah* (Allah's Conclusive Argument) has a potent message: Muslims cannot abandon the elixir of faith and hope for the intoxication of earthly success. Faith had to be pure, and separation was the antidote to pollution. This is what might be called the 'theory of distance'. The difference between believer and infidel had been blurred in India, and could be corrected only through forms of alienation. He told Muslims to live at such a distance from Hindus that they would not be able to see the light of the fires in Hindu homes.

The germination of the idea of Pakistan is clear, in retrospect, in the thought and *hidayat* (moral instructions) of Shah Waliullah: his Islamic state without dynasty is a virtual Islamic republic. His theory of distance was politically institutionalized in separate electorates, the first demand of the Muslim League after it was formed in 1906, through which only Muslims could vote for Muslim candidates. The natural corollary of distrust was a separate Muslim space; it was but a step forward to a Muslim homeland in which Hindus and non-believers were either ethnically cleansed

or marginalized demographically and economically, while the clergy continued its interminable jihad against infidel influences.[2] The belief that Shias are an obstacle to the creation of a Sunni Islamic state is one, if not the only, explanation for the frequent, continuing murderous attacks on them by hardline Sunni militia groups. *Jihad fi sabil Allah* is the declared motto of the Pakistan army. It is unsurprising that some Sunni Pakistani scholars have described Shah Waliullah as the father of Muslim modernism, for he clearly inspired the concept of Muslim political space in a post-Mughal polity.

One by-product of the Shah Waliullah legacy was a puritan resurgence, an ideological inheritance visible in Pakistan's regressive gender legislation, such as the *hudood* (transgression of limits) laws. In India, the Deoband-led clergy have succeeded in mobilizing a successful resistance whenever there is an opportunity for gender reform in Indian Muslim personal law. Shah Waliullah believed that men were intelligent, unlike women. Since humankind was divided into two categories, masters and slaves, it was incumbent upon women to be subservient. Nature had placed women on a lower religious scale, since they could not pray or fast during their menstrual cycle; but of course they had their rights, which should be protected.

His *wasiyatnamah* (will) took the theory of purity, pollution and distance to bloodlines. His last message to his followers was to abjure the customs and habits of Hindus. He expressed his gratitude to Allah for keeping him among the pure through the Arab (rather than Indian) blood in his genes, and for knowledge of Arabic, the language in which the Quran has been sent to the world. He wrote, 'I hail from a foreign country. My forebears came to India as emigrants. I am proud of my Arab origins . . .' He sought 'to conform to the habits of customs of the early Arabs and the Prophet himself' and 'to abstain from the customs of the Turks [*ajam*] and the habits of the Indians'.

Two and half centuries later, there is an interesting variation to the proposition 'nearer to Arabia, closer to Allah'. In the first instance, it reinforced a caste system of 'superior' and 'inferior'

Muslims, the latter being converts from Indian cultures. This distinction morphed, in India, into undertones of wealth and colour, with the fairer immigrants from 'beyond the Oxus' awarding themselves an '*ashraf*' status, and sniffing at the local, poorer brown-skins as '*ajlaf*'. After the oil boom of the 1970s, the Arab world was flooded with labour and professionals from the Indian subcontinent. A section of Wahabi clerics has assimilated this cleavage into an insidious narrative in which Indian Muslims, Bangladeshis and Pakistanis were urged to abandon local influences and adopt the 'purer' Islam of Mecca and Medina, or risk the sin of *shirk*, or apostasy. The *abaya,* or veil, is part of the message. The explosive growth of signs of external identity is evident in the subcontinent.

Shah Waliullah died within seven years of the battle of Plassey, in which the British defeated the nawab of Bengal, Siraj ud Daulah, and established a powerful base in India. The challenge to Islam was bifurcated; Hindus represented the danger of creeping polytheism, but the British not only threatened to demolish what remained of Muslim power, but also ushered in a new culture and language that were seen as equally inimical to Islamic values.

'Shah Waliullah's descendants and their disciples perpetuated his ideas of reform into the nineteenth century in two major areas ... in the political realm, his ideas of jihad and of Islamic solidarity in the face of external aggression were expanded to include both a recognition of the European threat and a desire to do something about it,' explains Ian Henderson Douglas.[3]

—◦◦◦—

The East India Company had been expanding for half a century at what might be called a measured pace. It had acquired the revenue of Bengal in 1765, and the prize of two military victories in Plassey and Buxar; the first is more famous, the second more important. Once in power, the British, naturally wary of those they had defeated, began to support the systems of government. They began to empower those Hindus who they had worked with,

their trading agents or *gumushtas*. They constituted the bulk of the new class of revenue collectors, created through the Permanent Settlement of 1793. Lands were granted in perpetuity to a new strata of lords, who became in effect tax collectors and bailiffs. Profit was but naturally the principal concern of the East India Company, listed on the London stock exchange. The superior British bureaucrat was called, appropriately, collector. Funds were also needed for a growing military–administrative machinery to protect the Company's gains, since London was never going to finance the defence of its Indian holdings, or indeed, later, its Indian empire.

The most important girder of the British steel frame was the sepoy army. By the nineteenth century, military fortresses, inland trade routes (through railways), production houses (industrial and agricultural), managing agencies, new technology and superior financial systems created a network whose political power and business interests extended far beyond its land or maritime boundaries.

The Mughal system was based on the premise that the emperor, as personification of the state, was the sole owner of land, permitting him to use it as an instrument of administrative policy. The Muslim elite, long used to positive discrimination, went into depression. Its principal sources of sustenance, land revenue, military service, the administrative and legal bureaucracy, went largely, if not completely, out of reach. Bengali Muslim peasants lost their rights after the Permanent Settlement, and were reduced to agricultural labour. The increasing use of British common law, as distinct from Hindu and Muslim laws previously in vogue, sidelined the qazi. A traumatic blow came in 1834, when English replaced Persian as the language of administration. A panoramic snapshot of 1834 indicates the emergence of a new, post-Mughal India with its centre of gravity in Calcutta: the British sovereign's image appeared on Company coins; Darjeeling, a Himalayan hill town in north Bengal acquired as a 'gift' from the state of Sikkim, became a Scotland-style holiday retreat of Calcutta-based Englishmen; the first tea gardens started production in Lakhimpur,

Assam; in Calcutta, La Martiniere School took its first pupils; and a symbol of the new Hindu nobility, Raja Rajendra Mullick, completed the unique Marble Palace that doubled as India's first Indo-European art gallery.

The Muslim response in this age of decline was not led by its traditional elite but by a group that showed remarkable resilience in the face of adversity, the clerics.

In 1803, the British reached the door of Shah Waliullah's seminary, now headed by his son and successor Shah Abdul Aziz. British troops under General Gerard Lake defeated the pre-eminent Maratha prince Mahadji Scindia, at Laswari, which opened the door to a defenceless Delhi and Agra. The blind and ragged Emperor Shah Alam II (ruled 1759–1806), who had once given Clive the diwani of Bengal, was allowed to hold on to his title, but as a virtual British prisoner in the Red Fort.

That year, Shah Abdul Aziz issued a series of fatwas declaring that India had become Dar al-Harb, a House of War, as against the Dar al-Aman (House of Peace) during Mughal rule, since Christians had become the true masters of the land between Calcutta and Delhi. The logic was clearly spelt out: 'In this city [Delhi] the *Imam al-Muslimin* [that is, the Emperor] wields no authority, while the decrees of Christian leaders are obeyed without fear [of consequences]. Promulgation of the commands of *kufr* [infidels] means that in the matter of administration and the control of the people, in the levy of land-tax, tribute, tolls and customs, in the punishment of thieves and robbers, in the settlement of disputes, in the punishment of offences, the *kafirs* act according to their discretion. There are indeed certain Islamic rituals, for example Friday and *Id* prayers, *adhan* [call to prayer] and cow-slaughter, with which they do not interfere. But that is of no account. The basic principles of these rituals are of no value to them, for they demolish mosques without the least hesitation, and no Muslim or *dhimmi* [non-Muslim under the protection of the Islamic state] can enter the city or its suburbs except with their permission ... From here to Calcutta the Christians are in complete control. There is no doubt that to the right and to the

left, in principalities like Hyderabad, Rampur, Lucknow etc, they do not govern directly as a matter of policy and because the possessors of these territories have become subject to them'.[4] It is an interesting fact that the fatwa was meant for both Muslims and Hindus, although of course the Hindus did not respond.

In Bengal, Haji Maulana Shariatullah (1781–1840), scholar, leader of the Faraizis, and the most influential cleric in Bengal, called on Muslims to rebel against the British. His son, Dudu Mian (1819–60), would continue the anti-colonial tradition in Bengal. There was precedence in classical Islamic law for such a fatwa. Abu Hanifah an-Numan, the eighth-century founder of the Hanafi code, had laid down the conditions: if the laws of Islam were suppressed, if there was no protection for Muslims, or if there was no formal contract between ruler and his Muslim subjects. Muslims felt a strong sense of alienation from the British.

The 1803 fatwa accepted reality; Mughal rule was over. If the region to the east of Delhi was under the British, an equally stark development had taken place to the west of the Mughal capital. By the turn of the century, a dynamic Sikh ruler, Maharajah Ranjit Singh, had established Sikh rule across the Punjab. In 1799, he took Lahore from the Afghans and made it his capital. For the first time since the tenth century, when the Ghaznavids had established their rule up to Lahore, this region was being ruled by someone who was not Muslim. In a gesture not shorn of symbolism, Ranjit Singh acquired the famed diamond, Kohinoor, in 1813, from the exiled Afghan king Shah Shuja-ul Mulk, who was living in Lahore as his 'guest'. This galled even more than the British advance. Shah Aziz prayed to Allah to sweep away the Sikhs, whom he called Islam's greatest enemies and bands of demons. He did not choose to lead a jihad himself; in fact, he got on well with the British authorities, who considered him a useful moderator during times of tension. He contented himself with what he called the 'Jihad i Zabani' or the Jihad of Words.

The leader of the military jihad conceived by Shah Waliullah and sanctioned by Shah Aziz was Sayyid Ahmad Barelvi, a *talib*

(student) of their Madrasa Rahimiya. The British would later call it the 'Indian Wahabi Movement'.

—◦◦◦—

Sayyid Ahmad was born in Rae Bareli, a rural town on the banks of a small river, Sai, in Awadh in 1786; hence 'Barelvi', or 'of Bareli'. He left home at the age of fourteen, when his father died. In Delhi, he offered *bai'at,* or the oath of allegiance, to Shah Aziz. In 1812, searching for a means to confront the British, he enlisted in the army of Amir Khan, the nawab of Tonk, a principality south of Delhi. Amir Khan, however, chose survival over jihad, and settled with the British. The first biography of Barelvi, *Makhzan-i-Ahmadi,* written by his nephew Sayyid Muhammad Ali, records that Barelvi warned Amir Khan that the British were treacherous (*daghabaaz*): they would leave a little land for Amir Khan, but render him militarily impotent. He was not wrong. Amir Khan's force of fifty-two battalions of disciplined infantry, 150 guns and a sizeable Pathan cavalry was reduced to forty guns after the treaty, while most of his troops were either disbanded or recruited into the East India Company's sepoy army.

Barelvi returned to Delhi in 1818. Two scholars, Shah Ismail and Shah Abdul Hayy, nephew and son-in-law of Shah Aziz, were the first to offer their allegiance to him. These three would fashion the long jihad, Ismail proving as capable a commander as he was erudite as a theoretician.

The disciples compiled a manifesto, the *Siratul Mustaqim,* or the Straight Path, in 1818 (published in Calcutta in 1822–23). A principal theme was the pollution that had affected Indian Islam, not only from Hinduism but also from Sufis: 'Among the *bidat* of the "sufistic polytheists" [*mushrikin Sufishiar*] which are greatly in vogue among the Muslim gentry and commoners is the performance of *nadhar* and *niyaz* [offerings of prayers and eatables in the name of the dead ones]. This involves the committing of a sort of polytheism . . .' It argued that 'people had introduced their own imaginations and superstitions . . . and the evil offshoots,

assiduously produced by fabrications, had prevailed'. They were scathing about 'obnoxious ceremonies' during weddings, which included decadent behaviour such as singing. 'It is apparent that one is not so much reproached for absence from performing the prayers as for neglect in arranging the death anniversary celebration of saints [urs] or singing and dancing on the occasions of marriages.' It compared jihad to heavenly rain, spreading salvation, a boon for non-Muslims as well, for it might inspire them towards Islam. It was the authentic voice of a student of Shah Waliullah.

Barelvi's fame began to spread as he travelled through towns between the Ganga and Jumna rivers in his first effort at mass mobilization for what he called the Muhammadi Order. The response had the frisson of an upsurge if not yet the bloodshed of an insurrection.

Contemporary descriptions indicate that Barelvi was a little above medium height, fair, strongly built, deceptively calm, prone to trances, with a grave, quiet, kind demeanour and a pleasant face complemented by a flowing beard that touched his chest. He wore a white cotton kurta, loose pyjamas and a white turban. His followers saw great significance in the fact that he was born on the first day of the thirteenth century, by the Hijri calendar. He preached four themes: the unity of God, the equality of man, the decay of Indian Islam through its contact with the superstitions of Hinduism, and the threat from the Christian British. Even his enemies were impressed. Sir William Hunter, a British civil servant, who would produce, under commission from the government, the seminal enquiry report in 1871 on the 'Wahabi revolt' that would influence British policy towards Muslims,[5] wrote: 'He [Barelvi] appealed with an almost inspired confidence to the religious instinct, long dormant in the souls of his countrymen, and overgrown with superstitious accretions, which centuries of contact with Hinduism had almost stifled Islam ... I cannot help the conviction that there was an intermediate time in Sayyid Ahmad's life when his whole soul yearned with a great pain for the salvation of his countrymen, and when his heart turned singly to God.'

In 1821, Barelvi established an office in Patna, from where a network of missionaries spread into rural India. Barelvi's clerics fanned out to purify the faithful from 'Hindu' cultural contamination. Patna had all the trappings of an alternative government modelled on a caliphate: four vice-regents, and a Shaikh ul Islam, equivalent to a state's head priest. He was positioning himself as a caliph to lead the jihad.

Several hundreds volunteered to join Barelvi when he decided to go on haj, an obligation he wanted to fulfil before he went to war. He reached Calcutta by boat along the Ganga, preaching en route to enthusiastic audiences in riverside towns. In Calcutta, some Muslims warned the British that Barelvi was preparing for war against the *firinghees* (a variation of the Arab term for French crusaders, *Franj*) and *nasranis* (Christians). The British did not interfere with the pilgrimage.

Barelvi reached Mecca in May 1822, where the *Siratul Mustaqim* was translated into Arabic. When he returned to India in April 1824 he brought back embers of a desert fire that had been doused but not extinguished.

—◈—

Muhammad bin Abdul Wahab (1703–92) was born in Wadi Hanifa in the Banu Tamim tribe in the same year as Shah Waliullah: the two, unknown to each other, had more than the year of birth in common. Their thinking was shaped by similar anguish, since both had watched empires that had nourished the faith and the faithful begin to wither. Both attributed the decay to corruption of the pristine, monotheistic, first principles of Islam. For Wahab, the betrayal was compounded by the fact that the Ottoman sultan was also caliph and custodian of the two holy mosques, at Mecca and Medina. Both were deeply hostile to Shias.

The Ottomans took the title of caliph in 1517 from the Egyptian Mamelukes, who had ruled from Cairo since their crucial victories against the Mongols and the crusaders in the middle of the thirteenth century, when Sultan Selim extended Turkish rule to

the Arabian Peninsula. Arabia consisted of three regions: Hijaz (which contains the holy cities of Mecca and Medina), the southern coastal sheikhdoms, and Najd. Wahab came from southern Najd.

Wahab became a *hafiz*, or someone who could recite the whole of the Quran from memory, at the age of ten. He studied theology at Mecca, Basra, Damascus and Baghdad before beginning to preach at Baghdad. He stressed *tawhid* (the indivisible unity of Allah) and accused Muslim elites of succumbing to the evil of *shirk* (polytheism). His best-known work is appropriately called *Kitab al-Tawhid*. His zeal did not make him popular with the authorities. In 1744, the amir of Hasa ordered his arrest and execution, and he escaped a premature end thanks to the sanctuary offered by a tribal chief in neighbouring Dariya, Muhammad bin Saud. His heir, Abdul Aziz bin Saud (1764–1803), continued this patronage and extended his rule to the whole of Najd. Military success and an aggressive new Wahabi theology were interlinked; one spurred the other.

Impelled by rage against the 'deviationist' Shias, Abdul Aziz bin Saud destroyed, in April 1801, the shrine of their revered Imam Hussain, grandson of the Prophet and son of his daughter Fatima and Hazrat Ali, martyred at the battle of Karbala in 680 by those who would call themselves Sunnis. In April 1803, his son Muhammad 'liberated' Mecca from the Turks but was later repulsed. The Shias took their revenge; a Persian killed Aziz in a mosque at Dariya to avenge the desecration of Karbala. The Wahabis seized Mecca again in February 1806, and the Hijaz witnessed for the first time the meaning of Wahabism: visiting shrines, a popular practice, was banned; prohibition was enforced strictly, music suppressed, women secluded; 'decadent' luxuries like jewellery, gold and silk, as well as dancing and poetry were banned. By this time, Aziz was said to have 100,000 troops under his command.

The Sublime Porte stirred late, but decisively. In 1812, Sultan Mahmud II ordered Muhammad Ali Pasha, the ambitious Khedive of Egypt, to end the Wahabi insurgency. An Egyptian army led by

Ibrahim Pasha left Suez for the peninsula in 1816 and squashed the threat by 1818.

The East India Company sent an envoy to congratulate Ibrahim Pasha, and politely warn him that success should not encourage the Egyptian to challenge British supremacy over the Persian Gulf. Wahabism would have to wait till the twentieth century to revive in the Arabian Peninsula, ironically with British help, when in 1924 the British permitted the Saudis to displace the Hashemites from the Hijaz and establish Saudi Arabia.

Key elements of Wahabi doctrine merged with intrinsic ideas to flesh out Barelvi's prescription for Indian Muslims: *tawhid*, or pure theism, an unwavering conviction in the indivisibility of God (in counterpoint to the Christian deviation that had split divinity between father and son); rejection of any mediation between Allah and man (through saints, which Indian Muslims, with their tendency towards adoration of Sufi mystics, are prone to); condemnation of clergy that was more loyal to government than to God; abhorrence of rituals that had become a corrosive overlay on faith; total obedience to the imam who would lead the faithful to victory; and jihad against infidels who had occupied Muslim lands.

—⟨ഗ⟩—

Barelvi received an imam's welcome on his return from haj. He was proclaimed the mahdi promised by the Prophet, the messiah who would precede the return of Christ. For two years after his return, Barelvi preached an unambiguous message: '*Hindustan . . . ast ke aktharash darin ayyam Daru'i Harb gardida.*' Hindustan had become a House of War. British observers held their peace, and gave the holy warriors a nickname, Crescentaders.

Barelvi was pragmatic enough to seek good relations with Hindu nobles who had fought the British. He sent a letter through a confidante, Haji Bahadur Shah, to Raja Hindu Rao, brother-in-law of Maharaja Daulat Rao Scindia. This remarkable missive

promised that once India was cleared of the British, their territories would be restored to traditional hierarchs, including Hindus. The enemy was that 'alien people from distant lands [who] have become the rulers of territories . . . traders and vendors of goods have attained the rank of sovereignty. They have destroyed the dominion of the big grandees and the estates of the nobles of illustrious ranks, and have eroded their honour and authority. Since the ruler and administrators of justice have retired into the nook of obscurity, inevitably the penniless and powerless have risen up to the occasion.' He expected that the rajahs who would benefit from his jihad 'should heartily help and support the cause of Islam and be firmly seated as the occupants of thrones'.

The battlefield that Barelvi chose was the Muslim North West Frontier, from where he believed, as caliph, he would rally tribals under his banner to supplement his band of 600, defeat the Sikhs and re-establish Islamic space in India. Inspired by a messianic conviction in victory, he left Rae Bareli on 17 January 1826, comparing his journey to Hijrat, the Prophet's emigration from Mecca to Medina. His route, across the belly of India, was south and west of the Sikh kingdom: Gwalior, Tonk, Ajmer (a British possession), Pali, Hyderabad (in Sind), and then up alongside the Indus to Shikarpur, then west to Kandahar, Ghazni, Kabul, Jalalabad, across the Khyber to Peshawar, ending at Nowshera.

In Gwalior, he was feted by Hindu Rao, and left with handsome gifts. His old mentor, Nawab Amir Khan, was similarly hospitable; the jihadi camp in a field at Tonk became known as *Bazaar-i-Qafila* (Bazaar of Processions). But once he came within the vicinity of the Sikh possessions he found Muslim potentates wary of offering commitment to the jihad. The temporal–religious leader of the Hurs, the pir of Pagara, Sibgatullah Shah, wanted to wait till Barelvi had established a base in the Frontier. The ruler of Baluchistan, Mehrab Khan, excused himself, pointing out that his threat came from Abdullah Khan Durrani in Kandahar rather than Maharaja Ranjit Singh in Lahore. The Durrani chiefs of Peshawar were so hostile to this maverick presence that Barelvi had to move quickly to Yusufzai territory, where a ghazi (warrior)

against the Sikhs was more at home. The primary motivation of those who did join Barelvi was not holy jihad but unholy loot. It was plunder that ensured the defeat of Barelvi in his first encounter with Budh Singh's army of 10,000 disciplined men. The jihadis broke through in a night attack, but their greed gave the Sikhs time to repulse and defeat Barelvi. An unintended consequence of this battle was that those who survived carried tales of booty, bringing in more recruits. Khade Khan, chief of the Hund, offered his area as a base for operations, but his main aim was to use the force for a raid on the commercial centre at Hazru.

Barelvi tried to reboot the war from the ridiculous to the sublime: on 11 January 1827, he declared himself imam and demanded loyalty in the name of Islam. He explained, in a letter to his disciples, that, 'It was accordingly decided by all those present at the time, faithful followers, Sayyids [descendants of the Prophet's family], learned doctors of law, nobles and generality of Muslims that the successful establishment of jihad and the dispelling of disbelief and disorder could not be achieved without the election of an imam.' Coins were struck which described him as 'Ahmad the Just, Defender of the Faith, the glitter of whose sword scatters destruction among the infidels'. His original ghazis called him Amir ul Momineen (Commander of the Faithful); locally he became known as Sayyid Badshah (King Sayyid); and he described himself more quaintly as khalifa (caliph) sahib. From his new pedestal, he wrote to the rulers of Kashmir, Chitral and Bukhara in Central Asia inviting them to join the jihad. Islam generated much more enthusiasm, and his army swelled to 80,000. But even Islam was not sufficient to dampen the duplicity that had become a trademark of behaviour among some chiefs.

Barelvi was warned that the Peshawar Durranis, Yar Muhammad Khan and Pir Muhammad Khan, would betray him, but he left events to God. The Durranis made a deal with the Sikhs and, on the eve of the battle of Shaidu, poisoned Barelvi. He was unable to take the field; the Durrani men stood out the fighting, and the jihad was defeated again by Budh Singh, who had supplemented his strength to 30,000 men. The Sikhs had tried to buy out Barelvi

as well, offering him land worth a revenue of Rs 900,000, but he was incorruptible.

Maulvi Mahboob Ali, who had brought a fresh batch of recruits from Delhi, voiced what was now obvious: before the Commander of the Faithful could defeat the unfaithful, he had to take care of Muslim 'infidels'. The irate maulvi lashed out at Barelvi as well, accusing him of succumbing to ostentation, and pointing out, acerbically, that ghazis had become crooks instead of martyrs under his leadership. The disillusioned maulvi returned home. With recruits and funds switched off from Delhi, Barelvi was forced to borrow Rs 35,000 from Hindu moneylenders in Manara, near Hund, at an usurious rate of 12 per cent, and collect taxes, which were obviously opposed even by the local mullahs. Sharia was even more difficult to impose. The people resented strictures on local practices like bathing naked in the river, which now invited a fine or lashes; or a ban on the local practice of daughters being offered to the highest bidder. The chiefs were upset by the challenge to the existing power structure in which the ulema listened to the chiefs rather than vice versa. Khade Khan, the first chief to offer loyalty to Barelvi, decided that Sikh rule was better than Barelvi's, and he was not alone. The jihad turned into an internecine war between Muslims in which Barelvi was badly mauled. But the seeds of a concept called Islamic nizam, or rule, had been sown in the region, and even if it did not flourish as well as the gardener might have intended, it never disappeared either.

Barelvi's last battle gave that concept a romantic power that has made his shrine in Balakot a place of pilgrimage to this day. He had selected the hillock at Balakot as his base for what would be his last confrontation with the Sikhs because it was considered impregnable. He would be betrayed again; local Pathans showed the Sikhs the winding route to his encampment. On the morning of 6 May 1831, Barelvi was stunned to discover the Sikhs, led by Sher Singh, at his defences.

Barelvi chose martyrdom. He completed his prayers, raised the *naara e takbir*, 'God is great!' [*Allah u akbar!*], and led the

counterattack. No one saw him being killed. There are different stories about his burial, and which part of his body was buried. One narrative says that Sher Singh gave his adversary an honourable burial. But the next day, after he left camp, some Sikhs disinterred the body and threw it into the river. Later, the head and the body, found separately, were buried at Garhi Habibullah and Telhatta. The circumstances of his death and burial inevitably led to a legend of 'disappearance' and the promise of return, adding to his mystique. In his death, Barelvi became a symbol of something he had not managed to achieve in life, the pure jihad. As twentieth-century admirers put it, the blood of Balakot runs in the veins of Muslims. The shrines of Barelvi and his close associate Shah Ismail (1779–1831) in Balakot, now a stronghold of the Pakistan Taliban, have become pilgrimage centres.

His death sparked off minor insurrections in the rest of India, and a major sympathy wave for his cause among Muslims. British bureaucrats, always happy to weaken an enemy without strengthening a friend, looked the other way when Barelvi went to war against Ranjit Singh. But they dealt quickly and effectively with the spillover into British India.

―――᜵᜵᜵᜵――

Among the Indians Barelvi met in Mecca was a Bengali from Chanpur, in the district of Barasat, Nisar Ali, popularly known as Titu Miyan. On his return, Titu Miyan began to mobilize the Muslim peasantry against those Hindu landlords who were excessively punitive. He was so successful that he set up a parallel government in the districts of 24 Parganas, Nadia and Faridpur. The Calcutta Militia proved ineffective against his ragged but determined followers. The British sent regular troops, and he was killed in November 1831.

But the British would be surprised by the depth of the resistance in the north-west when they took direct control after defeating the Sikhs by 1848. They were particularly apprehensive about a

Muslim revival centred around a state like Multan or a stronghold like Peshawar, which was a declared aim of the Barelvi-Wahabis. Lord Hardinge, Governor-General between 1844 and 1848, noted that Wahabis had re-established themselves in both places with the weakening of Sikh authority. He feared that jihadi success in Punjab would revive Muslim hopes throughout India, and made the elimination of such a possibility his highest priority.

On 13 April 1847, Sir Henry Lawrence, governor of Punjab, recorded the presence of 'fighters for religion', whom he described as Wahabi 'Ghozat or Majahiden' (variations of ghazi, or holy warrior, and mujahideen). Nor had the problem entirely disappeared in the east. British administrators had seen and noted, in Bengal in 1850, Wahabis 'preaching sedition in the Rajshahi district of Lower Bengal'.

Barelvi's jihadi successors were the brothers Wilayat Ali and Enayat Ali, known as the Patna Khalifas; their period is known as the 'Imarat' (Emirate). In the summer of 1850, Wilayat Ali set off from Patna, with a party of some 250, towards Delhi, where they camped in a house near the capital's Fatehpuri mosque. Wilayat Ali's sermons began to attract attention, and important members of the Mughal court, including Imam Ali, tutor of Zeenat Mahal, chief queen of the last emperor, Bahadur Shah, offered their allegiance.[6]

Imam Ali arranged an audience with Bahadur Shah Zafar. Wilayat Ali delivered an emotional address at the Diwan-i-Khas, the main durbar hall in the Red Fort, on the transitory nature of life, and the larger duty of Muslims. The emperor was moved. The British resident, who had his interests to protect, asked probing questions. Wilayat Ali sensed trouble and possible arrest. Bahadur Shah wanted the Wahabis to stay on, particularly as Ramadan was approaching, but Wilayat Ali left Delhi immediately and joined his brother Enayat in Ludhiana in November, from where they travelled together to the Frontier.

In 1851, Enayat and Wilayat Ali 'were found disseminating treason on the Punjab Frontier'.[7] In 1852, the authorities uncovered an effort by Wahabis to incite a rebellion in the 4th Native

Infantry, stationed in Rawalpindi. In 1853, as Hunter recorded two decades later, 'several of our native soldiers were convicted of correspondence with the traitors'. The general uprising of 1857 was not a sudden uprising inspired merely by pig's lard or beef tallow on new bullets. It was a conflagration that had been building up across north India through a series of firestorms. During the 1857 wars, Enayat Ali was active in the Mardan mountains near Peshawar. Sepoys of the 55th Native Infantry, garrisoned at the fort of Mardan, rebelled in the middle of May and joined the Wahabis.

The Frontier remained at war when the rest of north India had been subdued. By 1862, the Wahabi army was routinely described as the 'Fanatical Host' in British dispatches. A perilous moment for British arms came on 7 September 1863, when Wahabis descended upon a camp of the British Guide Corps. On 18 October, General Sir Neville Chamberlain set out at the head of 7,000 men to enforce British authority. Hunter puts on record that '. . . our column burned the villages of the rebel allies, razed or blew up the two most important forts, and destroyed the Traitor Settlement at Sultana . . . [but] so little was their power shaken, that a new Settlement at Mulka was immediately granted them by a neighbouring tribe'.

By the third week of November, the British were close to admitting defeat; on 19 November, Chamberlain sent an urgent telegram for immediate reinforcements. 'A great political catastrophe was now dreaded. Our Army, wearied out with daily attacks, might at any moment be seized with a panic, and driven back pell-mell, with immense slaughter, through the [Ambcyla] Pass,' wrote Hunter. Eventually, money achieved what arms could not. The commissioner of Peshawar bribed some tribal chiefs to either cease fighting or defect.

Between 1850 and 1857 alone, the British sent sixteen expeditions involving 33,000 regular troops against the 'Fanatical Host'. It needed another four expeditions, till 1863, and a total of 60,000 troops, to defeat the Wahabis. The Punjab government summed up the 1863 campaign thus: 'On no former occasion has

the fighting in the hills been of so severe or sustained a character.'
As late as in 1898, Winston Churchill, soldier and war
correspondent, was ruefully reporting that Frontier tribals would
never accept foreign occupation.

Even if actual fighting was restricted to the Frontier, the mood
of jihad was prevalent among Muslims. T.E. Ravenshaw, magistrate
of Patna, and oft-quoted by Hunter, reported to the Bengal
government in 1865 that troops had not succeeded in driving out
the jihadis from the Frontier hills, and that as long as they
remained, the minds of Muslims in Bengal would remain unsettled.
He had no doubt that the objective of the Wahabis and various
groups like Feraizees, Hidayatees or Muhammadiyas was the
restoration of 'Mahomedan' power. The *Risala-Jihad'*, a Wahabi
war song, extolled the rewards of martyrdom and demanded
from the faithful, 'Fill the uttermost ends of India with Islam, so
that no sounds may be heard but Allah! Allah!'. A *kasida* written
by Maulvi Karam Ali of Kanpur stressed the obligation of jihad
against the infidel; an ode by Maulvi Niyamatullah predicted the
coming of a king who would deliver Muslims from the Nazarenes
'by the force of the sword in a Holy War'; Maulvi Muhammad
Ali's *mahsar* announced the rise of another Mahdi and its
consequences in graphic and gory detail, with the very smell of
government being driven out of heads and brains.

The *Jama Tafseer*, a newspaper printed in Delhi in 1867,
insisted that Indian Muslims had only two options after the
failure of 1857: either jihad or emigration from British India. It
condemned those who sought accommodation with British rule
as hypocrites, similar to the *munafiqeen* who had betrayed the
Prophet of Islam: 'Let all know this. In a country where the ruling
religion is other than Muhammadanism, the religious precepts of
Muhammad cannot be enforced. It is incumbent on Mussalmans
to join together and wage war upon the infidels. Those who are
unable to take part in the fight should emigrate to a country of
The True Faith ... Oh Brethren, we ought to weep over our state,
for the Messenger of God is angered with us because of our living
in the land of the infidel. When the Prophet of God himself is
displeased with us, to whom shall we look for shelter?'

The Wahabi missionary network stretched from the Frontier to Bengal and Hyderabad in the south. In Qeyamuddin Ahmad's words, they 'helped build up an elaborate system of supply of men and material which sustained the movement till after their own time. They also initiated the important work of establishing contacts with the Indian units of the Company's army, leading to "conspiracies" in various cantonments stretching from [Punjab to Calcutta]. On the North-Western Frontier, they reorganized the affairs of the Wahabi State which had been established during the time of Sayyid Ahmad [Barelvi] and attained some notable successes against the British during 1850s.'

Wahabism seeped into small towns and villages. Ravenshaw wrote in 1865, 'They [Wahabis] have under the very nose and protection of government authorities, openly preached sedition in every village of our most populous districts, unsettling the minds of the Mussulman population, and obtaining an influence for evil as extraordinary as it is certain.' Hunter admitted that 'a network of conspiracy has spread itself over our Provinces', and that 'the bleak mountains that rise beyond the Punjab are united by an unbroken chain of treason-depots with the tropical swamps through which the Ganges merges into the sea'. Jihad had become 'a source of chronic danger to the British power in India'.

—⁓⁓—

Richard Bourke, sixth earl of Mayo and fourth viceroy of India, began his term in 1869. He wanted an answer to the question at the heart of the government's troubles: 'Are the Indian Mussalmans bound by their Religion to rebel against their Queen?' One of his ablest civil servants, Sir William Hunter, was commissioned to provide the answer. It came in the form of a report, referred to above, 'The Indian Mussalmans'.

There were, broadly, two views on the Muslim question in the upper echelons of British administration. Both admitted a certain admiration for the 'sturdy' Muslim, a worthy opponent in battle, and unwavering in his faith. One group thought Muslim hostility

was incurable. Alfred Lyall, another great name in the Indian Civil Service lists, wrote in *Asiatic Studies* (1904) that 'The Mahommedan faith has still at least a dignity, and a courageous unreasoning certitude, which in western Christianity have been perceptibly melted down ... by long exposure to the searching light of European rationalism'. This made Muslims 'distinctly aggressive and spiritually despotic'. They were prejudiced against Christians because of 'the religious rivalry of a thousand years'. Conciliation was no use; all the British could do was keep the peace in India and clear the way for the 'rising tide of intellectual advancement'.

One or two purple passages might suggest that Hunter was not very eager to trust Muslims either. They also seem eerily prescient of twenty-first-century rhetoric: '... no one can predict the proportions to which this Rebel [Wahabi] Camp, backed by the Mussalman hordes from the Westward, might attain, under a leader who knew how to weld together the nations of Asia in a Crescentade'. He continues, 'The Mussulmans of India are, and have been for many years, a source of chronic danger to the British Power in India.' The 'fanatics' among them, he pointed out, had engaged in 'sedition' long before 1857, while the 'whole ... community has been openly deliberating on their obligation to rebel'. Even Shia Muslims, he regretted, had been seeking a fatwa to justify 'overt treason'.

Hunter admitted some grudging respect for Wahabis. He praised their search for a 'purer life and a truer conception of the Almighty' and their 'great work of purifying the creed of Muhammad', comparing them to Protestant monks who had purged the Catholic Church. There is appreciation of the revival under Barelvi's successors: 'Again the fanatic cause seemed ruined. But the missionary zeal of the Patna Khalifas and the immense pecuniary resources at their command, once more raised the sacred banner from the dust. They covered India with their emissaries, and brought about one of the greatest religious revivals that has ever taken place.'

Hunter consulted 'doctors of law', that is, imams and qazis who

were qualified to speak on the Sharia, to find out if there was some aspect of Islamic law that made rebellion obligatory. The Hanafi, Maliki and Shaafi schools replied that as long as the British permitted Muslims to abide by the laws of Islam, and practise their faith, British India would be considered Dar al-Islam, a House of Islam, and not a house of war. The Shia interpretation noted that a jihad was valid only when the armies of Islam were led by the rightful imam, when there were enough arms and sufficient warriors with requisite experience, when the generals were in possession of their reason, and there was enough money to finance this war.

Hunter's purpose was to break the appeal of 'these misguided Wahabis'. 'Sir Bartle Frere informs me,' says Hunter, 'that the Wahabi organization of that day included a brother of the nizam [of Hyderabad, a crucial British ally], who was to have been raised to the Haidarabad [*sic*] throne ... It is not the Traitors themselves whom we have to fear, but the seditious masses in the heart of our Empire ...'

His approach was sensible: 'The British Government of India is strong enough to be spared the fear of being thought weak. It can shut up the traitors in its jails, but it can segregate the whole party of sedition in a nobler way – by detaching from it the sympathies of the general Muhammadan Community. This, however, it can do only by removing the chronic sense of wrong which has grown up in the hearts of the Mussalmans under British Rule.'

The principal Muslim grievances were an education policy that denied them opportunity, reducing them to 'contempt and beggary'. While the Hindu upper strata in Bengal, their confidence bolstered by rising rent receipts, abandoned Persian and grasped at English, Muslims rejected an alien language and a secular education. From 1828, the Company also began to confiscate waqf land endowments which financed Muslim education and which amounted to one-fourth of all land in Bengal. The abolition of the qazi system had left the ulema jobless; religious institutions, particularly charitable foundations under waqf, had been

sabotaged through 'misappropriation on the largest scale of their educational funds'; and the British had treated Muslims with 'the insolence of upstarts'. Hunter notes, wisely, that 'In India, the line between sullen discontent and active disaffection is a very narrow one'.

There is no reason, Hunter concludes, why Muslims should not be at peace with the Empire, even according to their own law. 'But the obligation,' he admits, 'continues only so long as we perform our share of the contract, and respect their rights and spiritual privileges. Once let us interfere with their civil and religious status (*aman*), so as to prevent the fulfilment of the ordinances of their Faith, and their duty to us ceases. We may enforce submission, but we can no longer claim obedience.' Hunter had an effective answer: 'While firm towards disaffection, we are bound to see that no just cause exists for discontent.'

The imbalance in education and employment had to be rectified. The thirty million Muslims in British India faced discrimination in urban jobs, particularly after 1857, while moneylenders preyed on an impoverished peasantry. Records compiled in April 1871 show that of 2,111 state jobs in the Bengal government, Europeans had 1,338, Hindus 681 and Muslims just 92. Between 1858 and 1878, there were only 57 Muslims out of the 3,100 graduates of Calcutta University.

Hunter quotes the lament of a Persian newspaper from Calcutta, published in July 1869: 'All sorts of employment, great and small, are being gradually snatched away from the Muhammadans, and bestowed on men of other races, particularly the Hindus. The Government is bound to look upon all classes of its subjects with an equal eye, yet the time has now come when it publicly singles out the Muhammadans in its Gazettes for exclusions from official post. Recently, when several vacancies occurred in the office of the Sundarbans Commissioner, that official, in advertising them in the Government Gazette, stated that the appointments would be given to none but Hindus. In short, the Muhammadans have now sunk so low, that, even when qualified for Government employ, they are studiously kept out of it by Government

notifications. Nobody takes any notice of their helpless condition, and the higher authorities do not deign even to acknowledge their existence.'

In Orissa, then a part of the Bengal jurisdiction, E.W. Molony, the commissioner, received a petition from Muslims that is all the more touching for its broken English: 'As loyal subjects of Her Most Gracious Majesty the Queen, we have, we believe, an equal claim to all appointments in the administration of the country. Truly speaking, the Orissa Muhammadans have been levelled down and down, with no hopes of rising again. Born of noble parentage, poor by profession, and destitute of patrons, we find ourselves in the position of a fish out of water. Such is wretched state of the Muhammadans, which we bring unto your Honour's notice, believing your Honour to be the sole representative of Her Most Gracious Majesty the Queen for the Orissa Division, and hoping that justice will be administered to all classes, without distinction of colour and creed. The penniless and parsimonious condition which we are reduced to, consequent on the failure of our former Government service, has thrown us into such an everlasting despondency, that we speak from the very core of our hearts, that we would travel into the remotest corners of the earth, ascend the snowy peaks of the Himalaya, wander the forlorn regions of Siberia, could we be convinced that by so travelling we would be blessed with a Government appointment of ten shillings a week.'

Education topped Hunter's list of solutions. He quotes, with approval, the officer in charge of Wahabi prosecutions, James O'Kenealy: 'I attribute the great hold which the Wahabi doctrines have on the mass of the Muhammedan peasantry to our neglect of their education.' E.C. Bailey, home secretary to the Government of India in 1870, commented: 'Is it any subject for wonder that they [Muslims] have held aloof from a system which, however good in itself, made no concession to their prejudices, made in fact no provision for what they esteemed their necessities, and which was in its nature unavoidably antagonistic to their interests, and at variance with all their traditions?'

'The central objective of Hunter's work was to urge upon the government a policy toward Muslims less unyieldingly hostile than the condemnation that had marked the period from Tipu Sultan to the Mutiny. In so doing, Hunter sought to distinguish between the "fanatical masses", and the "landed and clerical interests". The latter, he insisted, "bound up by a common dread of change", had no interest in the reformist enthusiasms of the Wahabi Movement, for such "dissent" was necessarily "perilous to vested rights". Hence, by a more equitable treatment of these classes, especially in Bengal where a century of dispossession had stored up a host of grievances, they could be prompted to support the British government,' writes Thomas Metcalf.[8] He adds, 'Despite its obsession with "conspiracy", Hunter's *The Indian Mussulmans* laid out a new policy initiative that, pushed forward by the successive viceroys Mayo and Northbrook, was to lead to a new alliance with India's Muslim elites, above all with men such as Sayyid Ahmad Khan, whose Cambridge-style Aligarh college gave visible shape to Hunter's vision.'

In a remarkable piece of social engineering, the British turned, through positive discrimination in education, job benefits and political empowerment, a hostile Muslim community into a resource for their Indian Empire within just two decades. They found a partner in another Syed [a variation of Sayyid] Khan, who was knighted and is popularly known as Sir Syed. His lasting contribution to Muslims is their first modern institution of higher learning, the Aligarh Muslim University.

Its alumni played a defining role in the history of Indian Muslims, in the establishment of their first political party, the Muslim League, then as allies of Mahatma Gandhi in his first great challenge to British rule, between 1919 and 1922; and lastly in the creation of Pakistan.

4

An English Finesse

—⟨∾⟩—

Both were Sayyids, or Syeds, a designation limited to those who trace their ancestry to the Prophet's family. Both were inspirational leaders of a bereft community in a century marked by crises. Their lives overlapped briefly. Syed Ahmad Khan (1817–98) was a young man when Sayyid Ahmad Barelvi was killed in battle in 1831. Their lives intersected obliquely: Syed Ahmad's mother was a devotee of Shah Aziz, who taught Barelvi, and Syed Ahmad was sufficiently moved by Barelvi's martyrdom to write an eulogy. But their interpretation of *hubbi-i-imani*, the way of the Prophet, differed.

While Barelvi sought salvation through holy war, Syed Ahmad believed that modern, English education was the only key that could release a community locked in its past. The British Raj, persuaded by the Hunter report, had come to the same conclusion, and expected in the process to earn the loyalty of the Muslims. They chose Syed Ahmad as their interlocutor with the community, honoured him with the Order of the Star of India in 1869 and a knighthood in 1888 (as well as an honorary doctorate from Edinburgh University) and helped him found a college that is today the Aligarh Muslim University.

Barelvi's ideological heirs, spurning social, financial or political association with the British, set up their own school, the Deoband Madrasa. Both Aligarh and Deoband had an impact on the future in ways their founders could never have imagined. In a sense, Shah Waliullah's theory of distance was split between these two fountainheads. While Deoband, rooted in local history, sought Muslim space within a shared Hindu–Muslim India, Aligarh's 'modernists', influenced by a rapidly changing world in which new nations were being created for emerging identities, took the idea, in stages, towards a separate horizon.

In October 1906, a group of Aligarh alumni initiated a chain of events that culminated in the creation of Pakistan, when they helped draft a charter of demands to the viceroy that asked for separate electorates for Muslims, dividing politics along communal lines. In December that year, the annual educational conference established by Sir Syed reconstituted itself as a political party, the All-India Muslim League. Within four decades, the Muslim League converted the politics of distance into a separate nation.

———✦———

The birth of a son in an upper-class *(sharif)* Muslim household during Mughal rule was announced with a proud gunshot – to get the child used to the sound of firearms. A maulvi or a senior member of the family would then bend down and whisper the azaan in the left ear and the kalimah in the right. Faith and fire were birthrights. Syed Ahmad Khan was born, on 17 October 1817, into such a home in Delhi.

His father, Mir Muhammad Muttaqi, was a bureaucrat who served as personal adviser to Akbar Shah II. The child grew up in a sprawling complex of houses owned by his maternal grandfather, Khwaja Fariduddin Ahmad, who was vizir, the equivalent of a prime minister. Courtesy, consideration, order, education (personally supervised by the family patriarch in the evenings), religious observance, poetry, elegant conversation: such were the elements that constituted the *sharif* lifestyle. Courtesy was a

prime virtue. His mother, Azis-un-Nisa, banished him from home when he was eleven or twelve because he hit an old family retainer. He had to live with an aunt until he sought forgiveness from the servant.

His ustad, Maulvi Hamiduddin, taught him the traditional disciplines of Persian, Arabic, Urdu and religion. Others gave lessons in astronomy, mathematics, unani medicine, classical music, painting, archery and, not least, the serious art of kite-flying; he later wrote a treatise on making kites and grinding broken glass into a powder with which the string was treated in order to slash competition in the sky. Syed Ahmad recalled an uncle, with élan, who would take him to the home of a Hindu friend and patron of ghazals, music and professional dancing girls.

The most useful uncle, though, was the one who got him a minor job in a British court after his father's death in 1838. He was appointed serestedar (responsible for records) in Agra. Within two years he was promoted to munsif. In 1846, he arranged for a transfer to Delhi to be with his mother. He had begun to make a name for himself as a scholar with the publication of *Athar Assanadid* (Great Monuments), a well-researched record of Delhi's architectural inheritance. In 1854 appeared a commentary on the Bible in which he examined the proximity between Islam and Christianity. In the same year, he became sadr amin at Bijnore, and was a senior Raj official when the uprising of 1857 shook northern India.

—⟨⟩—

The British used war as a necessary means to power, but understood that its costs were substantial and its perils avoidable. Defeat could add up to more than the sum of its parts. Always short of numbers in a heavily populated land, the British depended on a mystique of military invincibility; any dilution of this 'prestige' might induce a cascading downward spiral. The Company annexed Sind in 1844, in what is today the south of

Pakistan, at least partly to restore the 'prestige' that had been shattered by the Afghanistan disaster in 1841.

The most audacious British annexation, of Awadh in 1856, was entirely peaceful. Finance became the justification for encroachment, as Calcutta took revenue-bearing territory in lieu of debt. By 1831, Governor-General Lord Bentinck was warning the nawab of Awadh that he was in danger of becoming a titular pensioner, like the raja of Tanjore. Experienced officers like Colonel W.H. Sleeman, famous for subduing the menace of thugs in central India and now resident in Lucknow, told Calcutta that Muslims would resent the subversion of the most powerful Muslim dynasty of the north, and this would affect the loyalty of the Muslim sepoys in the 'native' army. Sleeman even warned that they might be provoked into 'some desperate act'; there were some 40,000 Awadhi sepoys in the Bengal Army. The high-minded Sleeman wanted the Company to become trustees of Awadh, spending its revenues wisely, on people-oriented projects. But the expansionist Lord Dalhousie (1848–56), who gave India the railways and believed that Indians had never had it so good as under British rule, was impervious. He received London's approval for the annexation of Awadh in January 1856.

The process was unceremonious. The British informed the despondent Nawab Wajid Ali Shah through a letter that he had just become ex-nawab. Wajid Ali Shah knew his fate; he had already ordered palace guns to be dismounted, and guards disarmed. The ex-nawab took the turban off his head, placed it in the hands of the British resident and burst into tears. Three days later, a proclamation was issued declaring Awadh a British territory. Not a shot was fired.

Awadh was the last conquest of British India.

The British were to pay a heavy price for destroying a dynasty that had bought, literally, peace with them since the battle of Buxar in 1765. Opinion across the spectrum, from nobility to sepoy, accused the British of the grave sin of injustice. Ghalib, the pre-eminent poet of his age and perhaps the finest in the Urdu language, wrote to a friend in Awadh on 23 February 1857,

'Although I am a stranger to Oudh and its affairs, the destruction of the state depressed me all the more, and I maintain that no Indian who was not devoid of all sense of justice could have felt otherwise'.[1] In his history of 1857, *Asbab-i-Baghawat-i-Hind* (Causes of the Rebellion in India), Syed Ahmad notes that the Honourable East India Company angered 'all classes' by acting 'in defiance of its treaties, and in contempt of the word which it had pledged'.

There was also a strong undercurrent of fear that the British wanted to convert, through missionaries, Hindus and Muslims into Christians. Well-meaning reforms, such as the abolition of sati and legalization of widow remarriage, were treated as evidence. Anger had been building for a while. In 1806, sepoys had rebelled in Vellore, where Tipu Sultan's son were imprisoned, because of a new cockade in the uniform: it was believed that its headwear was made of pig or cow skin, the first offensive to Muslims and the second sacred to Hindus. Moreover, Hindu sepoys (still mainly upper-caste Brahmins and Kshatriya) were ordered to erase 'uncivilized' caste marks on their foreheads, and Muslims told to trim their beards. About a hundred British soldiers and fourteen officers were killed before order was restored.

But 1857 was on a vastly different scale. The Indian Army had grown from 100,000 in 1790 to 280,000 by 1857, including 45,000 Europeans, making it the largest standing armed force in Asia. There were supplementary grievances, including pay: the Indian sepoy was paid one-third the salary of his British equivalent, and promotion was virtually non-existent. As early as in 1853, William Gomm, commander-in-chief of the Company army, had argued that the greased paper cartridge wrap of the new Enfield rifle, which had to be bitten off to ensure ignition, should not be used in India unless it was found acceptable to natives. The original greasing was a mix of vegetable oil and wax. The manufacturers discovered that beef tallow or pig fat were cheaper options and, as good capitalists, changed the formula.

Biting this bullet polluted faith. Of the seventy-four Bengal regiments, fifty-four mutinied. Across north India, every aspect of

British presence, including government buildings, churches, residences and tombs, was attacked. Many British officers retained the loyalty of their Indian men, but largely because of personal bonds. A famous case was that of Henry Lawrence, who defended Lucknow with 700 Indians.

To the relief of the authorities, the 'Devil's Wind' did not envelop the whole of the country, and the Company got crucial help from some powerful Indian potentates. As Sir Penderel Moon observes, '. . . it is hard to see how the British could have survived and recovered Hindostan without the support of the Sikhs and the Punjab generally. It was only by a hair's breadth that they pulled through.'[2] Almost all the important Maratha states, barring Holkar, who temporized, stayed out of the war; and Gwalior gave invaluable help to the British, as did the Punjabi states of Patiala, Nabha and Jind. The ever-faithful nizam of Hyderabad used artillery in July 1857 to disperse his fellow-Muslims when they attacked the British residency in Hyderabad. Without the support of its Indian neo-colonies, the British Raj would have ended in 1857, as predicted by some astrologers, rather than in 1947. Queen Victoria recognized this debt in 1858.

The East India Company won the war in India, but lost the battle in London; the Crown took over the government of India. On 1 November 1858, a 'Proclamation by the Queen in Council, to the Princes, Chiefs, and People of India' from 'Victoria, By the Grace of God, of the United Kingdom of Great Britain and Ireland, and of the Colonies and Dependencies Thereof in Europe, Asia, Africa, America, and Australia, Queen, Defender of the Faith' declared that the Queen 'had taken upon Ourselves the said Government'. Victoria made a solemn promise of non-interference to her Indian princes: 'We desire no extension of Our present territorial Possessions . . .' The boundaries of direct British rule were frozen. 'We shall sanction no encroachment on those of others. We shall respect the Rights, Dignity, and Honor of Native Princes as Our Own.'

Her Indian subjects were reassured that while the Queen might be Defender of the Faith in Great Britain and Ireland, she

would not defend the Christian faith as eagerly in India. 'Firmly relying Ourselves on the truth of Christianity, and acknowledging with gratitude the solace of Religion, We disclaim alike the Right and the Desire to impose our Convictions on any of Our Subjects. We declare it to be Our Royal Will and Pleasure that none in any wise favoured, none molested or disquieted, by reason of their Religious Faith or Observances; but that all shall alike enjoy the equal and impartial protection of the Law: and We do strictly charge and enjoin all those who may be in authority under Us, that they abstain from all interference with the Religious Belief or Worship of any of Our Subjects, on pain of Our highest Displeasure.' The government would not interfere, through legislation or coercion, in the practice of any faith, in the name of reason or civilization. This severely curtailed, even if it did not eliminate, official patronage to the missionary movement in India.

The year 1857 ended the pretence of Muslim rule in India. The sepoys had formally declared war in the name of the last Mughal, Bahadur Shah Zafar, crowned emperor in 1837, who was neither very bahadur (brave) nor much of a shah (king). Syed Ahmad described him as 'a mouldering skin stuffed with straw' to his biographer Altaf Hussain Hali (1837–1914). Zafar was in turns enthusiastic, frightened and self-pitying during the few months of conflict. His famous letter to the princes and people of Hindustan, issued on 20 May 1857, has the merit of identifying the crux of Indian anger against the British, but works more as a useful sermon rather than an inspirational call to arms. He asked for unity in the defence of Islam and Hinduism: 'It is now my firm conviction that if these English continue in Hindustan, they will kill everyone in the country, and will utterly overthrow our religions . . . all you Hindus are hereby solemnly adjured by your faith in the Ganges, *tulsi* and Saligram; and all you Mussulmans, by your belief in God and the Kuran, as these English are the common enemy of both, to unite in considering their slaughter extremely expedient, for by this alone will the lives and faith of both be saved.'[3]

The British, inverting logic, convicted the legal emperor of India for 'treason' in his own country. Zafar was exiled to Burma. No such lenience was shown to lesser prisoners, who were hanged. Their last illusions brutally exposed, Indian Muslims went into depression. They were punished individually and collectively. Their great cities and centres of high culture, Delhi and Lucknow, which Ghalib described as the Baghdad of India, were razed.[4] Syed Ahmad lamented to the Muhammadan Literary Society of Calcutta in 1863, 'In our ancient capitals once so well-known, so rich, so great and so flourishing, nothing is now to be seen or heard save a few bones strewn amongst the ruins of the human-like cry of the jackal.'

The confidence of the Muslim elite dropped from a heightened sense of superiority to a tortured collapse of self-confidence. Numbers, which had seemed irrelevant during the high noon of power, now became the focal point of despair as, having lost in the competition with the British, they began to compete with Hindus for the benefits of British rule. The ideologue of this new arithmetic was Syed Ahmad Khan. His life was devoted to lifting Indian Muslims out of what he called, in a mordant and brilliant phrase, a 'fatal shroud of complacent self-esteem'. The way out of the shroud, he argued, was not through confrontation but cooperation with the British.

His credentials for such an enterprise were sound. He had saved vulnerable British civilians in Bijnore during the uprising despite Muslim wrath; he was driven out of the city by Nawab Mahmud Khan's soldiers. Ironically, his family in Delhi paid a heavy price for being Muslim. The British killed his uncle and cousin, and ransacked their home. His beloved mother fled penniless to Meerut, where she died a few days later. Syed Ahmad recalled that '. . . it made an old man out of me. My hair turned white'.[5]

Hindus were permitted to return to Delhi in June 1858; Muslims

had to wait till August 1859: it was not till 1900 that the Muslim population of Delhi reached 1857 levels. Insult followed injury. The Jama Masjid was turned into a barracks for Sikh soldiers; most of the Fatehpuri Mosque was sold to a Hindu merchant, and restored to its clergy only in 1877. The Zeenatul Masjid, perhaps the most beautiful in the city, was converted into a bakery till Lord Curzon returned it to Muslims. Everything within 448 yards of the Red Fort was demolished to provide a clear range for British guns. The homeless were forbidden from pointing out the spot where their homes once stood. Land and property were confiscated from those unable to prove that they had not been insurgents; much Muslim land was transferred to Hindu bankers. The city's great libraries, imperial as well as theological, whether they belonged to Nawab Ziauddin Khan of Loharu or Shah Waliullah, were looted. Akbarabadi Masjid, whose clerics were descendants of Waliullah, was destroyed, as was the *khanqah* of Shah Kalimullah. A residential area of the intellectual elite, Kuchah-e-Chilau Mohalla, was emptied when some 1,400 were butchered. The nobility was uprooted from residential areas like Jhajjar, Ballabgarh, Farrucknagar and Bahadurgarh. Mughal Delhi could now be found only in the poetry of lament.

Syed Ahmad Khan was so depressed by this destruction that he contemplated settling down in Egypt. But he dismissed exile as cowardice and turned to what became his life's work: a programme of reform and education for Muslims, urging them to acquire the intellectual merits that had made the British victors, a modern scientific temperament, and fluency in the English language.

He founded a madrasa with a modern curriculum in Muradabad in 1859, but it was only after his transfer to Aligarh in 1864 that he began to concentrate on this commitment. That year, he started the Scientific Society of Aligarh to translate English educational texts into Urdu, written in the Persian script. When some Hindu colleagues sought to extend this scheme to Hindi, written in indigenous Devnagari, he was irritated; he did not want any dilution of focus. This soon developed a side-effect, a conflict between languages. The British, who had nearly been

destabilized by the emotional exuberance of unity, had every reason to encourage, albeit discreetly, such disputes.

English replaced Persian as the language of governance in 1834. The decision was not made without debate. The 'Orientalists', led by the scholar Sir William Jones (1746–1794), wanted the government to support the study of three classic eastern languages, Sanskrit, Persian and Arabic: famously, he called the structure of Sanskrit more perfect than Greek, more copious than Latin and more refined than either. But Thomas Babington (Lord) Macaulay (1800–59), law member of the Executive Council of the Governor-General of India, had the last word, and English became the medium of higher education and official work. Macaulay argued that, 'The languages of Western Europe civilized Russia. I cannot doubt that they will do for the Hindoo what they have done for the Tartar.' In a visionary paragraph, he suggested that 'our subjects . . . having become instructed in European knowledge they may, in some future age, demand European institutions. Whether such a day will ever come, I know not. But never will I attempt to avert or retard it. Whenever it comes, it will be the proudest day in English history.'

Macaulay's immediate purpose was practical: 'We must at present do our best to form a class who may be interpreters between us and the millions whom we govern; a class of persons, Indian in blood and colour, but English in taste, in opinions, in morals, in intellect. To that class we may leave it to refine the vernacular dialects of the country, to enrich those dialects with terms of science borrowed from the Western nomenclature, and to render them by degrees fit vehicles for conveying knowledge to the great mass of the population.' There was no finer Macaulayan Indian in his time than Syed Ahmad Khan.

But while English would be supreme, which Indian tongue would become the second language of the courts?

At the popular level, there was sufficient overlap between Hindi and Urdu. Firaq Gorakhpuri, the eminent twentieth-century Urdu poet, a Hindu who taught English literature at Allahabad University, estimated, in an essay written in 1979 for the Uttar

Pradesh Hindi Sansthan, that Urdu added about 3,000 Arabic–Persian words to an Indian–Hindi lexicon of about 60,000, and pointed out that Urdu words were in use even among the illiterate. But in governance, script mattered. The tension increased after the Bengal government notified that Devnagari could be used in courts and government documents in Bihar and Central Provinces which came under its jurisdiction.

Lobbies built up for a similar status for Hindi in Awadh, geographically equivalent to today's Uttar Pradesh, which had a Hindu majority but had been Urdu-centric because its nawabs were Muslims. The tussle went down to syllabus, since education was not an end in itself, but a passport to jobs. According to figures cited by P. Hardy in *The Muslims of British India*, there were 11,490 boys studying Urdu in government schools in 1860; it rose to 48,229 by 1873 as Muslims insisted on protecting the language they increasingly saw as their own. In the same period, there were 69,134 and 85,820 Hindi scholars.

Syed Ahmad told his biographer Hali that he first began to feel that Hindus and Muslims would go in different directions only when, in his estimate, the Hindu elite of the North West Frontier Province (the then British name for Awadh) began to confront Muslims over language in the 1860s. He recalled a conversation with the divisional commissioner of Banaras, a certain Mr Shakespeare, whence the latter remarked that this was the first time Syed Ahmad had referred to Muslims alone rather than Indians in general. Syed Ahmad was prescient, in Hali's account: 'I am now convinced that these communities will not join wholeheartedly in any endeavour. There is no hostility between the two communities at present, but it will increase immensely in the future – because of the so-called educated people. He who lives will see this.' The Englishman said that he would be sorry if this were to happen. Syed Ahmad replied, 'I am also sorry, but I am convinced about the accuracy of this prophecy.'

On 29 April 1870, during a visit to London, Syed Ahmad wrote to his friend Nawab Muhsin-ul-Mulk (1837–1907) that the Urdu–Hindi controversy would make Muslim–Hindu unity

impossible. 'Muslims will never agree to Hindi, and if Hindus also, following the new move, insist on Hindi, they also will not agree to Urdu. The result will be that the Hindus and Muslims will be completely separated.' Battles over language had resilience. Syed Ahmad did not help promote harmony when he described Urdu as the language of the gentry and Hindi that of the vulgar. Hindus saw the return of Muslim hegemony in the promotion of Urdu.

In 1900, consequent to a Hindi deputation, the lieutenant governor of the United Provinces, Sir Anthony MacDonnell, approved the use of Devnagari in provincial courts, in addition to Urdu. This provoked a Muslim agitation led by Nawab Muhsin-ul-Mulk and Nawab Viqar-ul-Mulk Mushtaq Hussain (1841–1917; he would become the first president of the Muslim League in 1906). The slow displacement of Urdu is borne out by statistics. In 1891, there were twenty-four Hindi newspapers with a circulation of about 8,000; by 1911, this had risen to eighty-six newspapers with a circulation of about 77,000. The figures for Urdu are sixty-eight (circulation, circa 16,000), and 116, but with a circulation of only around 76,000. In 1887, Muslims had 45 per cent of judicial jobs in the United Provinces (much above their population ratio); this dropped to below 25 per cent by 1913. Between 1889 and 1909, the number of Hindu lawyers doubled, while Muslim numbers rose by only one-third.

Syed Ahmad had created a forum for support to the British in 1866, the British Indian Association of the North Western Provinces and Oudh. He expected reciprocal support for his dream project, an English–Urdu university. He elaborated his brave vision in an article reproduced in the 5 April 1911 issue of the *Aligarh Institute Gazette*: 'I may appear to be dreaming and talking Shaikh Chilli, but we aim to turn this [Muhammadan Anglo-Oriental College] into a University similar to that of Oxford or Cambridge. Like the churches of Oxford and Cambridge, there will be mosques attached to each College . . .' Prayer, five times a day, would be mandatory but students of other faiths would be exempted. 'They will have food either on tables of European style or on *chaukis* [stools] in the manner of Arabs . . .' The squatting

Indian style was clearly taboo. 'At present it is like a daydream. I pray to God that this dream may come true.'

In 1869, six Muslims and four Hindus presented a petition to the authorities for what eventually became the Aligarh Muslim University. Syed Ahmad was keen to project a partnership with Hindus to offset communal controversy. If he often became fanciful in his exaltation of British virtues, the potential reward was worth the rhetorical investment.

He suggested, possibly with more hope than conviction, that, in 1857, Muslim blood should have mingled with Christian blood and those who shrank from such loyalty to the British and sided with the rebels were untrue to their salt, a high crime in the hierarchy of Indian values. He sneered at pre-British India as nothing more than a period of loot, murder, cruelty and rape, and praised the British for ending tyranny, permitting freedom of worship and ending injustice. He convinced himself that the security of Hindus and Muslims (including from each other) lay in British rule.

He was careful to defend Islam with as much passion as he reserved for the praise of the British, but he wanted reform in the static thinking of conventional theologians, as his commentary on the holy book, *Tafsir al-Quran*, indicates. Satirists like the poet Akbar Allahabadi were caustic about a man with the beard of a maulvi and the education of the English, but Syed Ahmad was either impervious or oblivious. He had managed to antagonize the clergy much before, with his independent interpretation of the Quran and the Hadith. He was called a kafir. His English university project did not enthuse them either. A fatwa from Deoband accused Syed Ahmad of apostasy.

Maulana Abdur Razzaq of Lucknow's influential Firangi Mahal had no time for Western imperialists who, he was certain, were determined to crush the only Muslim power left standing, the Ottomans. He founded the Majlis Muid ul Islam in 1878 to support the Ottoman Empire in its confrontation with Russia, issued a fatwa for funds and told Muslims that they could atone for their weakness in 1857 by helping an Islamic power against

Christian colonizers. His grandson, Maulana Abdul Bari, who wrote his grandfather's biography, would echo this view in an epic alliance with Mahatma Gandhi between 1919 and 1922. Perhaps the Syed's formidable beard was intended to reassure the faithful.

He was far ahead of his age in demanding education for girls; he had seen the advances in gender emancipation in the West. In 1869, Syed Ahmad went to England to place his son at Cambridge. Six months into his visit, he wrote a letter to the Scientific Society at Aligarh. He had been, he said, introduced to dukes and lords at dinner, met artisans and common folk as well, and concluded that Indian natives were dirty animals when compared to the handsome British. What impressed him most about England was the extent to which education had become a mass phenomenon. He mentioned a young girl, Elizabeth Matthews, a maid in the house where he was living. In spite of her poverty, he noted, she would buy a half-penny paper called *Echo* and would delight in *Punch* if she chanced upon a copy. Cabmen and coachmen could read, he reported, hugely impressed.

'The Muslims have nothing to fear from the adoption of the new education if they simultaneously hold steadfast to their faith, because Islam is not irrational superstition; it is a rational religion which can march hand in hand with the growth of human knowledge. Any fear to the contrary betrays lack of faith in the truth of Islam,' he wrote to his friend, Maulvi Tasadduq. He asked rhetorically, 'Did the early Muslims not take to Greek learning avidly? Did this in any respect undermine their loyalty to Islam?' English was the new Greek.

He stayed for seventeen months in Britain, and came to a salutary conclusion: '. . . although I do not absolve the English in India of discourtesy, and of looking upon the native of that country as animals and beneath contempt, I think they do so from not understanding us; and I am afraid I must confess that they are not far wrong in their opinion of us. Without flattering the English, I can truly say that the natives of India, high and low, merchants and petty shopkeepers, educated and illiterate, when

contrasted with the English in education, manners, and uprightness, are as like them as a dirty animal is to an able and handsome man. The English have reason for believing us in India to be imbecile brutes.'[6]

In England, he developed plans to model his proposed Aligarh institutions, school and college, on Harrow and Cambridge. By the time he returned, the Raj was more receptive. The widely reported trial of the leaders of the 'Wahabi conspiracy' in the 1860s, and the assassination of high officials by Wahabis had induced fears of the emergence of a 'Mussulman Cromwell' in India. On 8 February 1872, Sher Ali, an Afghan Wahabi prisoner in the isolated Andaman Islands, assassinated the touring viceroy, Lord Mayo. In London, Lord Salisbury linked Indian Muslim conspiracies to activists in Kabul, Constantinople and Cairo; the pan-Islamic 'conspiracy' theory was in full cry. In Calcutta, conciliatory voices like that of Sir William Hunter argued that the alternative to permanent war was assimilation through soft power. His report had pointed out that there were only seventy-seven Muslims out of 418 Indian judicial officers and recommended larger employment in civil services through an expansion of English education. Hunter was named head of an Education Commission, which included a special chapter on Muslims.[7] This chapter was retained in the annual report of the director of public instruction.

The first census of British India, held in 1872, indicated that Muslims were one-fifth of the population of British India. The census-takers divided Indian society into four ethnic groups: Aborigines (tribes, lower castes, untouchables), Aryans (upper-caste Hindus, primarily Brahmins and Thakurs), Mixed (the common ground between the first two) and Muslims. By the 1881 census, there were over fifty million Muslims, with twenty million of them in Bengal alone.

It was the right moment for a substantive gesture, and Syed Ahmad was the perfect partner. He had already established the Aligarh Mohammedan Anglo-Oriental School on 24 May 1875. In 1877, the viceroy, Lord Lytton, laid the foundation stone of the

Mohammedan Anglo-Oriental College at Aligarh, soon nicknamed the 'Muslim Cambridge' (it got the status of a college in 1878, and would become a university on 9 September 1920). In 1878, Syed Ahmad became a beneficiary of one of his own proposals, when he was nominated for a five-year term to the Imperial Legislative Council.

He wanted positive discrimination for Muslims, but not, at least yet, to the exclusion of Hindus. His speech in Patna on 27 January 1883 is often quoted: 'India is the home of both of us (Hindus and Muslims). We both breathe the air of India and take the water of the holy Ganges and the Jamuna. We both consume the products of the Indian soil. We are living and dying together ... My friends, I have repeatedly said and say it again that India is like a bride which has got two lustrous eyes – Hindus and Mussulmans. If they quarrel against each other that beautiful bride will become ugly and if one destroys the other, she will lose one eye.'

He stressed harmony even while he dwelt on the difference: 'Friends, in India there live two prominent nations which are distinguished by the names of Hindus and Mussalmans ... To be a Hindu or a Muslim is a matter of internal faith which has nothing to do with mutual relationships and external conditions ... Hence, leave God's share to God and concern yourself with the share that is yours ... India is the home of both of us ... By living so long in India, the blood of both have [sic] changed. The colour of both have become similar. The faces of both, having changed, have become similar. The Muslims have acquired hundreds of customs from the Hindus and the Hindus have also learned hundreds of things from the Mussalmans. We mixed with each other so much that we produced a new language – Urdu, which was neither our language nor theirs. Thus, if we ignore that aspect of ours which we owe to God, both of us, on the basis of being common inhabitants of India, actually constitute one nation; and the progress of this country and that of both of us is possible through mutual cooperation, sympathy and love. We shall only destroy ourselves by mutual disunity and animosity and ill will to each other.'[8]

Shah Waliullah's theory of distance had reached, imperceptibly, what might be described as an intermediate stage under the leadership of Sir Syed. He was not hostile to Hindus but did not believe that it was his responsibility to worry about their welfare. He wanted a Muslim deal with the British. This led him, particularly in the last decade of his active public life, towards imprudent oratorical prejudice. Speaking at Siddons Club in Aligarh in August 1884, he likened Indians to monkeys, adding that if Darwin was right, there was evolutionary hope even for natives. We can be sure that he was not referring to the fair-skinned Muslim of his north-west environment when he made the comparison; his family traced its origins to Herat in Afghanistan and Arabia. His attitude towards Hindus lost any shade of sympathy after the winter of 1885, with the birth of the Indian National Congress. From the very beginning he condemned the Congress as a Hindu organization that would make the 'Muslim nation' subjects of Hindus rather than Christians, who were at least people of the Book (that is, mentioned in the Quran and sharing the same God if not the same Prophet).

———⟋∿∿⟍———

The Congress was, oddly, founded by a Scotsman. Allan Octavian Hume, a distinguished ornithologist and unorthodox civil servant, had reason to feel that he had been denied promotion to the highest level of the Indian Civil Service, membership of the Viceroy's Council, because of his alleged bias towards 'natives'. In May 1885, he informed the viceroy, Lord Dufferin, that he was, with the help of Indians, helping to launch the Indian National Congress to promote the regeneration of India.

On the morning of 28 December 1885, seventy-two delegates (thirty-nine lawyers, fourteen journalists and one doctor) gathered in Bombay, with Hume in the chair, to ask for Indian representation in the civil service through competitive examinations, and in legislatures through elections. The Congress offered a united front of all Indians.

Syed Ahmad boycotted the inaugural gathering for ideological reasons, and prevented any coverage of the event in the *Aligarh Institute Gazette*. Congress leaders, however, recognized the importance of co-opting him. In the middle of 1886, Surendranath Banerjea wrote to him saying 'no assembly of national delegates would be complete without your presence'. Hume tried his persuasive charms, to no effect. Syed Ahmad responded by urging Hindus to boycott the Congress as well, to prove that they were not anti-Muslim, and stepped up efforts for exclusive Muslim projects. In 1886, the Muhammadan Educational Congress (the name was changed to Conference in 1890) was born, and received immediate support from prominent Muslims like Calcutta's Amir Ali and Abdul Latif. At its Lucknow session, Syed Ahmad lampooned the Bengali 'Babus' who were in the forefront of the Congress, as people 'who at the sight of a table knife would crawl under his chair [*uproarious cheers and laughter*].' Congress meant anarchy, he argued; only British rule could ensure peace between India's fractious communities since the British, luckily, were neither Hindu nor Muslim. He admired the manner in which the British had crafted and grafted their empire; and he reminded the pious that the British were Christians and therefore 'People of the Book'. In January 1888, within a week of the speech, Syed Ahmad had been knighted.

The instant, and vehement, rejection of the Congress by Sir Syed suggests a nudge from the authorities. The Congress was in search of Muslims; there were only two Muslims out of seventy-two at the first session, and, despite effort, only thirty-three out of 431 at the second session in Calcutta in 1886, none of them well known. The Congress was determined to correct this imbalance, and elected Justice Badruddin Tyabji (1844–1906), a Bombay Muslim, as its third president in 1887. It also invited several students from Sir Syed's college.

The educationist was furious, and said in a public speech on 28 December 1887 that Muslims would court disaster if they supported the Congress. Tyabji wrote to Sir Syed, wondering why he was trying to keep Muslims away from the Congress. Sir Syed

repeated his assertion that Hindus and Muslims were two separate nations: he had introduced this theme, and taken the theory of distance a quantum leap forward.

Sir Syed offered to join the Congress if it confined itself to social issues, but not if it was a political body. His rationale was that the Congress demand for election of Indians to the legislature meant that only Hindus would be represented, since there were more Hindu voters than Muslim. Tyabji was baffled. As he told the Congress in his presidential address at Madras, 'I, for one, am utterly at a loss to understand why Mussulmans should not work shoulder to shoulder with their fellow-countrymen, of other races and creeds, for the common benefit of all . . .'

In an article for *Pioneer* in April 1888, Sir Syed suggested that the real purpose of the Congress was to subjugate Muslims in a 'ring of slavery' under Hindu rule. This assertion went through its wobbles, and was even abandoned between the crucial years of 1916 to 1922, when Hindus and Muslims united to mount an unprecedented offensive against British rule. But although dormant, it never died, and when it was resurrected in the mid-1930s it had the power to partition India. Pro-partition historians like Ishtiaque Qureshi and S.M. Ikram had good reason to laud Sir Syed as prophet and father of Pakistan.

On 30 November 1888, Viceroy Lord Dufferin used the occasion of his St Andrews dinner speech in Calcutta to label Congress and its founder Hume seditious. Sir Auckland Colvin, lieutenant governor of the North-Western Provinces, stressed, the same evening, that the aims and aspirations of Muslims were different from those of the Congress. The authorities were beginning to divide in order to rule. Hume described Dufferin's accusation a shameful libel intended to promote a 'doctrine of discord and disunion'. Sir Syed had made the same charge in an article in the *Aligarh Institute Gazette* of 23 November 1886.

The evolution of the 'Muslim movement' was burdened by one serious, albeit comprehensible, flaw: it could not fully understand how democracy would function in post-British India. Nothing illustrates this better than a speech Sir Syed gave on 16 March

1888 'at the invitation of the Mussalmans of Meerut', where he
dwelt on his concept of 'one country, two nations'. He asserted
that the Congress, a creation of 'the Babus of Bengal', had 'made
a most unfair and unwarrantable interference in my nation' by
inducing Muslims to join the Congress. He condemned, to cheers,
those Muslims who had attended Tyabji's Madras session as
'nothing more than hired men'. They could not be true
representatives of the Muslim 'nation', he continued, because
they were not landlords, or nawabs, or *rais* (gentry): 'I should
point out to my nation that the few who went to Madras, went
by pressure, or from some temptation, or in order to help their
profession, or to gain notoriety, or were bought (*cheers*). No rais
from here took part in it.' The only Muslim there with some
credibility, he said, was Badruddin Tyabji, and he had made a
mistake.

He mixed pride with provocation in order to woo Muslims
towards the British: '. . . the Bengalis have never, at any period,
held sway over a particle of land. They are altogether ignorant of
the methods a foreign race can employ to maintain its rule over
other races . . . Oh, my brother Musullmans, I again remind you
that you have ruled nations, and have for centuries held different
countries in your grasp. For seven hundred years in India you
have had imperial sway. You know what it is to rule. Be not
unjust to that nation which is ruling over you, and think also on
this: how upright is her rule . . . We ought to unite with that
nation with whom we can unite.'

Sir Syed asked a question that would become central to the
politics of the next six decades: who would rule India if the
British left? 'Now, suppose that all the English and the whole
English army were to leave India, taking with them all their
cannon and their splendid weapons and everything, then who
would be the rulers of India? Is it possible that under these
circumstances two nations – the Mohammedans and the
Hindus – could sit on the same throne and remain equal in
power? Most certainly not. It is necessary that one of them should
conquer the other and thrust it down. To hope that both could
remain equal is to desire the impossible and the inconceivable.'

He could not quite grasp a future different from the old order. 'At the same time,' he thundered, 'you must remember that although the number of Mohammedans is less than that of the Hindus, and although they contain far fewer people who have received a high English education, yet they must not be thought insignificant or weak ... our Mussalman brothers, the Pathans, [could] come out as a swarm of locusts from their mountain valleys, and make rivers of blood to flow from their frontier on the north to the extreme end of Bengal.' The second rung of Muslim League leaders would delight in similar references in the election rallies of 1936–37, occasionally invoking Chingiz Khan.[9]

He laughed away the possibility of a government that represented both Hindus and Muslims. 'Can you tell me of any case in the world's history in which any foreign nation after conquering another and establishing its empire over it has given representative government to the conquered people? Such a thing has never taken place. It is necessary for those who have conquered us to maintain their Empire on a strong basis ... The English have conquered India and all of us along with it. And just as we [the Muslims] made the country [India] obedient and our slave, so the English have done with us.' He asked Muslims to make no demand for jobs in civil service, because the law of Empire demanded that the English only trust Englishmen in authority.

He invoked Islam, even if he had to tweak a bit: 'God has said that no people of other religions can be friends of Mohammedans except the Christians ... Now God has made them rulers over us. Therefore we should cultivate friendship with them, and should adopt that method by which their rule may remain permanent and firm in India, and may not pass into the hands of the Bengalis.'[10]

This activist mood spread to his staff and students. In 1889, Theodore Beck, principal of his college, led Aligarh students to the steps of the Jama Masjid in Delhi and collected almost 30,000 Muslim signatures for an anti-Congress petition to the British Parliament. An outbreak of Hindu–Muslim violence in 1892 over cow slaughter across north India gave Sir Syed an opportunity to raise the ante.

In 1882, Swami Dayanand Saraswati, the Hindu religious leader and reformer, had launched a movement to ban cow slaughter: the resentment was not against British preference for beef, but against the Muslim attachment to it. Muslims would often provoke Hindus by a public sacrifice of cows during the Id of the haj, when animal sacrifice is obligatory. In December 1893, at Beck's suggestion, Sir Syed formed the provocatively named Muhammadan Anglo Oriental Defence Association. Since it was a bit over-the-top, it withered by 1895.

Deoband's reaction to the formation of the Congress was significantly different: it urged cooperation between all Indians against the common colonial enemy. The famous madrasa at Deoband, Dar ul Uloom, began life as a small mosque which doubled as a classroom outside prayer hours, in 1867. Its founders, Maulana Muhammad Qasim Nanotvi, the orator–administrator, and Maulana Rashid Ahmad Gangohi, the Hadith scholar, rejected any association with the British, refusing any form of patronage or financial assistance, depending on the goodwill of the community for their funds. Their food was donated by the neighbourhood. The institution's other role was served by a Dar al-Ifta, a department to issue fatwas in response to legal questions sent by any Muslim. This, in effect, became a parallel system of jurisprudence that finessed British courts. Deoband ulema stayed away from politics, until a rapidly changing international situation and the defeat of the Ottomans in the First World War brought the ulema of every denomination out on the Indian street.

Deoband welcomed the birth of the Congress in 1885 through a fatwa from Maulana Rashid Ahmad Gangohi, its *sarparast* or guide–superintendent at that time, which, using the Prophet's alliance with non-Muslims in Medina as a template, judged that it was acceptable for Muslims to cooperate with Hindus to win concessions from the British. This would be the Deoband line till and beyond the formation of Pakistan in 1947.

Deoband's philosophy could not counter the two-nation theory perpetrated by Sir Syed. Increasingly, Muslims became convinced by his argument that in any form of democracy they would

always be outvoted three-to-one, as per the population ratio, as if Hindu and Muslim voters were unwavering regiments dictated by a single consideration. No one yet understood that political identity in a democracy is influenced by a series of subsets, including region, language, class, sectarian and even seasonal loyalties. One cannot glibly blame Sir Syed for misreading the complexities of democracy, for nowhere had democracy evolved to its modern liberal maturity.

Democracy arrived in British India on stilts. Legislatures were weighted in favour of those communities, like Europeans and Anglo-Indians, who could be depended upon to protect the government's interests. There was no single-standard correlation between population figures and seats in the legislature; everything was up for negotiation, leading to bitter arguments between leaders in a communal democracy. By the winter of 1945–46, in the last elections held under British rule, only about forty-one million Indians, or around ten per cent of the population, were eligible to vote. Women, incidentally, had the vote. The results of this limited franchise poll, in which the Muslim League won 460 of the 533 seats reserved for Muslims, became the moral bedrock upon which Pakistan was formed in 1947.

Muslim political consciousness was jolted sharply by the census data of 1881 and 1891, gathered under the supervision of Hunter, who was appointed India's first director general of statistics: they lagged far behind Hindus, whether in basic literacy or university degrees. Theodore Beck wanted a census to find out the extent to which 'respectable' Muslim families were educating their sons. Sir Syed dreamt of Aligarh as the apex of an all-India network of Muslim colleges.

His last years, however, were a nightmare. Heartbroken by dissent in Aligarh, driven out of home by family problems, he died on 27 March 1898 at the house of his friend Ismail Khan Shervani. Only in his death did Muslims realize what he had achieved. The community adopted his mission, and demanded upgradation of Aligarh from college to an independent university. Badruddin Tyabji sent a cheque for Rs 2,000 to the 'Sir Syed Memorial Fund'.

The impact of Aligarh was soon felt in national politics. Three alumni of Aligarh – Mahdi Ali, Viqar-ul-Mulk and Sayyid Husain Bilgrami – were the architects of a thirty-five member delegation from every province of British India, under the nominal leadership of the imam of the Ismailis, the Aga Khan, which presented a seminal petition to Viceroy Lord Minto at Simla on 1 October 1906. The draft was prepared on the Aligarh campus and contained a not-very-subtle warning: '. . . recent events have stirred up feelings, especially among the younger generation of Mohamedans, which might, in certain circumstances and under certain contingencies, easily pass beyond the control of temperate counsel and sober guidance.' The petition also suggested that if community-specific qualifications were not applied to electoral politics, it was 'likely, among other evils, to place our national interests at the mercy of an unsympathetic majority'. Muslims were again being described as a nation. Minto, in his reply, offered a 'hearty welcome' and praised Aligarh and its students for being 'strong in the tenets of their own religion, strong in the precepts of loyalty and patriotism'. This meeting won the promise of separate electorates for Muslims.

In November 1906, Nawab Salimullah invited Sir Syed's Muslim Educational Conference to hold its annual conference in Dhaka. On 30 December 1906, these fifty-eight delegates also became the founding members of the All India Muslim League. Its first president, Nawab Viqar-ul-Mulk Mushtaq Hussain, claimed that 'if at any remote period the British Government ceases to exist in India, then the rule of India would pass into the hands of that community which is nearly four times as large as ourselves . . . Then, our life, our property, our honour, and our faith will all be in great danger. When even now that a powerful British administration is protecting its subjects, we the Musalmans have to face most serious difficulties in safeguarding our interests from the grasping hands of our neighbours . . . woe betide the time when we become the subjects of our neighbours.'

'We can broadly identify four major responses to the crisis brought on by the loss of Muslim political power and the rise of

an alien Christian rule. These are modernism, reformism, traditionalism and Islamism, often called fundamentalism. They were represented respectively by the Aligarh, Deoband, Barelvi and Jamaat-e-Islami movements. The institutions and ideas which they forged during the colonial era continue to profoundly influence Pakistani society and politics, as does their history of confrontation,' notes Ian Talbot.[12] But these categories were not boxed in iron cases.

The nineteenth century was full of prophets whose apostles shaped the twentieth. The most unlikely of Sir Syed's apostles was Mohammad Ali Jinnah, who, in 1906, refused to join either the delegation to Lord Minto or the Muslim League and dismissed separate electorates as a calamity that would divide India. Among his good friends in Bombay, an eclectic group that included Parsis, Hindus and Christians, was Badruddin Tyabji, who had invited the contempt of Sir Syed by becoming president of Congress. But in the last two years of his life, Jinnah would convert Sir Syed's two-nation theory into two nations.

5

Grey Wolf

—◦◦◦—

Mohammad Ali Jinnah, aristocrat by temperament, catholic in taste, British in manners, reserved by preference, was the unlikeliest parent that the world's first Islamic republic could possibly have had.

For most of his adult life, Jinnah was the epitome of European secularism, in contrast to Mohandas Karamchand Gandhi's very Indian secularism. To understand the revolutionary alternative Jinnah represented in the first decade of the twentieth century, we only have to compare him with Indian Muslim leadership role models in the nineteenth. He broke every convention. He ignored the dress code of beard and pyjama, preferring a cosmopolitan wardrobe of what grew to 200 well-cut suits. He spoke English rather than his native Gujarati or Urdu. He did not, or perhaps could not, use the Quranic quote to impress Muslim audiences. In politics, he was antagonistic towards community-specific demands. He was sceptical about the partition of Bengal in 1905 and the creation of a Muslim-majority province. In 1906, he stayed aloof from the Muslim League, which was born in Dhaka; and he publicly opposed separate electorates, the principal demand of the League, foreseeing that it would be the death of Indian unity.

Even in the 1930s, the decade in which the demand for a Muslim state on the Indian subcontinent began to mature, Jinnah's model was Kemal Ataturk, who abolished the Ottoman caliphate and separated religion from state. In November 1932, while in self-imposed exile in London, he was so engrossed in a biography of Ataturk, H.C. Armstrong's *Grey Wolf*, that he finished it in two days and urged his thirteen-year-old daughter, Dina, to read the book. She nicknamed him her 'Grey Wolf'. He told a conference of the Muslim League on 27 October 1937, 'I wish I were Mustafa Kamal. In that case I could easily solve the problem of India. But I am not.' All units of the Muslim League were ordered to observe a 'Kemal Day' after the Turkish hero's death in 1938.

In contrast, Mahatma Gandhi believed that politics without religion was immoral, and pandered to the Indian need for a religious identity. He never publicly disavowed the 'Mahatma' attached to his name, even when privately critical. His heir, Jawaharlal Nehru, adopted the Brahminical prefix 'Pandit', although he was not particularly religious.

Jinnah was indifferent to faith rather than an agnostic. He was born an Ismaili Khoja.[1] He was persuaded by the eminent Muslim Congress leader, Badruddin Tyabji, a fellow Shia, to shift from the Khoja denomination, who gave their allegiance to the worldwide imam, the Aga Khan, to the mainstream Twelvers, who recognized no temporal leader. Jinnah's nominal faith did not include the practice of prayer, nor obedience to Islam's dietary restrictions. He would have dismissed any effort to turn him into 'Maulana Jinnah' as an absurdity. His preferred the title of 'Quaid-e-Azam' or 'Great Leader'. On his day of triumph, 14 August 1947, when Pakistan was born, he arranged a formal banquet for the last viceroy, Lord Mountbatten, at noon, quite oblivious of the fact that it was the month of Ramadan, and Muslims had been fasting for some weeks. Jinnah wanted the new country, Pakistan, to share his values, and become a secular nation with a Muslim majority, but not a Muslim hegemony. In an interesting coincidence, Jinnah's family came from Rajkot, barely forty-five kilometres south of Gandhi's ancestral home.

Jinnah was born in Karachi, where his father, Jinnahbhai Poonja, had moved with his wife Mithibai to establish the business of exporting fish to England. He was named Mahemdalli[2] Jinnahbhai. The Sind Madrasatul Islam, which Jinnah joined in 1887, records his birth date as 20 October 1875, but Pakistan celebrates its founder's birthday on 25 December. The change to Christmas has been attributed to the influence of Church Mission Society High School, where he was enrolled on 8 March 1892. When he became a gentleman-student of Lincoln's Inn at London, he deleted the extra 'l' and 'bhai', to reach a much neater appellation.

His nickname at home was Mamad. As a child, Jinnah loathed arithmetic, loved horses and was entranced by fairy tales full of flying carpets and djins. His doting father renamed his company after his son: Messrs Mohammad Ali Jinnah Bhai. At sixteen, after a few months in the family firm, Jinnah took his first independent decision. Ignoring his mother's bitter tears, he decided to accept an offer of a clerical position in the financial district of London. His one concession was to agree to his protective mother's insistence upon an arranged marriage; she was frightened that an English girl would steal her handsome son. A traditional arranged marriage with Emi Bai, the daughter of a fellow Khoja-Gujarati businessman, Gokal Lera Khemji, followed. He sailed in January 1893. His wife stayed back in India and died during an outbreak of cholera; he also lost his mother while he was in England. By the time he returned to India, his father's business was also severely hit by an economic downturn.

A clerical job in London was hardly commensurate with his ambitions. He joined Lincoln's Inn to become a barrister, received his degree on 29 April 1896, and slaked his fascination for politics by trips to the Visitors' Gallery in the House of Commons, which had just elected its first Indian MP in the Liberal wave of 1892, Dadabhai Naoroji (1825–1917). Naoroji was nicknamed 'Mr Narrow-Majority' because he had won by just three votes; he became better known when Prime Minister Lord Salisbury described him as a 'black man' during the campaign.[3]

When 'Mahomed Ali Jinnah Esquire, a Barrister of this Society'

set off for India on 16 July 1896, he was very much a post-Victorian gentleman. His monocle was styled on Joseph Chamberlain's, and he had even had a P.G. Wodehouse moment during a visit to Oxford, when he was arrested. Jinnah recalled this first 'friction with the police' to his biographer, Hector Bolitho, during an Oxbridge boat race. He, along with two of his friends, 'caught up with a crowd of undergraduates', came across a cart and 'pushed each other up and down the roadway'. They were arrested and taken to the police station, where they were let off with a caution.[4]

It was the only time Jinnah went into police custody. He was too much of a lawyer to break the law.

His secret student dream was to play Romeo at Old Vic, and only an anguished letter from his father ('Do not be a traitor to your family') prevented him from joining the stage. Till late in life, he relaxed after a tiring day by reading Shakespeare in a loud, resonant voice. England was a natural second home. When he set up residence in Hampstead between 1930 and 1933 with his sister Fatimah and daughter Dina, he hired a British chauffeur (Bradley) for his Bentley, kept two dogs (a black Doberman and a white West Highland terrier), indulged himself at the theatre, and appeared before the Privy Council to maintain himself in the style to which he was accustomed: Saville Row suits, heavily starched shirts and two-tone leather or suede shoes. He was sixty-one before political compulsions forced him, on 15 October 1937, to appear in an 'Islamic' costume at the Lucknow session of the Muslim League: this image, in lambskin cap and sherwani, is de rigeur in Pakistan's official portraits, but he used such apparel sparingly even after 1937.

He drank a moderate amount of alcohol and was embarrassingly unfamiliar with Islamic methods of prayer. The call for a Muslim state, in Lahore in 1940, was made in a speech delivered in English, despite catcalls from an audience that wanted to hear Urdu. An excellent lawyer, he was always ready with a good argument: since the world press was in attendance, he said, it was only right that he speak in a world language.

Despite a law degree from Lincoln's Inn, professional life was not easy when he returned to Bombay in 1896. His first break came when the Parsi doyen Sir Phirozeshah Mehta (1845–1915, president of the Congress in 1890) appointed him legal advisor to the Bombay Municipal Corporation. Dadabhai Naoroji helped him enter politics. He became a Congress delegate for the first time at its Bombay session in December 1904, where he met Gopal Krishna Gokhale (1866–1915; president of the 1905 session). Jinnah was so inspired that, in the words of the poet–politician Sarojini Naidu, he wanted to become 'the Muslim Gokhale'. She met him at the Calcutta Congress in 1906, and was entranced by his looks, persona and 'virile patriotism'.

The young Jinnah ('thin to the point of emaciation, languid and luxurious of habit') could not have hoped for higher praise than he received from Ms Naidu: 'Somewhat formal and fastidious, and a little aloof and imperious of manner, the calm hauteur of his accustomed reserve but masks, for those who know him, a naïve and eager humanity, an intuition quick and tender as a woman's, a humour gay and winning as a child's – preeminently rational and practical, discreet and dispassionate in his estimate and acceptance of life, the obvious sanity and serenity of his worldly wisdom effectually disguise a shy and splendid idealism which is the very essence of the man.'[5] Jinnah was only twenty-eight, and his rational spirit must have stood out during those years of political turmoil.

———⟋⟋⟍———

The *Moslem Chronicle* welcomed George Nathaniel Curzon to India on Friday, 6 January 1899, with an appeal for special attention towards Muslims. The new viceroy replied that 'my heart would be dull, did it not respond'. The unsentimental imperialist was clear about his priorities. If Bengalis were in control of Congress, and Congress had dared to hallucinate about 'swaraj', or self-rule, he would undermine the party's base by dividing Bengali Hindus from Bengali Muslims. Curzon explained

to John Bodrick, secretary of state for India, that 'Calcutta is the centre from which the Congress party is manipulated throughout the whole of Bengal, and indeed the whole of India. Its best wirepullers and its most frothy orators all reside here ... The whole of their activity is directed to creating an agency so powerful that they may one day be able to force a weak government to give them what they desire.'

On 3 December 1903, the Risley Paper, named after Sir Herbert Risley, the home secretary, proposed that the Bengal Presidency, of some 189,000 square miles, extending from Orissa in the west to Bihar in the north and Assam in the east, containing a quarter of the Raj population, was simply too large to be governed effectively. This was camouflage. Risley, in notes dated 7 February and 6 December 1904, explained: 'Bengal united is a power; Bengal divided will pull in different ways. That is perfectly true and is one of the merits of the scheme.'

Just in case the meaning was still unclear, Curzon, on a tour of East Bengal, promised Muslims that they would regain the unity and power that they had not enjoyed since Mughal days. On 6 July 1905, the decision to partition Bengal was announced from the summer capital at Simla. On 16 October, Muslim-majority Eastern Bengal (including Assam), with eighteen million Muslims and twelve million Hindus, was separated. Hindu-majority West Bengal declared it a day of mourning.

If Curzon thought that the Bengali Babu would limit his reaction to paper petitions and hot air, he was wrong. The shift to radical forms of protest startled the Raj. A magazine called *Sanjivani*, in its issue of 13 July 1905, suggested that Indians should boycott British goods. It may have borrowed the thought from a Chinese boycott of American imports in protest against US immigration laws. Congress president Surendranath Banerjea supported this idea at a meeting held at Calcutta's Town Hall on 7 August. On 16 October, partition day, Rabindranath Tagore, the great national poet, told Bengalis to wear a rakhi, the traditional coloured thread which sisters tie on their brothers' wrists, to symbolize the unbreakable bonds between the two

Bengals. Hindu schoolchildren adopted Bankimchandra Chatterjee's ode to the motherland, '*Vande Mataram*', as their anthem. When the British threatened to withdraw grants and affiliations from institutions that permitted student protests, a rich landowner, Raja Subodh Mullik, announced a donation of Rs 100,000, a small fortune at that time, as compensation. Unprecedented ferment was in the air.

The Congress was divided between enraged extremists, who began whispering about an armed struggle, and moderates whose ire fell short of rebellion. The militants, led by Aurobindo Ghosh, Bipin Behari Pal and Bal Gangadhar Tilak, were the popular heroes. Their slogan said it all: *swaraj, swadharma, dharmatattwa.*[6] Ghosh's journal, *Vande Mataram,* called for a boycott of not just British goods but also British education, courts, administration, and a social boycott of loyalists. A Bengali newspaper, *Yugantar,* suggested a one-day solution: a popular uprising that killed every British official within twenty-four hours. Calendar illustrations showed Curzon severing Mother Bengal with an axe. Calcutta cheered when Curzon left India without completing his full term. A few optimists even set a date for India's freedom: 1913.

The moderates, with the formidable Gopal Krishna Gokhale at the helm, described the division of Bengal as a 'cruel wrong' that showed a 'reckless disregard of the most cherished feelings of the people', but they also recognized that there was a communal dimension to the agitation. Rabindranath was aggrieved in 1907 when tensions provoked Hindu–Muslim riots. Motilal Nehru (1861–1931), brilliant lawyer, sophisticated aesthete, Gandhi's friend and Jawaharlal's father, suspected, in private correspondence with his son, Bipin Chandra Pal of being more courageous in his bathroom than in the street. Jawaharlal, who was at Cambridge when Pal addressed the Indian Majlis on the last Sunday of November 1908, remarked in a letter to his father that Pal was very obviously anti-Muslim. But nothing could diminish the fact that this spontaneous nationalist fervour had been, as Motilal wrote to his son, the 'wonder of the age'. Equally, he warned Jawaharlal that 'Many a Congressman was a

communalist under his nationalist cloak' and to 'beware of Congressmen in sheep's clothing' when his teenage son displayed some enthusiasm for militants. The Congress formally split at its Surat session in 1907, amidst pandemonium – the tent had to be cleared by the police; it would reunite only nine years later.

Jinnah sharply condemned Bengali Muslim excesses in a letter, dated 24 May 1907, to William Wedderburn, an Englishman who had served as Congress president. Jinnah castigated the 'ignorant and fanatical section of the [Bengali] Mahomedans' who had indulged in violence against Hindus. 'A number of Mahomedan rowdies,' he continued, 'have been preaching for some time a holy war against the Hindus . . . on religious grounds. The Red Pamphlet, which I have seen myself and which is of a most inflammatory character, has been circulated throughout the province and in this pamphlet the Mahomedans are called upon to rise and destroy the Hindus, so that the glory of Islam be once more re-established.' The Red Pamphlet was yet another call for jihad. Jinnah's personal sympathies seem to have been on the side of those who wanted a united Bengal. The British formula for dissent was monochromatic: prison. When Tilak was arrested in 1908 for 'sedition', Jinnah moved his bail petition, which of course was denied.[7]

--~/\/\/~--

The Muslim response to the Bengal agitation was to move closer towards the establishment in the hope of getting its support for domestic battles.

At 11 in the morning of 1 October 1906, the Right Honourable Sir Sultan Mahomed Shah, Aga Khan III, Imam of the Nizari Ismailis since 1885, educated at Eton and Cambridge, a British subject but not a citizen, presented an address, drafted by Aligarh alumni, to Curzon's Tory successor Viceroy Lord Minto (1845– 1914) in the ballroom of the Viceregal Lodge at Simla, on behalf of thirty-five 'undersigned nobles, jagirdars, taluqdars, lawyers, zemindars, merchants and others representing a large body of the

Mohamedan [*sic*] subjects of His Majesty the King-Emperor'. The text of this carefully vetted address was first published on 3 October 1906 in a now defunct Lucknow newspaper called the *Indian Daily Telegraph*.

After the obligatory praise, the petition appealed to the British 'sense of justice and love of fair dealing' that had brought these representatives of 'over 62 millions or between one-fifth and one-fourth of the total population of His Majesty's Indian dominions, and if a reduction be made for the uncivilized portions of the community enumerated under the heads of animist and other minor religions, as well as for those classes who are ordinarily classified as Hindus but properly speaking are not Hindus at all, the proportion of Mahomedans to the Hindu majority becomes much larger'. Racist bias towards 'uncivilized portions' considered 'untouchable' and towards tribals was not confined to upper-caste Hindus.

The plea was followed by a barely disguised threat: Muslims had 'abstained from pressing their claims by methods that might prove at all embarrassing, but earnestly as we desire that the Mohamedans of India should not in the future depart from the excellent and time-honoured tradition, recent events have stirred up feelings, especially among the younger generation of Mohamedans, which might, in certain circumstances and under certain contingencies, easily pass beyond the control of temperate counsel and sober guidance'. The 'circumstances' and 'contingencies' were not difficult to fathom: this was a threat of counter-violence in Bengal.

They offered support to the government if, while introducing an elective system, it did not 'place our national interests at the mercy of an unsympathetic majority'. Sir Syed's definition of Muslims as a separate nation was placed on formal record; Muslims had a 'national interest'. From this moment, the Muslim League would seek its own political, and eventually geographical, space.

Lord Minto's prepared reply described this petition as 'very full of meaning', called the delegation 'representative' of the whole

community, and offered fulsome praise to Sir Syed. 'Aligarh has won its laurels,' said the viceroy. He thanked the thirty-five noble delegates for the 'self-restraint' they had shown in Bengal, and assured them that Muslims would be able to elect their own candidates, without interference from Hindus.

If the Aga Khan had had his way, the number present before the viceroy would have been at least thirty-six. He later remarked in his autobiography upon the 'freakishly ironic' fact that 'our doughtiest opponent' in 1906 was Jinnah, who 'came out in bitter hostility' and was 'the only well-known Muslim to take this attitude'. As the Aga Khan noted, 'He [Jinnah] said that our principle of separate electorates was dividing the nation against itself.'[8]

The young Jinnah wrote an angry letter to the *Times of India* challenging the credibility of the Aga Khan delegation: who did they actually represent, he wondered.[9] The *Times of India* described, in an editorial, the petition as 'the only piece of original political thought which has emanated from modern times'.

In December 1906, Jinnah came to Calcutta for the Congress session, and helped draft Dadabhai Naoroji's presidential address.[10] He did not travel to nearby Dhaka, where, at the same time, the Mohammedan Educational Conference had convened at the invitation of Salimullah Khan, the nawab of Dhaka. The nawab had been too ill to travel to Simla, but chaired the reception committee when the fifty-eight-strong conference founded the Muslim League on 30 December 1906, with the Aga Khan as honorary president. Its first functional president, Nawab Viqar-ul-Mulk, was candid when he enumerated reasons for the creation of such a party.

After the usual obeisance to authority ('political rights of a subject race thrive best in the soil of loyalty'), he came to the nub. What would happen 'if at any remote period the British government ceases to exist in India'? His answer was plaintive: 'Now, gentlemen, each of you consider what your condition would be if such a situation is created in India. Then our life, property, honour, and faith will all be in great danger.'

Once again, as in the address to Lord Minto, the threat of

violence was slipped into the text. Viqar-ul-Mulk said, 'I do not
hesitate in declaring that unless the leaders of the Congress make
sincere efforts as fast as possible to quell the hostility against the
government and the British race ... the Musalmans of India
would be called upon to perform the necessary duty of combating
this rebellious [Congress] spirit, side by side with the British
government, more effectively than by the mere use of words.'

The rewards were immediate. The Indian Councils Bill of 1909
gave Muslims of the United Provinces, to cite one instance, the
same number of seats in the Imperial Council as Hindus although
Muslims were only 14 per cent of the population. In Bombay, a
Muslim with an annual income of 135 pounds could vote, but
not a Parsi or a Hindu. There were predictions of a Hindu–
Muslim conflict on the lines of the American civil war, still fresh
in memory. The government looked after its own in other ways
as well. In 1907, it helped save the nawab of Dhaka from
bankruptcy and honoured him with a Knight Commander, Order
of the Indian Empire (KCIE).

Jinnah was a trifle lucky to win election to the Central Legislative
Council in 1910 from the Muslim seat in Bombay. Two older
candidates hated each other so much that they compromised on
the thirty-five-year-old lawyer. Jinnah took his seat on 25 January
1910 as the 'Muslim member from Bombay'; he would never lose
it. The Hindu member from the general Bombay seat was the man
he admired, Gokhale.

Jinnah seconded the resolution, at the Allahabad Congress of
1910, strongly deprecating the 'principle of Separate Communal
Electorates to Municipalities, District Boards, or other Local Bodies'.
When he rose to speak for the first time, it was to defend Gandhi,
then leading a movement against indentured labour in South
Africa. When Lord Minto warned him against the use of harsh
terms, Jinnah replied that he wished he could have used much
stronger language. During his first term, Jinnah introduced the
Wakf (tax-exempt Muslim endowments) Validating Bill, the first
legislation sponsored by an Indian, which would earn him the
community's gratitude.

By this time, the Raj began to feel that appeasement of Muslim sentiment had become counterproductive. Lord Minto's successor, Charles Hardinge, first baron of Penshurst, viceroy between 1910 and 1916, a nominee of the Liberal Secretary of State for India John Morley, was soon convinced that some reversal was necessary. In December 1911, George V, who had visited India as Prince of Wales in 1905–06, during the height of the Bengal agitation, surprised the country during his Coronation Durbar when he revoked Bengal's partition. Bengal's ethnic unity was restored, but Bihar and Orissa were separated. That was not the end of the news. He also announced that the capital would shift to Delhi. Not everyone in Delhi was delighted at the prospect of the British ruling from the Mughal capital. On 23 December 1912, a bomb was thrown at Hardinge while he was passing through the Muslim area of Chandni Chowk on an elephant to examine the sites where the British would construct their own version of Delhi. He was injured. The assailant was never caught.

The reunification of Bengal was a cruel affront to those Muslims who had invested in loyalty. In March 1912, at a conference in Calcutta, the Muslim League condemned the decision for its utter disregard of Muslim feeling. An emerging Muslim voice, the Aligarh- and Oxford-educated journalist Muhammad Ali (1878–1931) wrote in his publication, *Comrade:* 'If the legitimate facilities afforded to the Musalmans can be taken away and solemn pledges broken at the bidding of a few demagogues with hysterical followings, there is no knowing that the general political status of the community may suffer the same fate.'

The Aligarh lobby had additional reason for discontent. The government refused to grant Aligarh university status without acquiring full control, which was unacceptable. In 1912, the government also denied Aligarh permission to become an all-India affiliating institution. Even the ever-loyal Aga Khan was upset.

—◦◦◦—

A distant conflict, the Tripolitan and Balkan wars of 1911–12, also began to shape a decade in India that culminated in an unprecedented nationwide non-violent rebellion against the British. Today's visa-dependent travel tends to obscure the political map of the Empire. British India bordered south Iran, which had come under the British 'zone of influence' after 1907. After Iran came the territories of the Ottoman Empire. The geography of 'Pan-Islamism' was often defined as the region between Istanbul, capital of the caliph, and Saharanpur, home of Deoband.

The Indian Urdu press had a simple explanation for the Balkan wars: this was yet another plot in a long Christian conspiracy to destroy the caliphate. British neutrality was dismissed as a hoax. The presence of Bulgarian troops at the walls of Istanbul in 1912 shook Indian Muslims out of their establishmentarian mood. It was taken as axiomatic that Bulgaria was merely a pawn fronting for the European colonial powers.

Aligarh responded by seeking to build a bridge with the orthodox sentiment it had thus far spurned. Viqar-ul-Mulk, honorary secretary of Aligarh between 1908 and 1912, stopped theatre on the campus, and enforced five-times-a-day prayer rigidly. The English-speaking elite reassured the ulema that their 'new light' was not '*la deeni*', or irreligious. Maulana Abdul Bari, the leading *alim* of Awadh's most famous seminary, Firangi Mahal, sent his children to Aligarh. From Deoband, Maulana Rashid Ahmad Gangohi decreed that it was lawful to learn English if this did not constitute a threat to Islam, and legal to use money orders and bills of exchange despite the element of interest in the transaction.

The Muslim League began to drift towards nationalist positions, enabling Jinnah to participate. In December 1912, both the Congress and the Muslim League held their annual sessions in Bankipur. Jinnah supported a League resolution seeking self-rule through constitutional means although he was not yet a member of the party. In 1913, he was invited to a mid-term conference of the League at Lucknow to receive congratulations for piloting the Wakf Validating Act; Sarojini Naidu was the other honoured guest. Muhammad Ali was among those who persuaded Jinnah to

become a member of the League. The careful Jinnah placed one condition: that loyalty to 'the Muslim interest would in no way and at no time imply even the shadow of disloyalty to the larger national cause to which his life was dedicated'.[11] Gokhale praised him in 1914, saying, 'freedom from all sectarian prejudice will make him [Jinnah] the best ambassador of Hindu–Muslim unity'. In the spring of that year, Jinnah chaired a Congress delegation to London to lobby on a proposed Council of India Bill.

The 'new' League attracted luminaries from the Congress tent. Maulana Abul Kalam Azad, who would be Congress president during the crucial years of 1940 to 1945, joined Congress stalwarts like Delhi luminaries Dr M.A. Ansari and Hakim Ajmal Khan at the League session of 1914. In 1915, Pandit Madan Mohan Malaviya, who founded the Banaras Hindu University in response to Aligarh, was present at the League session along with Surendranath Banerjea, Annie Besant, B.G Horniman, Sarojini Naidu and Mahatma Gandhi. This year marked Gandhi's first presence on Indian political platforms.

Jinnah and Gandhi had already met, in London, just after the outbreak of the First World War, at a reception for Gandhi. Gandhi was a British loyalist all through the Great War, Jinnah a dissident. Gandhi urged Indians to 'think imperially' and join the British Indian army. India was an incomparable resource base for the British war effort, a warehouse for men, money, wheat, jute, pig iron, leather goods and uniforms. Muslim soldiers under the British flag fought loyally against Ottomans in Iraq and Egypt, and against Germany in France. There was only one case of minor trouble among a few units in Singapore in 1915.

The Muslim League session in Bombay in December 1915 had one nasty moment that sheds some illumination upon the future. When the president, Bengali barrister Mazhar-ul-Haque (1866–1921), spoke of the need for a common programme with the Congress, there were protests in Urdu. Some mullahs made the intemperate demand that Haque should dress like a 'Mohammedan' and speak the 'Mohammedan' tongue, as if Allah spoke Urdu and the Quran had laid down a dress code.[12] But the police had to

intervene, and the League session resumed next day at the safer, westernized and sanitized Taj Mahal Hotel. A seventy-one-member committee was formed, under Sir Mohammad Ali Mohammad Khan Bahadur, raja of Mahmudabad (1869–1932), including Jinnah, the Aga Khan and A.K. Fazlul Haque (1893–1962) of Bengal, to frame a scheme of reforms that would allow the League and Congress to speak 'in the name of United India'. The Congress appointed a similar committee under Motilal Nehru.

They met in April 1916 at Allahabad, as guests of the munificent Motilal. Jinnah promoted 'goodwill, concord, harmony and cooperation between the two great sister communities' at every opportunity that year. Motilal was full of praise for Jinnah, 'as keen a nationalist as any of us', although he did add the rider 'unlike most Muslims', according to Stanley Wolpert. This meeting would bear important fruit.

In November, Jinnah and Congress president A.C. Mazumdar concluded an agreement on the percentage of Muslim representation in the legislatures: one-third in Delhi, half in Punjab, 40 per cent in Bengal; 30 per cent in the United Provinces; 25 per cent in Bihar and Orissa; 15 per cent in the Central Provinces and Madras. No bill, or any clause, affecting a faith could be passed without three-fourths support from that community. (Muslims were described as a community rather than a 'nation'.) Muslims would get one-third representation in the central legislature; there would be separate electorates until Muslims were ready to accept joint electorates; the concept of adult franchise was also introduced, expanding the limited franchise of Empire democracy.

When he addressed the League as its president in Lucknow in 1916, Jinnah was unusually passionate, dismissing the British bureaucracy as 'shallow, bastard and desperate'. A pent-up, altruistic energy of youth was surging through India's pulse, he said, and 'the most significant and hopeful aspect of this spirit is that it has taken its rise from a new-born movement in the direction of national unity which has brought Hindus and Muslims together involving brotherly service for the common cause'.

Wolpert notes that embarrassing as it was to the League's goals, this part of Jinnah's address 'was excised from the official pamphlet subsequently published and reproduced by advocates of the Pakistan Movement'.

This historic 1916 pact was soon forgotten in the more dramatic battles provoked by Gandhi, but Jinnah did not abandon its basic premise: unity was possible only through commitment on constitutional practicalities; goodwill, even if it came from a Gandhi, was not good enough.

Jinnah was forty, and at the peak of his personal, professional and public magnetism. Wolpert describes Jinnah at Bombay in 1915: 'Raven-haired with a moustache almost as full as Kitchener's and lean as a rapier, he sounded like Ronald Coleman, dressed like Anthony Eden, and was adored by most women as first sight, and admired and envied by most men.'

In April 1916, just after his meeting in Allahabad, Jinnah went for a two-month vacation in the eastern Himalayan hill station, Darjeeling, as a guest of Sir Dinshaw Manockjee Petit, a great Bombay-Parsi textile tycoon and patriarch.[13] Jinnah and Petit's beautiful daughter, the sixteen-year-old Ratanbai, nicknamed Ruttie, were in love by the time the holiday ended.

According to M.C. Chagla, who worked as a junior in Jinnah's chambers and would become India's foreign minister under Indira Gandhi, Jinnah went across to Sir Dinshaw and asked what he thought of inter-communal marriages. Sir Dinshaw thought it was a splendid idea that would considerably help national integration. Jinnah calmly asked for Ruttie's hand. Sir Dinshaw went apoplectic, dismissed the idea as absurd and fantastic, and took out a High Court injunction against the marriage since Ruttie was a minor.

Ever the stickler for the law, Jinnah did not meet Ruttie until she became eighteen on 20 February 1918. On the morning of 19 April, Ruttie accompanied Jinnah to Jamia Masjid of Bombay, was converted in the presence of Maulana Nazir Ahmad Khujandi, and married according to Shia rites. The witnesses included the raja of Mahmudabad, who brought the bride's wedding ring. The

dower was Rs 1,001, but Jinnah made an immediate gift of Rs 125,000.[14] Jinnah might have been happier with a civil marriage, but the law at the time demanded that those availing of this option must declare that they belonged to no religion. Jinnah represented a Muslim constituency, and such a declaration would have made his election null and void.

Sir Dinshaw refused to see his daughter again, and spoke to Jinnah only to inform him, eleven years later, of his now estranged wife's early death. But Ruttie's mother did not forsake her daughter, and gave invaluable support during the unhappy estrangement and final illness.

The Parsis of Bombay were livid at the conversion, writes Khwaja Razi Haider.[15] Parsi newspapers declared the day of the wedding a 'Black Friday'. A case of abduction was filed, and when the matter reached the court the judge archly asked whether Jinnah had married for money. An enraged Jinnah replied that this question could only be answered by his wife, who stepped forward and told the court that she become a Muslim out of love, and neither she nor her husband wanted any of her father's wealth. The heiress certainly did not have to cramp her style. Stories of her husband's indulgence abound. During one holiday in Srinagar, she spent Rs 50,000, a minor fortune at the time. Jinnah resigned from the Orient Club, where he played chess and billiards, to spend the evenings with his bride. Sarojini Naidu, writing to Dr Syed Mahmud, seems to have captured the marriage best: 'So Jinnah has at last plucked the Blue Flower of his desire. It was all very sudden and caused terrible agitation and anger amongst the Parsis; but I think the child has made bigger sacrifices than she yet realizes. Jinnah is worth it all – he loves: the one really human and genuine emotion of his reserved and self-centred nature.'

As Bombay's most famous and beautiful bride, Ruttie wore fresh flowers in her hair, headbands that sparkled with diamonds, smoked English cigarettes in ivory holders, wore rubies, emeralds and low-cut silk dresses that shocked elderly matrons. Hector Bolitho narrates the reaction of Lady Willingdon, hostess at a

dinner at Government House, Bombay: 'The story is that Mrs Jinnah wore a low-cut dress that did not please her hostess. While they were seated at the dining table, Lady Willingdon asked an ADC to bring a wrap for Mrs Jinnah, in case she felt cold. Jinnah is said to have risen, and said, "When Mrs Jinnah feels cold, she will say so, and ask for a wrap herself."' Jinnah did not step into Government House as long as Lord Willingdon was governor. Ruttie was independent by temperament. Once, in Kashmir, irritated by a form asking her to explain the purpose of her visit, she wrote, 'To spread sedition.' Their only daughter, Dina, loved her father but was sufficiently her mother's child to marry against the wishes of her father. In 1938, she wed Neville Wadia, a Parsi converted to Christianity, in a church off Little Gibbs Road in Bombay. Jinnah sent a bouquet, and never met her again – but he did not disinherit her. Dina stayed back in India. However, she must have been the only Indian to hang a Pakistani flag from her balcony on 14 August 1947.

It is possible to see in Jinnah's commitment, patience and resolve the characteristics that would make him succeed when he fought for the last love of his life, the idea of Pakistan. Within a year of his marriage, however, Jinnah's carefully crafted pedestal started to become irrelevant. A radical political storm, whipped up by a man who had kept quiet for four years, made the previous two decades irrelevant.

Gandhi pulled off something unique: he was the only non-Muslim in history to lead a jihad, albeit a non-violent one – another first. Between 1919 and February 1922, Gandhi was the undisputed leader of Indian Muslims, displacing or co-opting a generation that had worked to attain leadership for a decade or more.

Gandhi lifted the freedom movement out of the grasp of lawyers and professionals, and energized the peasant and artisan base among both Hindus and Muslims. Muslim sentiment travelled

on two currents: domestic outrage against British colonization and international anger against the defeat of the Ottoman caliph and the consequent fall of the holy cities, Mecca and Medina, to a Christian power, Britain, in the First World War. Mecca and Medina had never been lost to non-Muslims. Gandhi wooed and won the Muslim clergy and made them powerful partners in the struggle for India's liberation.

Jinnah was unable to come to terms with street politics. The first major confrontation between Gandhi and Jinnah came during the Calcutta and Nagpur sessions of the Congress in 1920. Jinnah discovered that he had been replaced by Gandhi in Muslim affections. He was the only Muslim delegate to dissent when he rose to speak at Nagpur on Gandhi's non-cooperation resolution. The resolution, he said, was a de facto declaration of complete independence, and India was not ready for it. He agreed completely, he said, with Lala Lajpat Rai's indictment of British rule, but he did not think the Congress had, as yet, found the means to this end. He was prophetic: ' . . . it is not the right step to take at this moment. You are committing the Indian National Congress to a programme which you will not be able to carry out.' His second objection was that non-violence would not succeed. In this, Jinnah was mistaken.

Jinnah did not quite appreciate the nature of the Gandhian revolution. However, Gandhi's new pre-eminence did not drive Jinnah into the compartments he had so assiduously rejected. Recalling the rift two decades later, Gandhi wrote in his journal *Harijan* on 8 June 1940: 'Quaid-e-Azam himself was a great Congressman. It was only after the non-cooperation that he, like many other Congressmen belonging to several communities, left. Their defection was purely political.'

There is a revealing subtext to this event. Jinnah, as was his preference, began his speech in Nagpur in December 1920 by addressing Gandhi as 'Mr Gandhi'. There were instant cries within the audience, asking him to change to 'Mahatma Gandhi'. Subsequently, when he referred to Muhammad Ali as 'Mr', there were angry shouts that the prefix should be 'Maulana'. Given the

religious connotations to the words 'Mahatma' and 'Maulana', Jinnah refused to use them to address Gandhi and Muhammad Ali.

It was a set of maulanas, Muhammad Ali, his brother Shaukat Ali, and Abul Kalam Azad, who gave Gandhi an alternative route to Muslim passions when he turned the survival of the last caliph of Islam into an Indian cause.

6

Gandhi's Maulanas

———◦◦◦———

The first country to declare the First World War a 'holy' enterprise was Tsarist Russia, when it opened hostilities against the Ottoman Empire on 2 November 1914.

On 16 November 1914, Sultan Mehmet V responded in kind. The Shaikh ul Islam, chief cleric of the state, proclaimed a jihad from the public square of Constantinople: 'Know that our state is today at war with the Governments of Russia, England and France and their allies, who are the mortal enemies of Islam. The Commander of the Faithful, the Caliph of the Muslims, summons you to jihad!'

There was no historical evidence that the then British Prime Minister Herbert Henry Asquith, or his First Lord of Admiralty, Winston Churchill, had any desire to scorch-earth Islam out of existence. Indeed, during the previous 'holy' conflict, the Crimean War of 1854, Britain and France had spent blood and money to protect Ottoman Sunni Islam from Russian Orthodox Christianity. The geopolitics of the region changed, however, with the Anglo-Russian entente of 1907, and the two powers joined France in the great confrontation with a German-led alliance for the domination of Europe and its colonies.

The political response of Britain's colonies in 1914 was split between an urge towards loyalty to Empire, and a desire to use this opportunity to further nationalist ambitions. Egyptian Arabs, who were nominally part of the Ottoman Empire but under de facto British rule, remained indifferent to the fate of either empire. Djemal Pasha's Fourth Army was easily defeated by the British when it attempted to retake the Suez Canal in January 1915; the local Arabs were in no hurry to rush to the help of fellow-Muslims in the jihad. The war began badly for the Turks. In December 1914, the Russians had destroyed Enver Pasha's Third Army in the Caucasus. Amid a good deal of gloating in London, Churchill formulated plans for the coup de grace, a naval attack through the Dardanelles that would capture Constantinople, put the Ottomans out of the war, and enable Britain and France to split their Arab territories.

The British could not afford similar equanimity about India, whose Muslims had shown a propensity for jihad through the nineteenth century and displayed active sympathy for the caliph in the turbulent prelude to the First World War. Jihad was a familiar word in Britain, and had crept into popular literature, thanks to generations of officers and soldiers who had fought in the north-west of India and Afghanistan. In the first Sherlock Holmes story, *A Study in Scarlet*, the great detective recognizes Dr Watson's wound from a 'Jezail bullet', during the battle of Maiwand in the Second Afghan War in 1880, 'which shattered the bone and grazed the subclavian artery. I should have fallen into the hands of the murderous Ghazi had it not been for the devotion and courage shown by Murray, my orderly . . .' John Buchan, author of spy thrillers like *The Thirty-nine Steps* and member of the British propaganda team in World War I, described jihad as 'a dry wind' blowing through the Muslim East, from Egypt to India, whose 'parched grasses wait the spark' in *Greenmantle.*

Barelvi's 1825 jihad had mutated, by the turn of the century, into a pan-Islamic sentiment that sought both to lend as well as borrow support for a common front against a seemingly

unstoppable European occupation of Islamic territory. The ulema, propelled by events – the Turko-Russian war of 1877, the Greece-Turkey conflict of 1897, the Italian invasion of Tripoli in 1911, and the Balkan wars of 1912 and 1913 – gradually turned the idea of transnational Muslim solidarity into mainstream conviction. Maulana Abdul Bari, head of India's most influential seminary, Firangi Mahal, which had created the standard curriculum (Arabic grammar, logic, philosophy and Quranic jurisprudence) for Indian madrasas, celebrated Turkey's victory against Greece in 1897 with a public meeting in Lucknow. In 1905, Bari raised eyebrows among the careful at Firangi Mahal by starting the anti-British school, the Madrasa-e-Nizamiya. Bari added Istanbul to his itinerary when he went on haj in 1910–11, and on his return collected donations for medical aid to Turkey's soldiers during the Balkan wars. In 1912, as European pressure on the Ottomans intensified, he helped establish the Khuddam-e-Kaaba, or Society of Servants of Kaaba, to defend the holy cities from infidel threat.

London was particularly concerned about the impact of jihad on Muslims serving in the Indian Army. Remarkably, there was only one sign of disaffection. In February 1915, half of the 5th Light Infantry, a wholly Muslim regiment posted in Singapore, acting in the belief that they were about to be sent to Mesopotamia to fight against the caliph, killed several British officers, released German prisoners, and marched into town in search of popular support before they were arrested.

The Indian Army remained faithful to its oath throughout the war, and Indians backed the Empire in its moment of peril. Sir Penderel Moon quotes John Buchan: 'But it was the performance of India which took the world by surprise and thrilled every British heart – India, whose alleged disloyalty was a main factor in German calculations . . .'[1] Before the war, in July 1914, the Government of India estimated that it might be able to contribute two divisions and one cavalry brigade in case of conflict. By the time the First World War ended, the Indian Army had sent 1.3 million troops, of which 1.1 million were Indians: 675,000 to Mesopotamia, 144,000 to Egypt and Palestine and 138,000 to

France. Recruitment rose from an annual rate of 15,000 in 1914 to over 300,000 in 1918. India's contribution in materials is estimated at a minimum of 150 million pound sterling.

The British Raj, which frequently described itself as the greatest 'Muhammadan power' since more Muslims lived under the British flag than the Ottoman, assured Indian Muslims that Jeddah, Mecca and Medina would never be attacked, and there would be no disruption in the haj pilgrimage. Caution encouraged precaution. Despite the surface calm, the government detained, under Defence of India rules, three Muslims capable of inciting public opinion against the government: journalist-orators Muhammad Ali, editor of *Comrade*, his elder brother Shaukat Ali, who ran the Urdu language *Hamdard*, and Abul Kalam Azad, editor of *Al Hilal*.

The Ali brothers belonged to an Aligarh generation that described itself as 'Nai Raushni', or the new light. As a young man, Shaukat Ali played cricket for Aligarh College, won its Cambridge speaking prize and was fond of matched cravats and handkerchiefs. He was eight when his father, Abdul Ali, a courtier of Nawab Yusuf Ali Khan of Rampur, died. His formidable mother, Bi Amman, inherited a debt of Rs 30,000, but pawned her jewels to send Shaukat and his brother Muhammad, six years younger, to an English school. Relatives were so impressed by her determination that they helped out financially. Both went up to Aligarh. Shaukat joined the civil service as a sub-deputy opium agent and financed his sibling's degree in history at Lincoln College, Oxford.

Both had a puckish sense of humour as well. When in his later incarnation as a fire-in-the-belly activist Shaukat grew an unruly beard, he described it as his 'fiercest protest against Europe and Christendom'. Muhammad Ali pointed out in an article in the *Times of India* in 1907 that if the English wanted Indians to be loyal, they should never have educated them.

By the turn of the first decade, reasons for Muslim discontent

had begun to accumulate. The government refused to grant university status to Aligarh without taking direct control of the institution; Bengal was reunited in 1911; and, on the international scene, Turkey was under siege. In 1912, Aligarh students joined the Red Crescent medical mission, led by Delhi's pre-eminent Muslim dignitary Dr M.A. Ansari, to help Turkey's war-wounded. In 1913, *Comrade* was fined for publishing a Turkish government pamphlet with the plaintive title, 'Come Over to Macedonia and Help Us'.

Muhammad Ali's first editorial in *Comrade*, in January 1911, recognized the value of Hindu–Muslim cooperation. He gravitated naturally towards a leader of a similar disposition, Jinnah, and together they sought to change the pro-establishment character of Muslim politics as evident in the positions taken by the Muslim League, which was heavily influenced by the ultra-loyalist Aga Khan, elected permanent president of the League in 1908. Jinnah was a key participant in a Hindu–Muslim unity conference held in 1910 at Allahabad. The League, sensing the changing mood of Muslims, passed a resolution supporting greater cooperation with Congress in 1911. In 1913, during a visit to London, Muhammad Ali persuaded Jinnah to join the League. In its March session that year, the League inched towards the Congress demand of a 'suitable' form of self-government for India. Gail Minault writes: 'Muhammad Ali already envisaged a role for the Muslim League transcending its immediate loyalist and separatist programme.' In an address in Allahabad in 1907, he spoke of the League as an organization which would promote the integration of India rather than its disintegration. Comparing the Congress and the League to two trees growing on either side of a road, he said: 'Their trunks stood apart, but their roots were fixed in the same soil, drawing nourishment from the same source. The branches were bound to meet when the stems had reached full stature ... The soil was British, the nutriment was common patriotism, the trunks were two political bodies, and the road was the highway of peaceful progress.'[2]

When war broke out between the British and Ottoman empires,

the Muslim heart was with fellow Muslims even if the mind advised ambivalence. In August 1914, Muhammad Ali wrote a famous article in *Comrade* titled 'The Choice of the Turks' in which he listed Turkish grievances against the British: its entente with Russia at the expense of Turkey; its not-so-neutral 'neutrality' in the Balkan wars; the occupation of Egypt; and, most crucially, Winston Churchill's decision to seize two Dreadnoughts (warships) being built in England under commission from Turkey and put them into service with the British navy (the Turks had already paid for the ships). But Ali still hoped for Turkish neutrality and promised Indian Muslim support for Britain in the event of war against Germany. The government persuaded prominent Indian Muslims to impress upon Turkey that its best interests lay in neutrality. Dr Ansari sent such a cable to the caliph after its text had been approved by government. The Aga Khan had already gone the extra mile, with an article in the *Times of India* in early 1913 suggesting that the Ottoman Empire would be wise to retire from Europe and concentrate on its Asia Minor possessions. The Urdu press labelled the Aga Khan anti-Muslim; later that year, the Aga Khan resigned from his permanent position as head of the League, citing frequent absence from India.

Ottoman reverses only increased support for the caliph, particularly since it became a very real possibility that Mecca and Medina would fall into British, and thus infidel, hands. The Ali brothers and Maulana Bari sought a donation of one rupee from every Indian Muslim; more ambitiously, they wanted Muslims to swear an oath to sacrifice all their property and their life in the name of Allah. (This was amended to the more reasonable 'all possible' property.) One-third from a fund of Rs 100 million so raised would be sent to Turkey, another third kept for Indian madrasas and missionary activity, and the rest retained for the defence of Mecca and Medina. All sorts of schemes were canvassed: a haj steamship to break the British control of pilgrimage; a dreadnought for Turkey, if not an aeroplane or two; and even a Muslim fleet to patrol the Indian Ocean. Bi Amman, mother of the brothers, began women activism at the popular level, a first

for Indian Muslims. The authorities banned the fund on grounds of sedition, but they could not prevent the Ottoman crescent from entering the imagination of Indian Islam. In his bureaucratic office in Bhopal, Shaukat Ali fantasized about German support for his war against Britain.

The Ali brothers were interned in May 1915, in Chhindwara, an isolated town in central India. Bari urged them to catch up on their faith in prison, and they did. They read the Quran in Urdu, and occasionally led Friday prayers at the local mosque, thus acquiring the reverent appellation of maulana. When jail authorities complained that Shaukat Ali had been heard praying for the victory of the caliph one Friday, he replied that he could hardly be blamed if the caliph of Islam also happened to be sultan of Turkey.

Jail was good for their reputation. Muhammad Ali was elected, in absentia, president of the Muslim League in 1917. His veiled mother, Bi Amman, stood beside the empty presidential chair and delivered a fiery speech on her son's behalf. It was the first time that a Muslim woman had addressed a political audience that included men. Her son was received with tears at the Amritsar sessions of the League and the Congress upon his release in 1919.

—◦◦◦—

Maulana Abul Kalam Azad was brought up in the conservative–classical tradition of Islamic life and education. He was born in Mecca on 11 November 1888; his father, Shaikh Muhammad Khairuddin Dehlavi, a respected Sufi of the Qadri and Naqshbandi orders, had migrated to Arabia, and married locally. The family returned to India in 1898, and settled in Calcutta. Azad was educated at home in Islamic sciences by his father. By his teens, he had read the work of both the conciliator Sir Syed Ahmad and the anti-imperialist ideologue, Jamaluddin Afghani, whose polemics would spawn radical movements like the Muslim Brotherhood in Egypt.

Azad saw no contradiction between a pan-Islamic alliance

against Western colonization and Hindu–Muslim unity against British rule in India. They were two pillars of the same architecture and reinforced each other. Azad believed that it was the duty of Muslims to declare a jihad against any power that had occupied even a small part of Dar al-Islam. Islamic solidarity could be extended to Hindus through a 'federation of faiths', an alliance of all eastern people against the West. He used the Prophet Muhammad's pact with Jews in Medina as a precedent for Hindu–Muslim unity, arguing that this was reinforced by the Quranic injunction to befriend those who believed in peace.[3]

Although they had much in common, Azad and the Ali brothers remained aloof from one another. Azad thought Shaukat Ali inferior, intellectually; and Muhammad Ali a bit common. Gail Minault says, 'To those who knew him well, Azad referred to Muhammad Ali as a *munshi.*'

Azad was only sixteen when he started his first journal, *Lisan us-Sidq*. He began to write on Turkey and the Middle East in other papers as well. In 1912, at the age of twenty-two, within three years of his father's death, he launched his own Urdu paper, *Al Hilal*, from Calcutta. The first edition appeared on 12 July 1912. Its prose was powerful, its content mature. Azad agreed that the obscurantism of some ulema was retrograde, but his solutions lay in the Quran, not the West. He attacked the Muslim League as a stooge of the British. Indian Muslims, Azad argued, '. . . do not need to lay new foundations or to exercise ingenuity. They have only to revive and reaffirm what has been commanded. There is no reason why we should feel distraught over the new houses to be built; we need only to settle in the dwellings we have forsaken.'[4] The paper's circulation reached a dizzying 26,000 copies at one point, helped by colourful reporting on the Balkan wars, including the innovative use of pictures and charts. In the 23 October 1912 issue, he wrote that Islam condemned narrow-mindedness and racial or religious prejudice, and that human virtue was not the exclusive preserve of Muslims.

In 1913, he launched a political party, Jamiat-e-Hizbullah, or the Party of Allah; he believed that politics could not be separated

from religion. The party did not take off, but its ideas did. A revealing British intelligence report in 1916 contains Azad's notes for a lecture he had prepared for his students at the madrasa Dar ul Irshad, which he had started to encourage independent thinking among the ulema: 'The Quran forbade Muhamedans [*sic*] to remain in subjection. A country like India, which had once been under Muhamedan rule must never be given up ... Ten crores [100 million] of Muslims were living in slavery; it was a disgrace.' The director of the C.I.D. in Calcutta, C.R. Cleveland, commented: 'I do not think there is any personality that could arouse the same personal sympathy and fanaticism in the general Muhamedan community.'

Azad condemned the 'minorityism' of the Muslim League as a sign of weakness, an unwarranted inferiority complex. Muslims were not a minority tail attached to Hindus in the struggle against the British; they were equals in the nationalist cause as well as part of a world struggle against British imperialism, he argued. The government closed *Al Hilal* after the outbreak of war. Azad resumed in 1915 with a different name, *Al Balagh*, but that too was shut down in March 1916. Azad was arrested and kept in Ranchi prison till January 1920.

—◦◦◦—

The romantic dream of Islamic unity suffered a grievous fissure when the Hashemite Sherif of Mecca, Hussein ibn Ali, with British help, rebelled against the caliph in 1916. Muhammad Ali was incredulous. He dismissed it as an absurd lie. Maulana Bari condemned the Arab emir as an enemy of Islam. On 27 June 1916, the All-India Muslim League criticized Sherif Hussein, while the Bombay unit of the League thought that there should be a jihad against such Arabs. Delhi warned London that a 'flame of fire' would rise in India if any British Christian soldier landed in the province of Hijaz, where Mecca and Medina are situated. In fact, such occupation was strategically unnecessary; the British occupied Palestine and Syria.

The British prime minister, Lloyd George, rubbed salt into wounded egos when he described the fall of Jerusalem to British forces in 1917 as the 'last and most triumphant of the Crusades'. By 1918, Indian Muslim leaders were convinced that every British assurance had been deceit, and there was further evidence for such a conclusion. On 5 January 1918, Lloyd George told Parliament that the Ottoman Empire would never be deprived of Constantinople, Thrace or Asia Minor, and recognized the 'separate national conditions' of Arabs. Rauf Bey, the Turkish official who signed the armistice on 30 October 1918 at Mudros, assured his countrymen at a press conference that 'not a single enemy soldier will disembark at our beloved Istanbul'. But by December, Constantinople was occupied. Italians landed at Adalia on 29 April 1919 and Greece began its massive invasion on 15 May 1919 from Smyrna (Izmir). The Treaty of Sevres, signed in June 1920, signalled the virtual destruction of Turkey.

Lord Curzon, who was instrumental in the British decision to occupy Constantinople, conquered by Muslims in 1453, thought this would raise British prestige in India and the Near East. Instead, it provoked the Indian Muslim rebellion that had been contained during the war. Small pro-caliphate associations sprouted across India, and then coalesced into a Central Khilafat Committee, which acquired an impressive head office, Khilafat House, in Bombay.

In 1919, the Congress became a dramatically different organization, thanks principally to a man who had played little part in its history till then, Mohandas Karamchand Gandhi. Gandhi returned to India in 1915 with a reputation for courage in adversity, but refrained from an immediate leap into politics. Gokhale advised Gandhi to keep 'his ears open and his mouth shut' for a year, and see India. Gandhi did just that, extending his tour to Burma. In Calcutta, en route to Rangoon, he made a rare speech in which he advised students to anchor their politics in religion.

Gandhi was present on the sidelines of the famous 1916 Lucknow Congress session where the Congress and the League

cemented their growing cooperation with a pact that promised to end any antagonism between Hindus and Muslims. Gandhi had a radically different strategy. On 9 April 1917, he reached Patna, en route to Champaran to see for himself the wretched state of workers on British-owned indigo plantations. The local administration ordered him to leave Champaran. Thousands of peasants who had never heard of him before April, and would never forget him after that day, crowded into the district magistrate's court on 18 April to witness Gandhi's first trial on Indian soil. To their surprise, Gandhi pleaded guilty. He had deliberately disobeyed the government, he said, and jail was his due. An impressed magistrate withdrew from this confrontation. On 20 April, the case was withdrawn, giving Gandhi his first victory against the British Raj. Gandhi said that he had forged a weapon in Champaran that would make India free. He kept his word. Gandhi shifted the momentum of India's response from legislature to street and lane, from professional to peasant.

The British had no reason to imprison Gandhi during the war, for he was a fervent ally of the war effort. He was honoured with the Kaiser-i-Hind medal on 3 June 1915, the same day that the national poet Rabindranath Tagore was honoured with a knighthood. When Britain was desperate for manpower after the German spring offensive of 1918, Gandhi volunteered to act as a recruiting agent. On 29 April 1918, Gandhi wrote to the viceroy, Lord Chelmsford, who had invited him to a war conference in Delhi, 'I recognize that, in the hour of danger, we must give – as we have decided to give – ungrudging and unequivocal support to the Empire, of which we aspire, in the near future, to be partners in the same sense as the Dominions overseas.'[5]

He offered to raise 500,000 men, but treated this support as an investment: he believed that the grateful British would grant India Home Rule, or dominion status, once war was over. He said as much to the viceroy: 'But it is the simple truth that our response is due to the expectation that our goal will be reached all the more speedily on that account – even as the performance of a duty automatically confers a corresponding right. The people

are entitled to believe that the imminent reforms alluded to in your speech will embody the main, general principles of the Congress–League Scheme, and I am sure it is this faith which has enabled many members of the Conference to tender to the Government their whole-hearted cooperation. If I could make my countrymen retrace their steps, I would make them withdraw all Congress resolutions, and not whisper "Home Rule" or "Responsible Government" during the pendency of the war. I would make India offer all her able-bodied sons as a sacrifice to the Empire at its critical moment . . .'

He wanted Indians to get the rights of Englishmen and become future viceroys. He attended the war conference, he said, in a spirit of 'fear and trembling', an attitude that the disdainful Chelmsford neither believed nor understood, but was happy to exploit. Gandhi sent a typical nationalist signal at the war conference. Although fluent in English, he chose to speak in Hindi. It was the first time that anyone had spoken to a viceroy in an Indian language. When fellow-Indians congratulated him, Gandhi was upset: 'I felt like shrinking into myself. What a tragedy that the language of the country should be taboo in meetings held in the country, for work relating to the country, and that a speech there in Hindustani by a stray individual like myself should be a matter for congratulations!'

On 30 April, the day after the conference, Gandhi followed up with a letter to the viceroy's secretary, advertising his credentials for some 'real war work': 'I was in charge of the Indian Ambulance Corps consisting of 1,100 men during the Boer Campaign and was present at the battles of Colenso, Spionkop and Vaalkranz. I was specially mentioned in General Buller's dispatches. I was in charge of a similar corps of 90 Indians at the time of the Zulu Campaign in 1906, and I was specially thanked by the then Government of Natal. Lastly, I raised the Ambulance Corps in London consisting of nearly 100 students on the outbreak of the present war, and I returned to India in 1915 only because I was suffering from a bad attack of pleurisy brought about while I was undergoing necessary training.'

Gandhi mentioned simmering Muslim concerns, although he was a shade elliptical: 'Lastly, I would like you to ask His Majesty's Ministers to give definite assurances about Mahomedan States. I am sure you know that every Mahomedan is deeply interested in them. As a Hindu, I cannot be indifferent to their cause. Their sorrows must be our sorrows. I have the most scrupulous regard for the right of these States, and for Muslim sentiment as to places of worship [that is, Mecca and Medina] and in your just and timely treatment of the Indian claim to Home Rule, lies the safety of the Empire. I write this, because I love the English Nation, and I wish to evoke in every Indian the loyalty of the Englishman.'

The people were more clear-headed about the British than Gandhi was. He found a distinct lack of interest when he urged Indians to pick up arms to impress the British lion. He argued that this would shame the British into lifting the Arms Act, by which Indians were forbidden guns, a classic colonial precaution.

As Gandhi noted in his autobiography, even his devoted comrade Sardar Vallabhbhai Patel was sceptical. Gandhi travelled through his native Gujarat on foot, without bedding, and only a little food in the satchel. Gujarati peasants were unimpressed: 'We had meetings wherever we went. People did attend, but hardly one or two would offer themselves as recruits. "You are a votary of Ahimsa, how can you ask us to take up arms?" "What good has Government done for India to deserve our cooperation?" These and similar questions used to be put to us.'

But Gandhi was persistent. On 23 June 1918, he issued a typical appeal from the small town of Nadiad: 'If we want to learn the use of arms with the greatest possible dispatch, it is our duty to enlist ourselves in the army. There can be no friendship between the brave [that is, the British] and the effeminate [Indians]. We are regarded as a cowardly people . . . The power acquired in defending the Empire will be the power that can secure those rights.'

The intensity of his recruitment campaign destroyed Gandhi's health. At one point he was convinced that he was close to death,

shifted to his ashram at Sabarmati, and began listening to the Bhagavad Gita in preparation for the afterlife. Sardar Patel brought relief with the news that Germany had been defeated. He spent the second half of November recuperating at Matheran, a hill station near Bombay, and learnt how to spin yarn during his convalescence in January 1919.

Gandhi's, and India's, reward for such selfless service to the Empire was not Home Rule, but a punitive law that gave the government powers of arbitrary arrest, without the right to appeal: the Rowlatt Act. It was premonition of another jihad that prompted such a measure.

—◦◦◦—

A secret militant faction in Deoband set off a chain of events that ended in this infamous legislation. In September 1915, Maulana Ubaidullah Sindhi, a convert to Islam from Sikhism who had left the seminary at Deoband to start a Quranic school for westernized Muslims in Delhi, slipped away to Afghanistan. His mentor, Maulana Mahmud al-Hasan, called Shaikh ul Hind by his followers, went on haj at the same time, but there was a political purpose to this religious mission: he wanted to contact Turkish officials. The plan was to use Afghanistan as a base for an invasion of India with the help of Turkey, and merge this with an Indian uprising. A letter sent by Hasan to Ubaidullah, sewn into the lining of the courier's coat, was discovered by the British; hence the label worthy of a popular novel, The Silken Letters Conspiracy.

The conspiracy itself was more ambitious than practical. Sindhi, along with fellow-revolutionaries Mahendra Pratap and Barkatullah, set up a Provisional Indian Government in Kabul in 1916. It was in this capacity that they met a Turkish–German mission, headed by Oscar Niedermayer and Kazim Bey, which was in Kabul to persuade Afghanistan's Amir Habibullah to switch from neutrality to an alliance with Turkey. Pan-Islamic sentiment was, if anything, stronger in Afghanistan than India.

But Amir Habibullah manoeuvred adroitly between competing demands and remained neutral. He paid a heavy price. Anti-British Afghan nationalists assassinated him in February 1919.[6]

The British, however, did not preserve their empire by being complacent. Maulana Hasan found himself under arrest when he refused to sign a fatwa supporting the sherif of Mecca's British-sponsored revolt against the caliph. The sherif handed him over to the British, who imprisoned him at Malta.

Apprehensive about the security of India, the British used the Silk Letters as justification for the continuation of harsh wartime laws after the war.

In 1917, the government appointed a Sedition Committee with Justice Sir Sidney Rowlatt as chairman to consider which special provisions of the Defence of India Act should be retained to deal with sedition and terrorism. The first bill based on its recommendations was tabled on 6 February 1919 in the Central Legislative Council. The government rushed through its passage though there was no particular need for hurry, since the war did not legally end till after the middle of 1921. All twenty-two Indian members of the Imperial Council opposed the 'Black Act', and two prominent members, Jinnah and Malaviya, resigned.

The mood in India had already soured because of rising prices, food shortages and an influenza epidemic since 1918 that had claimed at least six million lives.[7]

In his speech to the Muslim League on 12 December 1917, Jinnah was sharply critical of the British, and fulsome in his optimism about a joint Hindu–Muslim challenge to foreign rule. He expected consultations with the Congress, after which 'I take it that the Hindus and Mohammedans as one nation will make that demand and there will be no going back from it'. His choice of the phrase 'one nation' was deliberate. He calmed traditional Muslim League apprehensions: 'If seventy millions of Muslims do not approve of a measure which is carried by the ballot box, do you think that it could be enforced and administered in this country? Do you think that the Hindu statesmen, with their intellect, with their past history, would ever think of – when they

get self-government – enforcing a measure by ballot box? Then what is there to fear? Therefore I say to my Muslim friends not to fear. This is a bogey, which is put before you by your enemies to frighten you, to scare you away from the cooperation with the Hindus which is essential for the establishment of self-government. If this country is not to be governed by the Hindus, let me tell you in the same spirit, it was not to be governed by the Muslims either and certainly not by the English. It is to be governed by the people and sons of this country and I, standing here – I believe I am voicing the feeling of the whole of India – say that what we demand is the immediate transfer of the substantial power of Government of this country and that is the principal demand of our scheme of reforms.'[8]

The League president for 1918, A.K. Fazlul Haque, linked local Muslim anger to the world situation: 'Muslim countries are now the prey of the land-grabbing propensities of the Christian nations, in spite of the solemn pledges given by these nations that the World War was being fought for the protection of the rights of the small and defenceless minorities.'

Jinnah even opposed, with his usual scathing logic, the drive to recruit Indians to the British army. Jinnah argued during the debate on the budget, in the presence of Viceroy Lord Chelmsford, that Indians should first be 'put on the same footing as the European British subjects' before being asked to fight for British interests. When Chelmsford called this 'bargaining', Jinnah asked whether self-respect had any place in the British scale of values. 'Is it bargaining, my Lord, to say that in my own country I should be put on the same footing as the European British subjects? Is that bargaining?' He explained his stand later: 'A subject race cannot fight for others with the heart and energy with which a free race can fight for the freedom of itself and others. If India is to make great sacrifices in the defence of the Empire, it must be as a partner in the Empire and not as a dependency. Let her feel that she is fighting for her own freedom as well as for the commonwealth of free nations under the British Crown and then she will strain every nerve to stand by England to the last ... Let

full responsible government be established in India within a definite period to be fixed by statute with the Congress–League scheme as the first stage and a Bill to that effect be introduced into Parliament at once.'[9]

Gandhi, of course, thought otherwise. On 4 July 1918, Gandhi wrote to 'Mr Jinnah': 'I do wish you would make an emphatic declaration regarding recruitment. Can you not see that if every Home Rule Leaguer became a potent recruiting agency whilst, at the same time, fighting for constitutional rights, we would ensure that passing of the Congress–League Scheme, with only such modifications (if any) that we may agree to? We would then speak far more effectively than we do today. "Seek ye first the Recruiting Office and everything will be added unto you." We must give the lead to the people and not think how the people will take what we say. What I ask for is an emphatic declaration, not a halting one. I know you will not mind my letter.'[10]

But both Jinnah and Gandhi agreed that progress was impossible without Hindu–Muslim unity. Gandhi, writing about that period in his confessional, *An Autobiography: The Story of My Experiments with Truth*,[11] 'I had realized early enough in South Africa that there was no genuine friendship between the Hindus and the Mussalmans. I never missed a single opportunity to remove obstacles in the way of unity.' Gandhi spoke at the Muslim League session in Calcutta, where the presidential chair was kept empty because the president, Maulana Muhammad Ali, was in jail. He told Muslims it was their duty to secure Ali's release. He next went to Aligarh Muslim College (it had not become a university yet) and urged the students to become 'fakirs' in the service of the motherland. Gandhi does not record how the students responded.

Hell hath no fury like Gandhi scorned. The passage of the Rowlatt Act ended any remaining illusions about British generosity towards Indian hopes. In protest, Gandhi organized the first hartal, or strike, in Indian history, on 6 April 1919. (Due to miscommunication, some towns shut down on 30 March.) There were sporadic outbreaks of violence. Punjab, which had

contributed the most manpower to British battlefields, was especially restive. Prices of food in Lahore had doubled between 1917 and 1919.

What worried the British, however, was the Hindu–Muslim–Sikh unity in Punjab. Muslims participated in the Hindu Ram Navami procession on 9 April, and Punjabis of all faiths drank water out of the same vessels to demonstrate their solidarity. On 10 April, the police fired on a peaceful demonstration near Hall Bridge, and in response Punjabis attacked all symbols of authority – the railway station, town hall, banks. Meetings were banned and martial law was imposed on 11 April. A certain Brigadier General R.E.H. Dyer was in charge of maintaining order in British Punjab.

On 13 April, villagers, largely unaware that the ban extended to the traditional spring fair, gathered at Jallianwala Bagh, near the Golden Temple. There was not a hint of protest, let alone violence. Without warning, ninety Indian and Gorkha troops took up position on one side of the walled space. No orders were given to disperse. Instead, Dyer ordered his troops to open fire. Within ten minutes, his men poured 1,650 rounds at point-blank range. Official estimates put the number of dead at 379 and the wounded at over 1,200. Unofficial estimates were far higher.

State terrorism followed massacre: arrests, public flogging, torture. Troublesome professionals like lawyers were forced to do menial work, 'natives' had to salute white men, and Indians were made to crawl through a lane called Kucha Kauchianwala because a white woman had been insulted there. A brazen Dyer later told the Hunter Commission, set up to investigate Jallianwala, that his only regret was that his ammunition had run out, and that he could not bring up an armoured car because the lanes were too narrow. Lord Chelmsford would concede no more than that Jallianwala was an 'error of judgment'. Churchill, more forthcoming, called Jallianwala a 'monstrous event ... without parallel in the modern history of the British Empire'.

The support that Dyer received in the British press and Parliament, and some statements made before the Hunter

Commission, shocked Gandhi and all India. From the oral evidence before Lord Hunter's enquiry committee, it was apparent that many of the officials considered Indians an inferior race. Gandhi thought 'that a government that had always been found quick (and rightly) to punish popular excesses would not fail to punish its agents' misdeeds ... [but] ... to my amazement and dismay, I have discovered that the present representatives of the Empire have become dishonest and unscrupulous ... they count Indian honour as of little consequence'.[12] Gandhi returned his British medals, Tagore his knighthood.

Dyer was relieved of his command, but not immediately. In Britain, the *Morning Post* raised what Indians called a butcher's prize of 26,000 pound sterling, which was presented, along with a sword, to the 'Defender of the Empire'.[13] A pun became fashionable: Indians had asked for diarchy; instead they got Dyerarchy. Gandhi, now convinced that British rule was 'satanic', began to put a national response into place: history's first non-violent war.

Indian Muslims were eager for war, although they had to be persuaded to keep it non-violent. Nothing in their history provided any evidence of its efficacy. Gandhi wooed his maulanas, finding an entry point through their support for the caliph. The caliph had begun to creep into their prayers, literally, since the end of the Mughal Empire, during the *khutba*, an appeal to Allah for the welfare of Muslims and their ruler, during the congregational namaaz every Friday. Since the imams refused to pray for a British ruler, who was an infidel, they began to use the eponymous term 'Sultan ul-Islam'. It was a vague reference since there was no Indian Islamic sultan, but it gradually morphed into the caliph, the Ottoman sultan. Gandhi co-opted the caliph into his battles.

Gandhi wanted swaraj, or self-rule; the maulanas wanted to liberate both India and the caliphate from Britain. It was an adjustment Gandhi could live with, even if Hindus, including in the Congress, were puzzled and sceptical about the sudden transnational sweep of the struggle. But in the process, Gandhi

and his maulanas, for a little more than two years, not only submerged the divergent trend of Muslim politics, but also brought Hindus and Muslims as close as they had ever been politically. The theory of distance evaporated, almost as if it had never existed. It reappeared only after Gandhi accepted, in February 1922, that his movement had been a failure.

—*∞*—

Why did Gandhi, a passionate recruiter for the British war effort in 1918, insist on non-violence for Indians in 1919? Surely, if war was good enough, morally, to protect the British Empire, it was a good enough means to destroy it?

Those who see Gandhi merely in the fashionable spotlight of moralist, forget that he was first and foremost a realist. Without an honest appreciation of Indian weaknesses, he could never have controlled an incubation through the tribulations of a protracted and tortured labour to deliver freedom.

Philosophically, Gandhi recognized the corrosive impact of violence on the perpetrator. This was particularly dangerous in India, where old passions had repeatedly instigated bouts of Hindu–Muslim violence. He sensed that if he sanctioned violence, Indians would probably kill one another long before they killed the common enemy. Moreover, violence would pit Indians against Indians, for Indians manned the British instruments of repression, the police and army. Dyer may have been a white imperialist, but those who carried out his cold-blooded orders were from the subcontinent.

It is an illusion to think of India as a pacifist nation. All the major religions, Hinduism, Islam and Sikhism, include a war ethic in their religious doctrine. Islam, of course, has jihad. The two major Hindu epics, Ramayana and Mahabharata, are war narratives. The ideal Hindu king, Lord Rama, is pictured in popular iconography with a bow and a sheaf of arrows. His triumph over the evil Ravana is celebrated as a major festival across most of India each year. Rama's most famous warrior-

lieutenant, the monkey-god Hanuman, is worshipped fervently for his devotion and martial feats. Sikhism was the most pacific of the three faiths until, forced by circumstances, the tenth master, Guru Govind Singh, gave the community a striking martial identity in the Khalsa creed.

Gandhi knew that to sustain non-violence might require unprecedented heroism, but to permit violence would be suicidal.

These perceptions run through an essay that a deeply saddened Gandhi wrote in 1924, after his dream of independence had curdled, when communal violence had resurfaced and he had become the target of cynical barbs from all sides. Some Hindus were even calling him a turn-the-other-cheek Christian for advocating non-violence amidst riots. He writes in the 29 May 1924 issue of *Young India:* 'My claim to Hinduism has been rejected by some, because I believe and advocate non-violence in its extreme form. They say I am a Christian in disguise. I have been even seriously told that I am distorting the meaning of the Gita, when I ascribe to that great poem the teaching of unadulterated non-violence. Some of my Hindu friends tell me that killing is a duty enjoined by the Gita in certain circumstances ... What I see around me today is ... a reaction against the spread of non-violence. I feel the wave of violence coming. The Hindu–Muslim tension is an acute phase of this tiredness ... I am then asking my countrymen today to adopt non-violence as their final creed, only for the purpose of regulating the relations between the different races, and for the purpose of attaining Swaraj ... This I venture to place before India, not as a weapon of the weak, but of the strong.'

7

The Non-violent Jihad

=⚬⚬⚬=

Gandhi began his campaign for Indian 'self-rule' with a deep bow to Muslim sentiment. His first demand, made on 2 August 1920, was that the Ottoman caliph should retain suzerainty over Mecca and Medina despite being defeated in World War I. He also wanted victorious Britain to ensure the territorial integrity of Turkey and Muslim sovereignty over *Jazirat ul Arab* – Arabia, Iraq, Palestine and Syria – in the peace settlement. It was a strange cause for an Indian who had never set foot in Arabia or Turkey, but this was the essence of Gandhi's bargain with Indian Muslims.

The map of the Ottoman Empire lay in tatters after the First World War, and a new one was being drawn in ravenous ink. Britain had captured Palestine, Mesopotamia, Syria and Arabia; for the first time in the history of Muslims, Mecca and Medina were under infidel control. The Muslim League had warned, through a resolution, at its 1918 session, that the 'collapse of the Muslim powers of the world is bound to have an adverse influence on the political importance of the Mussalmans in this country [India], and the annihilation of the military powers of Islam in the world cannot but have a far-reaching effect on the minds of even the loyal Mussalmans of India . . .'

The League was so anxious for Hindu support at doomsday hour that it resolved to voluntarily stop the contentious cow slaughter during Bakr Id. There had been intermittent communal violence in 1917–18, starting from September 1917 when Hindus objected to cow sacrifice at Shahabad in Bihar. Maulana Bari, who participated in this League session, had adopted a provocative public posture during the riots, charging Hindus with oppressing Muslims. An alleged insult to the Prophet in an English newspaper published from Calcutta in 1918 brought him onto the streets at the head of a procession, leading to skirmishes, police firing and deaths.

Gandhi persuaded Maulana Bari about the necessity of non-violence at a meeting in March 1918 at the home of Dr Ansari, called to formulate a programme to press for the release of the Ali brothers. Gail Minault suggests that 'Gandhi saw in these bruised feelings a way to gain Muslim adherence to the drive for self-government, which he called *swaraj*. He wrote to Muhammad Ali: " . . . my interest in your release is quite selfish. We have a common goal and I want to utilize your services to the uttermost, in order to reach that goal. In the proper solution of the Mahomedan question lies the realization of Swarajya".'

—⟳⟳⟳—

Momentous is a word given to overuse, but 1919 had more than its share of high moments. On 6 February, the Rowlatt Bills were introduced in the legislature. These were passed on 18 March despite the near-unanimous opposition of Indians. Gandhi began his satyagraha in protest. Maulana Bari, still on his single track, argued publicly that the Rowlatt Act had been passed specifically to prevent Muslims from agitating against the peace conference at Versailles.

The street was ahead of the leaders; the slogan 'Hindu-Mussalman ki jai' was heard amid unprecedented scenes of amity. In a symbolic display of unity, Hindus were permitted into Calcutta's Nakhoda mosque for the first time. Muslims mobilized

under two banners: the mass-based All India Khilafat Committee and the clergy-specific Jamiat al-Ulema-e-Hind.[1] The Muslim League was marginalized. There were suspicions about its 'loyal' past, as well as its elitist leadership, who had too much to lose in any confrontation with the British. The clergy were also wary of 'westernized' Muslims; and while they were willing to cooperate with them, they believed that an Islamic cause like Khilafat needed religious leadership at both the apex and mass levels. The League had only 777 members in 1919, and four of six meetings scheduled for the year had to be cancelled for want of a quorum.

On 20 March 1919, the All-India Khilafat Committee was formed at a public gathering of some 15,000 in Bombay. The first president was Seth Mian Muhammad Haji Jan Muhammad Chotani, who had the indisputable advantage of wealth, made from supplying raw materials to the British during wartime. On 5 July, the committee decided to open units across the country. At an All-India Muslim Conference in Lucknow, in September, Maulana Bari pushed through a resolution to hold a nationwide Khilafat Day on 17 October with prayers, fasting, public meetings and Gandhi's new weapon, hartal. It was a great success, with Shias – who rejected the caliph, but did not want Mecca, Medina and Kerbala under Christian rule – showing as much enthusiasm as Sunnis. Gandhi asked Hindus to join the protest, and at points as distant as the Bombay beach and town halls in Madras and Calcutta there were 'monster' Hindu–Muslim meetings. An All-India Khilafat Conference followed in Delhi on 23 and 24 November; on 25 November, the inaugural meeting of the Jamiat al-Ulema-e-Hind was held. Maulana Bari presided.

This was the culmination of many months of effort by Bari and his colleague, Maulana Kafayatullah. In February 1919, Bari issued a fatwa making two points: any pretender to the caliphate, like the British nominee, Sherif Hussein, would be opposed by all Muslims; and non-Muslims must not be permitted to rule Arab lands. He then embarked on a rigorous tour to rally the clergy of different schools to set aside their differences at a time of crisis. He was largely, if not completely, successful. The Jamiat set itself

up as a third force, holding its own conference in Amritsar in December 1919, alongside those of the Congress and Muslim League.

The Khilafat conference on 23 and 24 November was the spark that set off the fireworks of 1920. On the first day, with Fazlul Haque in the chair, two resolutions were passed: it was a religious duty of Muslims to 'non-cooperate', and Muslims should begin a progressive boycott of European goods if Turkey did not get justice. Gandhi, who presided on 24 November, actually opposed the second proposal as premature; his views would change. Speaking from the chair, Gandhi explained, 'It ought not to appear strange for the Hindus to be on the same platform as the Muslims in a matter that specially and solely affects the Muslims. After all, the test of friendship is true assistance in adversity and whatever we are, Hindus, Parsis, Christians or Jews, if we wish to live as one nation, surely the interest of any of us must be the interest of all . . . We talk of Hindu–Muslim unity. It would be an empty phrase if the Hindus hold aloof from the Muslims when their vital interests were at stake . . . Conditional assistance is like adulterated cement which does not bind.'

Maulana Abdul Bari, speaking for the ulema, offered to stop cow slaughter 'because we [Hindus and Muslims] are children of the same soil'. This spirit infused the annual sessions of the established parties when they chose to meet in the same city, Amritsar, in December that year. Motilal Nehru was president of Congress, Hakim Ajmal Khan of the League, and Shaukat Ali of Khilafat. The just-released Ali brothers were greeted with the heady Indian combination of tears and cheers. Muhammad Ali grandly declared that he would rather return to prison than see India in chains. As Jawaharlal Nehru would point out later, the coincidence of a pun bridged the gap between the caliph and Indian resistance to Britain. In Urdu, 'Khilafat' also means opposition.

Gandhi and Jinnah were among the signatories to a petition presented to Lord Chelmsford by a Khilafat deputation on 19 January 1920. Others included Pandit Madan Mohan Malaviya, Arya Samaj leader Swami Shraddhanand, Motilal Nehru, Hakim

Ajmal Khan, Fazlul Haque and M.A. Ansari, who read out the statement before the viceroy. The language was convoluted, but the purpose was clear. War had ended, but peace was distant, and His Majesty's Government should not be under the illusion that 70 million Indian Muslims and 250 million Muslims elsewhere would be impassive, acquiescent or submissive. They would not tolerate non-Muslim control of the holy cities; the caliph alone could be its warden. Indian Muslims had been loyal to Britain because Britain had respected Islam; the contract could be broken only at British peril. 'A settlement unacceptable alike to Muslim and non-Muslim Indians, now happily reunited and standing shoulder to shoulder, will bring no peace because it will bring no sense of justice and no contentment.'[2]

Chelmsford, caught between an aggressive London and an implacable India, was not very helpful, but he did offer to finance a trip to London to see the prime minister. Lloyd George was cool towards the Indian delegation led by Muhammad Ali: Turkey, he said, would lose its empire and the victors would control the holy cities of Islam pending a final agreement on their future. The Khilafat Committee declared 19 March as a day of national mourning. Moving a resolution that day at a meeting in Bombay, Gandhi said, 'A loyalty that sells its soul is worth nothing.'

By this time, Muslims passions were sufficiently aroused for some of them to question the worth of non-violence. Gandhi's disarming response, at this Bombay meeting, was that he would not come in the way of a violent struggle if non-violence failed. That same month, Britain and its allies declared martial law in Constantinople, disbanded the local police, and exiled 150 Turkish military and civil officials to Malta.

On 14 May, the terms of the Treaty of Sevres, which would be signed on 10 August 1920, were published. The Ottoman Empire was to be liquidated; Iraq and Palestine would become British mandates; France would get Syria and what is now Lebanon. The Hijaz, containing Mecca and Medina, was treated as an 'independent' kingdom under the Hashemites who had helped Britain defeat Turkey. Greece was awarded Smyrna, parts of

eastern Thrace and some Aegean islands; the Dodecanese and Rhodes went to Italy. An international commission would take control of the Dardanelles; eastern Anatolia was divided between Armenia and an autonomous Kurdistan.

Kemal Ataturk's government in Ankara rejected Sevres without any hesitation. But the caliph wavered, first accepting the dismemberment, and then describing Sevres as 'Turkey's death sentence'. He refused to ratify Sevres, but his reputation was mud. Outraged Indian Muslims called him a 'Vaticanised' caliph.

On 28 May 1920, the Hunter Commission, entrusted with the enquiry into Jallianwala atrocities, released its 'Majority Report'. Gandhi dismissed it as 'page after page of thinly disguised official whitewash'. It did not make much practical difference in any case, as the government had already given protection to officials through an Indemnity Act.

On 22 June, Greece invaded Turkey, with financial and material support from Britain. The Greeks took Izmir immediately, and killed or drove out Turkish Muslims. Some Khilafat leaders declared British India Dar al-Harb, and an estimated 20,000 Muslims sold their possessions in order to emigrate to Afghanistan. Afghanistan, unprepared for such fervour, turned them back.

Such was Gandhi's charisma that Khilafat leaders did something unprecedented in the history of Muslims: they handed over leadership of a jihad to a non-believer. On 1 and 2 June, the Allahabad conference of the Central Khilafat Committee accepted the four-stage Gandhian programme for non-cooperation: boycott of elections; return of titles; withdrawal from civil services, armed forces, schools and colleges; and non-payment of taxes. Muslims accepted Gandhi as their leader even before the Congress did. They trusted Gandhi's transparent honesty with a zeal that the Mahatma could not immediately elicit from fellow-Congressmen. The Congress endorsed Gandhi's Khilafat Movement months after it began, and only by a thin margin, at a special session at Calcutta in September, after Gandhi pointed out that he would go ahead in any case.

Gandhi kept this jihad non-violent. His primary weapon was

satyagraha, developed in South Africa, where it was known by a less forceful phrase, 'passive resistance'. Gandhi was uncomfortable with the term, because, as he writes in *My Experiments with Truth*, it 'was too narrowly construed, that it was supposed to be a weapon of the weak, that it could be characterized by hatred, and that it could finally manifest itself as violence'. Gandhi offered a 'nominal' prize to any reader of his journal, *Indian Opinion,* who could define in a word what he was doing. A certain Maganlal Gandhi (no relation) thought of *sadagraha,* which is a combination of *sada,* truth, and *graha,* firmness. Gandhi amended this to satyagraha, which means the same thing but is easier off the tongue.

Satyagraha was the ideology of the victim, its moral centre of gravity firmly rooted in justice, its principal target the adversary's conscience. It was martial in spirit. All the characteristics required of a war hero – discipline, fearlessness and the readiness to sacrifice one's life – were prerequisites in Gandhian peaceful resistance. It was multidimensional, as useful in the struggle for reform within Hindu society as it was in rebellion against the Raj. As he wrote in a letter to Maganlal Gandhi on 4 May 1920, this 'simple-looking thing' would force a 'great power based on brute force' to submit.

Gandhi, who had no qualms about calling himself a dictator, used the inspirational power of faith to rise above its potential dangers. In specific terms, Gandhi asked Indians to stop all forms of cooperation with British rule. Non-cooperation was based on the premise that a ruler was impotent without support from his subjects; once it was withdrawn, British rule would collapse. The British co-option of Indians into their system, Gandhi argued, was a subtle method of emasculation. He shifted the axis of agitation. 'They [the British] want India's billions and they want India's manpower for their imperialistic greed. If we refuse to supply them with men and money, we achieve our goal, namely, *swaraj* ... I do not rely merely on the lawyer class, or highly educated men to carry out all the stages of non-cooperation. My hope is more with the masses. My faith in the people is boundless.'[3]

With the Congress behind him, Gandhi promised swaraj within
a year, provided Indians remained united, disciplined and non-
violent. It was an audacious dream at a time when the best Indian
minds considered British rule beyond Indian challenge. Before
the First World War, Sir S.P. Sinha, the first Indian to be named
to the viceroy's executive council, was convinced that the British
would be around for four centuries. Gandhi could not liberate
Indians within his promised year, but he succeeded in liberating
Indians from fear. As Nehru explains, 'It was a psychological
change, almost as if some expert in psychoanalytical methods had
probed deep into the patient's past, found out the origins of his
complexes, exposed them to his view, and thus rid him of that
burden.'[4]

Indian nationalism became national between 1919 and 1922,
moving out of the penumbra of the professional elite and into the
world of the peasant and the poor. Nehru noted the manifestations
of this change: European clothes gave way to homespun khadi;
lower-middle-class delegates began to appear at Congress sessions;
the language of communication became either Hindustani or a
regional language. Tagore honoured Gandhi with the title
Mahatma, or 'great soul'.

The Muslim commitment to Gandhi between 1920 and 1922
bridged wealth, language, caste, gender and profession. Sir
Harcourt Butler, one of the most distinguished of the bluebloods
who joined the Indian Civil Service, wrote to Lord Hardinge from
Rangoon (on 16 January 1916) that 'priests and women are the
most important influences in India ... and I am not very much
afraid of the politicians until they play on these two'.[5] Khilafat
and non-cooperation was the first popular upsurge in which
Indian Muslim women emerged from home or purdah.

Bi Amman, Muhammad Ali's mother, had addressed the Muslim
League in 1917 in a veil. She now took it off, saying that as every
man present was like a brother or a son, there was no need for
her to cover her face. She told women that it was their duty
towards God to support their men. In 1921, a Women's Khilafat
Committee was formed, headed by the wives of the two Delhi

doctor-politicians, Hakim Ajmal Khan and M.A. Ansari. Businessmen's wives, inspired by the passions of the moment, took off their bangles, earrings and anklets and threw them into handheld bed sheets that soon dipped under the weight of contributions. Muhammad Ali remarked, tongue only partly in cheek, 'My wife took up the beggar's bowl and disburdened the Khoja and Memon [two rich business communities] ladies of some of their superfluous cash in the name of Smyrna and the Khilafat.'

Dissidents charged that Muslim politics had become a never-ending sequence of fund-collection over the past decade: for Aligarh college, Balkan wars, the holy cities, the Muhammad Ali-led Khilafat delegation to London (which, to the consternation of donors, travelled first class and lived in expensive hotels), an Angora Fund (for Kemal Mustafa's war) and a Smyrna relief fund for refugees. But enthusiasm was so high it crossed class lines. Teashop owners donated a day's profits; businessmen like Seth Chotani of Bombay and Haji Abdullah Haroon of Karachi opened their large safes. Khilafat receipts were issued, in the form of one-rupee or ten-rupee notes, with a picture of the Kaaba and verses from the Quran at the centre. The money was not of much use to Turkey; there was no practical way of getting it to Ataturk. It was, eventually, largely used – at least that part which did not disappear suspiciously – to finance the movement and pay for the poor who wanted to go on haj.

In December 1921, Bi Amman was appointed president of the Ladies Conference at the Ahmedabad Congress, where she declaimed that the British had chained India to the twin fetters of slavery and eternal damnation. The ulema proved adept at exploiting the gaps that a boycott of British courts and schools opened up in Muslim life. They replaced British law with Sharia jurisprudence, and offered madrasas as an alternative to schools. By May 1921, Sharia courts called Dar ul Qaza (House of Justice), headed by an amir-e-Sharia, were functioning. Muslims were asked to divert taxes due to the government towards *zakat*, the obligatory Islamic charity, through the clergy for further

disbursement. Seeking to institutionalize their new-found power, the ulema elected an amir-e-Hind, an emir of India, ruler of a parallel system, with deputies across the country, an idea believed to have been proposed by Maulana Azad. The Ali brothers thought this excessive, but were ignored.

As far as Maulana Bari was concerned, Gandhi's 'self-rule' meant an informal Islamic dispensation for Muslims within multi-polar India, not quite a state within a state but a Sharia-centric framework for the community. Islam was in 'danger' from the British, in Constantinople, Mecca and Medina as well as in India. Gandhi was, in the meantime, giving political legitimacy to mosques, by repeatedly addressing congregations from their pulpits. Some awed imams rationalized the presence of Gandhi in their environment by suggesting that Allah had sent a Hindu ally to rid the whole of India, Hindu and Muslim, of the British.

But this battle cry of the Khilafat, 'Islam in Danger!', would have consequences far beyond the comprehension of those who raised the slogan in 1920. On the surface, it equated Islam with survival of the caliphate. The subtext was less obvious: if Indian Muslims did not protect their right to live by the law of the Quran, Islam would be in danger on the Hindu-majority subcontinent as well. Some Hindus began to wonder, even at the height of fraternity, if Muslims wanted a free India or a return to Muslim rule.

Urdu poets inspired Muslims with dreams of a new, if undefined, destiny. Poetry commands a special place in the hearts of most Indians, and is a passion among Urdu-speaking Muslims, for Urdu lends itself to nuance, wit and melody. The poets of Khilafat gave new interpretations to conventional symbols. Thus, wrote Zafar Ali Khan: *Qafas se andaleebon ke reha hone ka waqt aaya* (The time has come to free nightingales from the cage). Imprisonment was futile, wrote Hasrat Mohani: *Rooh azad hai, khayal azad hai, Jism-e Hasrat ko qaid hai bekaar* (The soul is free, the mind is free, To confine Hasrat's body is useless). As Bi Amman repeatedly pointed out, there were not enough British jails to imprison all the Muslims ready to go to prison.

The first signs of trouble rose, perhaps inevitably, over the grey area surrounding non-violence, a concept that Muslims had accepted out of deference to Gandhi rather than any conviction. On 2 April 1921, Muhammad Ali made a speech at Madras that seemed to welcome an Afghan invasion of India, inviting the charge of sedition. The suggestion was not as airy as might seem in retrospect.

In February 1919, the new amir of Afghanistan, twenty-six-year-old Amanullah Khan, whose father had been assassinated by nationalists for pro-British leanings, announced that he had acceded to the throne of the 'free and independent Government of Afghanistan'. Delhi took careful note of the assertion of independence. Britain and Russia had settled a long and bitter history of confrontation over Afghanistan in the Anglo-Russian Convention of 1907, with Russia conceding British hegemony. Neither superpower considered Afghanistan worthy of consultation. The situation changed in 1918, when communists overthrew the Tsars. Britain suspended the 1907 agreement. Lenin's Moscow responded by supporting the independence of Afghanistan.

Amanullah had a second surprise for Delhi. On 3 May 1919, Afghan troops crossed the border into British India. Citing the Jallianwala massacre, he justified the foray as fraternal reaction, in the name of humanity and Islam. The war lasted till June. The Royal Air Force bombed Afghan cities, which had a salutary effect; but Britain, perhaps wearied by war fatigue, relinquished control of Afghanistan's foreign affairs in the Treaty of Rawalpindi, signed on 8 August 1919. Amanullah immediately permitted Russia to set up consulates. In 1921, British intelligence broke the Russian code, and confirmed what it had suspected: Soviet agents were in communication with Muslim tribes on the Afghan–India frontier.

Muhammad Ali's speech on 2 April could not, therefore, be dismissed merely as harebrained hyperventilation. When, in August, a violent rebellion erupted in the southern state of Kerala among a sect known as the Mappillas, the government linked it

to passions and promises aroused by Ali's oratory in Madras, although Kerala is as far away from Afghanistan as it is possible to be on the subcontinent.

The new viceroy, Rufus Isaacs, Marquess of Reading, had taken office on the same day that Ali made his inflammatory speech. He demanded an apology from Muhammad Ali for the Madras speech as the price for non-prosecution. Reading gave Gandhi an 'interview' in mid-May, during which Gandhi negotiated a compromise. The Ali brothers issued a statement, published on 30 May, expressing 'our regret for the unnecessary heat of some of the passages in these speeches, and we give our public assurance and promise to all who may require it that so long as we are associated with the movement of non-cooperation, we shall not directly or indirectly advocate violence . . .'

The press was not very kind; it condemned the Ali brothers as cowards; the government took public delight in their humiliation. The brothers denied that they had retreated. Shaukat Ali took cover in humour, saying it was absurd to accuse him of retreat: 'Alas, you can see I am too fat to run!' Bari held Gandhi guilty for manipulating the apology. He wrote sarcastically to the Mahatma, 'Well done! Now the government will be satisfied!' Bari's irritation had been building for some time; his outburst was mild compared to what some of his fellow-maulanas had been saying, and what the Ali brothers would say next.

Reservations about Gandhian methods were building. The ulema had been careful to add a caveat to their commitment to non-violence: Muslims should not draw the sword in this jihad. They left the sword dangling for use in the future. There were also murmurs that Hindus were making less than their share of sacrifice. When, in March 1921, the Jamiat al-Ulema-e-Hind issued a fatwa declaring service in the British army or police to be *haram* (the highest sin), many wondered why Hindus were not equally eager to quit government service. Gandhi's metaphors left others perplexed. He promised Dharmaraj (Rule of Dharma; which would evolve into Rama Rajya), and told Hindu women that they could end Ravanraj (Rule of the evil demon king

Ravana, villain of the epic Ramayana, equivalent of British rule)
in six months if they wore homespun and spurned luxury just as
Sita, wife of Rama, had resisted Ravana's temptations. Did this
mean that Gandhi wanted Hindu rule in post-British India?

Money was breeding a parallel set of tensions. The Congress
launched the Tilak Swaraj Fund on 31 March 1921, an appeal for
'men, money and munitions'.[6] Gandhi pointed out in a pained
letter to Shaukat Ali on 30 November 1928 that only about Rs
200,000 out of a Congress collection of Rs 125,00,000 came
from Muslims. Hindus, on the other hand, had contributed far
more readily to Khilafat.

Muhammad Ali told a Khilafat gathering at Broach, Gujarat, on
2 June that their policy was Gandhian but their religion was not.
Islam made violence obligatory in certain circumstances, so if
Gandhi failed . . . There was, moreover, some badly needed good
news from Turkish battlefields, where Ataturk was defeating the
Greeks through more conventional methods. Ataturk was lauded
as the 'Sword of Islam', not the sheath of non-violence. Khilafat
was raising money for Turkey's war, not Turkish pacifism.

On 15 June 1921, Muhammad Ali said, at another Khilafat
meeting, that it was the duty of Indian Muslims to refuse to fight
in any war against Turkey. This was a barely disguised call for
mutiny in the Indian Army. London had not yet eliminated the
option of direct intervention in Greece's war against Turkey. In
fact, Lloyd George and Churchill lost their nerve only when
Australia and New Zealand refused to obey summons for fresh
adventurism. On 19 June 1921, at Belgaum, in Mysore, the
brothers went a step further. They said that India should declare
independence if Britain declared war on Turkey. The Khilafat
conference at Karachi, between 8 and 10 July, endorsed the
Deoband fatwa that service in the British Indian Army was
unlawful as it required Muslims to kill Muslims: the seventh
resolution said, '. . . in the present circumstances the Holy Shariat
forbids every Muslim to serve or enlist in the British Army or to
raise recruits for it.'

Gandhi paid some lip service to the continual Muslim demand

for escalation of the agitation. He agreed that if Britain sought to 'destroy Turkey', India would seek full independence, rather than mere Home Rule within the Empire. 'The duty of the Hindus is no less clear. If we still fear and distrust the Muslims, we must side with the British and prolong our slavery.'[7]

This was too close to the British bone. The government proscribed the fatwa, and the Jamiat-e-Ulema urged Gandhi to step up civil disobedience. Muhammad Ali was arrested while on tour with Gandhi and taken by special train from the south of India to Karachi. The train made only the briefest and most necessary stops, but platforms en route filled with supporters chanting 'Muhammad Ali-Shaukat Ali ki jai!' Gandhi appealed for calm, as did the brothers. Muhammad Ali's wife continued on the southern tour with Gandhi; Bi Amman sent a wire saying that she was ready to work till her last breath, and asked her sons to be brave: they were not alone, God was with them. At rallies, she vowed that she was ready to go to jail, or even the gallows, and taunted the government again with her familiar question: how many Indians could they arrest? What became known as the fatwa campaign started in earnest. Many Muslims resigned from the police.[8]

The Ali brothers were a spectacular hit at their trial, which had to be held in a public auditorium to accommodate the crowds. They argued that the government had denied them freedom of religion, which was sufficient reason to withdraw allegiance from the king. They refused to stand when the magistrate entered the court. When their chairs were removed from under them, they simply placed their flowing robes on the floor and sat down. Azad declared, upon their conviction, that every Muslim could be charged with the same 'crime', and said he was jealous of the honour that jail had brought to the brothers.

This positive ferment was perhaps too good to last. It did not long survive the Mappilla riots in August in Kerala.

—◦◦◦—

The Mappilla Muslims, of partial Arab descent thanks to traders who had settled on the coast through centuries, lived in the coastal Malabar region of Kerala. Many of them were landless peasants. For them, swaraj and Khilafat rhetoric translated into freedom from Hindu landlords and redistribution of land to the tiller. This peasant–landlord problem of course predated Gandhi's movement. In 1918, Muslim tenants rose against Hindu landlords after arbitrary evictions. The rains failed in 1921, adding hunger to distress. Young Muslims took to the streets as Khilafat volunteers, but used a national cause to settle local disputes. There were also demobilized Mappilla soldiers who, dressed in khaki, would brandish knives and spears at Khilafat rallies.

In late July, Mappilla volunteers prevented the police from arresting suspects in a burglary at a Hindu landlord's estate. On 20 August, the police, accompanied by soldiers, entered a mosque in Tirurangadi in search of three of their leaders. Word spread that the mosque had been desecrated. Within days the district was in flames.

There was rape, loot and murder. Temples were torched; there were instances of forced conversion. In some villages, 'Khilafat kingdoms' were proclaimed. For the British, this was further evidence of Muslim fanaticism, a dangerous truth thinly veiled by Gandhi's moralizing. The commander of Madras District, Major General J.T. Burnett-Stuart, reported to the Southern Command headquarters in Pune that Muhammad Ali's Madras speech had led Mappillas to believe that the amir of Afghanistan would send his army to their aid. Gandhians tried to repair the damage, distancing themselves from the violence, and treating the problem as economic rather than communal, and stressing the need for agrarian reform. British repression was harsh: 2,337 rebels were killed and 1,652 wounded; 45,404 were taken prisoner. They were dealt with brutally. On 20 November, the bodies of sixty-six Mappilla prisoners were discovered in the boxcar of a train at Podanur, killed by asphyxiation.

—〜〜〜—

Critics were quick to taunt Gandhi's idealism. A Calcutta newspaper sneered that the Muslim lion and the Hindu lamb would lie down together in Gandhi's India, but the lamb would be inside the lion. Annie Besant (1874–1933), a silver-tongued, no-nonsense Irish disciple of the spiritualist Madame Blavatsky, who came to visit India and stayed on to edit *New India* and work for Indian nationalism through her Home Rule League, started in 1915, was acerbic after a visit to Calicut and Palghat. She wrote in the 29 November 1921 issue of her journal: 'It would be well if Mr Gandhi could be taken into Malabar to see with his own eyes the ghastly horrors which have been created by the preaching of himself and his "loved brothers" Muhommad [*sic*] and Shaukat Ali. The Khilafat Raj is established there . . . that which I wish to put on record here is the ghastly misery which prevails, the heartbreaking wretchedness which has been caused by the Moplah [Mappilla] outbreak . . . The message of the Khilafats, of England as the enemy of Islam, of her coming downfall and the triumph of the Muslims had spread, to every Moplah home. The harangues in the mosques spread it everywhere and Muslim hearts were glad . . . The Government was Satanic and Eblis, to the good Muslim, is to be fought to the death.'

Besant described the condition of Hindu refugees: '. . . old women tottering whose faces become written with anguish and who cry at a gentle touch and a kind look waking out of a stupor of misery only to weep, men who have lost all, hopeless, crushed, desperate . . . eyes full of appeal, of agonized despair, of hopeless entreaty of helpless anguish, thousands of them camp after camp'. She recounted what she had heard of a Muslim prisoner on his deathbed in hospital. When told by his surgeon that he would not recover, he said he was glad he had killed fourteen infidels.

Maulana Azad, elected secretary of the Central Khilafat Committee in Shaukat Ali's place after the latter's arrest, intervened at this incendiary moment to offer a rationale for a united Hindu–Muslim struggle. The real purpose of Khilafat, he wrote in his newspaper, *Paigham*, was Indian freedom, since a Muslim could

not be subject of a government that imperilled his faith. Muslims therefore must cooperate with Gandhi to achieve swaraj and promote harmony with Hindus in order to assure their future as free citizens of an independent India. The Quran identified two kinds of infidels: those, like the British, who wanted to destroy Islam, and others, like Hindus, who wanted to live in peace with Muslims. Muslims therefore had a dual duty: to defend Islam against the British and to cooperate with Hindus.

There were other setbacks. On 17 November 1921, the Prince of Wales, on a long-planned if ill-timed visit to India, was greeted in Bombay with demonstrations that turned violent; mill workers, both Hindu and Muslim, attacked Parsis, Anglo-Indians and Christians, in the belief that these 'westernized' communities supported the British. Over twenty died. Gandhi blamed Muslims as the principal provocateurs, an accusation that their more vocal leaders resented. Gandhi announced a penitent fast on 19 November because, as he wrote in a note penned at 3.30 a.m., 'we have terrorized those who have differed from us, and in so doing we have denied our God ... I cannot hate an Englishman or anyone else ... Hindus and Musulmans will be unworthy of freedom if they do not defend them [Parsis] and their honour with their lives.' Within three days there was peace and Gandhi broke his fast on 22 November.

—◦◦◦—

The government began sweeping, repressive arrests on 19 November, including of a future prime minister, Jawaharlal Nehru, then editor of *Independent*, and his father Motilal. As one of India's richest lawyers, Motilal had lived in luxury: his chauffeur was British, and awed Indians spread the rumour that his laundry was sent to Paris. Motilal had, under pressure from an enthusiastic son, prepared himself for jail by learning to wash his own clothes. Police measures varied, from stripping anyone with a Gandhi cap and dunking him in a tank, to burning crops and homes. The one leader the government dared not arrest was Gandhi.

In December, Lord Reading offered a compromise through Pandit Madan Mohan Malaviya, suggesting talks on dominion status for India by January. At the Ahmedabad Congress session that same month, Malaviya and Jinnah urged Congress to accept the offer. Since C.R. Das, the president-elect, was in jail, Hakim Ajmal Khan was chosen acting president. Accommodation had been arranged for some 100,000 delegates; twice that number arrived. There were 22,000 volunteers to oversee arrangements. Some 40,000 visitors came to the exhibition ground each day for the eight days of the session. There was art from Tagore's Santiniketan, and musicians from all parts of the country. Gandhi had turned Khilafat into a multi-faith people's movement.

Malaviya wanted the Congress to respond positively to Reading. Neither Gandhi nor the Muslim leadership thought much of the offer. 'I want peace,' said Gandhi, 'but not the peace of the grave.' The Khilafat Movement was shifting gear towards greater militancy: hardliners, led by Hasrat Mohani, began to emphasize 'complete freedom' through civil disobedience. When, on 14 January 1922, Malaviya and Jinnah convened a conference in Bombay to discuss terms for a dialogue with the government, with Sir C. Sankaran Nair in the chair, Gandhi insisted on the unconditional release of the Ali brothers, which the British would not accept. Azad described this as a decisive mistake made by Gandhi in his memoir *India Wins Freedom*. Others have argued that Reading may have exceeded London's brief, and did not have the authority to negotiate dominion status, but he could have been held to his word. It is tempting to speculate on the consequences of an amicable settlement in early 1922: India would have had the status of Australia, and united India would have achieved a degree of Home Rule in the positive Hindu–Muslim environment of the early 1920s, much before the bitter politics of the 1930s and 1940s.

Gandhi thought that Reading was trying to 'unman [or castrate] India for eternity',[9] and asked the Congress Working Committee for 'dictatorial' powers, which he obtained. He was clear about what to do with his dictatorship. He had located the starting point

of a civil disobedience movement: Bardoli, in Surat, Gujarat. On 26 January 1922, the government withdrew its offer of a round table discussion. On 29 January, Gandhi took a pledge from about 4,000 Bardoli volunteers, including 500 women. On 31 January, the Congress Working Committee endorsed the decision. Gandhi promised to lead civil disobedience personally, and asked for no help from any other Indian leader, apart from 'friendly sympathy'.

He described this next phase of the agitation to the Congress: 'Mass civil disobedience is like an earthquake, a sort of general upheaval on the political plane. Where the reign of mass civil disobedience begins, there the subsisting government ceases to function … The police stations, the court offices etc, all shall cease to be the Government property and shall be taken charge of by the people.'[10] But the moment this disobedience became violent, he warned, it would become criminal: if 'there is the slightest outbreak of violence in any part of the country, then it would not be safe or advisable to prosecute the campaign any further'.

As events were to soon prove, Gandhi had overplayed a hand in which his array of cards had begun to lose coherence. Government brutality had darkened the Indian mood, and there was palpable tension. On 4 February, Gandhi sent the government an ultimatum: if it did not relent, civil disobedience would begin.

On that very afternoon, in a small village called Chauri Chaura, in Gorakhpur district of the United Provinces, a group of about 2,000 swaraj demonstrators turned excitable as it headed towards the police station. The police opened fire, killing three and injuring more. The enraged procession turned into a mob, pelted the police back into the station, and set it on fire, killing the whole force except for two who were beaten to death. Twenty-three policemen died. The news appeared in the papers on 8 February.

Gandhi called a meeting of the Congress Working Committee and explained his reasons for suspending civil disobedience: 'I personally can never be a party to a movement half violent and

half non-violent.' He was not willing to treat Chauri Chaura as an
isolated event, as so many believed it to be. It was not the first
such incident: the previous year, on 25 April 1921, a Khilafat
crowd burnt three policemen to death when their leaders were
arrested; but Chauri Chaura would be the last. On 11 February,
Gandhi suspended the nationwide movement on the dictates of a
force with which no one was permitted to argue: his conscience.
The working committee succumbed to his will.

On 16 February, Gandhi explained, citing God and Satan
intermittently, in a long article in *Young India:* 'The tragedy of
Chauri Chaura is really the index finger. It shows the way India
may easily go, if drastic precautions be not taken ... I would
suffer every humiliation, every torture, absolute ostracism and
death itself to prevent the movement from becoming violent ...
We dare not enter the kingdom of Liberty with mere lip homage
to Truth and Non-Violence.'

Indians, whether tea garden workers in the north-east, peasants
in Orissa, or miners in Bengal, were confused and stunned. 'God,'
announced Gandhi, 'spoke clearly through Chauri Chaura.' Since
no one else had direct communion with the Almighty, Indians
had to take Gandhi's word for it. Homilies about truth and non-
violence were insufficient for a people whose hopes for 'Gandhi
Raj' had risen to unprecedented, and perhaps unbelievable, levels;
suddenly, a charismatic genius who seemed to have near-
miraculous powers proved only human.

The loyal Nehrus, still in jail, were furious at what they
perceived to be Gandhi's capitulation. In his autobiography,
Nehru says 'almost all the prominent Congress leaders' were
upset, the younger ones more so. Gandhi wrote to Jawaharlal on
19 February 1922, 'I see that all of you are terribly cut up ... I
sympathize with you, and my heart goes out to father [Motilal].
I can picture to myself the agony through which he must have
passed ...' The country was so depressed that when Gandhi was
arrested and given a six-year prison term, there was not even a
shrug.

Indian Muslims could neither fathom nor forgive what Gandhi

had done with their jihad. Their trust in Gandhi was shaken immeasurably. An emotional bond snapped, and would never quite repair. It was still a long way to the complete rift of 1947, but the drift began in February 1922. Gandhi had turned an insight into policy when he argued that Indian nationalism could not be inclusive without non-violence. A bigger test awaited: could it remain inclusive after non-violence had failed?

Gandhi's arbitrary manner rankled as well. Hakim Ajmal Khan sent a wire approving of Gandhi's decision but could not hide his resentment that more people had not been consulted. Others were less polite. Hasrat Mohani persuaded the Kanpur Khilafat Committee to pass a resolution against Gandhi's decision. Maulana Bari described Gandhi, at a meeting of the Jamiat-e-Ulema on 3 March 1922, as 'a paralytic whose limbs are not in his control, but whose mind is still active. I am doubtful of his success [in the future] . . .' He added that there was 'general depression' among Muslims. Non-violence had failed Muslims, he said, and Muslims now needed their own programme for their objectives. Moderates like Dr Ansari condemned Bari as 'brainless, insincere and a notoriety-hunter', but Bari was closer to Muslim sentiment. Mohani sprinkled fuel on the fire, accusing Hindus of deceit, arguing that they had grabbed government jobs that Muslims had quit on Gandhi's insistence.

Gandhi knew that Muslims were not committed to non-violence as a principle of struggle. At the beginning of Khilafat, he had written a letter to the viceroy, described by officials as 'most impudent': 'I venture to claim that I have succeeded by patient reasoning in weaning the party of violence from its ways. I confess that I did not attempt to succeed in weaning it from violence on moral grounds but purely on utilitarian grounds. The result for the time at any rate, has, however, been to stop violence.'[11]

Gandhi tried his best to calm Muslim wrath. He met Maulana Bari in March 1922. A partially mollified Bari attributed, in a statement to the press, his anger to depression and hoped that the movement might still succeed. Gandhi was arrested soon after

from his ashram at Sabarmati. Bari's fading hopes were evident in a letter to fellow Muslims, titled 'Non Violence and the Muslims'. Bari recalled his doubts about non-violence and Hindu–Muslim unity before 1919. Gandhi had helped overcome misgivings, but with Gandhi in jail, Bari warned Muslims that they might lose their identity if they got too close to either Hindus or the British. The 'theory of distance' began to re-emerge, albeit a trifle hesitantly.

Bari and Mohani, convinced that Gandhi had deserted Muslims, decided to restore the old policy of dealing directly with the British. Pro-Gandhi voices argued, at the Central Khilafat Committee meeting in Bombay on 25–26 March 1922, that it would be sinful to turn against Hindus, who had stood by the Khilafat cause, and they should now work for an honourable place for Muslims in a free India. But the unravelling had begun.

Muslims had made ideological adjustments and practical sacrifices. A new generation of English-speaking professionals which had just begun to get government jobs was suddenly in disfavour again. The clergy, which had mobilized with unprecedented fervour, and the masses, who had shed layers of inculcated suspicion to believe in a common Hindu–Muslim cause, felt a sharp sense of betrayal.

Gandhi's achievement hid an insidious danger: when the harmony between Hindus and Muslims soured, the rancour also percolated down to the working class and peasantry, which had so far been oblivious to the turmoil and passions of nationalist politics.

———

Words can hardly do justice to the transformation that Gandhi achieved in making the masses a part of India's freedom movement. British officials, who had no reason for sympathy, documented moving eyewitness accounts of Hindu–Muslim devotion to Gandhi, particularly in villages. The weekly report of the Director, Intelligence Bureau, dated 10 March 1921, described Gandhi's

appeal in a small town of United Provinces: '. . . it was a sight to see Hindu and Moslem villagers coming from long distances – on foot, with their bedding on their heads and shoulders, on bullock carts, on horseback, as if a great pilgrimage was going on, and the estimate was that nearly a lakh [100,000] of persons had come and gone back disappointed. It was simply touching to see how eagerly they inquired if there was any hope of his coming. Never before has any political leader, or perhaps even a religious leader, in his own lifetime stirred the masses to their very depths . . .'

Even the crusty Lord Willingdon, then governor of Bombay, wrote to Lord Reading, on 3 April 1921, 'Gandhi is here with the whole of his gang. It is amazing what an influence this man is getting. One of my ADCs came from Calcutta with them in the train and was tremendously impressed with the huge crowds at every station, their orderliness, and absolute devotion . . . Now I admit the position is becoming one of extraordinary difficulty. There is no doubt that Gandhi has got a tremendous hold on the public imagination.'

This hold provoked some officials towards wild theories: one suggested that Gandhi had become a tool of Bolsheviks, in silent league with Lenin, who was encouraging pan-Islamism against British rule across Asia. Edwin Montagu, secretary of state for India, was convinced that non-cooperation and Khilafat were part of a 'Bolshevik conspiracy'. He wrote to Lord Chelmsford (who had preceded Reading as viceroy) that 'what frightens me is the way in which Pan-Islamism . . . is taking charge of the extremist movement'.

Erik Erikson, the path-breaking psychoanalyst, who was an admirer, explained, much later, that 'Gandhi's activities of 1918 simply made no coherent psychological sense' without an awareness of the state of the Indian masses and the contemporary Russian revolution.[12] The Indian communist leader S.A. Dange, who wrote *Gandhi versus Lenin* in 1921, noted the Mahatma's debt to Tolstoy, and envisaged an eventual swaraj in which big factories would be nationalized, a ceiling imposed on wealth, and

land redistributed among peasants. He also accepted, unusually for a communist, that non-violence was an effective tactic.

But Gandhi, who once hoped that Khilafat would create an 'everlasting' Hindu–Muslim bond, also created conditions for a chasm.

Khilafat died in India; coincidentally, Ataturk also buried the caliphate in Turkey when he abolished it on 3 March 1924. It is a matter of minor interest that one of the last pleas for the caliph was made in a letter, dated 24 November 1923, written by Ameer Ali and the Aga Khan on behalf of Indian Muslims, to the Grand National Assembly in Ankara.

Muslim enthusiasm for non-violence, unequivocal as long as it lasted, was constantly buffeted by a powerful reference point: Ataturk. While Gandhi kept them non-violent, the Turkish hero, honoured as a 'ghazi', proved by 1922 that you could humble the imperial confidence of mighty Britain with the sword. All that Gandhi proved by 1922, as far as Muslims were concerned, was that he did not know how to succeed.

Gandhi and Ataturk (Father of the Turks), both anointed fathers of their nations, make a fascinating comparison.

Ataturk eliminated an obsolete caliphate from nationalist space and released politics from the embrace of religion. Gandhi used the caliphate to stir a dormant community by infusing religion into politics.

Ataturk defeated the West, but welcomed its script, clothes and lifestyle, serving alcohol in public and dancing in immaculate tie and tails. Gandhi was more prohibitionist than any mullah and his battledress was a homespun cotton loincloth. He used khadi as economic weapon and dress code. 'I consider it a sin to wear foreign cloth ... it is sinful for me to wear the latest finery of Regent Street, when I know that if I had but worn the things woven by the neighbouring spinners and weavers, that would have clothed me and fed and clothed them,' he wrote in the 13 October 1921 issue of *Young India*. (In 1930, he was spinning 220 yards of yarn each day.)

Ataturk banned the Islamic veil and Ottoman fez and promoted

skirts and suits. Gandhi welcomed the veil and fez, signature apparel of the Khilafat Movement. Having stepped out of trousers himself, he dragged his most famous disciple and heir, Nehru, a child of privilege and student of Harrow and Trinity, away from bespoke suits into tight homespun pyjamas and long, loose, knee-length cotton shirt developed during centuries of Turkish–Muslim rule in Delhi.

Ataturk and Gandhi used the same slogan between 1919 and 1922: 'Victory or Death' cried Ataturk; 'Do or Die!' demanded Gandhi. But while Ataturk's battlefields did not offer a third option, Gandhi believed that a final confrontation could always be postponed on India's minefields. Gandhi always lived to fight – or fast – another day, until 1947 broke his country and 1948 took his life.

8

The Muslim Drift
from Gandhi

Jinnah was the only prominent Indian Muslim who kept his association with Khilafat to minimal requirements. As a constitutionalist, he saw nothing in Gandhi's mass agitation except an invitation to chaos; he believed India was not ready for independence. Many honoured names in the Congress were either privately apprehensive or publicly critical. Annie Besant, who had been arrested for 'seditious journalism' and had presided over the Calcutta Congress session in 1917, thought Gandhi had opted for a 'channel of hatred'. V.S. Srinivasa Sastri, who had taken over as head of the Servants of India Society after the death of Gokhale,[1] dismissed swaraj as 'fanciful'. Eminent nationalists like C.R. Das of Bengal were unsure, but almost everyone, and every objection and alternative, was swept away in the Gandhi wave.

This included Jinnah's carefully structured solution to the 'Muslim question', the Lucknow Pact. Jinnah had some reason for optimism. He had been a vigorous advocate for Hindu–Muslim harmony since the Lucknow Pact. He told the Bombay conference

of the Muslim League in 1915: '. . . our real progress lies in the goodwill, concord, harmony and cooperation between the two great sister communities . . . the solution is not difficult . . . I would, therefore, appeal to my Hindu friends to be generous and liberal and welcome and encourage other activities of Muslims even if it involved some sacrifice in the matter of separate electorates.' The 'transfer of the power from the bureaucracy to democracy' could be best facilitated if Hindus and Muslims 'stand united and use every Constitutional and legitimate means to effect that transfer . . . We are on the straight road; the promised land is within sight. "Forward" is the motto and clear course for young India.'

Gandhi, conversely, was subverting the Constitution and glorifying illegitimate means, a huge deviation from Jinnah's straight road. Gandhi's strategy seemed zigzag. He had challenged the British over the condition of indigo workers at Champaran in Bihar in 1917, but became an ultra-loyalist recruiting agent for the British Indian Army in 1918 in the hope of future political rewards for India. Jinnah did not share such illusions. He was vehemently opposed to the war effort. Jinnah was perplexed, and then livid, at Gandhi's 'do-or-die' stance after 1919.

On 28 December 1920, Gandhi moved a resolution at the Nagpur session of Congress for the 'attainment of *swaraj*' before 14,500 delegates, twice the number of the previous year. Jinnah thought the resolution impractical and dangerous without greater preparation. Delegates dismissed him as a coward. The next day, Gandhi's resolution was carried to deafening acclaim. Jinnah demanded to be heard, but his speech was frequently interrupted with cries of 'shame, shame' and 'political impostor'. He was booed when he addressed Gandhi as 'Mr' rather than Mahatma; and finally abandoned any honorific rather than submit to the pseudo-religious 'Mahatma'. He appealed to Gandhi to 'pause, to cry halt before it is too late'.

Gandhi refused to halt, so Jinnah walked away. He told the journalist Durga Das after the Nagpur session, 'Well, young man, I will have nothing to do with this pseudo-religious approach to

politics. I part company with the Congress and Gandhi. I do not believe in working up mob hysteria.'² He did not quite part company with politics, but he recognized that this was not his moment. He ignored the Muslim League, where the mood was similar to that in the Congress, although he was named president of the 1920 session. When he did return to centre stage, fifteen years later, as undisputed leader of the Muslim League, he would apply what he had learnt about the power of mob hysteria to Muslim politics.

—◈—

The collapse of Khilafat left a bitter aftertaste, its acrid centre fermented by communal violence that spewed across the country once passions were released from Gandhi's moral authority. Discontent adopted many forms. Disenchanted Muslims soon turned on Khilafat leaders, accusing them of theft. No accounts were published after 1920. An enquiry discovered that cash contributions had not always been banked, and Shaukat Ali had sent his doctor's, barber's and laundry bills for reimbursement. Seth Chotani had diverted Rs 16 lakhs, the last of the Smyrna and Angora fund, to his family business. There were allegations that Maulana Bari's Chevrolet had been paid for from Khilafat funds. (It was a gift from a disciple.)

Similar accusations against the Congress withered against Gandhi's reputation for fiscal integrity. But Gandhi's political dictatorship was no longer viable. A powerful group rejected Gandhi's view that the Congress should abstain from elections and formed the Swaraj Party, with C.R. Das as president and Motilal Nehru as secretary. Jawaharlal remained with Gandhi, and became general secretary of the Congress. The Swaraj Party won nearly half the seats in Central Assembly in 1923. Jinnah contested as an independent and retained his Bombay seat. Das, who was trusted by Muslims as much as Hindus, died in 1925, and his loss was mourned deeply at a time of rising tension between the two communities.

Even during the movement, at the height of support from the community, Gandhi had noted, ruefully, that 'I can wield no influence over the Muslims except through a Muslim'.[3] These interlocutors began to abandon Gandhi within three weeks of the decision to suspend Khilafat. Maulana Bari told the Jamiat-e-Ulema conference at Ajmer, on 3 March 1922, that non-violence had failed and Muslims should seek their own methods. Gandhi, he declared, had 'exhausted all the items of his programme and no arrow was now left in his quiver. The Mussalmans would not remain silent like a woman but need some forward programme for the achievement of their aims ... he was ready to commit violence by hand, teeth and by all the implements available'.[4] The exhortation to violence was happily received by those Muslims who had never had faith in the diktat of a holy Hindu. Firebrands like Maulana Hasrat Mohani began to fashion the conceit that Khilafat had been a largely Muslim struggle, and Hindus, if anything, had taken advantage of Muslim sacrifice. He claimed, at Ajmer, that 95 per cent of those arrested were Muslims, and 99 per cent of those who had resigned from government as a gesture of non-cooperation were Muslims. Hindus, he alleged, had quickly filled the vacancies. The figures were manifestly wrong, but they passed into lore. In the same spirit, the Ajmer conference passed a provocative resolution for the collection of a new Malabar fund, to help Muslims who had suffered from government repression, when Hindu opinion held Muslims guilty of multiple crimes during the Malabar uprising.

Gandhi, who had begun Khilafat with a visit to Firangi Mahal, Bari's home and seat of his seminary in Lucknow, in March 1919, was now unable to calm the hurt. In an echo of Shah Waliullah's prescription for survival, Bari began to warn Muslims against losing their identity in the search for unity with Hindus. (Bari's grandfather, Maulana Abdul Razzaq, held Shah Waliullah's intellectual legacy in high esteem.) In mid-March, Bari and Mohani organized a conference in Lucknow which proposed that Muslims should deal directly with the British on the Turkish issue. As the prospect of change in India receded, Bari and the

ulema turned their attention to the fractious conflicts of Arabia, and their impact on the fate of the holy cities. Bari was deeply perturbed when the Wahabi Sauds invaded the Hijaz in 1925, drove out the Hashemite Emir Hussein and began to destroy the tombs of the heroes of Islam. This led to a split with his friend Muhammad Ali, who believed, incorrectly, that the Sauds would be more hostile to the Hashemites, who had rebelled against the caliph in the First World War. The break would last until Bari's death on 19 January 1926. His epitaph was a verse written at the height of his influence, by the famous poet Akbar Allahabadi, who for a change was not in his usual satirical mode: *Ae charkh hawaein shauq chale, Ae shaakh-e amal gulbari kar, Kuch kaam karein kuch sa-e karein, Har Sheikh ko Abdul Bari karein* (Let the heavens blow storms of passion, Set action free from the spring, Let us work and let us strive, Let every leader be an Abdul Bari).

'For many of the Muslims,' writes Barbara Metcalf, 'cooperation with non-Muslims was merely expedient as, indeed, was the acceptance of Gandhi's policies; they joined him out of desire to present a common platform of opposition to the rulers. This was largely true of the charismatic journalist and politician Muhammad Ali. The *ulama*, moreover, cherished a plan for a wholly autonomous social and political life, linked to non-Muslims in the loosest of federations once Independence was attained ... [the Jamiat-e-Ulema formulated] a scheme to create a separate system of law courts under an organization of the *ulama* as the beginning of what might be called the "mental partition of India" that they envisaged'.[5] This 'mental partition' would slowly evolve towards a geographical one.

The most toxic strand in the Hindu–Muslim relationship was intermittent bloodshed. There were riots before the harmonious phase of Khilafat. One cluster occurred in October 1917 when, thanks to the vagaries of Hindu and Islamic lunar calendars, the Hindu festival of Dussehra coincided with the ten days of Muharram during which Muslims mourn the martyrdom of Imam Hussain, grandson of the Prophet. Allahabad, home of the Nehrus, witnessed the worst clashes. In 1918, there was sporadic

violence over cow slaughter during Bakr Id. But the intensity and spread of the violence after Khilafat's abrupt halt was remarkable. It began in Multan (September 1922) and Amritsar (April 1923) in Punjab. The riots of Kohat in 1924 were particularly vicious, and in 1926 the cancer spread to Calcutta, Dhaka, Patna, Rawalpindi and Delhi. There were ninety-two minor and major communal incidents in the United Provinces between 1923 and 1927.

On 6 May 1926, Azad sent a telegram to Gandhi that underlined his anxiety: 'Please try for special Congress session in July or August to consider Hindu Muslim question (stop) This is last chance (stop) If disregarded all efforts useless for long time (stop) And instead of nationalism and patriotism whole country will be plunged in communal religious strife (stop).'

Gandhi sounded helpless in his reply, saying that no purpose would be served because 'unfortunately we have neither policy nor programme. On the contrary, the tallest among us distrust one another and even where there is no distrust there is no agreement as to facts or opinion. Under the circumstances, a Congress session can only accentuate the existing depression.'[6]

Mayhem was not the only manifestation of animosity. The dynamic Arya Samaj leader, Swami Shraddhanand, influenced by stories of forcible conversion to Islam in Malabar, began a nationwide Shuddhi (Purification) movement for re-conversion of Muslims to Hinduism. The Arya Samaj targeted Muslim communities like the Meos of Mewat, just south of Delhi, who had not shed their pre-Islamic cultural practices despite conversion. The press played up reports of prodigals returning to the Hindu fold among Jat, Gujjar and Rajput tribes in western United Provinces and Punjab.

Muslim ulema reacted by reviving a slogan that had been smouldering within Khilafat: 'Islam in danger!' In 1920 and 1921, Islam had been in danger from Christians; at the Karachi conference of Khilafat between 8 and 10 July 1921, Muhammad Ali accused Britain of destroying Islam across the world. Now, it was Hindus who threatened the existence of Islam in India. A

slogan takes a while to become a conviction, but this one would become a decisive factor in the tilt of Muslim opinion towards partition in the 1940s.

The Muslim response, led by Maulana Bari and Khwaja Hasan Nizami of Delhi, was to strengthen systems and symbols of separation through a network of organizations like Bari's Bazm-i-Suffiya-i-Hind, which sought to eliminate from Muslim life 'Hindu' influences like the indigenous dhoti, the unstitched loincloth which Gandhi made internationally famous. Tensions built up in villages and small towns as Hindu and Muslim volunteers confronted one another.

Bari told a press conference on 20 August 1923, 'The position of the Muslims has been rendered very awkward. Those who pretended to be our friends at one time and made a catspaw of the ulema now seem anxious to get rid of them.' You did not have to be Sherlock Holmes to decipher that he meant Gandhi. Bari stayed away from the 1923 Congress session in Delhi, claiming illness, but sent a tough message through the press: 'We can sacrifice our all to obtain self-rule except our beloved faith. A Muslim is a Muslim first and last and if any community wants our support it must learn to respect Islam . . . we are determined to non-cooperate from every enemy of Islam whether he be in Anatolia or Arabia or Agra or Benaras.'

Sir Penderel Moon's obituary of the Khilafat Movement is sharp but accurate: 'With Gandhi's arrest there was also a final irretrievable breakdown of the Hindu–Muslim alliance which had been such a feature of the movement and caused the British such alarm. It was a frail, artificial alliance, resting on no basic reconciliation of conflicting interests, but on Hindu support for Muslims over a religious issue that was of no interest to Hindus and, in reality, of only marginal and transient interest to Muslims.'[7]

—◆—

The Congress tried to placate Muslim sentiment. It named Maulana Azad and Muhammad Ali president of successive sessions, both

held in 1923, one in Delhi in September and the second in December at Kakinada. Azad thus became, at thirty-five, the youngest person to sit on the exalted chair. Unity, inner-party and Hindu–Muslim, was the prevailing theme at Kakinada. Gandhi was still in jail in 1923, and Azad, ignoring Gandhi's expressed reservations about those who had split the party, gave Swarajists permission to contest elections, opening the door for their return.

Azad's ritual obeisance to Hindu–Muslim harmony could not obscure the bitterness in his presidential address: 'Instead of Swaraj and Khilafat, slogans of *shuddhi* are being raised. "Save the Hindus from Muslims", says one group, "Save Islam from Hinduism", says another. When the order of the day is "Protect Hindus" and "Protect Muslims", who cares about protecting the nation? The press and platform are busy fanning bigotry and obscurantism, while a duped and ignorant public is shedding blood on the streets. Bloody riots have occurred at Ajmer, Palwal, Saharanpur, Agra and Meerut. Who can say where these unfortunate consequences will lead?'[8]

Jinnah presided over the 1924 session of the Muslim League which met in Lahore. For the first time, the League demanded full autonomy for provinces, within a federation, to protect Muslim-majority regions from 'Hindu domination'. This would be the argument, sixteen years later, at another session in Lahore, for the creation of a separate state. In 1925, a respected former judge of Bengal, Abdur Rahim, was applauded when he said that Congress could not be trusted to protect Muslim interests in any future self-rule, and Muslims had either the option of fighting their own battles or forging an alliance with the British.

D.G. Tendulkar, chronicler of Gandhi's life, cites the post-Khilafat mood in the second volume of his nine-part opus, mentioning the 'wave of riots' that overwhelmed the country in 1924. He draws special attention to the Kohat riots of September 1924, following which the entire Hindu population evacuated Kohat. These riots began with the publication of *Rangila Rasul* (Colourful Prophet), a scurrilous life of the Prophet.

Kohat was a town on the North West Frontier beyond Punjab,

and the riots of 9 and 10 September 1924 exposed the underlying volatility that needed but a spark from an agent provocateur. Jivan Das, secretary of the Kohat branch of Sanatan Dharma Sabha, published a provocative pamphlet, which threatened to build a temple to Vishnu at Kaaba and obliterate all those who offered namaaz. Muslims burnt pictures of Lord Krishna in retaliation. The violent tremors it provoked stretched all the way to the east of the subcontinent, to Calcutta.

Gandhi decided that it was time for his last resort, a penitential fast. He chose as his venue Muhammad Ali's home in Delhi, and began his twenty-one-day fast on 18 September. Astonishingly, he continued to work, writing a piece on 'God is One', on 'Our Duty' to aboriginal tribes, and, on the sixth day, 'No Work, No Vote' – until 'medical tyrants' (his doctors) ordered him to stop. Ali was petrified lest Gandhi should die in his care; the implications for Hindu–Muslim relations would be incalculable. Conscious of his host's dilemma, Gandhi wrote a long article on 22 September in which he reassured India that he had 'never received warmer or better treatment than under Mahomed [sic] Ali's roof'. The impact on community leaders was immediate. A unity gathering, attended by Bishop Westcott of Calcutta, Annie Besant, Shaukat Ali, Hakim Ajmal Kham, Swami Shraddhanand and Madan Mohan Malaviya began with a prayer for Gandhi's life. On the evening of 8 October, the twenty-first day, Gandhi drank some orange juice: the opening verses of the Quran were recited, and his favourite Vaishnava and Christian hymns ('When I survey the wondrous Cross') were sung. But peace among the people remained elusive. There were serious riots in Allahabad that day.

Gandhi devoted the 29 May 1924 issue of Young India to the Hindu–Muslim relationship, offering, through the bland headline ('Its Cause and Cure') an analysis of reasons and promise of a solution. Some Hindus had accused Gandhi of 'awakening' Muslims, and thereby emboldening them to get violent. Gandhi replied: 'Had I been a prophet and foreseen all that has happened I should still have thrown myself into the Khilafat agitation. The awakening of the masses was a necessary part of the training. It

is a tremendous gain. I would do nothing to put the people to sleep again.'

He found an ingenious answer to the Shuddhi and Tabligh antagonists engaged in battles of conversion and re-conversion: 'My Hindu instinct tells me that all religions are more or less true. All proceed from the same God but all are imperfect because they have come to us through imperfect human instrumentality ... What is the use of crossing from one compartment to another, if it does not mean a moral rise?'

He disturbed the logic of Hindus who fomented riots over cow slaughter: 'Though I regard cow protection as the central fact of Hinduism, central because it is common to classes as well as masses, I have never been able to understand the antipathy towards the Musalmans on that score. We say nothing about the slaughter that daily takes place on behalf of Englishmen. Our anger becomes red hot when a Musalman slaughters a cow. All the riots that have taken place in the name of the cow have been an insane waste of effort ... In no part of the world, perhaps, are cattle worse treated than in India. I have wept to see Hindu drivers goading their jaded oxen with the iron points of their cruel sticks ... The cows find their necks under the butcher's knife because the Hindus sell them ... I am convinced that the masses do not want to fight, if the leaders do not ... I agree with Mr Jinnah that Hindu–Muslim unity means swaraj.'

But he could not hide his dejection at the collapse of a dream. Romain Rolland might describe him, in a biography written at the time, as 'the man who has stirred 300 million people to revolt, who has shaken the foundations of the British Empire, who has introduced into human politics the strongest religious impetus of the last 2,000 years',[9] but Gandhi bitterly rued the accolade he had been given during Khilafat, that of 'Mahatma'. 'The word "Mahatma" stinks in my nostrils,' he told a Bombay audience in 1924. In an effort to restore confidence, Gandhi even became president of the Congress for the 1924 session at Belgaum. On its eve, he issued a written statement: 'The Congress took a resolution in 1920 that was designed to attain swaraj in one year. At the end

of the year we were within an ace of getting it ... we must be determined to get swaraj soon, sooner than the chilly atmosphere around us will warrant.' His presidential address was the shortest on record: there was clearly not much to say about the chill.

—*∿∿∿*—

Others did have some things to say about the chill. Speaking in Hindi at the special session of the Hindu Mahasabha on 31 December 1922 at Gaya, Malaviya urged both Hindus and Muslims to build up physical strength to face assailants. 'I do not say this because I want Hindus to get ready to attack anyone, but because their weakness is the reason for all riots. Wherever there has been a riot, it has been because of the physical weakness of Hindus. Those Muslims who create riots are convinced that Hindus are cowards and weak.'

Six months later, at a public meeting in Lahore on 28 June 1923, Malaviya regretted the negative swing in the mood of Punjab: 'Yesterday there was joy in your hearts, today there is unhappiness.' Hindus and Muslims had grown apart even in a province like Punjab, said Malaviya, and asked the two communities to heal their differences, just as Catholics and Protestants had ended their problems in England. The English, he said, had one advantage over Indians: patriotism. That was the only reason why the English had advanced, while Indians had regressed.

Premchand, the great Hindi litterateur, writing in *Pratap* in 1925, made the poignant point that 'Hindus and Muslims have lived together in Hindustan for a thousand years but have not understood each other. Hindus consider Muslims to be a "rahasya" [mystery], and Muslims consider Hindus to be a "muamma" [puzzle].' Muhammad Ali summed up the political reality in the 6 February 1925 edition of his revived publication, *Comrade:* 'The Hindus and Muslims don't seem to have that joint hatred of slavery which is necessary for working out a national program.'

—*∿∿∿*—

Despite his failure, the British never underestimated Gandhi, and many officials, at an individual level, admired the courage of his extraordinary idealism. In jail, Gandhi's behaviour was exemplary. But he never forgot his national mission. Satyagrahis had to preserve their self-respect: their clothes had to be clean, they were told to refuse inedible food, and never crouch before authority, or open their palms in the manner of beggars, or shout, loyally, '*Sarkar ek hai!* [There is only one government!]' or salute an official with '*Sarkar salam*'. In Yeravda, he was permitted only four letters a year. He wrote two, the first to his wife Kasturba and the second to Hakim Ajmal Khan, because they were censored. He was allowed seven books, among which he kept an Urdu manual given to him by Azad. The Congress leader C. Rajagopalachari persuaded the government to permit Gandhi the luxury of a pillow. Gandhi took the pillow but wished he could do without it.

On 11 January 1924, Gandhi was shifted to Sassoon Hospital with acute appendicitis. Tendulkar identifies the doctor who operated on Gandhi as Colonel Maddock, the surgeon-general. When Gandhi's hand shook while signing the consent to his emergency operation, he remarked to the doctor, 'See how my hand trembles. You will have to put this right.' The colonel told him, 'Oh, we will put tons and tons of strength into you.'

On the night of 12 January, a thunderstorm cut off electricity while Col. Maddock was operating on Gandhi; he completed the one-hour surgery with the help of a flashlight and then a hurricane lamp. One of the nurses was British. She chatted with Gandhi about her dogs, her experience in English and African hospitals and the most important lesson she had learnt – never try to be popular. She would decorate his room with the finest flowers. As Mahadev Desai wrote in *Young India* on 29 January, 'A compelling love chokes all other consciousness.' His prison superintendent, Colonel Murray, visited and said the other prisoners were missing him.

On 5 February, Colonel Maddock barged in, looking pleased, while Gandhi was talking to his friend, C.F. Andrews, and

announced that orders had come for Gandhi's release. Gandhi remained quiet for a while, and then asked the colonel with a smile, 'I hope you will allow me to remain your patient and also your guest a little longer.' The colonel laughed and hoped that Gandhi would at least go on obeying his orders, and it would give him great pleasure and satisfaction to see Gandhi fully recovered. In a statement, Gandhi thanked Colonel Murray and Colonel Maddock for saving his life. He added that he would remain under the latter's care till the wound had fully healed.

———§§§———

By this time, Khilafat was dead in every sense of the word. The caliph had already been dethroned by an act of Turkish Parliament on 21 November 1922; in March 1924, he was packed off to Switzerland with a one-way train ticket. Azad wrote an inspired series of articles in *Zamindar*, published from Lahore, that the caliphate did not automatically cease to exist after its abolition in Turkey but would be merely transferred to the most powerful independent Islamic state. In Mecca, Sherif Hussein promptly declared himself the new caliph. He was soon overthrown by a more careful Abdul Aziz ibn Saud, who did not revive the caliphate but adopted its most important religious function, as Custodian of the Two Holy Mosques. The June 1924 meeting of the Khilafat committee formally withdrew the title *Saif ul Islam* given to Ataturk in 1922, and split into Hashemite and Wahabi factions. Neither the British nor the old or new custodians of Mecca and Medina took Indian Muslims seriously any more.

The most serious political consequence of the Khilafat Movement was the Muslim disenchantment with Gandhi. They were largely indifferent to his second Non-cooperation Movement, famous as the Salt Satyagraha of 1931; their support for Congress in the 1937 elections was patchy; and when, after 1937, Jinnah's Muslim League gathered momentum, the shift towards the League became a cascade.

Paradoxically, Khilafat helped promote Hindu mobilization along

sectarian lines. The first Hindu Sabha had been formed in Punjab in 1909 after the introduction of separate electorates. Speaking at the first Punjab Provincial Hindu Conference, held on 21 and 22 October 1909, Lala Lajpat Rai argued that '. . . there can be no doubt that Hindus are a "nation" in themselves because they represent a type of civilization all their own'. Hinduism had also become a 'national' project, at least on the fringe. By 1915, various sabhas had coalesced into an informal Hindu Mahasabha to act as a pressure group within the Congress. Curious arguments arose to promote a parallel fear that Hinduism was in danger. In 1909, for instance, U.N. Mukherji argued, in an influential series of articles in a journal called *Bengalee*, titled 'Hindus, A Dying Race', that within a very precise 420 years Hindus would be driven to insignificance because of demographic decline as compared to Muslims and Christians.

'The apparent failure of Gandhi's non-cooperation movement, which was followed by widespread rioting, convinced many Hindu revivalists that a different approach was needed. Many believed that the "weakness" of the Hindu community could be overcome only if Hindus strengthened community bonds and adopted an assertive *kshatriya* (warrior caste) outlook. Accordingly, communal peace, they argued, would result only if Muslim and Hindus both realized that an attack on one community would result in a devastating response by the other,' write Walter Andersen and Shridhar Damle.[10]

This variation of the mutually assured destruction theory led to a great expansion of the Sabha movement in Punjab, the United Provinces and Bihar. In his presidential address to a national convention called to revitalize the Hindu Mahasabha, in August 1923, Malaviya asked Hindus to consider the possibility that some of their problems might be their own fault. He urged caste Hindus to end segregation against 'untouchables' in schools, wells and temples, and launch an effort to reclaim Hindus who had been 'willingly or forcibly' converted to Islam or Christianity. The convention recognized that the equality inherent in a mosque was a powerful magnet for Hindus who suffered discrimination.

In a similar spirit, Swami Shraddhanand would propose the establishment of Catholic Hindu Mandir devoted to the worship of three mother-spirits, Gau Mata (Cow-Mother), Saraswati Mata (Goddess of education) and Bhumi Mata (Motherland). One such reformist temple was constructed in Delhi in 1931, financed by Jugal Kishore Birla, patriarch of the most powerful Hindu industrialist family of the time.

In 1923, Vinayak Damodar Savarkar (1883–1966), a brilliant Chitpavan Brahmin who combined an English education with Sanskrit scholarship, published a seminal text, *Hindutva: Who Is a Hindu?*, articulating the philosophy that sought to refashion India as a Hindu rather than a secular nation. Savarkar had been rusticated from Pune's elite Fergusson College in Pune in 1905 because he had organized a bonfire of Western cloth. He met Gandhi in 1909 in London, but the two had nothing in common: Savarkar's self-professed disciple, Nathuram Godse, would take Gandhi's life on 30 January 1948. In 1911, Savarkar was sentenced to life imprisonment in the remote Andaman Islands on charges of terrorism and for inciting violent rebellion, but released after eleven years in near-solitary confinement.

His thesis was uncomplicated: only Hindus could be true patriots since their fatherland (*pitribhumi*) was the same as their holy land (*punyabhumi*). The holy land of Muslims and Christians was Arabia and Palestine. He argued, 'Mohammedans are no race nor are the Christians. They are a religious unit, yet neither a racial nor a national one . . .' Muslims might be anti-British, but this was not tantamount to being pro-Indian. This became the creed of the organization that would have a major impact on Indian politics before and after freedom, the Rashtriya Swayamsevak Sangh (RSS), founded by Keshav Baliram Hedgewar in 1925.

In 1925, in his presidential speech at the eighth Hindu Mahasabha session, the eminent Punjab leader Lala Lajpat Rai went so far as to blame Gandhi for weakening Hindus: 'We cannot afford to be so weak and imbecile as to encourage others to crush us, nor can we be so obsessed by the false ideas of *ahimsa* but at our peril.' There was a growing feeling that Gandhi

had shot his bolt. Andersen and Damle quote Government of India's Home Political File (I) No. 18-21/25, reporting on Gandhi's visit to Punjab in late 1924: 'It is literally true that people who not long ago credited the Mahatma with superhuman and even divine powers, now look upon him a "spent force", "an extinct volcano", and a person altogether divested of power and capacity.'

On 23 December 1926, a Muslim, Abdul Rashid, stabbed Swami Shraddhanand to death. Rashid was celebrated as a servant of Islam, a martyr who had eliminated a Hindu intent on forcing Muslims back to Hinduism. Muslims raised funds for his defence in court, but were unable to save Rashid from the gallows. Gandhi mourned the death of Swami Shraddhanand, but the mood of Hindus had shifted away from him and the Congress, towards the breakaway Swaraj Party. In the 1926 elections, Motilal Nehru, who was back in Congress, was accused of an unpardonable sin for a Brahmin, eating beef. On 30 March 1927, Motilal wrote to his son Jawaharlal that 'The only education the masses are getting is in communal hatred'. In Bengal, Swarajists won thirty-five out of forty-seven Hindu seats but only one out of thirty-nine Muslim seats.

—◦◦◦—

This fallow period came to an end on 8 November 1927, when London announced the appointment of a three-member commission, led by a lawyer, Sir John Simon, to review the Government of India Act of 1919, honouring a commitment to examine its provisions within a decade. London was in a bit of a hurry as the Conservative government was unsure of winning the next general election, and wanted its imprint on India policy. When Indians protested against the absence of Indians in a commission tasked to determine their future, Lord Birkenhead, secretary for India, remarked that Indians were incapable of agreeing on any workable political framework.

He was soon to discover that Indians were perfectly capable of rejecting the Simon Commission. Apart from the anti-Brahmin

Justice Party of Madras, and the pro-establishment Unionist Party of Punjab, all political groups decided to boycott Sir John and work towards an all-parties conference that would draw up a Constitution for India by Indians. This was Jinnah's territory and he, along with liberal legal minds like Sir Tej Bahadur Sapru, took the initiative.

Jinnah had the basis for a formula. In March 1927, he persuaded a conference of Muslim leaders in Delhi to abandon the one substantive issue that had driven the Congress and the Muslim League in different directions: separate electorates. Given that the League considered this a birthright, Jinnah's persuasive skills were clearly phenomenal. His plan ceded separate electorates in return for reserved Muslim seats in joint electorates, one-third Muslim representation in the central legislature, proportionate representation in Punjab and Bengal, and the creation of three new Muslim-majority provinces, Sind, Baluchistan and the North West Frontier Province. The Muslim League endorsed this proposal at its December 1927 session despite dissent by the Punjab leaders Mohammad Shafi and Fazli Hasan, who broke away and offered to cooperate with the Simon Commission.

The Congress response was positive. It accepted the Jinnah plan at its AICC in May 1927, and the annual session at Madras in December that year.

An all-parties conference met in Delhi in February 1928 and authorized Sapru and Motilal Nehru to draft what is familiar to historians as the 'Nehru Report'. The conference met again in Bombay in May and Lucknow in August, but by this time the Congress had become susceptible to the Hindu lobby, which would not concede a guaranteed Muslim majority in the legislatures of Punjab and Bengal. The Nehru Report accepted what Jinnah had conceded, but denied what he wanted in return. It offered reserved Muslim seats only at the Centre and in provinces where Muslims were in a minority, but not in a majority.

Jinnah made an anxious, last-minute attempt at unity in December 1928 at the Calcutta meeting of the all parties

conference, even adding the rider that these reservations for Muslims could be abandoned once elections were held on the basis of adult suffrage. 'We are all sons of this land. We have to live together . . .' he appealed. 'Believe me, there is no progress for India until the Mussalmans and Hindus are united . . .' His appeal failed.

According to Hector Bolitho, Jinnah told a Parsi friend after this failure, 'This is the parting of ways.'[11] The normally taciturn Jinnah was, it seems, close to tears. He set his emotions aside, reunited with Shafi and Hasan, and in March 1929 announced his famous 'Fourteen Points': separate electorates would stay till such time as the other demands were accepted by Hindus. In Jinnah's lexicon, Congress was now becoming synonymous with Hindus. 'Not for the first or last time, Hindu communalism had significantly weakened the national anti-imperialist cause at a critical moment,' says Sumit Sarkar.[12]

The episode confirmed for many Muslims that the Congress could not be trusted with their welfare. Nor had Gandhi used his considerable influence with the Congress to accommodate the Muslim view. Instead, Gandhi returned to agitation. He announced a revival of satygraha at the place where it had paused in 1922, at Bardoli in Gujarat, this time to protest a tax hike by the Bombay government.

Indians were ready for another spell of mass ferment. People in Calcutta poured on to the streets when the Simon Commission reached the capital, and boycotted British goods; in Lahore, Lala Lajpat Rai was severely injured in a lathi charge (and later died, possibly as a consequence); while Lucknow chose a unique form of protest, flying 'Go Back, Simon' kites over a reception hosted by landlords for the visitors.

The younger Congress leaders, like Jawaharlal and Subhas Bose, felt constrained by Gandhi's limited demand for dominion status; they wanted freedom. Jawaharlal introduced a snap resolution for full independence at the Madras Congress in 1927. At the Calcutta Congress in 1928, Gandhi pacified the radicals with a promise: if the British did not confer dominion status

within a year, the Congress would demand full freedom. In 1929, Jawaharlal was named president of the Lahore session that passed the historic Purna Swaraj, or full independence, resolution. It was celebrated across India on 26 January 1930. 'I must frankly confess that I am a socialist and a republican, and no believer in kings and princes . . .' said Jawaharlal at Lahore: a new ideology was also being introduced to the Congress.

When Gandhi announced the Salt Satyagraha that year, he discovered an absence of Muslims at the base. M.A. Ansari told Gandhi what was obvious to most Muslims: he should not undertake a national movement without a Hindu–Muslim pact.

Ansari had been trying hard to bring Muslims back to the Congress. He was the main architect of the All-India Nationalist Muslim Party formed on 27–28 July 1929 to fill the vacuum left by a defunct League and a decrepit Khilafat Committee. He hoped to shape the Muslim mind and find solutions that had been left in abeyance by the Nehru Report. His effort was squeezed out of political space, with leaders like Shaukat Ali taunting Ansari that he had chosen to live at the mercy of Hindus, and Hindu Mahasabha stalwarts accusing him of masquerading as a nationalist in order to increase his influence within the Congress. When Ansari sought, with Gandhi's support, an invitation to the Round Table Conferences of 1930 and 1931 as the representative of Muslims, League leaders like Punjab's Fazli Hasan dismissed it as a 'Hindu device', to warm applause from the Urdu press. Ansari was not invited.

Neither could Ansari mobilize much Muslim support for Gandhi's second satyagraha movement. The Khilafat generation was either politically or physically dead. Hakim Ajmal Khan passed away in 1928.[13] Muhammad Ali was still active but, as Mushirul Hasan points out, 'his enthusiasm for [Congress] was not dampened until the publication of the Nehru report in August 1928'.[14] Muhammad Ali accused Gandhi of being a front for Hindu communalism: 'We refuse to join Mr Gandhi because his movement is not a movement for the complete independence of India but for making seventy millions of Indian Mussulmans

dependants of the Hindu Mahasabha.' Note the use of 'Mr' rather than 'Mahatma'.

Gandhi's freedom struggle contained three spells of brief but intense mass mobilization: Khilafat; the Salt Satygraha of 1930–32; and the Quit India Movement of 1942. In between came phases of almost yogic calm during which his disciples went off to lead other lives – while the Mahatma spent time in introspection, penance, writing, prison, and a missionary's passion for erasing the evils that had degraded India, like untouchability.

Gandhi waited eight years after Khilafat before he stirred India again, in 1930, with a challenge to an increase in the tax on salt. The viceroy, Lord Irwin, was not particularly alarmed, writing to the secretary of state, Wedgewood-Benn, on 20 February 1930, 'At present the prospect of a salt campaign does not keep me awake at night.' Such complacency suited Gandhi, who was left undisturbed as he formulated a brilliant equation between nationalism, poverty and economic injustice.

On 12 March, Gandhi set off on a 240-mile (384 km) trek from his ashram in Ahmedabad to the sea coast at Dandi to break the law. He demanded the disloyalty of every Indian, Hindu or Muslim, writing in the 27 March issue of *Young India*: 'The spectacle of 300 million people being cowed down by living in the dread of 300 men is demoralizing alike for the despots as for the victims. It is the duty of those who have realized the evil nature of the system, however attractive some of its features may, torn from their context, appear to be, to destroy it without delay.'

Gandhi raised eleven demands (including prohibition), but decided to take a stand on salt. Salt was a government monopoly, and the tax on it had just been doubled. Even Gandhi's closest disciples, like Nehru, could not immediately grasp the significance of the idea. By the time Gandhi reached Dandi on 5 April, he had seized the world's headlines. He was arrested on 5 May and sent to the familiar Yeravda jail, but he had resurrected the freedom movement.

There were only two Muslims in Gandhi's band of seventy-eight. Muslims across the country seemed indifferent even as

superlatives poured in from others. Motilal Nehru likened the Salt
March to Rama's campaign against Ravana; a venerable Bengali
leader like P.C. Ray compared it to Moses leading the Israelites
out of Egypt. The iconoclast-writer Nirad Chaudhuri, member of
upper-class Bengali Hindu gentry, claims in his memoir that
Muslims of his district in East Bengal abandoned Gandhi altogether:
'... in the next nationalist agitation, the Civil Disobedience
Movement of 1930–32, they (the Muslims) sided with the British
and in Bengal even sacked and looted Hindu homes in towns and
villages.'[15]

Gandhi's most important Muslim associate during the salt
agitation was a man whose name does not figure in Khilafat
annals, Khan Abdul Ghaffar Khan, a towering (both physically
and morally) Pathan from the Frontier, son of a prosperous tribal
chief from Utmanzai, near Peshawar. His Pathan followers, known
as Khudai Khidmatgar (Servants of God), stunned the British,
who were familiar only with their tribal disunity, with their
commitment to the man they nicknamed 'Badshah Khan' or 'King
Khan'. One incident stands out among many. When Ghaffar
Khan was arrested on 23 April 1930, thousands of his supporters
surrounded the prison. Armoured cars were ordered out; one was
torched, leading to rampant police firing in which hundreds died
or were wounded. For a week, between 25 April and 4 May, the
government lost control of Peshawar. The Royal Air Force had to
be used to recapture the city. There was one remarkable episode:
two platoons of the Second Battalion of the 18th Royal Garhwali
Rifles, with only Hindu troops, refused to shoot at their Muslim
countrymen. Seventeen men of the Royal Garhwali were sentenced
to heavy prison terms. But this revival of the Khilafat spirit was
restricted to Ghaffar Khan's Frontier.

Gandhi explained in *Young India* of 24 April 1930 that his
views had not changed in forty years; self-rule was impossible
without Hindu–Muslim unity. He was careful to qualify his
objectives: the present campaign was not designed to win
independence but to make the people capable of such an objective.
When that moment came, 'Mussulmans and all other minorities

will have to be placated. If they are not, there must inevitably be civil war.' Gandhi proposed a Gandhian solution: 'The only non-violent solution I know is for the Hindus to let the minority communities take what they like. I would not hesitate to let the minorities govern the country. This is no academic belief.' Such idealism was illusion.

Francis Robinson sums up this period: 'By the late 1920s Hindu Mahasabha influence over Congress "high command" reached its peak, raising Congress demands to an unrealistic level as it negotiated with Muslim organizations over the future distribution of power . . . Intransigence of this kind meant that Hindu revivalists were left with the greater part of the blame . . . for the failure to reach some form of Hindu–Muslim agreement . . .' As a result, the Muslims turned to the government 'for whatever it would grant them, meaning in this case the Communal Award of 1932' which, forming as it did much of the structures of interests that formed the basis of Pakistan, turned out to be of some importance. Robinson's point is irrefutable: 'It is clear that the failure of the Indian National Congress either to cherish within its fold substantial numbers of Indian Muslims, or to make deals with Muslim separatist groups which would encourage them to work within the Indian Nationalist movement, must remain the greatest question mark beside its achievement.'[16]

Judith Brown comes to a similar conclusion: '[Gandhi] failed conspicuously to achieve [in 1930–31] what he had so hoped – common action by Hindus and Muslims in the national cause. In contrast to non-cooperation, Muslim participation was paltry, except on the Frontier, where Gandhi's gospel of non-violence received an unexpected following. In Muslim-majority areas such as Bengal and Punjab, civil disobedience was much weakened by Muslim abstention and in all only just over 1,000 Muslims were in gaol in mid-November, out of a total of 29,000 prisoners.'[17]

Gandhi continued to reach out to Muslims in phrases that seemed a curious mixture of hope and contrition. He even accepted an invitation from Sir Mohammad Shafi to address the Council of the All-India Muslim League on 22 February 1931. He

was welcomed, pointedly, as leader of 21 crore (210 million)
Hindus: India's population was then 300 million. Gandhi
responded, 'Brethren, I am a *bania* [of the business caste], and
there is no limit to my greed. It had always been my dream and
heart's desire to speak not only for 21 crores but for the 30 crores
of Indians. Today you may not accept that position of mine. But
I may assure you that my early upbringing and training in my
childhood and youth have been to strive for Hindu–Muslim unity,
and none today may dismiss it merely as a craze of my old age.
My heart is, however, confident that God will grant me that
position when I may speak for the whole of India, and if I may
have to die striving for that ideal, I shall achieve the peace of my
heart.' He died striving for that ideal, and perhaps there was
peace in his heart when he sacrificed his life for Muslims in
1948, but there was no peace in India.

On 7 March 1931, Gandhi told a mass meeting in Delhi, in
which Maulana Shaukat Ali had pointedly refused to participate,
'I am sick of these squabbles for the seats, this scramble for the
shadow of power.' The shadow of power, however, mattered to
those who wanted clarity on substance.

A disheartened Jinnah had left India in the first week of
October 1930 for the comparative peace of London. The president
of a greatly depleted Muslim League that year was Sir Muhammad
Iqbal, a graduate of Trinity, Cambridge, a doctorate from Munich
University, a barrister from Lincoln's Inn, and the acknowledged
poet laureate of Indian Muslims.[18]

Iqbal opened the session, in Allahabad, on 29 December 1930,
with a demand for a 'Muslim India' within India: 'I would like to
see the Punjab, the North West Frontier Province, Sind and
Baluchistan amalgamated into a single State. Self-government
within the British Empire, or without the British Empire, the
formation of a consolidated North West Indian Muslim State
appears to me to be the final destiny of the Muslims, at least of
North West India.'

It was yet another attempt to find an integrated answer to the
vexed question of competing nationalisms. Iqbal sought a rational

Muslim province, rather than a separate country. A scholar of Islam, he did not fall into the trap of believing that Islam was co-terminus with nationalism; and indeed claimed that this Muslim province would be the best guardian of the Hindu-majority subcontinent against foreign invasion along a vulnerable border: 'The idea need not alarm the Hindus or non-Muslim minorities within the area. India is the greatest Muslim country in the world. The life of Islam as a cultural force in this living country very largely depends on its centralization in a specified territory. Thus ... the North West Indian Muslims will prove the best defenders of India against a foreign invasion, be that invasion one of ideas or bayonets.'[19]

The geography of Pakistan today is exactly as envisaged in Iqbal's 'Muslim India', except that it is a separate nation. The father of separation was, of course, Jinnah, who had chosen exile in London. For three years, Jinnah ignored continual pressure from an emaciated Muslim League to return. In the summer of 1933, Nawab Liaquat Ali Khan was in England for his honeymoon, and, in Wolpert's words, his '. . . imprecations, offers of assistance, and flattery were, of course, an added factor, for Jinnah always responded to appeals aimed at his ego, his unique capacity to "save" the situation'. Jinnah returned to India in October 1935, in time for a general election that would transfer power at the provincial level, thanks to the Government of India Act of 1935, and set course for the final stage of the Indian Muslim's journey to Pakistan.

9

Breaking Point

—◦◦◦—

There were five 'swivel' moments in Congress–Muslim relations before the formation of Pakistan. The pact negotiated by Jinnah in 1916, in which the Congress accepted separate electorates, was widely described as the basis on which Hindus and Muslims could unite against the British. The second moment, Gandhi's Khilafat struggle, promised liberation but ended in despair. Jinnah crafted the third opportunity, in 1927 and 1928, when an all-party effort was made to create a Constitution for India by Indians; he failed to bridge the League–Congress gap. In 1937, the two parties could have cemented an electoral understanding with a post-election coalition in the United Provinces, but an ascendant Congress underestimated the potential of a depressed Muslim League. The fifth, and most tantalizing, chance appeared at the very last minute, in 1946, when the Congress and the League accepted the British Cabinet Mission Plan to retain a united India, but the Congress, fearful of Balkanization, reversed its decision. After this, their separate paths became irreversible.

Given that Muslim confidence in Gandhi had waned visibly by 1930, so much so that even a genuine believer like M.A. Ansari

advised him to postpone his Salt Satyagraha until he could be sure of Muslim support, it wasn't surprising that the British treated Congress as a largely Hindu party during the three Round Table Conferences convened in 1930 and 1932. These conferences, designed to formulate the next stage of the evolving political structure of the Raj, were held between 12 November and 19 January 1931, 7 September and 1 December 1931, and 17 November and 24 December 1932.

On 12 November 1930, George V, standing next to his throne in the Royal Gallery of the House of Lords, with Prime Minister Ramsay MacDonald and prime ministers of dominions in the audience, addressed fifty-eight delegates from British India and sixteen from the princely states. Gandhi was not there; he was still in jail.[1] Notables like Jinnah, V.S. Srinivasa Sastri and Sir Tej Bahadur Sapru, princes and officials, had been selected to represent India.

Jinnah, as de facto leader of sixteen Muslim delegates, was given the floor after Sastri. He did not send the authorities an advance copy of his speech, as protocol required.[2] Jinnah made a simple and sharp point: too many British sovereigns and prime ministers had offered India self-government but none had given it.

On 20 November, Jinnah argued that there were four interested parties: the British, princes, Hindus and Muslims. He wanted dominion status with satisfactory guarantees for Muslims: separate electorates, and insurance that the 'Muslim' status of Bengal and Punjab would be protected by a plurality of Muslim seats in the respective legislatures. Hindu and Sikh groups rejected the idea.

It took some heavy lifting to persuade Gandhi to sit at the Second Round Table, but the viceroy, fellow-vegetarian Lord Irwin, proved to be a muscular negotiator during their famous series of talks between 17 February and 5 March 1931. Irwin called this dialogue the 'most dramatic personal encounter between a viceroy and an Indian leader'. As a special gesture to the Mahatma who wanted to rid India of viceroys, Irwin would see Gandhi off at the steps of the vast new 'viceroy's palace on Raisina Hill'. Gandhi would walk, sometimes late at night and

alone, the five miles back to Dr Ansari's home, where he stayed. The success of the Irwin–Gandhi Pact, as it came to be known, was ambiguous; Irwin was in no position to concede a long list of Gandhian demands, including prohibition, halving of land revenue and abolition of salt tax, but he did agree that the scope of the Round Table conferences could extend beyond the recommendations of the Simon Commission report.

The two vegetarians were relaxed enough to banter on the last day. Irwin offered tea to celebrate agreement. Gandhi took out a paper bag hidden in his shawl and put some untaxed, illegal salt in his tea 'to remind us of the famous Boston Tea Party'. Both also joked about Churchill's acerbic remark on Gandhi, made during these talks: 'It is alarming and also nauseating to see Mr Gandhi, a seditious Middle Temple lawyer, now posing as a fakir of a type well known in the East, striding half-naked up the steps of the Viceregal palace, while he is still organizing and conducting a defiant campaign of civil disobedience, to parley on equal terms with the representative of the King-Emperor.'

Freeman Thomas, the First Marquess of Willingdon, replaced Irwin when he left India at the end of his term on 18 April 1931. In August, Gandhi announced that he would travel to Britain. While Willingdon publicly assured Gandhi of his fullest support, privately he sent a less flattering assessment to Prime Minister MacDonald: 'He [Gandhi] is a curious little devil – always working for an advantage. In all his actions I see the "bania" predominating over the saint!'

Gandhi, as evident from the anecdotes wafting in his wake, conquered Britain on this visit, but not the British government. He was the focus of conference attention but made no substantive proposals. He rejected separate electorates in principle (including for depressed classes, the polite term for Hindu untouchables), blamed the British for the communal divide ('Were Hindus and Muslims and Sikhs always at war with each other where there was no British rule?') and claimed that Congress was the only party that represented the whole of India rather than merely a part of it. The discussions were about as desultory as the weather.

If clothes make the man, Gandhi was homespun. He disregarded some whispered advice and went in his trademark loincloth and patched woollen shawl to meet King-Emperor George V at a reception in the Buckingham Palace. When reporters asked about his scanty apparel during an audience with royalty, Gandhi replied, 'The King had enough on for both of us.'

On 4 August 1932, the British announced what was called, quite accurately in retrospect, the 'Communal Award', a provisional scheme for minority representation in the legislatures – in which untouchables were given the status of a political minority. Gandhi realized that this would seal the caste division among Hindus. On 20 September, he went on a familiar fast-unto-death to pressurize Dr B.R. Ambedkar, charismatic leader of the untouchables, to keep them within the Hindu electorate. The solution was, in fact, similar to the one Jinnah wanted for Muslims in 1928: joint electorates with a higher proportion of reserved seats for untouchables. But the Congress was not ready to offer Muslims in 1928 what it conceded to the untouchables in 1932. Ambedkar would have got seventy-one seats with separate electorates; the pact with Gandhi gave him 148 reserved seats in Hindu, or 'general', seats. Ironically, a little before he died, Ambedkar converted to Buddhism.

Willingdon wanted the previous tilt towards Hindus reversed, particularly in Bengal. The Communal Award gave Muslims 33 per cent of the seats in the central legislature and 51 per cent of the seats in Punjab. Bengal's Muslims (28.8 million, or 54 per cent of the population) were allotted a preferential 119 seats out of 250, compared to Hindus who got eighty, despite numbering 27.2 million, out of which ten were reserved for untouchables. In the previous legislature, Bengali Hindus had forty-six seats against thirty-nine for Muslims, despite their numerical disadvantage. The British government held the balance of power through a pro-government 'European Group' which was allotted twenty-five

seats in Bengal, although it constituted only 1 per cent of the
population. The Bengali Hindu elite, long used to political and
economic dominance, rejected these proposals and looked upon
the Congress to fight for what it considered its rights.

Bengali Muslim faith in the Congress, badly bruised by Khilafat,
had been dented further in 1928 on a bread-and-butter issue. In
that year, Congress took the side of largely Hindu landlords in
debates over the Bengal Tenancy Amendment Bill, which tried to
provide some long overdue relief to the predominantly Muslim
peasantry. The vehemence generated by the Communal Award
turned alienation into rupture. It was, in Joya Chatterji's words,
'the result of London's decision to divide power in the provinces
among the rival communities and social groups which, in its
view, constituted Indian society'.[3] Instead of attacking the award
as a British design, Calcutta opinion-makers treated it as a
Muslim conspiracy. The leading Indian English-language
newspaper, the *Amrita Bazar Patrika*, was convinced it was a
trick to ensure Hindu subservience to Muslims. Intellectuals
warned that Muslims would restore the Dark Ages of Mughal
rule.

A petition, signed, among others, by Nobel Prize winner
Rabindranath Tagore, philosopher Brajendranath Seal and scientist
P.C. Ray, and sent on 4 June 1936 to Lord Zetland, till recently
governor of Bengal, argued, '. . . your memorialists belong to the
Hindu community of Bengal, which constitutes a Minority
Community, and as such, is entitled to the same protection that
is guaranteed to Minorities of other Provinces [who] claim their
due weightage of representation as a recognized Minority right'.

Joya Chatterji quotes a speech made by Ramananda Mookerji at
a Calcutta Town Hall meeting presided over by Tagore: '. . . let
the Hindus and Moslem be organized as separate nationalities in
the matter of their separate cultural interests, their education,
personal law and the like, and then they can without discord
come together on terms of Equality, Equity and Brotherhood in an
all-Bengal Federal Assembly.' Chatterji comments, 'Their shared
fury against the Communal Award not only prompted Congress

to forget their factional rivalries, but persuaded them to join the die-hard loyalists and Hindu communal leaders on the same platform.'

It is relevant to note that the term 'Hindu' was ambiguous, since the protests were really about the political and economic power of upper-caste Hindus, rather than lower castes and tribals like Santhals, Bagdis, Namasudras, Rajbangshis, Mahishyas and Sahas. In 1931, the census commissioner recorded six million untouchables in British Bengal.

One argument often used by Bengali Hindus was that they compensated for their numerical minority with superior culture and education. It implied that education had lifted upper-caste Bengali Hindus from petty hatreds, while suggesting that faith and illiteracy made Muslims fanatics. On 23 April 1932, 'The Bengal Hindu Manifesto', signed by some of the most important Hindu zamindars, was circulated. If Bengali Muslim demands were conceded, it said, 'it will keep Hindus in a perpetual state of inferiority and impotence . . . The achievements of Hindu Bengalis stand foremost in the whole of India in the fields of Art, Literature and Science, whereas the Muslim community in Bengal has not so far produced a single name of all-India fame in these fields. Political fitness cannot be divorced from the larger intellectual life of the Nation, and in political fitness the Mussalmans of Bengal are vastly inferior to the Hindus . . .'

The initial Muslim reaction to the Communal Award was guarded. On 17 August 1932, A.K. Fazlul Haque was reported in the *Amrita Bazar Patrika* as saying that he would not want to touch the award with a pair of tongs. The next day, he joined a group of young politicians in suggesting that the award had not gone far enough in favour of Muslims, who should have had a clear majority in the Bengal legislature. Other Muslims described it as a betrayal akin to the reversal of partition in 1911. Haque then suggested compromise: Muslims would accept joint electorates on condition that adult franchise was introduced. The franchise so far was limited to males above twenty-one who had paid a 'sum of not less than eight annas as cess' for land, or were

matriculates, graduates, pleaders or medical practitioners. Democracy was the preserve of the educated and propertied.[4]

Positions hardened on both sides. On 12 October 1933, the *Statesman* quoted Haque's mix of frustration and stridency: 'I am prepared to be hanged if I cannot demonstrate to the satisfaction of any judge that the Hindus of Bengal constitute the very personification of communalism based on intense selfishness.' Congressmen turned the argument around, suggesting that constitutional safeguards should be on the basis of backward social status, rather than faith, thus circumventing the Muslim demand through a seemingly higher form of justice. Muslims began to ask a potentially explosive question: if Hindus were not prepared to accept Muslim-majority rule in Bengal, why should Muslims accept Hindu-majority rule in Bihar or the United Provinces?

Liberals sensed the dangers in permitting the extreme to shape the agenda. Nehru chose the Banaras Hindu University as the venue for a speech, in November 1933, to describe the Hindu Mahasabha as 'degrading, reactionary, anti-national, anti-progressive and harmful'.[5] In April 1935, Jinnah told Muslim students in Bombay that he was happy that the Congress had begun to realize that without Hindu–Muslim unity there was no hope of any great achievement, whether in social or constitutional advance, and urged the Congress to challenge the Hindu Mahasabha rather than letting it influence the Congress, as had happened in the past. He and Rajendra Prasad met for a round of talks to pare differences between the League and the Congress, and although the two got along well, no common plan resulted. Despite this, Jinnah felt that the two could cooperate to resist the more obnoxious features of the new Constitution that the British had offered.

But leaders were groping for options as they negotiated the trials of political triangulation. On 12 April 1936, in a speech at the Muslim League session in Bombay, Jinnah argued that if 'the Muslims of India could unite they could then reach a settlement with the Hindus as two nations if not as partners. This "two

nation" view was one with which Jinnah was familiar, but which he had not previously accepted. The substance of the ideal, although not its form, had been expressed by Muhammad Iqbal, when in 1930 as President of the Muslim League he called for the creation of an autonomous Muslim state in the North West, to be confederated with the rest of India.'6 B.R. Nanda sums up the increasingly intense discussions between partisans in a pithy aphorism: Hindu politicians were incapable of generosity and Muslim politicians were incapable of trust.

Jinnah was surprised by the low support for the Muslim League in the 1937 polls. League leaders did not have much to offer apart from emotionalism. A typical appeal for votes was published on 25 June 1937 in a newspaper called *Khilafat*: '. . . Mussalmans should unite among themselves as they have been ordered to do by God and His Prophet to support the Muslim League candidate to give a crushing reply to the non-Muslim organization so that in future it will not dare to interfere in the affairs of Mussalmans [*sic*].' Jinnah could hardly ignore Allah as common denominator. In a statement published on 30 June, he appealed: 'The Muslim League has been established with a view to coordinate the actions of Muslims according to the dictates of Allah and the Holy Koran . . . By defeating the Congress candidate, let us give them such a crushing reply that those non-Muslim organizations never dare to interfere in problems which concern our religion and community alone.'

This was the burden of the party: only the Muslim League could represent Muslims, Gandhi had no right to ask for their vote. Congress leaders like the youthful, if not quite young, Jawaharlal Nehru were astonished at such bigotry. Nehru said in some anguish: 'The cry is raised that Islam is in danger, that non-Muslim organizations have dared to put up candidates against the Muslim League . . . Is this the way to raise the political consciousness of the masses and lead them to a consideration of our urgent problems? Is it thus that we teach them to look upon our demand for political freedom, our urgent need to end poverty and unemployment? . . . To exploit the name of God and religion

in an election contest is an extraordinary thing even for a humble canvasser. For Mr Jinnah to do so is inexplicable ... It means rousing religious and communal passions in political matters; it means working for the Dark Age in India. Does not Mr Jinnah realize where this kind of communalism will lead us to?'

Ironically, the Jinnah of 1920 might have agreed with Nehru. In 1937, seeking to reinvent Gandhi as a Hindu bigot, he turned one of Gandhi's favourite religious symbols on its head. Gandhi's favourite metaphor for a post-British India was 'Rama Rajya', the ideal vision of peace, prosperity and justice in the epic, Ramayana. Jinnah warned Muslims that Gandhi was offering Hindu rule after freedom.

The ulema, but naturally, warmed to this theme. Stanley Wolpert notes, 'The platform adopted by the League's central board in 1936 included, indeed, a number of important concessions to Islamic fundamentalist groups within India, if not as yet to the extremist advocates of a Pakistan National Movement. Three out of fourteen planks were drafted exclusively to appeal to special concerns of the Muslim minority, whose 482 separate electorate seats alone were among those contested by League candidates.'[7] These included protection of the 'religious rights of the Mussalmans' and protection of the Urdu language and script.

The Congress was hardly immune to Hindu communalism, but its socialists and liberals were always ready to challenge obscurantism. Their pressure forced the Congress in 1938 to end 'dual membership'; in other words, a member of the Hindu Mahasabha could no longer join the party. By this time, the Mahasabha had been exposed as a bit of a dud; it did not win a single seat in 1937.

The League's results were better than that, but depressing nevertheless. It managed only a thin presence in Punjab, Bengal, Sind and the Frontier (the regions that would constitute Pakistan in 1947), getting only five per cent of the Muslim vote; 2 seats out of 87 in Punjab; 39 out of 107 in Bengal, 3 out of 33 in Sind; none in Bihar and the Frontier; but 20 out of 29 in Jinnah's Bombay. Its total tally was 109. Its best results were in the United

Provinces, where it won 29 of the 66 Muslim seats. Muslims rejected the Congress as well; it lost all 9 of the 66 Muslim seats it contested in the United Provinces, and won 26 of 58 Muslim seats in the central legislature. Its success in the general, or Hindu, seats was spectacular. It won a simple majority in six out of eleven provinces, and formed governments in eight with the help of allies.

This created the fourth opportunity for a Congress–League entente. Many in both parties wanted to take pre-poll cooperation forward to a coalition government in the province. The raja of Mahmudabad, who began to take an interest in the League once again in 1936, announced that the Congress and the League were two parts of the same army. From the Congress, Azad, who was in charge of negotiations with the League, thought this was a splendid opportunity to turn a hug into a squeeze. A coalition, he felt, would lead to a de facto merger over time as experience in office created trust and shared interests.

But Nehru took a lofty position, arguing that the League was a handmaiden of landlords (true, in United Provinces) and would sabotage Congress plans for land reform (possible); more grandly, he argued that there were only two relevant forces, British imperialism and Indian nationalism, and the League represented neither. It is relevant that the UP League leader, Chaudhury Khaliquzzaman, who played a crucial part in discussions with Azad, told the Cabinet Mission in 1946 that to destroy zamindari was to 'strike at the root of Muslim existence'. Discord increased when Congress leaders began to insist that the League should dissolve its parliamentary board to ensure harmony in the coalition. Khaliquzzaman says in his book *Pathway to Pakistan* that this would have been tantamount to signing the death warrant of the League. Congress did not need the League for a majority in the House, and trotted out high principle to deflect a coalition.

Jinnah appealed to Gandhi, and even suggested a nationwide Congress–League agreement. Ever the hermit when lesser men squabbled for office, Gandhi had retired to his ashram at Wardha. The Mahatma sent an ingenious reply: 'I wish I could do something

but I am utterly helpless. My faith in unity is as bright as ever; only I see no daylight out of the impenetrable darkness and, in such distress, I cry out to God for light.'[8] God did not reply, and the opportunity was lost. Jinnah could now effectively claim that Congress wanted to keep 'genuine' Muslim leaders (as opposed to toadies) out of power. Nehru thought he could woo Muslims over the head of the League, through a 'mass contact' programme; he failed.

Failure made Jinnah even more determined to revive the League. B.R. Nanda quotes a letter written by Lord Brabourne, governor of Bombay, to Lord Linlithgow on 5 June 1937: 'Jinnah went on to tell me some of his plans for consolidating the Muslim League throughout India ... His policy is to preach communalism, noon and night, and endeavour to found more schools, to open purely Muhammadan hostels, children's Homes and teach them generally to stand on their own feet and make them independent of the Hindus'.[9]

Jinnah's response was a fine example of the lawyer's art: he recognized his weakness and shifted the narrative. As long as Indian Muslims had provincial identities, and therefore regional leaderships, their influence would be dispersed. He set about recreating the Indian Muslim as a national minority. He absorbed local leaders into a larger circle, set himself up as a pan-Indian Muslim champion and stoked the old fear of Muslims sinking into a huge Hindu swamp. Provoked by campaign taunts that the League was an elitist club with no roots among even the lower middle class, Jinnah turned to the one thing that every Muslim valued over class difference: *din*, faith. Gandhi had exploited the notion that Islam was in danger from Christian imperialists in 1920. Jinnah warned that Islam was in danger from Indian Hindus. With the Congress in administration for the first time, incidents were bound to crop up that could be construed as evidence.

Nehru recognized the pitfalls inherent in the dangerous combination of inexperience and power. He felt the Congress should not assume office despite victory, since the new

Constitution, which went into effect on 1 April 1937, was a 'charter of slavery'. But the prevailing view in the party was semi-clever self-justification: the Congress could use provincial government to subvert British authority, thin cover for the less noble desire for ministerships. Jinnah, denied office by the electorate and the Congress, used opposition space to undermine the eight Congress governments that were sworn in, most effectively in the United Provinces and Bihar, converting these provinces into bastions of the League. He used Congress mistakes, or perceived mistakes, to convince Muslims that it was a barely disguised 'Hindu' party, and its leader, Azad, nothing more than a 'showboy'. Neutral Muslim opinion began slowly to shift towards the League.

Jinnah complemented efforts at the base by reaching out to the apex, the powerful Muslim leaders in Bengal, Sind and Punjab who had contested under their own banners. He was happy to let them retain their regional identities, as long as he was permitted sole control of national fortunes. And so Fazlul Haque, who had refused to join Jinnah's Muslim League in the 1937 elections, or accept him as a Quaid-e-Azam, eventually seconded the 1940 resolution of the Muslim League that became the basis for the partition of India. Barbara Metcalf explains: 'Jinnah, who had just returned to India after five years in England, faced the problem that the Muslim League had virtually no popular base. Despite deep reservations about the aristocratic bent and loyalism of the League, Congress and other Muslim parties forged a deal to cooperate with it on the assumption that they shared fundamental nationalist goals. The Jamiat [e Ulema] leadership, including Maulana Madani, agreed to support the League candidates upon assurances from Jinnah himself that the League would defer to the Jamiat on matters related to religion and would reshape the League's governing structure by including religious figures and giving less power to the aristocratic members who had dominated up to this point.'[10]

But surprisingly, after the elections, the Jamiat, instead of veering towards the League, tilted towards the Congress. The

most intriguing advocacy for Indian Muslim nationalism was
surely offered by Maulana Husain Ahmad Madani (1879–1957),
product and later patron of the Dar ul Uloom at Deoband, who
spent seven years in British jails and wore Gandhian homespun.
His letters from jail were often signed 'Chiragh-i-Muhammad'
(Light of Muhammad), and his rationale for Muslim patriotism
was theological. It was an attempt to rebut Savarkar's charge that
Islam did not consider India a holy land and therefore could not
treat it is a motherland.

India, Madani claimed, was the second holiest place on earth
for Muslims since Adam, according to tradition, had fallen on
Adam's Peak in Sri Lanka upon expulsion from Paradise. It was
Adam who had carried exquisite fruits and fragrant plants from
Paradise, like cardamom, clove, *kewra*, cinnamon, camphor,
jasmine, ambergris, saffron, which could only be found in India.
Since Adam was the first Prophet of Islam, India became, logically,
the site of the first mosque, and Muslims the original inhabitants
of the subcontinent. In the modern era, Muslims had an equal
claim to the soil of the land, for their dead were buried, and not
burnt, as was the case with Hindus.

The Prophet, he said, had left precedence for Hindu–Muslim
unity in the Constitution of Medina, which was a political pact
with non-believers, Jews and Christians. The parallel had been
invoked by a theologian of the stature of Maulana Anwar Shah
Kashmiri in an address to the Jamaat in 1927, and Azad cited it
in his speech to the Karachi Congress in 1931. Madani scored an
effective hit when he pointed out that the British were eager to
promote nationalism when they wanted Arabs to revolt against
Ottomans, but found it perverse when Muslims and Hindus
united against them in India. Madani told a meeting in Delhi in
December 1937, 'Nowadays nations [*qaumein*] are based on
territorial homelands [*autaan*], not religion [*mazhab*].' A common
nationalism, *muttahidah qaumiyat*, was distinct from *millat*
[community]; the Hindustani *qaum* bore no reference to religion.

—∽ɷ∾—

The conflict between the Congress and the League was not over Islam, but between shared space and exclusive territory. In Jinnah's narrative, a nation was defined by control; India therefore was a Muslim country under Mughal rule, and had become British when the Mughals fell. It was nonsense, he said repeatedly, to say that 'Hindustan' belonged to Hindus. The British took India away from Muslims and the two needed to sit down and negotiate a return of rights, if not for all India then at least a significant part of India. The League resolution of 1940, which spoke of two Muslim spaces, one in the west and the other in the east, triggered fertile imaginations: Bangistan (united Bengal plus Assam), Usmanistan (a Nizamate of Hyderabad), Moplaistan (in Malabar), a Muslim Hindustan (consisting of the old Awadh regions), Mominstan (a Muslim state around Bihar).

It was in such a context that Gandhi suggested, in August 1942, prior to his third and decisive mass agitation for freedom, that Jinnah should be invited to form a national government. Jinnah's response was extraordinary, and not without a touch of pomposity: 'If they [the Congress] are sincere, I should welcome it. If the British Government accepts the solemn declaration of Mr Gandhi and by an arrangement hands over the government of the country to the Muslim League, I am sure that under Muslim rule, non-Muslims would be treated fairly, justly, nay, generously; and further the British will be making full amends to the Muslims by restoring the Government of India to them from whom they have taken it.' Jinnah saw himself as the First Mughal of the twentieth century.

Azad read the history of Indian Muslims in a completely different script: they were a vital building block in the construction of modern India, and India would be incomplete without them. The Congress, in an attempt to stem the rising tide of Jinnah, elected Azad president at the Ramgarh session on 15 February 1940.

Azad challenged the very definition of 'minority' and 'majority' in his presidential address: 'The term "minority" in political vocabulary does not imply a group which in simple arithmetical

calculation is numerically smaller than any other group and should, therefore, be given protection. It means a group of people who find themselves ineffective, both numerically and qualitatively, with a bigger and stronger group, so that they have no power or confidence to protect their own rights.'[11] The British had exploited the communal problem, he said, but he did not blame Britain: why would a foreign power allow internal cohesion in a country she wished to rule? 'But,' he asked, 'do the Muslims in India constitute enough of a minority to, justifiably, have apprehensions and fears about their future, and nurture misgivings that create agitation in their minds?' His answer had not wavered since he began his newspaper *Al Hilal* in 1912: '. . . nothing in India's political development has been as blatantly wrong as the assertion that the Muslims constitute a political minority, and that they should be wary of their rights and interests in a democratic India.'

This was a fine and important distinction, because a demographic minority did not necessarily translate into a political minority. 'Wrong arguments,' he said pithily, 'have been built upon false foundations.' He asked a psychological question that lifted the debate beyond the limitation of numbers: 'Do we, the Muslims of India, look at the future of Independent India with doubt and mistrust, or with courage and confidence?' He answered it: 'If we follow the path of fear, we must look forward to its continuance.'

Using the flowing cadence of Urdu in his oratory, Azad explained, 'It was India's historic destiny that its soil should become the destination of many different caravans of races, cultures and religions . . . This vast and hospitable land welcomed them all and took them into her bosom. The last of these caravans was that of the followers of Islam, who came in the footsteps of their many predecessors and settled down here. This was the meeting point of two different currents of culture. For a time they flowed along their separate courses, but Nature's immutable law brought them together into a confluence. This fusion was a notable historic event. Since then, destiny, in her own secret ways, began to fashion a new India to take the place of the old.

We had brought our treasures with us to this land which was rich with its own great cultural heritage. We handed over our wealth to her and she unlocked for us the door of her own riches. We presented her with something she needed urgently, the most precious gift in Islam's treasury, its message of democracy, human equality and brotherhood.'

This was a radical analysis: Islam had offered democracy, equality and brotherhood to caste-ridden Hindu India. How could Muslims be frightened of the very values that they had offered to their country? 'Our shared life of a thousand years has forged a common nationality . . . we have now become an Indian nation, united and indivisible. No false idea of separatism can break our oneness.'

His passion mirrored the tensions of that tenuous year: 'I am a Muslim and profoundly conscious of the fact that I have inherited Islam's glorious traditions of the last 1,300 years. I am not prepared to lose even a small part of that legacy . . . I have another equally deep realization, born out of my life's experience, which is strengthened and not hindered by the spirit of Islam. I am equally proud of the fact that I am an Indian, an essential part of the indivisible unity of Indian nationhood, a vital factor in its total make-up without which this noble edifice will remain incomplete. I can never give up this sincere claim . . . Islam has now as valid a claim on this land as Hinduism. If Hinduism has been the religion of its people here for several thousands of years, Islam, too, has been its religion for a thousand years.'

Jinnah was indifferent to such eloquent testimony. His vision of the future emerged within a few weeks of Azad's speech, on 23 March 1940, at the Lahore session of the Muslim League at Minto Park, in the form of a resolution that was polite, firm and prophetically imprecise. It did not mention Pakistan by name but made separation the League objective. It demanded that 'geographically contiguous units [be] demarcated into regions which should be so constituted, with such territorial adjustments as may be necessary, that the areas in which the Muslims are numerically in a majority as in North-Western and Eastern zones

of India should be grouped to constitute "Independent States" in which the constituent unit shall be autonomous and sovereign'. Journalists noted that Jinnah's hands quivered as he sat on the dais at Lahore, but his intentions were firm. 'Hindus and Muslims belong to two different religions, philosophies, social customs and literature ... To yoke together two such nations under a single state, one as a numerical minority and the other as a majority, must lead to growing discontent and final destruction of any fabric that may be so built up for the government of such a state,' he said.

The comparatively sober tone of the resolution could not quite disguise the breathless passions unleashed on the street. The United Provinces Muslim Students Federation issued a typical 'manifesto' in 1941, describing Pakistan as 'our Deliverance, Defence and Destiny!' It denied that Muslims were 'one nation with the Hindus and the rest' and continued, 'We Declare ... that we are a NATION, not a minority ... a NATION of a hundred million, greater than Germans in Greater Germany ...' It was ready to go to war: 'Pakistan is our only demand! History justifies it; Numbers confirm it; Justice claims it; Destiny demands it; Posterity awaits it; AND By God, we will have it! Muslims unite! You have a world to gain. Muslims unite! You have nothing to lose but your chains!'

Some elders, like Sir Sikander Hayat Khan, leader of Punjab, Sir Mirza Ismail, dewan of Mysore, or the nawab of Chatari, who had set up the UP National Agriculturist Party, were convinced that Jinnah was only playing with a bargaining chip; they could not imagine a divided India. Congress stalwart Rajendra Prasad, who would become the first president of the Republic of India, reacted to the 1940 resolution by describing Pakistan as 'Dinia', a nation based on faith. It was clever wordplay: *Din* means faith, and Dinia is an anagram of India, suggesting the reverse of a secular state.

The escalating acrimony alienated Jinnah from even those leaders who had grown antagonistic towards Gandhi, like the left-leaning Subhas Chandra Bose. Bose broke from Gandhi and

launched his own party, Forward Bloc, on 29 April 1939. Released from non-violence, he took the freedom struggle on a breathtaking diversion. In the early hours of 17 January 1941, he escaped from house arrest in Calcutta and surfaced on 28 March in Berlin, via Afghanistan. Using the 'enemy's enemy' strategy, Bose went, in 1943, to Japan by German submarine to Japan, and then to Singapore, where he set up a government in exile, and raised a Hindu–Muslim Indian National Army from Indian prisoners of war to fight alongside the Japanese against the British Empire. The present Indian anthem was his government's anthem.

On 18 July 1943, while appealing, over Bangkok radio, to Indians in British uniform to defect, Bose said: 'I approached Mr Jinnah for a settlement in 1940, but I came away disappointed. The Muslim League is a pro-British body and is supported mainly by "yes-men" and traitors. That is why the viceroy frequently calls Mr Jinnah and consults him on important matters. It is the British who are creators of the Muslim League, which is supported by millionaires and landlords. Had the Congress and Muslim League come to an understanding in 1940, at the time of the collapse of France, and when British morale was at its lowest, India would have been free now . . . A free Indian army has been organized to deliver Indians from alien bondage and Indian soldiers will render a great service to Islam by uprooting British influence from their country.'

—————

The last chance to keep India united came between 24 March and June 1946 when a team of three Cabinet ministers – Secretary of State for India Lord Pethick-Lawrence, Sir Stafford Cripps, president of the Board of Trade, and A.V. Alexander, First Lord of the Admiralty – tried to forge agreement on a Constitution for a free India. The Raj had been shaken by a naval mutiny earlier that year; there were police strikes in Kerala, Andamans, Dhaka, Bihar and Delhi; and nearly two million workers struck work 1,629 times in 1946. The British realized that they could not hold on.

Both the Congress and the League were sceptical when the Cabinet Mission landed in Delhi on 24 March 1946. Congress leaders, just out of their longest spell in jail (Nehru spent a total of 3,251 days in prison), worried that 'English Mullahs' – mainly, the Raj bureaucracy – were determined to take revenge against Gandhi for non-cooperation in the war effort with a 'parting kick' in the form of partition. The League, having invested in the Conservative Churchill, was apprehensive about his Labour successor Clement Attlee's intentions. Some of its bombast was ominous. On 26 March 1946, the League newspaper *Dawn* quoted Abdur Rab Nishtar, who would be nominated by Jinnah to join the Cabinet in the interim government in Delhi in August 1946, as saying, 'The real fact is that Musalmans belong to a martial race and are no believers of the non-violent principles of Mr Gandhi'; while League leader from the Frontier, Abdul Qaiyum Khan, pointed out that his people were well-armed and ready to rebel at a sign from Jinnah. The same paper quoted Sir Feroz Khan Noon on 11 April as saying that if Muslims were forced to live under 'Hindu Raj, the havoc which the Muslims will play will put to shame what Chengiz Khan and Halaku did'.

At the formal level, the Muslim League placed its minimum demands in writing: two federations, with their own Constitutions, would cooperate in a confederation that would be responsible for defence, foreign affairs and such elements of communications policy as were relevant to defence. There would be parity in the Union executive and joint legislature. Any decisions about communities would require a three-fourths majority. Provinces would have the right to secede through a referendum. The Congress saw nothing but Balkanization in such demands.

On 16 May at 8.15 p.m., Pethick-Lawrence outlined, in fifteen minutes over All India Radio, the Cabinet Mission vision for a free India. There would be a three-tier federal structure: Group A consisted of eight Hindu-majority provinces; Group B was what would become West Pakistan; Group C was Bengal and Assam. The executive and legislative parity and 'three-fourths' points were dropped; 'secession' was redefined as 'reconsideration of the

Constitution'. Although a separate Pakistan was denied, as some Muslim League papers lamented, there was enough flexibility in the proposals to ensure that Muslim-majority provinces retained the ability to opt out if the experiment did not succeed. This provision for secession could be exercised after ten years. But, as Metz has noted, 'The novel and complicated plan of the Cabinet Mission appeared, however, to be something which could be developed in any direction. Furthermore the wording of the statement in which the plan was contained was itself open in a number of places to a variety of interpretations.'[12]

Jinnah was in no hurry to accept the plan but did so after a private and confidential letter from Lord Wavell, the viceroy, sent on 4 June 1946. Lord Archibald Percival Wavell, who was in Delhi between October 1943 and March 1947, disliked Gandhi. He held the conventional Conservative view of the British Raj, that it had done India unprecedented good, which had been undone by a manipulative and evil Gandhi. He wrote in his diary on 26 September 1946: 'The more I see of that old man, the more I regard him as an unscrupulous old hypocrite; he would shrink from no violence or bloodletting to achieve his ends, though he would naturally prefer to do so by chicanery and a false show of mildness and friendship . . .' And at various other points: 'His one idea for forty years has been to overthrow British rule and influence and establish a Hindu raj; and he is as unscrupulous as he is persistent . . . He is an exceedingly shrewd, obstinate, domineering, double-tongued, single-minded politician; and there is little true saintliness in him . . .' Even on hearing of his assassination in January 1948, Wavell could only comment, 'I always thought he had more of malevolence than benevolence in him, but who am I to judge, and how can an Englishman estimate a Hindu? Our standards are poles apart.'[13]

But Wavell also wanted to protect Indian unity to the extent that he could. He told Jinnah, in his private letter, that the government would go ahead with the Cabinet Mission plan even if only one party accepted it, although he hoped that both would. On 5 June, speaking to the Muslim League Council, Jinnah said,

'Let me tell you that Muslim India will not rest content until we have established full, complete and sovereign Pakistan ... Acceptance of the [Cabinet] Mission's proposal was not the end of their struggle for Pakistan. They should continue their struggle till Pakistan is achieved ... Believe me, this is the first step towards Pakistan.' On 6 June, the League accepted the plan, adding the rider that this would lead ultimately to a sovereign Pakistan.

On 25 June 1946, the Congress Working Committee accepted the plan, and the AICC endorsed the decision in Bombay on 7 July. This was the last achievement of Azad as president of Congress, and he was convinced that he had done his nation a historic service by preserving its unity. He calls the Congress–League consensus a 'glorious event' in his autobiography, *India Wins Freedom*. But others had reservations, which had been articulated during the AICC debate on the resolution.

Azad handed office to Nehru at this 7 July AICC. Nehru made a long speech from which one sentence stood out like a stick of dynamite: 'We are not bound by a single thing except that we have decided to go to the Constituent Assembly.' Three days later at a press conference in Bombay, Nehru extended his argument to reiterate the long-held Congress position that the Constituent Assembly 'would be unfettered in its work', or, completely sovereign. The implication was that it was not bound by the terms of the Cabinet Mission plan, and could amend it if it so decided. The League attacked this as breach of faith, even though its own commitment was heavily compromised. On 5 June, speaking to the Muslim League Council, Jinnah said, 'Let me tell you that Muslim India will not rest content until we have established full, complete and sovereign Pakistan ... Acceptance of the [Cabinet] Mission's proposal was not the end of their struggle for Pakistan. They should continue their struggle till Pakistan is achieved.'

Congress leaders like Nehru and Patel worried that the League would make governance in united India impossible through violent, obstructive behaviour and, by continuing the struggle for separation in post-British India, encourage forces that could

dismember India in the name of religion or region. Muslim-majority Punjab and Bengal–Assam were populous and powerful enough to stretch provincial autonomy into quasi-independence. The border of undivided 'Muslim' Punjab stretched to the edge of Delhi. Details of the League's reservations and threats have been forgotten while Nehru's statement is remembered, precisely because it provided Jinnah an excuse to abandon his acceptance of the Cabinet Mission plan. In trying to protect India from a 'virtual' Pakistan, Nehru had inadvertently provided the Muslim League with the opportunity to seek a real Pakistan. With the country once again torn by riots (there was Hindu–Muslim violence in Ahmedabad on 2 July, which soon spread to Bombay), the League was prepared to up the ante.

On 29–30 July, the Muslim League withdrew its acceptance of the Cabinet Mission plan and called for a Direct Action Day on 16 August 1946 to press for the creation of Pakistan.

There were unprecedented riots in Calcutta on 16 August. Muslims took the offensive, and then were punished. About 4,000 died, and 10,000 were injured. As India's home minister, Sardar Patel, pointed out in a letter dated 19 October to Stafford Cripps, more Muslims had died than Hindus, although it gave him no satisfaction to point this out. The September riots in Bombay were a spread of single incidents, stabbings rather than mayhem: 162 Hindus and 158 Muslims died. In October, Muslim peasants killed some 300 Hindus and damaged vast property in Noakhali in East Bengal. Bihar retaliated brutally that same month; Hindu peasants killed some 7,000 Muslims. Nehru wrote, in a letter to Patel on 5 November 1946, 'The real picture that I now find is quite bad, and even worse than anything that they [League leaders] had suggested.' Jinnah began to demand a transfer of populations, even though he did not elaborate on specifics.

The counting of corpses had just begun, and it inevitably affected sentiment in the 1946 elections to the Constituent Assembly. The Muslim League took 86.7 per cent of the Muslim vote in the Central Assembly, compared to a mere 1.3 per cent for

the Congress. The provinces were no different: the League got 74.7 per cent and the Congress just 4.67 per cent. All thirty Muslims seats in the Central Legislative Assembly and 439 out of 494 seats in provinces went to the Muslim League.

It was now the turn of Muslim League leaders, particularly in Bengal, to wonder if the Jinnah adrenalin might lead to severe side-effects. Hassan Suhrawardy, the League premier of Bengal, was merely consoling himself in November 1942 when he claimed that the Pakistan movement did not 'require any uprooting of associations and ties of homeland which have existed for generations by an interchange of population from the Hindu majority provinces to the Muslim majority provinces'.[14] He energized the idea of a separate, united Bengal based on shared history, tradition and culture. Suhrawardy, in alliance with Sarat Bose, brother of Subhas Bose, became the standard-bearer of an united, independent Bengal, and asked Delhi to delay a final decision on partition till November 1947 to give this idea more time. Fazlul Haque went further; he thought it would be preferable to let the British stay rather than divide Bengal.

On 27 April 1946, Suhrawardy told a press conference in Delhi that his proposed independent Bengal would abandon separate electorates to allay Hindu worries. He wanted the inclusion of three adjacent, Hindu-majority districts, Purnea, Manbhum, Singbhum in Bihar and the Surma valley in Assam to even the population balance. He and Bose sent a joint proposal to Gandhi, who was candid enough to admit, in a letter on 1 June 1947, that both Nehru and Patel thought the idea only a ruse to 'drive a wedge between the caste and the depressed-class Hindus and this is not their doubt only. They say they are convinced of it.'

Bose met Jinnah on 9 June. But this dream did not have legs. Bengali Hindus had no desire for a return of 'Muslim rule', and Bengali Muslims had no appetite for a continuation of 'Hindu domination'. When the last viceroy, Lord Mountbatten, raised Suhrawardy's proposal with Nehru on 23 May 1947, Nehru disingenuously supported the idea – on condition that united Bengal remain in India. But the people were in a different mood.

There were jubilant crowds on the streets of Calcutta when the decision to partition Bengal was announced on 3 June 1947. All hope of Indian unity was dead.

Nehru and Patel could sense that Hindus had tired of the League's tactics of threat, bluster and violence. The experience of a joint Congress–League interim government had been horrific. League ministers had no interest in its success, and everything to gain from sabotage. As reasonable a man as the finance minister, Liaquat Ali Khan, for instance, stonewalled any Congress proposal. At a personal level, age was catching up. As Nehru told Leonard Mosley later, 'We were tired men. We were not prepared to go to jail again.'[15]

Gandhi's secretary Pyarelal recorded, on 4 June 1947, a despairing statement from the father of Indian freedom, given while he lay on a cot in an 'untouchable' colony in Delhi: 'Today I find myself alone. Even the Sardar [Patel] and Jawaharlal think that my reading of the situation is wrong and peace is sure to return if partition is agreed upon ... They wonder if I have not deteriorated with age ... I can see clearly that the future of independence gained at this price is going to be dark ... But maybe all of them are right and I alone am floundering in darkness. I shall perhaps not be alive to witness it, but should the evil I apprehend overtake India and her independence be imperiled, let posterity know what agony this old soul went through thinking of it. Let it not be said that Gandhiji was party to India's vivisection. But everybody is today impatient for India's independence. Therefore there is no other help.' Azad was silent when the Congress Working Committee accepted partition on 4 June. Only the Frontier Gandhi, Ghaffar Khan, voted against the resolution. With tears in his eyes he said, 'Hum to tabah ho gaye' (We have been destroyed). Gandhi did not have the strength to oppose partition any more; he advised AICC members to endorse the working committee's decision when the larger forum met on 14–15 June. His reason was simple. He needed an alternative before he could ask for rejection, and he had none.

Oddly, the birth of Pakistan spurred the rebirth of secularism in

Jinnah. The man who had insisted that the only thing Hindus and Muslims had in common was their slavery to the British, felt in August 1947 that Hindus and Muslims could live together within the 'fabric that may be so built up for the government'. In his first, extempore speech to Pakistan's Constituent Assembly, on 11 August 1947, he told the still-pregnant nation, 'Any idea of a United India could never have worked and in my judgment it would have led us to terrific disaster.' He was objective enough to add, immediately, 'Maybe that view is correct; maybe it is not; that remains to be seen.' History did pass judgment within three decades, when Pakistan fell apart and Bangladesh was created.

An immediate question had to be answered: how should Pakistan deal with Hindus who were traditional residents of Sind and Punjab? 'If you will work in cooperation, forgetting the past, burying the hatchet you are bound to succeed,' Jinnah said. 'If you change your past and work together in a spirit that every one of you, no matter to what community he belongs, no matter what relations he had with you in the past, no matter what is his colour, caste or creed, if first, second, and last a citizen of this State with equal rights, privileges and obligations, there will be no end to the progress you will make ... in course of time all these angularities of the majority and minority communities, the Hindu community and the Muslim community – because even as regards Muslims you have Pathans, Punjabis, Shias, Sunnis and so on and among the Hindus you have Brahmans, Vaishnavas, Khatris, also Bengalees, Madrasis, and so on – will vanish.'

It was startling revisionism.

'You are free,' he told the citizens of Pakistan, 'you are free to go to your temples, you are free to go to your mosques or to any other place of worship in this State of Pakistan ... in the course of time Hindus would cease to be Hindus and Muslims would cease to be Muslims, not in the religious sense, because that is the personal faith of each individual, but in the political sense as citizens of the State.'

It was a speech that could have been made in the Constituent Assembly of united India.

Gandhi refused to celebrate the freedom of India on 15 August 1947. He would have preferred to be servant of a united India than parent of a divided India. He was not in Delhi when the British flag was lowered, a moment captured for eternity in the haunting words of his heir, Jawaharlal Nehru: 'Long years ago we made a tryst with destiny, and now the time comes when we shall redeem our pledge, not wholly or in full measure, but very substantially. At the stroke of the midnight hour, when the world sleeps, India will awake to life and freedom.'

At that hour, Gandhi was in Calcutta, trying to protect Hindus and Muslims from havoc in a city that a year ago had initiated the last stretch towards division with murder and mayhem. He fasted for peace on 15 August. When a Government of India official asked for a message to the nation, he replied that he had 'run dry'. When the BBC turned up, he told the voice of Empire that they must forget he knew English.

The miracle of 15 August 1947 was not that India became free, for freedom had now become inevitable, a business of the calendar, a matter of time. The miracle was that a lonely, forlorn Gandhi saved millions of Muslims and Hindus in Bengal from a civil war. There would be riots in Bengal, but not as long as Gandhi was alive.

There is a notable anomaly in the partition drama: Jinnah and Azad were the two towering leaders of Indian Muslims. Jinnah was the epitome of the Anglicized gentleman, in education, language, dress, behaviour. His photographs indicate immaculate suits and elegant ties. Wolpert says that when Jinnah tried for a Labour seat in Yorkshire in 1931, a party member said, after hearing him speak before the selection committee, 'We don't want a toff like that!' Wolpert's biography could never get patronage in Pakistan because he mentioned Jinnah's preference for ham sandwiches and moderate amounts of whisky. The man who had little religion divided India in the name of religion.

Azad studied theology as a child, wrote a treatise on the Quran, was a true 'maulana' and dressed in a homespun long-coat, the sherwani, and churidaars, or tight pyjamas. He lived, breathed

and practised Islam but never once exploited religion for political gain. On 15 April 1946, Azad explained, discussing the Cabinet Mission, that the term Pakistan was un-Islamic, more redolent of orthodox Brahmanism 'which divides men into holy and unholy ... the Prophet says "God has made the whole world a mosque for me".' Pakistan, in his view, was a symbol of defeatism, a confession that Indian Muslims could not hold their own and had to find a reserved corner. One could understand the Jewish demand for a homeland, since they were scattered, but there were ninety million Indian Muslims at every level of administration and policy. If a majority of Muslims had moved towards the League, it was because of 'the attitude of certain communal extremists among the Hindus' ... who saw this as a pan-Islamic alliance between Indian Muslims and others to their west. All differences would disappear once Indians controlled their own destinies.

Nirad Chaudhuri, who employed his formidable intellect to provoke as much as to explain, noted in *Continent of Circe* that partition was made 'possible by a combination of three factors – Hindu stupidity in the first instance and Hindu cowardice afterwards, British opportunism, and Muslim fanaticism'. He pointed out the self-evident irony 'that the most fanatical and determined of the Muslim champions of a Dar al-Islam in India, the man who made a political impossibility a fact, was Jinnah, a man who had no deep faith in Islam as a religion, but treated it as a form of nationalism'.

10

Faith in Faith

━━⚜━━

Indians and Pakistanis are the same people; their nations were the first to win freedom from the mightiest empire in history. Why then have the two countries moved on such divergent arcs since 14 and 15 August 1947? The idea of India is stronger than the Indian; the idea of Pakistan is weaker than the Pakistani. Secular democracy, a basis of the modern state, was the irreducible ideology of India, while the germ of theocracy lay in Pakistan's genes.

India's Constitution incorporates four principles which constitute the pillars of modernity: democracy, secularism, gender equality and free speech. Jinnah urged nascent Pakistan to become a secular nation with a Muslim majority just as India was a secular nation with a Hindu majority, but Pakistan was impelled towards a different dimension, in which faith became the basis of nationalism. In a slow but almost inevitable glide, Pakistan slipped towards a confused polity in which theocratic urges were patched onto the legislative framework as it sought to define and redefine itself.

Religion was unable to guarantee Pakistan's unity. In 1971, cultural identity proved more powerful than Islamic cohesion.

Bengali Muslims rejected a country created for Muslims and formed Bangladesh, because they discovered that independence from India did not translate into equality in Pakistan.

Instead of re-examining its formative ideas, Pakistan responded to this existentialist dilemma by reaffirming one strand within its DNA: Islam. Jinnah's prescription was abandoned in stages. Islamists, in uniform or civilian dress, pushed towards an oppressive legal code that institutionalized persecution of other faiths, gender discrimination, and forced civil society to institutionalize hypocrisy in its lifestyle. Extremist theologians, encouraged by a shifting domestic environment and international funds, began to change the popular, Sufi-and-shrine-based culture of Sind and Punjab, lands in which Hindus and Muslims had lived together for a thousand years.

On a parallel track, uncertainty over the polity created a crisis in which democracy was frequently hijacked by generals, and elections became a fitful fact, compelling those who sought power to compromise with theocrats who were confident that time and divinity were on their side. A direct line, sometimes faint, sometimes sharp, can be traced between the debate on the Objectives Resolution of the Pakistan Constitution in 1948 and the rise of the Pakistan Taliban six decades later.

—◦◦◦—

Pakistan was born out of the wedlock of two interrelated propositions. Its founders argued, across the acrimonious deathbed of the British Raj, that Hindus and Muslims could never live together as equals in a single nation, a thesis sustained by nostalgia for the past and fear of the future. 'Tyranny of Hindu rule' in united India became the motif of pre-partition Muslim politics, and Gandhi's secularism was dismissed as 'bania' cunning: 'bania' in popular parlance is synonymous with the shopkeeper who sold you short. The archetypal Hindu, in League lexicon, was summed up in a pithy phrase, '*Bagal mein churi, munh mein Ram*' (Ram on his lips, but a knife under his arm). This sly Hindu,

went the logic, would take revenge for past Muslim dominance by keeping Muslims in permanent subservience, even as he tried to obliterate Islam from the subcontinent. Such a threat perception locked Muslims into a minority complex even in provinces like Punjab, Sind and the Frontier where Muslims had no history of fear.

The Muslim elite, a coalition of landlords, professionals, quasi-nobility and businessmen, had its own agenda. It sought a state in which it could exercise power without interference, or competition, from Hindus, and retain its traditional privileges without challenge from socialists like Jawaharlal, who had become a force in the Congress. There was little consciousness of what a separate country might mean. Its experience was limited to the political map of British India, a medley of directly ruled regions and allied princely states under nawabs, maharajahs and lesser breeds on an intricate regal scale. Borders on this map did not restrict movement of people or commerce; and Pax Britannica had eliminated war in the subcontinent after 1857. For many of its founders, the Pakistan they envisaged was no more than a republican variation of an independent princely state, a Muslim-majority land without hereditary rule, whose citizens would continue to enjoy traditional links within a homogenous subcontinent. They wanted something that history does not often provide: the best of both worlds.

The emotional din surrounding the demand for Pakistan drowned out, for Muslims, the possibility that united India might fashion a secular, democratic, modern nation whose values would be radically different from those of past kingdoms and empires. By the 1940s, the overriding image of the Hindu–Muslim equation had been the intermittent violence that punctuates the narrative of the independence movement. Both Congress and Muslim League were wounded by riots, but they treated their scars differently.

But when the two-nation theory first went out in search of geography, there were difficulties. The largest Muslim concentrations were on the eastern and western wings of a subcontinent, making geographical contiguity impossible. Moreover, a vast Muslim population lived in-between, along the

Gangetic belt, in Hindu-majority areas. How would their interests be protected by separation? It was also difficult to hard sell insecurity to Muslims who had felt secure for a millennium, as in Punjab and Sind.

In the face of such facts, the politics of fear proved a useful gambit. In his presidential speech to the Muslim League in 1937, Jinnah accused Hindus of deceit and worse. They were operating under the thin guise of 'Congress secularism' but their real intention was to 'bully you [Muslims], tyrannize over you and intimidate you'. In 1938, he upped the ante, saying that the Congress 'is determined, absolutely determined, to crush all other communities and culture in this country and to establish [Hindu] Raj ... [Gandhi's] ideal is to revive the Hindu religion and establish [Hindu] Raj in this country'.

Jinnah could not afford a repetition of the 1937 results in the winter elections of 1945–46. The electorate was limited to around 11 per cent; voting rights were based on property, taxes, literacy and combatant status (for those who had served in actual fighting). Without a sweeping victory, his case for Pakistan would implode, particularly in the crucial province of Punjab, where voters had demonstrated that they preferred the harmony offered by the aptly named Unionist Party, an alliance of Muslim, Hindu and Sikh landlords, lawyers and businessmen.

Islam and Sharia came back into play; both were in danger from Hindus. This made support for Pakistan a holy duty.

Jinnah campaigned especially hard in Punjab and the Frontier, appealing to religious and sectarian heads he would never have dined with. He promised Sharia where that would work. Khalid bin Sayeed records that in November 1945, Jinnah wrote a letter to the Pir of Manki Sharif (a powerful leader of one of many religious sects among Muslims) saying, 'It is needless to emphasize that the Constituent Assembly [of Pakistan] which would be predominantly Muslim in its composition would be able to enact laws for Muslims, not inconsistent with the Shariat laws and the Muslims will no longer be obliged to abide by the unIslamic laws.'[1] He offered God's law in God's country because he wanted

to bring out the vote, not because he believed in it. A voter tends to remember a campaign promise long after the candidate.

The hereditary heads of Sufi shrines across Punjab and Sind translated this into their own terminology for their disciples: those who voted for the Muslim League would go to heaven; those who did not would be denied burial in a Muslim cemetery and suffer hellfire along with the kafir. Jinnah added another twist during an inflammatory campaign tour of the Frontier in 1946: 'If you do not vote for Pakistan you will be reduced to the status of Sudras [low castes] and Islam will be vanquished from India. I will never allow Muslims to be slaves of Hindus.'

It worked. In 1937, the Muslim League had won only two seats out of 86; in 1946 it won 75. The League swept 113 out of 119 seats in Bengal; 33 out of 34 in Assam; 28 out of 34 in Sind; 54 out of 66 in the United Provinces; 34 out of 40 in Bihar; all 30 in Bombay and all 29 in Madras. Its only defeat was in the Frontier, where it got only 17 out of 38 seats. In the elections to the Central Legislative Assembly, the League won all Muslim seats, polling 90 per cent of the vote. Jinnah celebrated 11 January as victory day; he was now the undisputed 'sole spokesman' of Indian Muslims. The Congress claim that it represented both Hindus and Muslims collapsed. Jinnah's point was indirectly proved by the fact that the Congress swept the 'general', or Hindu-dominated, seats.

The security of Muslim 'culture, religion and other interests' became a determinant in the last-lap consultations which were, inevitably, bitter, with each word, written or spoken, being measured for overt and covert meaning. Jinnah's forensic skills were at their sharpest during discussions with the three-member Cabinet Mission which reached Delhi on 24 March 1946 to formulate a plan for British departure. The broad difference between the proposals submitted by the Congress and the Muslim League was that the former wanted a federal government strong enough to prevent Balkanization and the latter demanded a loophole large enough to permit secession at the end of ten years if united India proved inadequate to its promise.

The League proposed a coalition of six provinces, which would be known as the Pakistan Group and have its own Constituent Assembly and 'own form of government', code for the inclusion of Sharia within the legal framework of a 'Pakistan Federal Government': Punjab, Frontier, Baluchistan, Sind, Bengal and Assam. The Cabinet Mission noted, in proposals announced on 16 May 1946, that it was 'greatly impressed by the very genuine and acute anxiety of the Muslims lest they should find themselves subjected to a perpetual Hindu-majority rule'. This could not be allayed by 'mere paper safeguards'; Muslims needed Constitutional security for their 'culture, religion and other interests'. It also pointed out that the League wanted to 'decide their method of government according to their wishes'.

Conceding that there was 'an almost universal desire, outside the supporters of the Muslim League, for the unity of India', the Cabinet Mission recommended a Union of India with a central government in charge of only foreign affairs, defence and communications. It gave provinces the right to form sub-groups, a recipe for internal blocs, and added the lethal provision that the province or sub-group could 'call for reconsideration of the terms of Constitution after an initial period of ten years and ten-yearly intervals thereafter'. It divided Indians into three categories, General, Muslim and Sikh, and assured the Muslims and Sikhs that no law could be passed about them without their overwhelming consent. The fact that 37.93 per cent of the western Muslim provinces was non-Muslim, and Hindus were 48.31 per cent of Bengal and Assam, was dealt by the proposal to divide the provinces. Some twenty million Muslims would be left in Hindu-majority British India, which had a population of 188 million; nothing was said about them.

Azad, then president of Congress, was content. For him, the unity of India was worth any price. He trusted a basic tenet of Congress faith that since the Hindu–Muslim divide was essentially a British construct, it would fade the moment the British left. Other Congress leaders, particularly Nehru, who succeeded him as president, were not so sanguine. They believed that the Cabinet

Mission plan was an invitation to chaos; perhaps even a clever device to prove the point, for history, that Indian unity was a British gift and India must necessarily fracture along many fault lines when they left. They could barely hide their view that the Muslim League was a British stooge. It seems pertinent to point out, in passing, that while every Congress leader spent years in a British jail for demanding India's freedom, not a single League leader was ever sent to prison for seeking Pakistan.

The Muslim League had one option unavailable to the Congress: the invective of strife. When Congress backtracked on the Cabinet Mission, the League decided to protest through a 'Direct Action Day' on 16 August 1946. A typical pamphlet distributed among Muslims said, 'The Bombay resolution of the All-India Muslim League has been broadcast. The call to revolt comes to us from a nation of heroes . . . the greatest desire of the Muslim nation has arrived. Come, those who want to rise to heaven. Come, those who are simple, wanting in peace of mind and who are in distress. Those who are thieves, *goondas* [thugs], those without the strength of character and those who do not say their prayers – all come. The shining gates of Heaven have been opened for you. Let us enter in thousands. Let us all cry out victory to Pakistan.'

The British were weary enough by 1947 to leave on any terms. Gandhi held out for unity, but he was drifting into isolation. A joke began to circulate about the interminable negotiations: that while Gandhi had a solution for every problem, Jinnah had a problem for every solution. Gandhi was no longer the 'dictator', a status he had enjoyed in earlier battles. Nehru and Patel, as flag-bearers of the future, began to doubt Gandhi's wisdom in insisting on Indian unity at any cost. Ego added to the friction at a tense time. As the British civil servant Sir Frank Messervy noted acidly, 'Jinnah, being over honest, thought everyone else dishonest; Nehru, being highly intelligent, thinks everyone else stupid.' There was a far more important difference; they were divided by radically different visions of the future.

'The communal basis of partition, coupled with the religious

frenzy generated by it, made religion more central to the new state of Pakistan than Jinnah may have originally envisaged,' writes Husain Haqqani, a protégé of General Zia ul Haq who later crossed over to Benazir Bhutto and Asif Zardari, and was appointed Pakistan's envoy to Washington in 2008.[2] Pakistan, therefore, would serve not merely as history's largest refugee camp, a sanctuary for Indian Muslims, but also as a laboratory and fortress of the faith.

—∿∿∿—

Independent India's Constituent Assembly finished its work without any major substantive controversy. The Constitution was adopted on 26 January 1950 and the first general elections were held in 1951–52, five years after 1947. Nehru's government soon formulated a quasi-socialist economic plan which recognized that a sustained attack on poverty, particularly through land reform, was a compulsion in postcolonial South Asia. Freedom had to mean a better life for the famished. India moved quickly to abolish the zamindari system through which the British had outsourced tax collection to 'native' landlords who grew rich by pocketing the difference between what they squeezed out of the peasants and what they passed on to the government. Within the first ten years of independence, India had implemented substantial land reforms in large parts of the country. But poverty proved a more troublesome problem, and even six decades after freedom, India's anti-poverty program is still a work in progress. But periodic insurrections against inequity were launched under the secular banner of Naxalism, a local variant of communism, and not along faith lines.

The Pakistani ruling class, in contrast, co-opted faith into patriotism, but repeatedly sabotaged weak gestures towards land reforms, leaving a pool of poor who fed the supply chain for extremist madrasas or militias.

Competing strands in Pakistan's DNA began to split the Muslim state's personality from inception. The father of the nation,

Jinnah, thought he had produced a child in his own image, but his secular prescription, powerfully elaborated in his first speech to the Pakistan Constituent Assembly in Karachi, was insidiously interred with his bones.

Jinnah had no clarity on state structure. There was no mention of Islam in the Muslim League's seminal Lahore resolution of 1940. This was not an oversight. Jinnah envisaged a Pakistan in which non-Muslims were equals, and applauded a speech made at the Lahore session by a Christian delegate, Chaudhry Chandu Lal, demanding equal rights for minorities in the Constitution of the new Muslim state.

When the Constituent Assembly of Pakistan met on 10 August 1947 (four days before the formal birth of the country) in Karachi, a Bengali Hindu 'untouchable', Joginder Nath Mandal, was nominated interim president for a day before Jinnah could be voted in. This may have been tokenism, but it was meant to signal that Pakistan would be an inclusive state. Speaking, from the Assembly, to his about-to-be-born nation on 11 August, Jinnah was unambiguous: 'Make no mistake, Pakistan is not a theocracy or anything like it.'

The speech is strewn with sentences that, over time, have become more famous outside Pakistan than inside it. Jinnah told Hindus and Muslims of the new state, 'You are free. You are free to go to your temples. You are free to go to your mosques or to any other places of worship in this State of Pakistan. You may belong to any religion or caste or creed – that has nothing to do with the business of the state ... We are starting with this fundamental principle, that we are all citizens and equal members of one State.' There is more in the same vein.

Jinnah named Mandal minister of law and labour in the first, seven-member Cabinet. He asked a Hindu poet from Lahore, Jagannath Azad, to write Pakistan's first national anthem. (After Jinnah's death, his heirs simply erased this fact from public memory and a Muslim, Hafiz Jullunduri, was asked to write a new anthem.) On 17 August 1947, Jinnah joined a thanksgiving service at the Holy Trinity Church in Karachi, and reaffirmed that

there would be no discrimination against Christians. When Jinnah died on 11 September 1948, prayers for his soul were offered at temples and churches.

One of his Parsi friends, Jamshed Nusserwanjee, told Hector Bolitho, on 10 March 1952, 'Mr Jinnah wanted the minorities to stay in Pakistan. He promised them full protection, and he kept his promise. But, unfortunately, trouble began in West Pakistan and most of Hindus left. I saw him in tears on 7th January 1948, when he visited a camp of minorities in Karachi ... Mr Jinnah had no friendliness for the activities of Muslim priests or ulema. He had never any kind of outward show for religious ceremonies or prayers. He had no ill feeling towards Hindus. He was a type of Constitutional ruler.'[3]

Jinnah was deeply distressed by anti-Hindu riots. His famous icy reserve is said to have broken down in public only twice; once, on 22 February 1929, at the funeral of his young but estranged wife, Ruttie, at the Khoja cemetery in Mazgaon, Mumbai, after he had sat in tense silence for five hours. The second occasion was when he visited a Hindu refugee camp in Karachi on 7 January 1948. He told an aide, Mohammad Noman, bitterly, 'They used to call me Quaid-e-Azam but now they call me Qatil-e-Azam [The Great Killer].'

There is sufficient textual as well as anecdotal illustration to indicate that Jinnah did not fully understand the theocratic forces that would claim Pakistan. He believed that ties of travel, trade and investment between India and Pakistan would remain unaffected. Jinnah sold his Delhi residence for Rs 3 lakhs before leaving for Pakistan, but retained his palatial Mumbai home, which he had constructed with so much personal care.[4] Jinnah assumed that token references to Islam, and Islamism, were sufficient to pacify a religious fringe. But while Jinnah was elevated into a demigod in official propaganda after his death, his views were slowly erased from public perception and discourse.

Jinnah's heirs started to concede space during the drafting of the Objectives Resolution of the Constitution, even as they vociferously denied they were moving towards theocracy. On

7 March 1949, Prime Minister Liaquat Ali Khan, while introducing the 'Objectives Resolution', declared that the state would be based on 'the ideal of Islam' and then tied himself into knots as he sought to explain what he meant: 'Whereas sovereignty over the entire universe belongs to Allah Almighty alone and the authority which He has delegated to the State of Pakistan, through its people for being exercised within the limits prescribed by Him, is a sacred trust ... Wherein the principles of democracy, freedom, equality, tolerance and social justice as enunciated by Islam shall be fully observed ... Wherein the Muslims shall be enabled to order their lives in the individual and collective spheres in accordance with the teachings and requirements of Islam as set out in the Holy Quran and the Sunnah ...'

This, Liaquat argued disingenuously, actually eliminated the danger of a theocracy since 'such an idea is absolutely foreign to Islam ... the question of a theocracy simply does not arise in Islam'. His statement bears scrutiny if only to witness the tortured logic: 'I just now said that the people are the real recipients of power. This naturally eliminates any danger of the establishment of a theocracy. It is true that in its literal sense, theocracy means the Government of God; in this sense, however, it is patent that the entire universe is a theocracy, for is there any corner in the entire creation where His authority does not exist? But in the technical sense, theocracy has come to mean a government by ordained priests, who wield authority as being specially appointed by those who claim to derive their right from their sacerdotal position. I cannot overemphasize the fact that such an idea is absolutely foreign to Islam. Islam does not recognize either priesthood or any sacerdotal authority; and, therefore, the question of a theocracy simply does not arise in Islam. If there are any who still use the word theocracy in the same breath as the polity of Pakistan, they are either labouring under a grave misapprehension, or indulging in mischievous propaganda.

'Pakistan,' intoned Liaquat, 'was founded because the Muslims of this subcontinent wanted to build up their lives in accordance with the teachings and traditions of Islam, because they wanted

to demonstrate to the world that Islam provides a panacea to the many diseases which have crept into the life of humanity today ... We, as Pakistanis, are not ashamed of the fact that we are overwhelmingly Muslims and we believe that it is by adhering to our faith and ideals that we can make a genuine contribution to the welfare of the world. Therefore, you would notice that the Preamble of the Resolution deals with a frank and unequivocal recognition of the fact that all authority must be subservient to God.'

Pakistan's minorities sensed danger immediately, although the 'Objectives Resolution' assured them freedom to 'profess and practise their religions and develop their cultures'. Liaquat insisted that 'a new social order based upon the essential principles of Islam' included 'the principles of democracy, freedom, tolerance, and social justice'. A Bengali Hindu member of Pakistan's Constituent Assembly, S.C. Chattopadhaya, suggested that the proposed Constitution would condemn minorities to the status of 'Herrenvolk': 'For the minorities a thick curtain is drawn against all rays of hope, all prospects of an honourable life.' The only Muslim member to protest was the leftist Mian Iftikharuddin, who wanted a class war between have-nots and haves.

Islamic straws began to float in the euphoric wind. Some senior figures in the government wanted to change the script of the Bengali language, spoken by a majority of Pakistanis (living in the east) into the Arabic–Persian used for Urdu, since the Bengali script had originated in Sanskrit and was therefore 'Hindu'. The president of the Muslim League, Chaudhry Khaliquzzaman, announced that Pakistan would gather all Muslim nations into an 'Islamistan'. One assumes he meant that Pakistan would head a modern, pseudo-caliphate. (The idea continues to bounce around, whether on the Islamist fringe or in provocative opinion polls.)

Pakistan convened a world Muslim conference in Karachi in 1949, which led to the formation of the Motamar al-Alam al-Islami (Muslim World Congress) 'which has since played a crucial role in building up the feeling of Muslim victimization that subsequently fed the global Islamist movement', according to

Husain Haqqani. The monarchies of Saudi Arabia and Egypt were the only states to show any interest. However, personalities like Amin al-Husseini, the pro-Nazi former grand mufti of Palestine, could be certain of a warm welcome in Karachi, the first capital of Pakistan.

Islamists fought their first street battle for the future of their dreams in 1953 through a question: who is a Muslim? The Jamaat-e-Islami, in collusion with some Punjab politicians who were playing their own games, initiated the first communal riots in Pakistan. Their target was a sect called the Ahmadiyas who professed to be Muslims.[5] The most important Pakistani Ahmadiya of the period was the brilliant Zafarulla Khan, a Cabinet minister who argued persuasively in the United Nations on the Kashmir dispute.

The Jamaat-e-Islami formed a coalition of religious groups and began a campaign in 1953 to pressurize the state to declare Ahmadiyas non-Muslims, to dismiss them from government, and seize the assets of their businessmen. Over 2,000 Ahmadiyas were killed before the federal government called out the armed forces, who imposed limited martial law and quickly restored peace.[6]

A two-person committee was asked to enquire into the causes of the 1953 incidents, and took its name from the senior member, Chief Justice Muhammad Munir. His colleague was Justice Muhammad Rustam Kayani. When 'The Report of the Court of Inquiry into the Punjab Disturbances of 1953' was published by the Government Printing Press, Lahore, in 1954 it had a visceral impact. It asked, and attempted to answer, all the inconvenient questions that had been buried under the compromise between the secular followers of Jinnah and religious hardliners. The best way to understand its assessments is through quotations:

'It has been repeatedly said before us that implicit in the demand for Pakistan was the demand for an Islamic state. Some speeches of important leaders who were striving for Pakistan undoubtedly lend themselves to this construction. These leaders while referring to an Islamic State or to a State government by Islamic laws perhaps had in their minds the pattern of a legal structure based

on or mixed up with Islamic dogma, personal law, ethics and institutions ... The Quaid-i-Azam [Jinnah] said that the new State would be a modern democratic State, with sovereignty resting in the people and the members of the new nation having equal rights of citizenship regardless of their religion, caste or creed ... The word "nation" is used more than once and religion is stated to have nothing to do with the business of the State and to be merely a matter of personal faith for the individual.'

'We asked the *ulama* whether this conception of a State was acceptable to them and everyone of them replied in an unhesitating negative ... If Maulana Amin Ahsan Islahi's evidence correctly represents the view of the Jamaat-e-Islami, a State based on this idea is the creature of the devil, and he is confirmed in this by several writings of his chief, Maulana Abul Ala Maudoodi, the founder of the *Jamaat.* None of the *ulama* can tolerate a State which is based on nationalism and all that it implies: with them *millat* and all that it connotes can alone be the determining factor in State activity. The Quaid-i-Azam's conception of a modern national State, it is alleged, became obsolete with the passing of the Objectives Resolution on 12th March 1949; but it has been freely admitted that this Resolution, though grandiloquent in words, phrases and clauses, is nothing but a hoax and that not only does it not contain even a semblance of the embryo of an Islamic State but its provisions, particularly those relating to fundamental rights, are directly opposed to the principles of an Islamic State.'

Jinnah's Pakistan, not to put too fine a point on it, was, in the estimate of the Jamaat-e-Islami, a creation of the devil, obsolete by March 1949, and merely waiting to be re-established as a true Islamic State. When the commission sought a definition of this ideal Islamic State, examples varied from the Prophet's rule in Medina, the period of the Four Caliphs who followed the Prophet, to Sultan Mahmud of Ghazni (well known for temple destruction in India), Muhammad bin Tughlaq of the Delhi Sultanate (a curious choice, since he was both brilliant and bizarre), the pious and aggressive Mughal Aurangzeb (who reimposed the jiziya on Hindus), and the contemporary Wahabi royalty in Saudi Arabia. As Justice Munir refined the questions, the answers became

more specific: he notes, 'That the form of Government in Pakistan, if that form is to comply with the principles of Islam, will not be democratic is conceded by the *ulama*.' The report explained in some detail that a democracy, based upon the will of the people, was incompatible with an 'Islamic state' in its strict sense.

The commission, in a remarkable passage, explains the consequences of 'ideological confusion' as was evident during the riots against Ahmadiyas: 'That such confusion did exist is obvious because otherwise Muslim Leaguers, whose own Government was in office, would not have risen against it; sense of loyalty and public duty would not have departed from public officials who went about like maniacs howling against their own Government and officers; respect for property and human life would not have disappeared in the common man who with no scruple or compunction began freely to indulge in loot, arson and murder; politicians would not have shirked facing the men who had installed them in their offices; and administrators would not have felt hesitant or diffident in performing what was their obvious duty. If there is one thing which has been conclusively demonstrated in this inquiry, it is that provided you can persuade the masses to believe that something they are asked to do is religiously right or enjoined by religion, you can set them to any course of action, regardless of all considerations of discipline, loyalty, decency, morality or civic sense.'

The last sentence is telling, and continues to haunt the affairs of Pakistan. 'Pakistan,' said the report, 'is being taken by the common man to be an Islamic State, though it is not. This belief has been encouraged by the ceaseless clamour for Islam and Islamic State that is being heard from all quarters since the establishment of Pakistan.' But it was inevitable that when Pakistan adopted its Constitution on 23 March 1956, it would describe itself as an 'Islamic Republic'.

Few politicians cared (or dared) to examine what such a republic might mean. One who did was the charismatic Shaheed Suhrawardy, last premier of undivided Bengal, Pakistan's prime minister in yet another short-lived administration between 1956

and 1957, and the first person to hold this office from outside the Muslim League. During debates in the Constituent Assembly, he had repeatedly fought against attempts to include 'Islamic' provisions. He argued, in an article in *Foreign Affairs* (April 1957) that the emphasis on an Islamic ideology would 'keep alive within Pakistan the divisive communal emotions by which the subcontinent was riven before the achievement of independence'. He was dismissive about pan-Islamism. This was brave and visionary in an environment prone to Islamist fantasizing. Suhrawardy foresaw the dangers of institutionalizing the hatreds of the 'two-nation theory' into the breadth of Pakistan's policies, since this could so easily be used to sabotage Pakistan's evolution into a liberal, democratic nation state. His own party, the Bengal-centric Pakistan Awami League, had proclaimed secularism as a basic principle. Such ideas were incompatible with Pakistan, and in 1970, the Awami League spurred the popular movement in Bengal which split Pakistan and created Bangladesh.

Islamism was thwarted by the military coup of 1958, but would be revived in 1976 after Pakistan's second coup, which brought General Zia ul Haq to power. General Zia believed that Pakistan could not survive except as an Islamic state. His ideological mentor was not Jinnah but Maulana Maududi.

11

The Godfather of Pakistan

---❧---

For those who wanted a united India, Jinnah's death came too late. For those who sought a secular Pakistan, Jinnah's death came too early.

Jinnah died of tuberculosis on 11 September 1948. Within six months, Pakistan was set on a course he might have recognized, but would not have approved. Jinnah's antithesis was a powerful intellectual and ideologue, Maulana Sayyid Abul Ala Maududi (1903–79), founder of the Jamaat-e-Islami, who developed a model independent of both Gandhi's plural India and Jinnah's secular-Muslim Pakistan.

'Maududi,' writes Francis Robinson, 'was the founder of Islamic 'fundamentalism' – or, better put, the Islamist movement – in South Asia, and the most powerful influence on its development worldwide. Like Saiyid Ahmad Khan [founder of Aligarh Muslim University, more popularly known as Sir Syed] he was not madrasa-educated and stood outside the traditional oral systems of transmission; he was also self-educated in European social and political thought. His prime concern was that Islam and Islamic society should be able to withstand its increasingly corrosive encounter with the West. To do this, rightly-guided Muslims had

233

to take control of the modern state; he had no time at all for the Muslim protestants who avoided the realities of modern politics and relief in individual human wills to make Islamic society. Political power was to be used to put revelation into operation on earth. All the guidance that was needed already existed in the holy law, the Sharia, which embraced all human activity. God was sovereign on earth, not man; the state, manned by the rightly-guided was His agent. This is the basic blueprint of Islamic fundamentalism. It has been carried forward by the organization of the rightly-guided, the Jamaat-e-Islami, whose influence in Pakistan and elsewhere is out of all proportion to its numbers.[1]

Sayyid Maududi was born in 1903 in Aurangabad, the second-largest city of the most powerful Muslim state in British India, Hyderabad. Sir Syed knew the family and persuaded his father, Ahmad Hasan, to join Aligarh. But a strong streak of conservatism in family culture intervened, and he was recalled because Aligarh made him adopt 'infidel' dress (shirt and trousers) and required him to play cricket. Hasan later turned towards Sufism and eliminated all traces of 'firangiyat' (westernization) from his life.

Maududi absorbed an eclectic mix of influences. He was taught by private tutors till the age of nine, and went, at eleven, to the Oriental High School, where he added English, mathematics and natural sciences to his studies. By the time he went to Delhi in 1919, he was absorbed in a question that had fascinated so many others: the power of the West. He sought its 'secret' in philosophy and literature, immersing himself in masters like Hegel, Comte, Mill, Adam Smith, Malthus, Rousseau, Voltaire, Darwin, Goethe. He bought the whole of the *Encyclopaedia Britannica*. Later, when he rediscovered the Quran and exalted it as the only 'root of knowledge', he would describe this phase as *jihaliyat*, or ignorance.

Early pictures of Maududi show him in conventional tie and jacket; or the Ottoman fez, which became a nationalist symbol during the Khilafat Movement. It was only in 1936 that he grew a beard; a short one to begin with, arguing that the Prophet had left no instructions on the size of the beard. Like most other

Muslims, he supported Gandhi and the Congress during Khilafat, and only moved away after 1937. But the most remarkable fact of Maududi's life was surely his marriage to Mahmuda Begum.

This admirable lady, daughter of the biggest Muslim moneylender in Delhi, had been educated at Queen Mary School, scorned the veil and rode a bicycle during an age when hardline ulema used to habitually say that it was better to send girls to brothels than to English schools. It also indicates the ideological evolution of a man whose probing mind took years to arrive at a conviction, but then never wavered. The collapse or decay of the last symbols of Muslim power, whether the Ottoman Empire abroad or Hyderabad at home, persuaded him that the only hope for revival lay in the vitality of 'pure' Islam.

Maududi came to the attention of Islamic scholars in 1927 when he published a collection of essays with a self-explanatory title, *Al Jihad fi al-Islam* (Jihad in Islam). In 1933, he started *Tarjuman al-Quran* (Interpretations of the Quran), a monthly magazine, in which he began to advocate the view that in authentic Islam there was no distinction between spiritual and temporal worlds, between physical and metaphysical, since Allah was master of both. It was, therefore, wrong to divide the Islamic ummah (community) into nation states. 'Nation' and 'nationalism' were concepts from the Western historical experience; the unity of Sharia, the guiding philosophy of Muslims, could not be parcelled out into borders. Maulana Azad argued, on the other hand, that there was no sanction in the Quran for a division of territories and populations on the basis of belief and unbelief. No scholar of Islam had divided the dominion of God on this basis, since it was contrary to the concept of Islam as a universal system. If this had been so, he pointed out, Muslims would never have entered non-Muslim lands, and the ancestors of Pakistan's proponents would not have come to India!

Maududi turned against the Congress after its elected governments of 1937 launched an expansion of schools under a programme called Vidya Mandir, or Temple of Knowledge. Temples were synonymous with idol worship, and he was soon

describing Congress rule as one vast shuddhi movement. His collection of articles was published in three volumes titled *Kashmakash* (Dilemma). The Muslim League distributed the second volume at its conferences between 1937 and 1939, and thought it had found its answer to Azad.

Both Maududi and Jinnah campaigned against the Congress 'Hindu Raj', but their objectives were different: Maududi had a Sharia state in mind, and Jinnah a secular democracy. Maududi sneered at the League as nothing but a Muslim Congress. Irfan Ahmad writes: 'To Maududi, the leadership of the League was "trained wholly on the Western pattern" and he viewed the League as "Jamaat e jahiliyat [roughly, a party of pre-Islamic ignorance]".' Maududi lamented that not a single person in the league, from the quaid-e-azam to the ordinary followers, had an Islamic outlook. 'These people do not know at all the meaning of being a Muslim and his special status.'[2]

Maududi dismissed Jinnah's promised Pakistan as '*napakistan*' (impure land), and even an infidel state run by Muslims. He used an earthy metaphor: Congress would kill Islam by *jhatka* (beheading) while Jinnah would destroy it in *halal* fashion, by bleeding it to death. A secular state was the obverse of Islamic ideology, he claimed. On 31 August 1941, Maududi formed the Jamaat-e-Islami at Lahore, the city from where Jinnah had, a year earlier, started his movement for Pakistan. His objective was to usher in *Hukumut e Ilahiya*, the Kingdom of Allah, on the Indian subcontinent.

His divisive theology was keenly contested by the old guard of the ulema, led by Maulana Madani of the Jamaat-e-Ulema, who wanted Muslims to live in a united India. 'This for Madani was the proof that Maududi lived in a dream world, abstracted from the reality in which the Muslim population of India actually lived,' writes Barbara Metcalf. 'Muslims with Maududi's vision would also have to live without treatment by non-Muslim doctors, the work of non-Muslim engineers, the buildings of non-Muslim architects, the administrative work of non-Muslim bureaucrats, and on and on.'[3]

Madani addressed a far more ideologically sensitive point: 'Second, Madani writes, given that among Muslims themselves there is hardly any consensus on religious grounds: just *what* would Islamic rule mean? He provided a list of different orientations (somewhat controversial, since members might resist these labels), what he calls "Easternism", "Westernism", "Shiism", "Qadiyaniyat", "Khaksariat" and "Adam taqlid" ... It is at this point that Maulana Madani makes clear the extent to which he has internalized the fundamental values of a democratic order: he points out that in a post-colonial country the only sources of authority would be persuasion, guidance, and advice, yet only a draconian state could enforce Islamic conformity given Muslims' own diversity.' Madani could clearly see very far ahead.

Maududi was not troubled by Jinnah's success in 1947; instead, he saw Pakistan as an opportunity. Within a fortnight of partition, he migrated to Lahore, then the largest city of Pakistan, quickly building a base among students, workers and government servants. He set down his rationale and vision for Pakistan in *Islamic Law and Constitution*, published by Pakistan Herald Press in 1955. 'Political slavery,' he argued, 'gave birth to an inferiority complex and the resultant intellectual serfdom, which eventually swept the entire Muslim world off its feet, so much so that even those Muslim countries which were able to retain their political freedom could not escape its evil influences. The ultimate consequence of this evil situation was that when Muslims woke up again to the call of progress, they were incapable of looking at things except through the coloured glasses of Western thought. Nothing which was not Western could inspire confidence in them. Indeed, the adoption of Western culture and civilization and aping the West even in the most personal things became their craze. Eventually, they succumbed totally to the slavery of the West.'

It is impossible not to detect a subliminal rage against Jinnah, the very epitome of Western lifestyle, in this passage. This degeneration, Maududi went on, had also infected religious leaders, causing them to abandon Sharia as the fully formed construct for all aspects of life and legislation: '... the leadership

of political and cultural movements fell into the hands of those who were shorn of all Islamic background. They adopted the creed of "Nationalism", directed their efforts towards the cause of *national* independence and prosperity along secular lines, and tried to copy step by step the advanced nations of our age. So, if these gentlemen are vexed with the demand for Islamic Constitution and Islamic laws, it is just natural for them ... The case of Pakistan is not, however, the same as that of other Muslim countries, certain similarities of situation notwithstanding. This is so because it has been achieved exclusively with the object of becoming the homeland of Islam. For the last ten years, we have been ceaselessly fighting for the recognition of the fact that we are a separate nation by virtue of our adherence to Islam ... Indeed, if a secular and Godless, instead of Islamic, Constitution was to be introduced and if the British Criminal Code had to be enforced instead of the Islamic Sharia what was the sense in all this struggle for a separate Muslim homeland? ... The fact is that we are already committed before God and man and at the altar of History about the promulgation of Islamic Constitution and no going back on our words is possible. Whatever the hurdles and however great they are, we have to continue our march towards our goal of a full-fledged Islamic state in Pakistan.'

And if Pakistan had been created to defend Islam, who would be the true sentinels of Fortress Islam?

Maududi mapped a path for the conversion of Pakistan into an Islamic state. As a first step, he would create a cadre of 'Saleheen', or the pious ones, from the professional classes, and they would take over the state at its functional levels to 'break the power of unIslam'. His nine-point agenda for Islamic revival included a theory of 'Islamic sciences', a cornerstone of which would be a revised history.

The 'westerners', notably Prime Minister Liaquat Khan, were unimpressed by Maududi but wary of his potential as a political rival who might challenge the hegemony of the Muslim League. Liaquat warned civil servants against joining the Jamaat, banned its publications and arrested its leaders. But Maududi was not

without support. Influential leaders like Nawab Iftikhar Mamdot, then chief minister of the largest province, Punjab, were eager to enlist Jamaat support for practical (the cadre was an asset) as well as theoretical reasons. The Jamaat slogan – roughly translated, 'Pakistan belongs to God; it must be ruled by God's law; its rulers must be pious' – had a distinct appeal, now that the work of the 'westernized' Muslim League, partition, was over.

Maududi's moment, as we have noted, came in 1953, when Mumtaz Daulatana, chief minister of Punjab, set in motion a cynical manoeuvre to bring down the federal government and become prime minister in the ensuing vacuum. Daulatana instigated the Jamaat through his secret service to launch a violent agitation against Ahmadiyas. As so often happens, the violence went out of control and martial law was imposed for the first, but hardly the last, time. The Ahmadiyas were not banned in 1953, but the Jamaat had demonstrated its street power. Maududi claimed the adoption of Pakistan as 'Islamic Republic' in 1956 as his achievement. But before he could influence civilian politicians any further through persuasion or street power, the armed forces intervened to stem a growing chaos, and Maududi faced his first serious obstacle to the reformation of Pakistan into an Islamic state.

Pakistan's civilians had not shown much respect for democracy, so it was hardly surprising that its soldiers should have contempt for a system that seemed plagued with pettiness and instability. Ayub Khan's judgment of civilian politicians in the first decade of Pakistan's existence, as noted in his diary, was heartfelt: 'Yesterday's "traitors" [were] today's Chief Ministers, indistinguishable as Tweedledum and Tweedledee!'[4]

—∿∿—

The first Tweedledum was Ghulam Mohammad, a bureaucrat who climbed a fairly greasy pole to take the post once held by Jinnah, Governor-General. On 17 April 1953, he arbitrarily dismissed the ranking Tweedledee, Khwaja Nazimuddin, who had

become prime minister after Liaquat's assassination on 16 October 1951, despite the fact that the latter had majority support in the legislature and had just passed the budget. Pakistan's ambassador to the United States, Mohammad Ali Bogra, was recalled and sworn in as prime minister. On 22 September 1954, the Constituent Assembly adopted four amendments to limit the Governor-General's powers, particularly his ability to arbitrarily dismiss a prime minister. On 24 October, a piqued Ghulam Mohammad declared a state of emergency and dissolved the Constituent Assembly. Bogra announced fresh elections for a new Constituent Assembly and inducted a 'Cabinet of Talents' in which General Muhammad Ayub Khan (1907–70), the army chief, was named defence minister, formally inducting the forces into the power structure. On 20 December, Suhrawardy, leader of the Awami Muslim League, was sworn in as law minister, an office entrusted with the responsibility of drafting the first Constitution of Pakistan.

The dissolution of the Constituent Assembly was successfully challenged in the Sindh High Court. But on 25 March 1955, the Supreme Court, headed by Chief Justice Mohammad Munir, upheld the dissolution, invoking a rationale that would destroy the country's nascent democracy, the 'doctrine of necessity'. Curiously, the Supreme Court also ordered the Governor-General to reconvene the Constituent Assembly, thus obviating the need for an immediate general election. In 1955, Ghulam Mohammad became too ill to continue, and was replaced by General Iskander Mirza (1899–1969), a graduate of Sandhurst who had moved to the Indian Political Service in 1931, and became defence secretary of Pakistan in 1947. He stayed in this post till 1953, and became a leading light of the military-bureaucratic elite.

Mirza was renamed president after the Constituent Assembly adopted the first Constitution on 2 March 1956, but politics had slipped outside the logic of any framework. 'During the thirty months of his presidential office he manipulated party position, trying every permutation and combination to create situations under which as many as four ministries fell one after the other,

the most short-lived being the one headed by I.I. Chundrigar which lasted barely seven weeks,' writes Air Marshal M. Asghar Khan, who became air chief in 1957.[5]

The absence of constitutional propriety had serious consequences on relations between West and East Pakistan, already tense over the fact that Urdu-centric rulers in Karachi had denied Bengali equal rights. On 30 May 1954, Bogra dismissed the East Pakistan government of A.K. Fazlul Haque, the pre-eminent Bengali leader who had seconded the Pakistan resolution in 1940 at Lahore, because of 'treasonable activities'. When the governor of the province, Chaudhry Khaliquzzaman, another stalwart of the Pakistan movement, protested, he was replaced by General Iskander Mirza.

As the balance of power gradually shifted towards the cantonment, Bengalis became conscious of their virtual absence from the officer class. A comparison of the ethnic composition of officers tells a story. In 1955, there were 3 lieutenant generals and 20 major generals from West Pakistan, none from the East. There were 34 brigadiers, 49 colonels, 198 lieutenant colonels and 590 majors from the West against 1, 1, 2 and 10 from the East. The East had only 7 officers in the navy, against 593 from the West; and 40 officers in the air force, against 640 from West Pakistan. The unexpressed but prevalent view was that Pakistan's security was safe only in the hands of West Pakistanis. The West was always worried that since it was divided into ethnic provinces, and the Bengalis were homogenous as well as in a majority, the latter would get a majority in the legislature and form a 'Bengali' government.

In 1956, West Pakistan was combined into a single province, called One Unit, and given parity with East Pakistan, since elections could not be postponed for ever. As Ian Talbot writes, this could 'be understood as an attempt to safeguard the center from a populist Bengali challenge. Indeed one reading of the causes of Pakistan's first military coup in October 1958 is the need to postpone elections which would have endangered Punjabi class and institutional interests'.[6]

Military rule came on the evening of 7 October 1958, when President Mirza and General Ayub Khan abrogated the Constitution, abolished legislatures, banned political parties, and imposed martial law. Reflecting the temperament of the time, the coup was civilized. Asghar Khan recalls a meeting on 8 October at which he was present. Ayub Khan asked Chief Justice Munir how he should get a new Constitution approved by the people. The inventive and obsequious Chief Justice replied that ancient Greek states used the method of public acclaim. Ayub Khan should get the draft printed in newspapers, and then address public meetings in major cities where he could hold up the draft and organize an approving roar from the assembled crowd. To their credit, all present at the meeting began to laugh, with Ayub Khan laughing the loudest.

Authority is rarely shared in a dictatorship. Mirza, having used Ayub Khan, now tried to get rid of him. The army was ahead of civilians; it had tapped Mirza's phone. Brigadier Yahya Khan (later Ayub's successor) intercepted a call made by Mirza to Syed Amjad Ali, whose son was scheduled to marry Mirza's daughter, in which the president said he would 'sort Ayub Khan out in a few days'. Ayub Khan moved first. On 27 October 1958, three generals were sent to get Mirza's resignation. He had retired to bed when they arrived. Summoned, he turned up in his dressing gown and promptly signed on the dotted line. He was packed off to comfortable retirement abroad. Pakistan settled down to a decade of what its first dictator described as a 'revolutionary' regime.

—◦◦◦—

Ayub Khan and the military brass, still steeped in Sandhurst culture, made clear their dislike for Maududi and his socio-political agenda. It is ironic that, but for the accident of temperament, Ayub Khan might have become a mullah rather than an Army officer. His father, Risaldar Major Mir Dad Khan, was known for his piety while serving in a glamorous regiment, Hodson's Horse. The major wanted his son Ayub to become a

'hafiz', someone who could recite the Quran from memory, without a single blemish. But his teacher made the mistake of beating young Ayub, and Ayub responded by slapping the bearded maulvi. That ended a potential career as a mullah. As Ayub Khan recalls in his autobiography,[7] his father sent him to Aligarh College (it had not yet become a university) to 'learn to feel like a Muslim'. Life, rather than a campus, would make him conscious of his identity; as advisory officer to the Punjab Boundary Force, he saw the havoc of communal killings.

But he dismissed the mullah as an enemy of modern education, and for him the success of Pakistan lay in its ability to modernize. In a famous speech to a gathering of Deoband ulema who had migrated to Pakistan, he said that Islam had started as a dynamic and progressive movement, but now suffered from dogmatism: 'Those who looked forward to progress and advancement came to be regarded as disbelievers and those who looked backward were considered devout Muslims. It is great injustice to both life and religion to impose on twentieth century man the condition that he must go back several centuries in order to prove his bona fides as a true Muslim.' The speech was included in an anthology of Ayub speeches published by the Pakistan government in 1961.

Ayub Khan tried to dilute theocratic elements in his 1962 Constitution, even going to the extent of removing 'Islamic' before the 'Republic of Pakistan'. More significantly, he dropped the direct reference to the Quran and Sunnah in the Repugnancy Clause and altered the phrase to an assertion that no law should be repugnant to Islam. His intentions were evident when the Muslim Family Laws Ordinance was promulgated on 15 July 1961. It created a referral body for arbitrary divorce through instant talaaq: anyone who remarried without permission from the Arbitration Council faced a year's imprisonment plus a fine of Rs 5,000. Ayub Khan wrote in his autobiography that polygamy had caused 'immense misery to innumerable tongue-tied women and innocent children' and ruined thousands of families by 'the degenerate manner in which men have misused this permission' to marry more than once.

Ayub Khan did not, or could not afford to, argue with the principle that the 'ideology of Islam' was crucial to the survival of Pakistan, but Ayub Khan's Islam was a mechanism for a social revolution, not tired dogma. When he proposed a six-point programme for his party, the Muslim League, in 1966, the purpose of Islam was defined thus: 'Inculcate it and make it play a positive role in attaining unity, and higher spiritual and moral values. Also make it a prime mover in attaining our objective of progress, prosperity and social justice. Help the needy and poor personnel, organizations on governmental basis [*sic*].'[8]

Just two days later, on 6 September, he comments bitterly on the Jamaat-e-Islami's campaign against him, centred on 'the family law which has brought so much relief to the poor women, orphans and helpless people, and the family planning scheme. The idiots or rascals are calling these things anti-Islamic ... they are the deadliest enemy of the educated Muslim. They cannot bear such people being the leaders and have the responsibility of running the country. In the name of Islam, they are dead against progress and society having the right to think for itself. Their religion and philosophy has not the slightest affinity with the true spirit of Islam.'

On 5 September 1968, Ayub Khan notes, with regret, the resignation of the director of the Islamic Research Institute, Dr Fazlur Rahman, whose scholarly work, *Islam*, published by the Oxford University Press, and written for an European audience, provoked Pakistan's mullahs into calling him an enemy of the faith. Dr Rahman held two press conferences to explain. Ayub Khan writes: 'These clarifications would have satisfied any honest critic, but the mullah, who regards any original and objective thinking on Islam as his deadly enemy, was not going to be pacified. This sort of argument is just the grist he wants for his mill. Meanwhile, the administrators at the centre and the provinces got cold feet. Some of them must have persuaded the doctor to resign. He must have also got frightened. After all, it is not easy to stand up to criticism based on ignorance and prejudice. So I had to accept his resignation with great reluctance in the belief

that he will be freer to attack the citadel of ignorance and fanaticism from outside the government sphere. Meanwhile, it is quite clear that any form of research on Islam which inevitably leads to new interpretations has no chance of acceptance in this priest ridden and ignorant society. These people will not allow Islam to become a vehicle of progress. What will be the future of such an Islam in the age of reason and science is not difficult to predict.'

Perhaps, in the context of what happened to Pakistan in the next three decades, the last few sentences need to be heavily underlined.

Maulana Maududi declared war against Ayub Khan's Constitution the moment it was made public. He summoned the Markazi Majlis-e-Shura (Central Council) in the first week of August 1962 and passed resolutions against the government's Advisory Council of Islamic Ideology, the family laws ordinance, the Pakistan Arts Council, the Girl Guides, cinema halls and the import of books deemed to be critical of Islam. Maududi's anger against Ayub Khan persuaded him to join the National Democratic Front created by Suhrawardy on 4 October, merging the pro-democracy and pro-Islamic platforms. Ayub Khan retreated. 'Islamic' was restored to the name of the nation in 1963, and political parties permitted to function again.

The military regime soon discovered that 'Islamic' had one invaluable use, in the confrontation with 'Hindu' India. 'Islamic Pakistan' had an array of virtues, including true faith and martial prowess; India's secularism was concocted by 'Brahmins' who used cunning to compensate for innate cowardice. India's defeat in the 1962 war against China confirmed such timeless prejudice, and Ayub Khan could never resist asking any Indian he met after the war, with barely disguised pleasure, 'What happened to the great Indian army?'

The personal lifestyles of Ayub Khan and his successor, Yahya

Khan, who rather overdid the alcohol in his diet, did not mean that either challenged the central place of Islam in Pakistan's national identity, except that they were not willing to hand over Islam to the mullah. In 1959, after he had consolidated his power, Ayub Khan circulated a paper, in his name, defending the theoretical necessity of an 'Islamic Ideology in Pakistan'. He stresses in his autobiography that Islam was the basis for Pakistan, and describes India as the irreconcilable enemy of both Islam and Pakistan. The conflation of Islam and Pakistan is a constant; and he is convinced that the different ethnic strains in Pakistan cannot unite except under the umbrella of faith.

A new course, 'Islamiyat', was added to the school curriculum during Ayub Khan's dictatorship. In it, Pakistan became the culmination of a 'dream' that originated in AD 712, when the first Arab armies landed on the coast of Sind under Muhammad bin Qasim, rather than an idea that had emerged from the long and complex debates about insecurity. The retro-management of history would become a critical aspect of Pakistan's self-image, and would remain a constant through the turmoil and tailspin that buffeted the nation. The *Historical Dictionary of Pakistan*, written by Shahid Javed Burki, former chief economist of the Government of Pakistan and a vice-president of the World Bank, published in 1999, begins its chronology with AD 712. Next stop is AD 977, when Ibn Shayban, another Arab general, was sent to add territory and conquered Multan. The third date is AD 1001, when Mahmud of Ghazni launched his expeditions into India, and the fourth is AD 1026, when Ghazni destroyed the Somanath temple. The sequence fits well into imagined history, in which anyone or anything anti-Hindu was ipso facto pro-Pakistan.

Both Ayub Khan and Yahya Khan fought wars with India, and sharpened 'Islamic' rhetoric during the confrontations, without quite realizing that mullahs could not be kept permanently in quarantine. Husain Haqqani makes a good point: 'The secular elite assumed that they would continue to lead the country while they rallied the people on the basis of Islamic ideology. They thought they could make use of Muslim theologians and activists,

organized in religious parties such as the Majlis-e-Ahrar [Committee of Liberators] and Ulema-e-Ulema Islam [Society of Muslim Scholars]. Pakistan had inherited the "religious sections" of the British intelligence service in India, which had been created to influence different religious communities during colonial rule. The religious sections had often manipulated these groups to ward off pressures for Indian independence. With classic divide-and-rule thinking, leaders of the British Raj assumed that they would have better administrative control if groups within the various religious communities, especially Hindus and Muslims, could be persuaded to pursue sectarian issues. After independence, the Pakistan intelligence organizations hoped to use the same tactic against perceived and real threats to the state.'

One great admirer of Ayub Khan was an American academic who became a worldwide name three decades after this paean. Samuel Huntington thought Ayub Khan 'More than any other political leader in a modernizing country after World War II ... came close to filling the role of a Solon or Lycurgus, or "Great Legislator" on the Platonic or Rousseauian model'.[9] By the time this was published in 1968, even the few Pakistanis who knew of Solon or Rousseau had given up on a man who seemed closer to tired dictator than revolutionary philosopher.

Ayub Khan's regime was effectively over when he lost the great gamble of war: he fantasized about flying the flag of Pakistan over Srinagar in the autumn of 1965, and ended up by putting his signature to a humiliating no-war pact with India, brokered by the USSR at Tashkent, on 10 January 1966, that reaffirmed the Ceasefire Line of 1948 as the working border between Indian and Pakistan-held Kashmir. Within three days, on 13 January 1966, a coalition that included the Jamaat-e-Islami, Nizam-i-Islam, Awami League and Council Muslim League accused Ayub Khan of betraying the 'just cause of Kashmir' at a press conference. Bhutto, Ayub's foreign minister, who had been instrumental in starting the war, distanced himself from the denouement, claiming that he had not participated in the direct talks between Ayub Khan and Indian Prime Minister Lal Bahadur Shastri at Tashkent.

(However, the official picture released by the Pakistan government shows him applauding when Ayub Khan is signing the treaty.)

But army rule proved more resilient than Ayub. When nationwide demonstrations forced his departure in March 1969, Ayub Khan handed power to the Army chief, General Agha Muhammad Yahya Khan. Yahya Khan returned to Islam to protect the Army's shattered credibility: the armed forces would henceforth also be guardians of Pakistan's 'ideological frontiers'. As defender of both faith and geography, the Army could claim to be the spine of the nation.

Yahya Khan appeased outrage against long years of military dictatorship by announcing elections for a new Constituent Assembly and promised to retire when an elected government had been formed. Privately, the generals believed that no party would win a simple majority, and the army would be able to play off competing politicians and retain its place in the power structure. Yahya set two preliminary conditions for the return of democracy: politicians would have to swear to protect the integrity of Pakistan and the glory of Islam. He then appointed a retired general, Sher Ali Khan, to supervise the glory.

Sher Khan, scion of an Indian princely family, the Pataudis, more famous for cricket than prayer, was named minister for information and national affairs. A nationwide campaign began on 1 January 1970 to warn the country that both Islam and Pakistan were in danger. The generals divided political parties into two broad categories, 'Islam Pasand' (Lovers of Islam) and the rest, and funded the former through intelligence agencies. Naturally, the 'Islam Pasand' were synonymous with patriotism. Sher Khan acquired an extra-large ego and even began to suggest that he communicated with Allah five times a day. When some senior officers protested against thrusting religion into the barracks, Yahya Khan responded that it could hardly be considered a crime to preach Islam in Pakistan. As a caveat, he would add that he

was not expecting any excessive personal piety. With a Scotch in hand much before sunset, Yahya Khan was a good example of multiple loyalties.

Punitive laws were introduced. In July 1969, Martial Law Regulation No. 51 instituted seven years' rigorous imprisonment to anyone in possession of a pamphlet or book which could be considered offensive to Islam. Indian books and newspapers were banned. Many liberal journalists were forced out of newspapers, and their jobs given to Jamaat-e-Islami cadres. Bhutto's Pakistan People's Party took cover: 'Islamic socialism' became its guiding thesis, and its theorists found a Quranic equivalent to egalitarianism in the term *musawat*. The Jamaat attacked Bhutto's lifestyle as un-Islamic, but refrained from any comment on Yahya Khan's. Bhutto was pilloried as the son of a Hindu mother, which was true, but hardly his doing. The Awami League in East Pakistan, however, refused to budge from its commitment to secularism, and was therefore condemned as 'pro-Indian' and 'pro-Hindu'. Bengali Muslims were accused of virtual apostasy because of their cultural affinity with Bengali Hindus. On 31 May 1970, the Islam Pasand group celebrated Shaukat-e-Islam Day (Glory to Islam Day). Several leading ulema issued a fatwa declaring both socialism and secularism as *kufr*, or disbelief. Their slogan was *Socialism kufr hai; Muslim millat ek ho* (Socialism is heresy; Muslims, unite).

The Muslim electorate rejected such Islamic hyperventilation when it voted on 7 December 1970. The Awami League won 72 per cent of the vote in East Pakistan and 160 seats, giving it a majority in the house of 300. In West Pakistan, Bhutto's 'Islamic-socialist' PPP won eighty-one seats. The 'Islam-Pasand' parties got a total of about 10 per cent of the vote.

But rather than hand over power to the Awami League, the generals began to fan Islamic sentiments in a bid to derail democracy. Trite tactics were revived to drum up fears of 'anti-Islam'. One incidental target was a book called the *Turkish Art of Love* which apparently combined three great evils: it allegedly desecrated the Prophet; it was written by a Jew; the Jew was of Indian origin.

Yahya Khan began political negotiations whose only purpose seemed to be to thwart the Awami League. Dr Kamal Hosain, later foreign minister of Bangladesh, narrates the story of Yahya Khan holding a glass of Scotch and lecturing the League leader Sheikh Mujibur Rahman that they must work together for the glory of Islam and the integrity of Pakistan. On 25 March 1971, the government declared the Awami League a secessionist party. This was not new either; Fazlul Haque had been dismissed in 1954 for being a traitor. But this time the repression of the Awami League became reason for mass rape and murder that has been called a genocide. The operation to save 'Islamic' Pakistan in 1971 began when soldiers moved into Dhaka's hostels and homes to slaughter Bengalis, with the cry *'Allah o Akbar'* on their lips.

The *Times*, London, reported on 3 July 1971 that Yahya Khan had told Bengalis that the Constitution 'must be "based on Islamic ideology" and must be "the Constitution of the Islamic Republic of Pakistan in the true sense" . . . The militant ring of Islam in this context is unmistakable. "Every one of us," the president declared, "is a Mujahid [holy warrior]".' A whisky-fuelled jihad against fellow-Muslims split Jinnah's Pakistan. The two-nation theory died when Bangladesh was born in December 1971, but it was not buried. As Pakistan searched for answers during this identity crisis, it retreated further into the false comfort of a religious cocoon.

Some three million refugees spilled over into India in the summer of 1971, and a civil war developed as India helped rebel units, operating under the loose nomenclature of Mukti Bahini. By December, the conflict had blown up into a full-scale war which ended in the ignominy of the formal surrender of some 93,000 'invincible' Pak troops to the Indian Army in Dhaka. The shock in the West was so intense that there was a near revolt among junior officers. Instinctively, they connected failure to betrayal of Islam. They demanded immediate prohibition in the messes, the implication being that infidel vices had been punished by defeat. An Urdu newspaper from Lahore gave a memorable headline on 19 December 1971: *'Ek awaaz, ek elaan, Qaum ka*

qatil Yahya Khan' (One voice, one demand, Nation's killer is Yahya Khan). Yahya Khan transferred power to Bhutto on 20 December 1971, making Bhutto the first civilian chief martial law administrator.

———◦◦◦———

The charismatic, Western-oriented-gentleman Zulfiqar Ali Bhutto (1928–79) was, like his two predecessors, the Khan generals, and indeed most Pakistani leaders since Jinnah, Western in his personal preferences and Eastern in his public persona. He claimed that he had been breast-fed on politics, and described politics as the art of ideological mobility. He had campaigned to give '*roti, kapda, makan*' (bread, cloth and home) to the poor, and envisaged gender equality while fighting obscurantism and prejudice. He was also a feudal autocrat who fancied himself as another Napoleon. But, as a traumatized nation's first civilian dictator, with a mandate for a new Constitution, he could have relaid the foundations along Jinnah's democratic–secular blueprint. But the pull of his nation's DNA, and his own inclination towards compromise, kept shifting the weightage between 'Islamic', 'democratic' and 'socialism' in Bhutto's 'Islamic democratic socialism' formula.

Instead of shaping politics to match ideology, Bhutto shaped ideology to suit politics. One immediate consequence of 1971 was a visible hardening of popular attitudes towards minorities, Christians and Hindus. On 1 September 1972, in a sort of sideswipe, Christian schools and colleges were nationalized by a man who was a product of one. (Some institutions were returned to the Church after protests.)

The debate over nationalism intensified, for obvious reasons, after the separation of Bangladesh. The hyphenation of Islam and Pakistan was articulated by one academic at a government-sponsored meet on history and culture, when Professor Waheed-uz-Zaman argued, 'The wish to see the kingdom of God established in a Muslim territory was the moving idea behind the demand for

Pakistan, the cornerstone of the movement, the ideology of the people, and the raison d'être of the new nation state . . . If we let go the ideology of Islam, we cannot hold together as a nation by any other means. If the Arabs, the Turks or the Iranians, God forbid, give up Islam, the Arabs yet remain Arabs, the Turks remain Turks, the Iranians remain Iranians, but what do we remain if we give up Islam?' The converse argument could have been considered, that religion was not an effective glue, and that a democratic, secular polity would be a far better vehicle for the resurrection of Pakistan as a modern state. But Bhutto thought he could exploit Islam as easily as he had exploited socialism, without being fully faithful to either.

On 10 April 1973, Bhutto gave Pakistan its third Constitution. Bhutto accepted the view of the religious parties that the Objectives Resolution of 1949 be included in the preamble. Islam was declared the state religion. The offices of president and prime minister were reserved for Muslims, making minorities second-class citizens in theory as well as in practice. It became a duty of the state to enable Muslims to lead an Islamic life, promote study of the Quran and Sunnah, and teach Islamiyat in schools. A Council of Islamic Ideology was created to ensure that every law was in harmony with the tenets of the faith. Self-professed liberals like Bhutto have been as instrumental in the Islamization of Pakistan as ideologues. The momentum lay in the idea of Pakistan. Bhutto's motivation might have been expedience rather than conviction, but he too encouraged the growth of a strain in Pakistan's metabolism that had preceded him, and would acquire viral strength after his departure.

If Bhutto thought such gestures would buy off the Jamaat-e-Islami, he was fooling himself. In early 1973, the head of the Jamaat went so far as to demand an army coup to end the 'liberal' and 'socialist' Bhutto blasphemy. Bhutto tried to mollify the Maududi clan by appointing a former Jamaat member, Maulana Kausar Niazi, as Cabinet minister for a newly created department of religious affairs. Niazi's main activity seemed to be sponsoring conferences, but there were less visible, and more substantive,

benefits for the religious lobby. Many indigent mosques were placed under the waqf ministry of provincial governments, giving imams a regular salary. In return they were expected to support Bhutto. General Zia expanded this mutually beneficial arrangement, but Bhutto thought of it first.

The Jamaat was more ready to cooperate in Bhutto's Afghan policy, because it served its long-term interest to do so. Afghanistan had been traditionally close to India, as leverage against a neighbour with whom it had a dispute over the border along the Durand line. When Bhutto sought to expand Pakistan's influence westwards, Islam became an instrument of foreign policy.

In 1972, acting on intelligence, Pakistan seized a cache of arms from the Iraqi embassy in Islamabad. Bhutto alleged that the weapons were meant for a secessionist insurrection being planned by the National Awami Party government in Baluchistan, which straddles both the Afghan and Iran border. The regional government was dismissed, and an ensuing tribal uprising quickly crushed. Pakistan accused Afghanistan of helping the 'rebels', and the traditional rivalry was bumped up by Islamabad into a security threat. Bhutto tried to persuade the White House of Kissinger and Nixon that India was also involved in this conspiracy to 'Balkanize' Pakistan, but Washington, despite its animosity to Prime Minister Indira Gandhi, was not ready to buy this line.

In 1973, Sardar Muhammad Daoud overthrew the Afghan monarchy, declared that the country had become a republic, and warmed up relations with Moscow. Bhutto set up an Afghan cell in the foreign office and authorized Pakistani intelligence to fund and arm two young, unknown Islamists, Burhanuddin Rabbani, who belonged to the Jamaat-e-Islami, and Gulbuddin Hekmatyar, whose Hizb-e-Islami maintained informal links with the Muslim Brotherhood. There is neat symmetry in the fact that Bhutto's daughter Benazir created the Taliban two decades later, for similar purposes.

Bhutto found Islam a convenient camouflage for a much grander project. In 1972, he began exploring the possibility of arming Pakistan with nuclear weapons. He had proposed, unsuccessfully,

the idea as foreign minister under Ayub Khan. Now that Bhutto was his own master, there was nothing to stop him except possibly pressure from America, and Washington seemed indifferent. America did persuade France to suspend an agreement for the supply of a nuclear power station and reprocessing plant, but the French company, SGN, had conveniently transferred 95 per cent of the blueprints to Pakistan by then. Bhutto sold his dream of an 'Islamic bomb' to oil-rich Arab nations for cash and political support, particularly after India tested its nuclear device in 1974. Pakistan's bomb became their comfort food.

Bhutto's 'Islamic' high came in February 1974, when he hosted, with patronage from Saudi King Feisal bin Abdel Aziz, an Islamic summit in Lahore. (The commemoration tower remains part of Lahore's skyline.) The gathering of leaders was unprecedented, with the Shah of Iran the only notable absentee. Bhutto's guests included the prime minister of Bangladesh, Sheikh Mujibur Rehman, who, three years before, was in a Pakistan jail for treason. The summit established Pakistan as a leading power among Muslim states, and set up a permanent structure for the Organization of Islamic Conference. There was much congratulatory rhetoric. Qaddafi, speaking at the Lahore stadium named after him (finance gives you naming rights), called Pakistan the 'fortress of Islam' in Asia and placed Libya's resources at Bhutto's command. It was heady stuff. His PR men began to call him the 'Supreme Leader'; the only contemporary to share such an honour was North Korea's Kim il Sung.

In substantive terms, Bhutto had done little to deserve this or any other accolade. His leftist admirers expected him to challenge the landholding pattern in much of Pakistan, which had not changed since the 'chieftain' system under the Ghaznavids a thousand years before. It was estimated that in 1947 some eighty families controlled three million acres. Ayub Khan made an attempt, restricting individuals to 500 acres of irrigated and 1,000 acres of non-irrigated land. In practice, only 2.3 million out of 43 million acres of farmland were affected. Bhutto announced a lower ceiling of 150 and 300 acres. In theory,

another 2.82 million acres could have been redistributed. In practice, only 512,886 acres were acquired. (After Bhutto, a Sharia court ruled that Islam did not recognize any limit on landholdings.)

In May 1974, Jamaat students clashed with Ahmadiya youth at the railway station of Rahwah, a small town which the isolated sect had inhabited to find shelter in numbers. Ulema from eight organizations formed a coalition under the leadership of Maulana Muhammad Yusuf Binnawri to start a 100-day agitation to deprive Ahmadiyas of their Muslim status, a demand that had been raised by Maududi in 1953. Bhutto conceded.

The wooing of Islamists continued in many forms. In early 1976, Bhutto invited the imams of Kaaba and the Prophet's mosque in Medina for a tour of Pakistan. All first-class hotels were ordered to keep copies of the holy book in their rooms. But when elections were announced in January 1977, Bhutto discovered that religious parties had joined a formidable eight-party coalition against him.

Bhutto refused to take chances. Assuming he was invulnerable in his home province, Sind, his party rigged the elections in most of the constituencies of Punjab. The American ambassador, Henry Bryoade, invited to watch the results in the 'Supreme Leader's' company, remembers Bhutto drinking heavily. Bhutto's apprehension was justified. The opposition did not accept the results, claiming that they had been cheated of victory, and the street echoed this sentiment. The Jamaat-e-Islami and allied religious partics led a violent agitation for fresh elections. Their slogan was unambiguous: Allah's law for Allah's country.

Bhutto tried to buy his way out with further concessions. He would not survive, but those concessions would. On 17 April, Bhutto banned night clubs, gambling and liquor (the interesting fact, surely, is that such pleasures were legal in the Islamic Republic till then). Bhutto changed the weekly holiday from Sunday to Friday, and invited Opposition ulema to join his advisory council for the implementation of Sharia. It was all in vain.

Bhutto's most important contribution to Islamization was inadvertent. On 1 March 1976, he named Muhammad Zia ul

Haq (1923–88), juniormost of six claimants, an officer with an undistinguished record, chief of staff of the Pakistan army. Given Bhutto's thirsty ego, the tendency is to attribute Zia's elevation to flattery. Bhutto later explained that he was influenced by the advice of Lt General Ghulam Jilani Khan, chief of ISI. Zia was well known in army circles for being deeply religious, and advocating the virtues of political Islam to those under his command. He would hand out books by Maududi as prizes for officers during garrison games.

Bhutto certainly wanted a chief who seemed ethnically incapable of engineering a coup. Zia came from the Punjabi Arain clan, which, unlike the Pathans or Rajputs, was not considered a martial race, nor had alliances in the clan-conscious officer hierarchy. Zia's reputation for religiosity did not bother Bhutto; nor did he object when Zia changed the motto of the Pakistan army soon after taking over as chief. The Zia creed was *Iman, Taqwa, Jihad fi Sabil Allah* (Faith, Piety and Jihad in the name of Allah). The new chief ordered all ranks to offer prayers regularly, included Islamic tenets in training manuals and built mosques or prayer halls for all units. He was reclaiming legitimacy and purpose for a psychologically devastated army by reinventing it as 'soldiers of Islam'.

Zia began to tiptoe away from his mentor when the environment changed. At the height of the disturbances, he claimed that his troops were unwilling to fire upon anti-Bhutto demonstrators since they too wanted God's law, or Nizam-e-Islam. On 5 July 1977, Zia, with utmost courtesy, sent Bhutto to temporary confinement and took over. The Jamaat-e-Islami distributed sweets.

Zia promised fair elections by October. Bhutto was held in soft detention in a comfortable home, where he could play cards and discuss politics. When massive crowds welcomed Bhutto upon his release three weeks later, Zia became nervous. On 1 September 1977, Zia told a press conference that an election date was not written in the Quran. Since Allah had not left specific instructions on democracy, Zia did not hold an honest election for the whole of his period in office, till he died on 17 August 1988, in an air crash attributed by some to a foreign hand and others to divinity.

12

God's General

———❧———

General Zia ul Haq was thrust into power with an unexpectedness that prompts the faithful to believe in divine intervention. By the time Maulana Maududi died in 1979 at the age of seventy-six, he could have asked God for no bigger blessing than an autocrat in Islamabad who wanted 'Islamic' to be something far more than window-dressing for Pakistan. During his eleven years in power, General Zia was untroubled by doubt, unfazed by criticism.

Zia's father, Akbar Ali, a civilian working in the army, had been nicknamed 'Maulvi' because of the piety he constantly paraded. Son took after father. Zia would recall that when he joined the army, drinking, gambling, dancing and music were the preferred activities of his brother officers in their spare time. Zia preferred prayer.

His prayers were answered on 5 July 1977. Zia was confident that Allah had sent him to claim Pakistan for Allah. He repeatedly stressed that he was on a mission from God and would stay in power as long as Allah wanted. His critics, ironically, have often attributed Zia's death in a mysterious air crash also to divine judgement.

Air Marshal Asghar Khan, by then in active politics, recalls that
he was woken at 2 a.m. on 5 July 1977 by a young army officer,
told martial law had been imposed, and taken to the cantonment.
BBC did not have the story that morning; curiously, Radio Pakistan
put the news of Bhutto's ouster and martial law only at the end
of its morning bulletin. Zia addressed the nation that evening and
claimed that the survival of Pakistan lay in democracy and
democracy alone. On 28 July, Bhutto was released along with
other political leaders and told to prepare for elections in October.

The crowds that welcomed Bhutto on his release went to the
head of a leader always susceptible to megalomania. On 15 July,
Bhutto reprimanded Zia and pointed out that a death penalty
awaited anyone who toppled a government by force. Zia got the
message, and acted first. On 3 September, Bhutto was arrested on
a much more serious charge, for the murder of a certain Nawab
Ahmad Khan. The Lahore High Court gave him bail, but Bhutto
was back behind bars on 17 September. He would not come out
alive. There would never be a free election. And religious parties
soon realized that there was no need to remove Zia since he was
one of their own.

Within days of his coup, Zia began to change the culture of
governance, in subtle and not-so-subtle ways. Government letters
now began with Bismillah, or 'In the name of Allah'. Eating places
were shut down during that year's Ramadan and tea was forbidden
in offices. On 2 December 1978, the beginning of Hijri 1399,
Islamic laws and punishment were introduced for theft, adultery,
drinking. Shariat benches were added to high courts and an
Appellate Shariat Bench was attached to the Supreme Court. The
changes were made applicable from the twelfth of Rabi ul Awwal,
the Prophet's birthday.[1] Zia initiated a debate on how to rid the
banking system of usury, which is forbidden in Islam. There was
clear bias against non-Muslims in the new jurisprudence: for
instance, a Muslim who murdered a Hindu could not be punished
unless four Muslim witnesses had given confirming evidence. A
non-Muslim's evidence was not treated on par with a believer's.

Speaking to the BBC in April 1978, Zia stressed that his mission

was to 'purify and cleanse' his country. On 6 January 1979, Zia gave an interview to Ian Stephens, a Raj official who went on to become editor and director of the British Empire's most important newspaper, *The Statesman*, and later wrote books sympathetic towards Pakistan. Zia explained: 'The basis of Pakistan was Islam ... It was on the two-nation theory that this part was carved out of the sub-continent as Pakistan ... Therefore, to my mind the most fundamental and important basis for the whole reformation of society is not how much cotton we can grow or how much wheat we can grow. Yes, they are in their own place important factors; but I think it is the moral rejuvenation which is required first and that will have to be done on the basis of Islam, because it was on this basis that Pakistan was formed ...'[2] He blamed Bhutto for the 'complete erosion of the moral values of our society'.

The Jamaat-e-Islami became the standard-bearer of moral values, with official authority to help impose them if the people seemed reluctant to be morally correct. At one point, the Jamaat held the portfolios of information and broadcasting, production, water power and natural resources, and was given charge of the Planning Commission so that it could Islamize the economy. The Jamaat's support was also important in the lurid legal process that ended with the conviction and hanging of Bhutto, in April 1979, on the murder charge. Zia took care to brief the Jamaat chief, Mian Tufail Muhammad, over a ninety-minute conversation on the night before Bhutto was hanged; the next morning, Jamaat members celebrated his judicial assassination.

The Election Commission was authorized to deregister any political party 'prejudicial to the ideology of Pakistan'. In November 1979, Zia outlined his concept of an Islamic Pakistan: only good Muslims would be permitted to contest polls; women's rights would need reformulation; a Majlis-e-Shoora would advise the president, who would have greater powers; armed forces would get a political role; those who did not believe in Islamic ideology would have no place in the system; media was prohibited from criticizing either the armed forces or Islamic ideology.

An exhilarated Maududi described these measures as the 'renewal of the covenant between government and Islam'. This was literally correct. Promotions in the bureaucracy could be influenced by how often an officer prayed; and Quranic study groups, prayer sessions and evangelism became preferred pastimes in the barracks. When Maududi died, President Zia honoured the godfather of his Pakistan by attending the funeral.

The ideological net was widened. Zia issued invitations liberally to clerics from the Muslim world, and gave them time and attention. Pakistan soon became a sort of international headquarters of Islamist movements as the length of visas became commensurate with the length of beards. The West-financed-and-armed Afghan jihad against the Soviet Union added a battlefield patina to missionary zeal. Pakistan became the rest-recreation-and-rearmament zone for the multiple bands or more organized groups contesting the Russian occupation. There was plenty of money for Allah's warriors and demagogues.

Passion often outraces reason. Zia encouraged heady talk of a range of projects in the defence–offence of Islam: an Islamic fleet, a science foundation, even an Islamic newsprint industry. The handpicked Majlis-e-Shoora discussed a range of punitive measures, including death, for drug trafficking and prostitution, and advocated a Utopia without ballroom dancing, obscene books or feminine jewellery. On a more bathetic level, stand-up male public urinals were changed to squat-models on some religious excuse.

There was something in the psyche of fundamentalists that made them gender chauvinists. Women had to keep their heads covered in public. They were kept away from 'lewd' activities like sports and theatre because that could encourage sexual temptation. For a while, some mullahs even thought that the handsome Imran Khan, captain of the Pakistan cricket team, should not be permitted to rub the red cricket ball on his flannels before bowling, since this rub was dangerously close to his crotch. (He continued to do so.) More significantly, the law of evidence was amended to deny women equality. Uncorroborated testimony by women became

inadmissible in Hudood (crimes listed in the Quran) laws, leading in practice to terrible miscarriage of justice in cases of rape, for instance. A woman's signature in a financial contract required a confirmatory witness, since women were deemed to be emotional and irritable. Men apparently did not suffer from such maladies. Qazi Hussain Ahmed, leader of the Jamaat, justified this by saying that this would protect Pakistani women from the worry and trouble of appearing in court.

—∿∿∿—

The Zia–Jamaat attitude towards women reflects the teaching of conservative Deoband clerics like Maulana Ashraf Ali Thanawi and his student Maulana Muhammad Ilyas, who praised women as pious reformers of the community while condemning them to flagrant inequality. Concocted stories about the Prophet were sometimes used to reinforce gender bias. In this construct, a husband was master (*sardar*), and obedience was binding on the wife. Heaven and hell were at the pleasure of the husband, rather than a judgement of Allah. Heaven was denied to the wife if she so much as answered back.

An influential book by Maulana Ashiq Elahi Bulandshahri, a leading ideologue of the Tablighi Jamaat Movement, argues that Allah will not accept the prayers of three categories: a runaway slave (until he returns to his master); an intoxicated person; and a wife who has angered her husband.[3] Bulandshahri says that the moment a woman steps out of the house, the devil begins to accompany her. A woman has to be hidden at home more carefully than silver, gold and precious stones. She must not appear before a stranger even if the stranger is blind. To permit a woman to step out is an invitation to adultery. Women should not be allowed to adorn themselves, lest they become an object of temptation to men. This is the rationale for that social evil, the head-to-foot veil. A woman must not see what she is buying in a market if it means adjusting the veil. At home she must be the perfect slave. If she massages her tired husband's body without

being asked, she acquires merit equivalent to seven *tolas* of gold in charity; if she does so upon being asked, it comes down a bit, to only seven *tolas* of silver.[4]

The third emir of the Tablighi Jamaat, Enam ul Hasan (who died in 1995), called women 'weak' and 'emotional'. Such thinking was reflected in the social and legal norms established for women by General Zia. Many of these attitudes existed in parts of Pakistan much before Zia, principally in the tribal areas. His legislation gave them wider currency. Later, gender-slavery became central to the culture imposed by the Taliban in Afghanistan.

Zia's social legislation is best understood through the theories of his ideological mentor, Maulana Maududi. Maududi writes in *Purdah and the Status of Woman in Islam*: 'Since biologically woman has been created to bring forth and rear children, psychologically also she has been endowed with such abilities as suit her natural duties. This explains why she has been endowed with tender feelings of love, sympathy, compassion, clemency, pity and sensitiveness in an unusual measure. And since in the sexual life man has been made active and woman passive, she has been endowed with those very qualities alone which help and prepare her for the passive role in life . . .' This made a woman 'soft and pliable, submissive and impressionable, yielding and timid by nature', a sort of romantic slave.[5]

———⋘⋙———

Zia met resistance only when he began to route the collection and disbursement of *zakat* through government. This 2.5 per cent charity levy on assets and savings is obligatory on Muslims, but its disbursement is voluntary. The individual has the right to give to whoever he or she chooses. Zia turned it into a virtual tax, and used these funds to spread patronage to ideologically compatible committees.

Shias, who formed about 10 per cent of the population, opposed the decision, and held a massive rally in Islamabad that shook the

calm of a dictatorship. They were eventually exempted, but the dispute provoked sentiment and led to regular bouts of Sunni–Shia bloodshed as Sunni institutions exacted revenge on Shias for non-compliance in an arrangement that suited them splendidly. The creation of Pakistan may have ended Hindu–Muslim violence, primarily because West Pakistani Hindus left for India, but it was replaced by Muslim–Muslim bloodshed.

Islam was not a Maududist enterprise for every Pakistani, but even liberal Pakistanis found it difficult to offer a national identity without Islam, although experience suggested that it was an inadequate glue for nationalism. The Islamist objective was to cleanse Allah's country of its 'Hindu' influence and restore it to a 'pristine' Arab–Muslim region. The pressure on non-Muslims, therefore, was deliberate and calibrated.

Zia's 1985 Constitution did not leave room for ambiguity: 'Wherein the State shall exercise its powers and authority through the chosen representatives of the people; wherein the principles of democracy, freedom, equality, tolerance and social justice as enunciated by Islam shall be fully observed; wherein the Muslims shall be enabled to order their lives in the individual and collective spheres in accordance with the teachings and requirements of Islam as set out in the Holy Quran and the Sunnah.' The Blasphemy Law followed in 1986. Section 295C was added to the Pakistan Penal Code, making blasphemy against the Prophet a capital offence: 'Whoever by words, either spoken or written, or by visible representation or by any imputation, innuendo, directly or indirectly defiles the sacred word of the Prophet Muhammad shall be punished with death or imprisonment for life and shall be liable to fine.'

The law became a virtual instigation for those who wanted to harass non-Muslims with false or thin allegations. The blasphemy case against Selamat Masih and Rehmat Masih became an international scandal.[6] (A third accused, Manzoor Masih, was shot dead after a court appearance.) Selamat was a minor. They were held guilty by a sessions court, but the verdict was overturned by the Lahore High Court in December 1994.

Newsline, the Pakistani newsmagazine, has done some courageous reporting on the harassment and worse of minorities; see, for instance, its issue of April 1995 and the story 'The Price of Faith' by Tahir Mehdi and Mudassar Rizvi. It reported that alleged blasphemy was the excuse for anti-Hindu riots in March 2009 in Umarkot, one of the few remaining places with a sizeable Hindu population in Sind, where traditional harmony was still expressed in a common celebration of festivals of colour and light, Holi and Diwali.[7] On the afternoon of 11 March, word spread that someone had blasphemed the Prophet by writing his name on a road near Dr Rab Nawaz Kunbher Chowk. An eyewitness later said that it was not clear that the name written was Manoj or Muhammad, but the damage was done. There are also constant reports of conversion, some forcible, some willing, some in-between. One nasty method has been abduction of women, and then conversion prior to marriage to one of the kidnappers: the Hindu woman buys survival through conversion.

Zia repeatedly stressed (including in interviews with the author) that Pakistan and Israel were the only two nations that had been created for the defence of a faith. Pakistan, therefore, could not survive except as a model Islamic state on the lines of Nizam-e-Mustafa (Rule of the Prophet). The social order had to be driven towards the 'perfection' of the golden age of the Prophet. Zia claimed legitimacy from the Quran and the Hadith: as long as a head of state followed the injunctions of Allah, it was mandatory for subjects to be obedient. This was the logic of a caliph.

Zia often wondered what would happen to his purification regime after his departure, and could be piously pessimistic. More than a decade and a half after his death, the reformist Pervez Musharraf scrapped the Hudood ordinances in 2006, and in 2009 the Federal Shariat Court, reflecting a similar spirit, declared that drinking alcohol was only a minor offence. It decreed that punishment for this offence should only be light strokes from a date-palm stick, rather than Zia's eighty heavy lashes.[8]

But despite some correction of Zia's puritanical excesses, no

one could, in theory, challenge the march towards Sharia as the logical goal of an Islamic state. Benazir Bhutto, her family credentials and Oxford education notwithstanding, was prime minister when in 1990 a private member moved a Shariat bill, which was adopted and passed by the Senate. However, for reasons that had nothing to do with the bill, the National Assembly was dissolved before it could discuss the legislation.

Nawaz Sharif, who succeeded her, pursued the Zia agenda more loyally, for Zia was his mentor, and he fancied repositioning himself as the 'Amir' of Pakistan rather than remain a mere prime minister. He passed the Enforcement of the Shariat Bill and notified it on 8 June 1991. The act sought establishment of commissions for the Islamization of the economy, media and education. Zia's ideology had made little difference to the private-sector-driven economy, while the media shrugged and carried on as best it could. But 'Islamization' of education was a work in progress. One of Zia's most important projects was an intensified conversion of school history into anti-Hindu and anti-India distortions. India and the Hindu were converted into caricatures, with two outstanding features: cowardice and deviousness. The old chestnut, that one Muslim Pakistani soldier was equal to ten Indians, was revived, although fantasy valour never did translate into fantasy victory.

Pakistan's most curious assault, in the process of distancing itself from India, has been on its own past. Some rewriting of history was self-serving, as for instance when Bhutto added a chapter on 'Islamic history' to eighth-grade textbooks, linking the Prophet's benediction to the 'victory' of brave Pak soldiers in the 1965 war with India. Perhaps such an exalted alibi was needed for psychological confidence after Ayub and Bhutto promised triumph in Kashmir and delivered only a depressing status quo. Zia's manipulation of education, however, introduced deep, communal distortions from the primary-school level that no successor, civilian or military, has had the courage to correct. Maududi lived long enough to see a law passed by Parliament in 1976 by which every school (except for those doing O-levels)

had to follow the blueprint for studies laid down by the Curriculum Wing of the Federal Ministry of Education. Professor Shahida Kazi, writing in Pakistan's *Dawn* newspaper (27 March 2005), notes, 'So deep is this indoctrination that any attempt to uncover the facts or reveal the truth is considered nothing less than blasphemous.'

Pakistan is home to Mehrgarh, one of the world's oldest excavated settlements dating to 7,000 BC, located in Baluchistan, Harappa and Mohenjodaro, urban cities of the Indus valley civilization which flourished in the millennium between 2800 BC and 1800 BC. But, as Professor Kazi notes, 'Our [official] history begins from AD 712, when [Arab invader] Mohammad bin Qasim arrived in the subcontinent and conquered the port of Debal. Take any social studies or Pakistan studies book, it starts with Mohammad bin Qasim. What was there before his arrival? Yes, cruel and despotic Hindu kings like Raja Dahir and the oppressed and uncivilized populace anxiously waiting for a "liberator" to free them from the clutches of such cruel kings. And when the liberator came, he was welcomed with open arms and the grateful people converted to Islam en masse. Did it really happen? This version of our history conveniently forgets that the area where our country is situated has had a long and glorious history of 6,000 years. Forget Mohenjodaro. We do not know enough about it. But recorded history tells that before Mohammad bin Qasim, this area, roughly encompassing Sindh, Punjab and some parts of NWFP, was ruled by no less than 12 different dynasties from different parts of the world, including the Persians (during the Achamaenian period), the Greeks comprising the Bactrians, Scythians and Parthians, the Kushanas from China, and the Huns (of Attila fame) who also came from China, beside a number of Hindu dynasties including great rulers like Chandragupta Maurya and Asoka. During the Gandhara period, this region had the distinction of being home to one of the biggest and most important universities of the world at our very own Taxila. We used to be highly civilized, well-educated, prosperous, creative and economically productive people, and many countries benefited a

lot from us, intellectually as well as economically. This is something we better not forget. But do we tell this to our children? No. And so the myth continues from generation to generation.'

Yvette Claire Rosser, who has specialized in education in South Asia, points out that 'this blinkered approach to history was not always the case'. Till 1972, textbooks included sections on the history of the subcontinent, describing the Hindu era, the Muslim era and the colonial era. History textbooks, such as *Indo Pak History, Part I,* published in 1951, had chapters on the 'Ramayana and Mahabharata Era', 'Aryans', 'The Era of Rajputs'.[9] But the two-nation theory, the fundamental premise of partition, demanded different histories as well, even if one had to be invented in the name of Pakistan's ideology.

It is only with Bhutto and then with the active intervention of Zia ul Haq that non-Islamic history has been discarded, and worse still 'vilified and mocked and transformed into the evil other', so much so that Gandhi, whom a textbook published as late as 1970 eulogized and mentioned having died for Pakistan, began to be referred to as a 'conniving bania'. 'Islamiyat was made a required subject up until class eight.'

Marie Lall narrates the failure of efforts to reverse this trend in her essay 'What Role for Islam today?'.[10] Zia's syllabus, she says, required the teaching of 'The difference between the cultures of Hindus and Muslims; The need for an independent Islamic state; Ideology of Pakistan; The malicious intentions of India against Pakistan; The Kashmir dispute; The need for defence and development of Pakistan ... It is very clear from this that Islam plays a central role in defining the Pakistani nation as well as differentiating it from others, India and Hindus in particular. Religion was further used as a reason to present a curtailed Pakistani history. History eradicated the pre-Islamic period and started with the advent of Islam.'

When, in April 2004, Musharraf's education minister Zubaida Jalal suggested, in Parliament, changes in the syllabus and substitutions, including of some Quranic verses, that might help make Pakistanis less militant and reduce the vilification of Hindus

and other foreigners, she was shouted down by MPs, particularly of the six-party religious alliance called the United Action Forum, and lambasted in mosques across the country. It was unsurprising, adds Lall, that the first two Objectives of Education for 1998–2010 remain 'Making the Quranic principles and Islamic practices an integral part of the curricula so that the message of Holy Quran could be disseminated in the process of education as well as training and educating and training the future of Pakistan as true practising Muslims who would be able to enter the next millennium with courage, confidence, wisdom and tolerance'.

—⋘∾⋙—

Zia was the ultimate fusion of military and mullah, interrupting meetings if necessary for his obligatory namaaz five times a day. He stripped Sindhi Hindus of many of their rights as citizens and targeted Christians even as his government fattened on largesse from America in the name of a jihad against the Soviet Union. His legacy lives in what children are taught, as for instance in the textbook of Social Studies, Grade VII (Sindh Textbook Board, 1997), that Hindus are backward, superstitious, burn their widows and given the chance would deprive Muslims and lower castes of education by pouring molten lead in the ears.

This revisionism had to include the dapper Jinnah who had invited an array of grand guests to a lunch in honour of Lord Mountbatten on the day Pakistan was born, 14 August 1947, unaware that Muslims were fasting because it was the holy month of Ramadan. He was recast, in 'Pakistan Studies', a compulsory course for students from Class 9 to first year in college, as an orthodox Muslim who wanted a theocratic state. Jinnah also had to share ownership of the concept of an Islamic state with Aurangzeb, the sixth Mughal emperor, hated by Hindus because he imposed the jiziya on non-Muslims. There was a further leap backwards to the Arab invader Muhammad bin Qasim, who established the first Muslim kingdom on the subcontinent in 712 and upon whose 'departure from Sindh, the

local people were overwhelmed with grief'.[11] In popular lore, Qasim is less benevolent – he is believed to have beheaded every man over eighteen who might become a potential soldier of the local cause, and sent thousands of women to the harems of Baghdad.

History disappears for three centuries and reappears with Mahmud Ghazni, who is glorified because he destroyed the Somanath temple in 1025. Ghazni is lifted to a martial-missionary who brought the 'light of Islam' to 'pagans' through 'holy jihad' and 'blew the idol into pieces. The success was a source of happiness for the whole Muslim world'.[12] The metaphor might be misguided since Ghazni was not known to carry gunpowder. There is no evidence that Baghdad cared one way or the other about the destruction of a temple in remote India. The value of a Muslim icon seems to be in direct proportion to the anger he arouses among Hindus.

Another few generations elapse before Muhammad Ghori defeats Prithviraj Chauhan in 1192 to establish the first Muslim state in the Indian heartland. Then, inexplicably, we have to wait till 1526 for Babur to establish the Mughal Empire. The Turko-Afghan Sultans of the interim centuries, also Muslims, are underplayed. Akbar, the most famous of Mughals, is expectedly derided as an apostate and enemy of Islam; while Aurangzeb, who created conditions for decline, is venerated because of his alleged simplicity, piety and, most of all, his decision to inflict multiple economic and emotional wounds on Hindus.[13]

The glory of jihad is a constant drumbeat of Zia's school history. M. Ayaz Naseem writes in his essay 'Textbooks and the Construction of Militarism in Pakistan'[14] that 'no scientists, artists, social workers, journalists or statesmen are deemed worth of inclusion' among the heroes in textbooks; 'military heroes are the only heroes. Civilians, minorities and women are simply absent'. He adds, 'A class 5 Urdu textbook (2002), for example states that, "Hindu has always been the enemy". This reinforces the message contained in the Urdu textbook for class 4 (2002), which wants the students to understand that the Indians/Hindus are scheming

and conniving people. A class 4 Social Studies textbook (2002) tells the students that it is the Hindu religion that makes them so as it does not teach them "good things".'

Although it is well known that jihad is not among the five basic principles of Islam (which are faith, prayer, fasting, charity and haj), and armed conflict is only one of over fifty kinds of jihad, textbooks glorify combat as the only form of jihad worth attention. 'The curriculum documents further direct the writers,' notes Naseem, 'to include/write stories about martyrs of Pakistan in order to incite jihad, create love and aspiration for jihad, *tabligh* [prosyletization], *shahadat* [martrydom], sacrifice, *ghazi* [victor of war] . . . and that the students are taught to make speeches about the primacy and importance of jihad.'

There is a thin line, often smudged, between such strident advocacy of jihad as a duty, and jihad as an excuse for aggression. Pakistan's first significant decision, within weeks of freedom in August 1947, was to start a jihad for Kashmir, when the negotiating table had a chair for the British as well. It was not Zia who made jihad the central determinant of Pakistan's India policy; this began in the autumn of 1947, when leaders like Jinnah and Liaquat Ali Khan sent irregular combatants to begin a war that has become a corrosive, nuclear millstone around the neck of southern Asia.

13

The Long Jihad

—⟨ళ⟩—

Jihad was the first child of the two-nation theory. Pakistan had some reason to feel aggrieved when the status of geographically contiguous, Muslim-majority princely state Kashmir, ruled by a Hindu Maharaja, Hari Singh, was left indeterminate in August 1947. 'K' stood for 'Kashmir' in the acronym, PAKISTAN. The liberation of Kashmiri Muslims from an 'infidel' quickly became the first 'religious duty' and fit cause for jihad.

Maharaja Hari Singh added a singular twist to the two-nation theory by projecting a three-nation possibility. He delayed accession to either India or Pakistan in the hope of acquiring a unique or separate status, although independence was not on offer within the legal framework of transfer of power. Every princely state was bound to opt for either India or Pakistan. In south India, there was a similar variation, when the Muslim nizam of Hyderabad, ruler of a Hindu-majority state, declared independence and sought a security pact with Pakistan. India ended Hyderabad's pretensions with armed action in late 1948. Kashmir became the provocation for war without an end.

India and Pakistan might have claimed freedom in 1947, but legally they were dominions of the Empire until their Constituent

271

Assemblies passed a Constitution on the basis of which they could
become independent republics. Britain retained a presence on the
subcontinent till the summer of 1948 in the person of the last
viceroy, Lord Mountbatten, who continued as head of the Indian
government with the title of Governor-General and chaired the
powerful defence committee of the Indian Cabinet. A British
citizen could be a functioning member of the executive and polity
only because of dominion status.

Nehru expected difficulties over Kashmir. In April 1947, he
told Mountbatten that he would prefer discussions on Kashmir
after the spring thaw of 1948, although he was apprehensive that
Pakistan might pre-empt the situation by military intervention.
Mountbatten records this in a telegram to the Earl of Listowel,
secretary of state for India, dated 29 April 1947, on the
arrangements for the Gilgit subdivision of Kashmir, administered
by Britain since 1935 under a sixty-year agreement: 'But Nehru
has suggested that the question of terminating the agreement be
reconsidered next Spring when the nature of Kashmir's relationship
to the Union of India will be much clearer.'[1]

Within six weeks of partition, Nehru had credible information
that Pakistan was contemplating military action to seize the
Kashmir valley instead of waiting for a dialogue process. On 27
September 1947, he wrote to his colleague, Home Minister
Sardar Vallabhbhai Patel, warning that Pakistan was making
'preparations to enter Kashmir in considerable numbers ... I
understand that the Pakistan strategy is to infiltrate into Kashmir
now and to take some big action as soon as Kashmir is more or
less isolated'. Snow was inevitably a vital strategic consideration
and in 1947 the first heavy snowfall was expected by November.
The logical deadline for war was October/early November.

Pakistan's rush to war can be explained, partly, by its deep
distrust of Mountbatten. This was compounded by popular
optimism born from the success of the Pakistan movement, a
sense that if Pakistan could be created by the sheer willpower of
Muslim opinion, anything was possible. The rhetoric that
accompanied the unacknowledged preparations for a jihad in

Kashmir sounds contemporary. In 1947, religious leaders like the Pir of Manki Sharif publicly announced a reward of houris in heaven for martyrs and hard cash for survivors of the jihad for Kashmir. The plan was to send hordes of raiders collected from the Frontier tribes to simulate a 'spontaneous uprising' within the Kashmir valley. Pakistan was indifferent to the fact that the pre-eminent leader of Kashmiri Muslims, Sheikh Muhammad Abdullah, did not seem particularly enthusiastic about merging with an Islamic Pakistan, and publicly said that he would prefer to remain within the secular and socialist ethos of India.

Exporting jihad, however, became the Pakistan government's first substantive project. Prime Minister Liaquat Ali Khan approved funds and weapons for an invasion of Kashmir. The serving army officer in charge of the operation, Colonel Akbar Khan, took on the revealing nom de plume of General Tariq, after Tariq bin Zayed, the Berber hero who invaded Spain in 711. (Gibraltar is a corruption of Jebel el Tariq, or Hill of Tariq.)

The most recent, and best, historian of the Pakistan army, Shuja Nawaz, quotes Col. Akbar Khan's memoir to confirm the linkages.[2] In September 1947, Col. Khan, then director of weapons and equipment at General Headquarters in Rawalpindi, met Sardar Mohammed Ibrahim Khan, a Kashmiri lawyer–politician who believed that peaceful negotiations with the maharaja or India would be futile (in fact, they had not even begun), and wanted 500 rifles for a rather modest liberation force. Col. Khan reported this conversation to his political masters, rather than services hierarchy, since Pakistan's armed forces were still under the command of British officers (as was the case in India). British officers were under unofficial instructions from London to keep out of Indo-Pak disputes. Liaquat Ali Khan presided over a day of meetings, during which Finance Minister Ghulam Mohammad was also present for a while. 'General Tariq' was given permission to proceed with his Kashmir offensive on condition he screened out all traces of official involvement. 'General Tariq' commandeered 4,000 rifles sanctioned for the Punjab police, then beleaguered by riots, and some condemned ammunition, to implement a plan he called 'Armed Revolt inside Kashmir'.

In Rawalpindi, Col. Khan briefed the deputy director of Military Intelligence, Colonel M. Sher Khan. By 10 October 1947, according to Shuja Nawaz's nugget-filled account,[3] Sher Khan had prepared a secret two-and-a-half-page assessment of the possible problems and advantages in case of an October offensive in Kashmir. Bad weather, he believed, would block an Indian response till spring 1948.

Shuja Nawaz notes, 'Given the nature of the Prime Minister's relationship with Mr Jinnah, it seems unlikely that all this planning was being done without Mr Jinnah's tacit approval although there has been some debate among Pakistanis about this issue. Regardless, a plan was approved by the prime minister and action initiated.' Akbar Khan was posted as military adviser to the prime minister after hostilities began.

Karachi, then capital of Pakistan, began to stoke up a mood of impending crisis in early October with a telegram to the Kashmir government warning that 'the situation is fraught with danger'. British civil servants posted on the Frontier knew what was going on. Sir George Cunningham, governor of NWFP, wrote in his diary on 17 October 1947 that a member of his staff told him that 'there is a real movement in Hazara [a tribal district] for a jehad [sic] against Kashmir. They have been collecting rifles and making a definite plan of campaign, apparently for seizing the part of the main Jhelum valley above Domel.'[4] Cunningham predicted that it would lead to war between India and Pakistan. Days before the invasion, Pakistan set up an economic blockade, preventing essential supplies from entering Kashmir.

Before first light on Thursday, 23 October 1947, according to Shuja Nawaz, about 2000 tribesmen, mainly Afridis from Khyber and Mehsuds from Waziristan, 'aided by the Kashmiri-born Chief Minister Khan Abdul Qayyum Khan and the commissioner of Rawalpindi division Khwaja Rahim', crossed into Kashmir through the Jhelum valley. Pakistan's acting commander-in-chief, Lt Gen Sir Douglas Gracey, informed his counterpart in Delhi, General Rob Lockhart, of the incursion. On the night of 24 October, Nehru interrupted an official dinner to pass on the news to

Mountbatten; in Nehru's estimate, about 5,000 tribesmen were already in the Valley, with advance units only thirty-five miles from Srinagar. The punctilious Mountbatten, as both Governor-General and chief of the defence committee, insisted on proper paperwork before ordering a military response. A senior official, V.P. Menon, was sent to Kashmir immediately. On 26 October, the maharaja of Jammu and Kashmir signed a document of accession to India. Indian Army units were airlifted to Srinagar airport, which they managed to save at the last possible moment.

Why didn't Pakistan use regular forces instead of amateurs who wasted time in rape and plunder en route to a virtually defenceless Srinagar? Lt Gen Gul Hassan Khan, who was ADC to Jinnah in 1947, answers this question in his autobiography *Memoirs*. On 27 October 1947, Jinnah called on Liaquat Ali Khan in Lahore. They met in Liaquat's bedroom since the latter was indisposed (he had had all his teeth removed). Sir Francis Mudie, governor of Punjab, pointed out that the tribesmen were already proving a liability. Jinnah wanted a composite regular Pak force to secure Srinagar's airfield to thwart an Indian response, and back up the offensive with a sizeable reserve. Mudie conveyed this decision to Gracey from the Governor's House in Gul Khan's presence. Gracey refused to obey. He wanted permission from Field Marshal Sir Claude Auchinleck, supreme commander, which was not forthcoming.

In a parallel diplomatic joust, Jinnah seized on the plebiscite clause in the terms of Maharaja Hari Singh's accession to India and invited Mountbatten and Nehru to Lahore for talks on its immediate implementation. Nehru did not go, but Mountbatten arrived on 1 November. Jinnah offered a three-point solution: both governments should proclaim a ceasefire within forty-eight hours; Indian forces and the tribesmen should withdraw; the Governors-General of India and Pakistan should set up a joint administration to hold a plebiscite. It is interesting that Jinnah was accepting responsibility for the tribesmen, who still constituted, in official parlance, a 'spontaneous' internal 'uprising'.

The other points suited Jinnah; withdrawal of Indian forces would ensure Pakistan's strategic dominance over the Kashmir

valley. Mountbatten rejected this, but, on the spur of the moment, suggested that the United Nations would be better suited to supervise a plebiscite.[5] Nehru could hardly afford a public confrontation with his own Governor-General, and concurred the next day. Then he began picking holes in the proposal. When Liaquat formally accepted UN supervision on 16 November, Nehru responded by saying that he did not think the UN had enough troops to push the invaders out; only Indian forces were capable of that. On 12 December 1947, Nehru sent a cable to Karachi saying the UN could only have an advisory capacity. On 1 January 1948, India did refer the matter to the United Nations, but ordered its troops to continue operations. Nehru kept piling on stipulations during speeches in Parliament and interviews. The 13 August 1948 UN resolution asked India and Pakistan to agree on a ceasefire within four days and told Pakistan to withdraw its troops 'as the presence of troops of Pakistan ... constitutes a material change in the situation'; an evacuation of Indian troops would follow. The ceasefire came a minute before midnight of 1 January 1949, but India had already been given the perfect loophole for continued presence. Since Pakistan did not withdraw its troops, neither did India.

Pakistan lost the military initiative within days of its invasion in October 1947. The behaviour of the tribesmen was unforgivable, in both human and military terms. They entered Baramulla on 26 October, and could have continued to a defenceless capital, just thirty-five miles down an open road. Instead, the holy warriors stopped to loot, rape and kill. An Indian nun, Philomena, was shot while trying to protect a Kashmiri woman who had just given birth from being raped. Nine other nuns were shot at St Joseph's convent. One Kashmiri shopkeeper, Sherwani, who organized some resistance, died when nails were driven through his palms in the public square because he refused to say that Kashmir belonged to Pakistan. Barbarism continued even after the war became more formal. When Indian troops took Rajouri in April 1948, they found a devastated city full of dead and dying, and girls who had been raped multiple times.

By 5 November 1947, the tribesmen, now significantly less enthusiastic about either martyrdom or hard cash, had been driven back to Uri. On 4 December, at a meeting in the Circuit House, Rawalpindi, Liaquat authorized direct participation of the Pak army, but it was only in April 1948 that Pak army units were in the field. The story of the war, the reference of the dispute to United Nations, the promise of a conditional plebiscite, and, on 1 January 1949, the declaration of a ceasefire along a line that has held till today, has been told often enough. What remains inexplicable is Nehru's acceptance of a ceasefire when, by Gracey's admission, the Indian Army had the advantage and could have gained more territory. It is generally believed that the reference to the UN was Nehru's worst blunder; the Indian Army believes, although it is too disciplined to say so publicly, that the ceasefire was a colossal mistake.

—◦∾∾◦—

Ceasefire did not end the conflict, although the proxy war of the 1950s seems amateurish compared to twenty-first-century terrorism. Col. Akbar Khan, according to his autobiography, devised a second plan titled 'What Next in Kashmir?' followed by 'Keep the Pot Boiling in Abdullah's Kashmir' (Sheikh Abdullah had taken over after the maharaja resigned). The first paper prophesied that India would never hold a plebiscite, and the second suggested a strategy: not direct war, but military training and guns to Kashmiris on the Pak side of the ceasefire line who could then be exported across the divide to operate as a 'people's militia' against India. Liaquat Ali Khan sanctioned a million rupees for the project. Sten guns and cartridges were purchased.

In 1956, Khan wrote yet another paper, arguing that only a revolt within Indian Kashmir would nudge the United Nations Security Council. If India responded with an all-out war, the world would be 'forced' to rush to Pakistan's help. Iskander Mirza was president, and heard him out. Khan wanted 1,000 young men, half in the field and the rest in reserve, armed with

knives, guns and dynamite to blow up unprotected bridges, unguarded transport and generally inflict damage. There were periodic explosions in the Valley and, on 28 June 1957, the Palladium cinema in Srinagar was blown up. These proved to be flea bites on the Indian presence in the Valley.

There was only one period of four months, between December 1962 and March 1963, when there could have been a peaceful, negotiated settlement of the Kashmir dispute. India had just been humiliated in the autumn 1962 war against China, changing equations in the region. Pakistan used the Indo-China breach to its advantage, ceding China's border claims in Kashmiri territory under its control to initiate an alliance that has held for more than four decades. Britain and America persuaded Pakistan not to open a second front while Indian troops were retreating along the Himalayas in 1962, and Pakistan wanted compensation for good behaviour.

Bhutto, then Ayub Khan's young foreign minister, led the Pakistan delegation; the elderly Swaran Singh headed the Indian side. Talks were held in Rawalpindi, Delhi, Karachi and Calcutta. Both sides agreed that Kashmir should be divided, and India offered 1,500 square miles to seal the deal. Bhutto was contemptuous of this gesture from a 'defeated nation'. He demanded the whole of the Valley, graciously leaving only the small district of Kathua for India. Ayub Khan was equally overconfident. He truly believed an old bit of self-delusion, that Hindus could not fight.

India, relieved that such a generous offer had been rejected, and the Western powers placated, continued the process of gradual legal integration of Kashmir into the Union of India. It weakened Kashmir's special status by diluting Article 370 of its Constitution, through which Kashmir had become part of India. Pakistan prepared for its second war for Kashmir.

General Gul Hassan Khan, former chief of staff of the Pak army, reveals that in 1964 Ayub Khan ordered General Headquarters to prepare plans for a two-stage offensive. In the opening move, saboteurs would enter Kashmir; regular troops would follow-up

at the appropriate moment to support the 'guerrillas' injected into Indian Kashmir. The assumption was that Kashmiri civilians would rise when they saw Pak troops, while fear of China would prevent India from enlarging the scope of the war. Major General Akhtar Malik set up ten groups of 500 each, with names like Khalid [bin Waleed], Tariq [bin Zayed], [Muhammad bin] Qasim, Salauddin [Ayyubi], [Mahmud] Ghaznavi, [Alauddin] Khilji and Babur, all Arab or Turko-Afghan warrior-heroes, in the hill town of Murree, adjacent to Kashmir. The code name was Gibraltar, echoing 1947.

In February 1965, ISI, or Inter-Services Intelligence, briefed Ayub Khan, Commander-in-Chief Musa Khan, Bhutto and Foreign Secretary Aziz Ahmed on the merits of the plan. Air force and navy chiefs navy were not invited, in order to limit the possibility of a leak, and because a wider war was not anticipated. Bhutto wrote a persuasive letter to Ayub making the point that if Pakistan did not act 'boldly and courageously' the initiative would shift to India, which would then 'liquidate' Pakistan at a time of her own choosing. This view prevailed.

On 13 May, Major General Malik gave Ayub Khan a detailed assessment of Gibraltar, and received the president's signed assent. Ayub Khan told Malik that he should concentrate on taking the town of Akhnur; that would be the strategic blow, cutting off Indian troops in the Valley from India. Malik was given extra units under his command.

The green signal came on 24 July. On 8 August, covert groups began to infiltrate across the ceasefire line. India was surprised but recovered quickly. Kashmiri Muslim herdsmen gave the first information about infiltration to the Indian Army. Only the Ghaznavi brigade had some success; the others were eliminated or dispersed. In its counteroffensive, India seized the vital Haji Pir pass in Pakistan-controlled Kashmir on 28 August. Grand Slam fell short of a few tricks; it was always an overbid.

On 29 August, Ayub Khan signed a directive, sent to his foreign minister and commander-in-chief, titled 'Political Aim for Struggle in Kashmir' in which he predicted that 'As a general rule Hindu

morale would not stand more than a couple of hard blows at the right time and place'. But he did warn that India might extend the front to a general war. On 31 August, the Pak armed forces launched Operation Grand Slam.

Hindu morale did not collapse, and Muslim soldiers in the Indian Army displayed equal valour in battle: the great Indian hero of the war was a Muslim, Abdul Hamid, a havildar, a trooper. The Indian government and media, however, were deeply suspicious about the loyalty of non-Kashmiri Indian Muslims. Lurid 'spy' stories appeared in newspapers, of fifth columnists directing Pakistan air force planes with the help of torchlight and poisoning the water supply. Delhi ordered any influential Indian Muslim with a Pakistan connection, which meant anyone with a relative who had opted for Pakistan in 1947, interned; and the whole community was put under the dragon-watch of intelligence services.

Akhnur did not fall; Malik's assault was blocked at the Munuwwar gap. One Muslim soldier did not prove to be the equivalent of ten Hindu soldiers, as Pakistani officers had told their men since 1947. On 2 September, Malik was removed from the battlefront, and at 3.30 a.m. on 6 September, India crossed the international border at Lahore. When fighting stopped on 19 September, India had occupied 740 square miles against 210 square miles gained by Pakistan. Pakistan would have got 1,500 square miles of Kashmir territory if it had accepted Swaran Singh's offer in 1963.

Defeat shocked the Pakistan establishment and street; both had been led to believe, through state-sponsored propaganda and media hysteria, that invincible Muslim armies were on the verge of crushing Hindus and raising the Pakistan flag over Srinagar. Instead, in January 1965, Ayub Khan was forced to accept a no-war pact with India at Tashkent. The two countries exchanged land taken across both the international border and the Ceasefire Line, thereby confirming its position as the defining border in Kashmir. What was left of Pakistan's military and civilian morale collapsed after the third Indo-Pak war, which led to the formation

of Bangladesh in 1971, when 91,000 Pak troops surrendered to
a jubilant Indian Army in Dhaka.

———*ᴗᴗᴗ*———

Pakistan lost the will for another conventional war against India,
but it did not lose the will for Kashmir. In a sense it could not,
because to accept Kashmir as part of India was to deny the
rationale for the creation of Pakistan. The 'liberation' of Kashmiri
Muslims from 'Hindu tyranny' was a religious duty as much as a
national cause. Clerics continued to call for a Kashmir jihad
across thousands of pulpits in the network of seminaries, mosques
and shrines. Terrorists continued to get support from the Pak
army. About eighty underground cells, it is estimated, were
funded by ISI during the six years between 1965 and 1971, the
most effective being the Al Fatah and the Plebiscite Front. In
1969, an Indian Airlines aircraft was hijacked, with a toy pistol.

When General Zia, who came to power in 1976, felt confident
enough to pick up dormant threads of the Kashmir project, some
significant shifts had occurred in the regional and international
environment. On the debit side, Pakistan's big battalions were not
available any more as the second prong of an uprising-cum-
invasion strategy. But this was more than compensated by the
upside. The Soviet Union had stepped into Afghanistan; suddenly,
the muscle and money of the West and the Muslim world were
mobilized on Pakistan's side as it became base and sanctuary for
war against the Soviet Union.

Pakistan could now pursue jihad against both its neighbours,
Afghanistan and India. India was the only Soviet ally in South
Asia; ipso facto, anything that kept India on the defensive would
be welcome in Washington. The internal situation in India
deteriorated sharply after 1980. A serious Sikh insurrection in
Punjab unnerved Delhi, with tragic consequences in 1984, a
traumatic year during which the Indian Army destroyed the
holiest Sikh place of worship, the Golden Temple, Sikh bodyguards
assassinated Indira Gandhi and there were murderous anti-Sikh

riots in Delhi and elsewhere in retaliation. In Kashmir, the harmony that Sheikh Abdullah had brought to politics was punctured after his death on 8 September 1982. Delhi used blatantly undemocratic methods to topple his son Farooq from office.

Zia did not know that the future would be so promising when, in 1980, he reactivated clandestine moves against India, even as he made all the right noises at the official level and warmed up people-to-people relations with cricket diplomacy. He had been held back since 1976 for many reasons, not the least of them being his personal unpopularity in Kashmir. Indian Kashmir shut down in protest when he hanged Bhutto. But by 1980, Bhutto was a memory, and Zia was in control.

Zia changed the dynamics of the Kashmir confrontation when he outsourced the jihad to Jamaat-e-Islami and similar ideologically motivated groups. It was not merely a shift from quasi-state actors to non-state actors; the arm's length approach was useful for deniability, but gave more flexibility to those who knew how to use it. But it also introduced a new element in the struggle, for the purpose was no longer limited to 'liberation' of Kashmir from 'Hindu India' but included the conversion of Kashmir into 'Islamic space'. Kashmiri nationalists could be, and often were, secular, with an equal place for Kashmiri Hindus in their construct. Moreover, most of them sought independence, not merger with Pakistan. Jamaat, and Jamaat-influenced, fighters wanted a Kashmir cleansed of Hindu 'perfidy' and presence. In 1992, they were instrumental in driving Kashmiri Hindus out of the Valley and into refugee camps in Jammu and Delhi.

Zia's thesis was that while Pakistan could not afford a conventional war with India, India would never negotiate without the pain of unconventional war. He was, however, careful since he knew that the army, which was in power, would be overthrown by popular anger if it suffered another military setback against India. In 1987, for instance, he stalled and then shelved a plan to open an offensive on the heights of Kargil, a strategic vantage point much desired by some of his fellow-generals. By then, his clandestine war was in top gear.

The Jamaat-e-Islami, predictably, was Zia's nodal point in the splinter offensive. Its commitment to both Kashmir and Islamism was unquestionable. It was well organized in both parts of Kashmir. Although its presence extended to the whole subcontinent and beyond, each Jamaat unit (India, Pakistan, Bangladesh, the two Kashmirs and Britain) was free to take decisions independently. The Jamaat had proved its usefulness as an adjunct of the armed forces during the crackdown against Bengalis who had taken up arms for Bangladesh in 1971. The students' wing, Islami Jamaat-e Tulaba (IJT), worked as both an information gathering and hunter-killer support system that year in East Pakistan, operating under names like Al Badr and Al Shams.

In Indian Kashmir, the Jamaat was set up by Said ud Taribali, the first amir, Qari Saifuddin and Ghulam Ahmad Ahrar. The Jamaat chief in Pakistan-occupied Kashmir, Maulana Abdul Bari, met Zia in early 1980. 'According to Bari,' writes Arif Jamal, 'the general stated his intentions plainly: he had decided to contribute to the American-sponsored war in Afghanistan in order to prepare the ground for a larger conflict in Kashmir, and he wanted to involve the Jamaat-e-Islami of Azad Jammu and Kashmir. To the general, the war in Afghanistan would be a smokescreen behind which Pakistan could carefully prepare a more significant battle in Kashmir. The general said he had carefully calculated his support for the American operation, predicting that the Americans would be distracted by the fighting in Afghanistan and, as a result, turn a blind eye to Pakistani moves in the region.' Bari claims he was sceptical. But Zia was persuasive: how could Americans, he pointed out, stop 'us from waging Jihad in Kashmir when they themselves are waging Jihad in Afghanistan?'.[6]

Zia also wanted Bari to help mobilize international opinion through Islamic organizations. Bari used his connections with the Rabita Alam Islami (Muslim World League), based in Saudi, to do just that. Zia told Bari that the biggest share of funds would go to that Afghan group which trained the 'boys from Kashmir'.

Bari then applied for a visa to visit Indian Kashmir, ostensibly to meet his family. India obliged, if only to find out whom he would contact. Bari believed that he managed to elude intense

intelligence scrutiny and spoke to his counterpart, Maulana Saidudin Taribali, in secret, in a small village called Ajis. His message was uncomplicated: the Pak army would not start a war to liberate Kashmir, but ISI would pay the bills for an armed uprising. Maulana Taribali did not seem convinced; he felt that no action should begin until success was assured.

In September 1982, Jamaat leaders from Indian Kashmir were taken for a secret visit to Pakistan via Saudi Arabia, which was their official destination. According to Jamal, 'Their plan was the product of many conversations, but it lacked detail. The strategy was jihad – a holy war waged against Indian oppression, a campaign for "freedom". Members of Jamaat-e-Islami were to return to Indian-controlled Kashmir and begin the recruitment of young Kashmiris – who would, the plan went, be sent at first opportunity for military training.' It took a personal conversation in 1983 between Zia and Maulana Saidudin to convince the latter. When the first group of Jamaat volunteers crossed the Ceasefire Line to get 'military training', the maulana's son was among them. Jamal reports that Kashmiri 'boys' were trained at the Khalid bin Waleed, Al Farooq and Abu Jindal camps (in 1998, Osama bin Laden held a press conference at Abu Jindal). A nexus was established, which has survived dramatic shifts in the political mood of Kabul, Islamabad, Delhi and Srinagar.

In 1983, Kashmir's jihadis were encouraged by the fact that the Sikhs in Punjab had mounted a major challenge to the Indian state under the leadership of Sant Jarnail Singh Bhindranwale, and it seemed possible that India could be lopped off north of Delhi. The ISI extended the front by supporting militant organizations like the Jammu and Kashmir Liberation Front (JKLF), which had no desire for either an Islamic state or merger with Pakistan, as liberally as it supported Jamaat and its armed wing, the Hizbul Mujahideen. By 1988, the JKLF had some 300 sleeper cells in the Valley, with an estimated 10,000 fighters trained by Pakistan. Sabotage, bomb-explosions, kidnapping and assassination became a routine part of news from Srinagar.

The death of General Zia, through a mysterious explosion on Pak One, the official plane of the president, along with ISI chief General Akhtar Abdur Rehman and American ambassador Arnold Raphael, was a setback for the Jamaat. But Pakistan policy towards Kashmir remained reasonably consistent under Benazir Bhutto, who became prime minister at the age of thirty-five in 1988. Non-Jamaat groups like JKLF got greater support, but ISI also set up small groups like Zia Tigers (named after the late general, of course), Ansarul Islam and Al Hamza who were close to Jamaat. A meeting was held on 11 June 1989 in Budgam district to consolidate such ideologically motivated units into a more substantial force, loyal to Jamaat and Pakistan, called Hizbul Mujahideen (Party of Holy Warriors). Early in 1990, ISI felt confident enough about Hizbul to cut off funds to JKLF.

There was much confusion, and more bloodletting, but eventually a jihadi called Syed Salahuddin brought the bulk of fighters under the control of the Jamaat. The difference between JKLF and Hizbul Mujahideen is best described by their slogans. JKLF demanded *azadi* (freedom). The Hizb slogan was *Azadi ka matlab kya? La e la ha il Allah!* (What is the meaning of freedom? There is one God and His name is Allah!). There were thousands of casualties in internecine battles, and although the Indian security forces were remorseless, there were times when civilian Kashmiris preferred the sanctuary of Indian Army camps to escape Hizbul excesses.

The Pak army made one serious effort to exploit strategic advantage out of such conditions, when it tried to seize the heights of Kargil in 1999, hoping to sabotage, in the process, a brave effort made by Indian Prime Minister Atal Bihari Vajpayee and his Pak counterpart Nawaz Sharif for peace. Pakistan was once again defeated in battle and humiliated diplomatically when President Clinton forced a complete withdrawal of its troops and surrogate forces.

This did not deter the jihadis. The clandestine war was revived with brutal effectiveness, and with additional players like Lashkar-e-Tayyiba and Jaish-e-Muhammad. On 22 December 2000, the

former group attacked the Red Fort in Delhi. This was followed up by an even more daring display of terrorism, on 13 December 2001, when India's Parliament escaped destruction thanks to courageous policing and some luck. India blamed both Lashkar and Jaish.

Pervez Musharraf had taken over by then, through a coup; and 9/11 altered the geopolitics of the region once again. Under severe pressure from Washington, Musharraf made a famous speech on 12 January 2002, promising 'enlightened moderation' and banning five terrorist organizations, including Lashkar and Jaish. There was much praise in America as thousands were arrested and hundreds of offices raided. But within twelve days, by 24 January, the police began releasing those detained using a familiar excuse: not enough evidence. Sceptics described Musharraf's policy as moderate enlightenment.

When pressed, Pakistan explains the neither-war-nor-peace strategy by the 'root cause' theory: as long as the root cause, Kashmir, is not addressed, violence will continue since terrorists cannot be fully controlled by the state. The Indian suspicion is that the Pak is not doing much against those who threaten India. A new level of atrocity was scaled in Mumbai in November 2008, when a Lashkar-e-Tayyiba operation struck at Indians in hotels and a railway station and Israelis in a Jewish home. The consequences – threats of war by India, the promise to cooperate by Pakistan, the absence of 'evidence' to justify the slow pace of legal action and the diplomatic push to return to 'normalcy' and discuss Kashmir – followed a pattern that has been visible in the past. By 2009, America was urging Delhi to settle its disputes with Pakistan, not in response to the 'root cause' argument, but in pursuit of its own needs: it could not fight in Afghanistan alone. It bought, at least partially, into Islamabad's argument that the Pakistan army could not be fully effective against America's enemies in Af-Pak if its back was vulnerable to India. By this time, Pakistan itself was under siege from holy warriors it had created for Afghanistan and India.

The crux of the problem is absence of negotiating space on

Kashmir. Pakistan wants a change in the status quo, arguing that anything less would mean that the struggle of the last six decades was worthless. India would happily close the dispute at the point where it was frozen in 1948, by converting the Ceasefire Line into the international border; there is no public or political appetite in Delhi for any further concession.

This impasse leaves the road open for continued jihad.

14

Pakistan: The Siege Within

—◦◦◦—

General Zia ul Haq was not playing to any fundamentalist gallery when in 1976 he changed the motto of the Pakistan army to *Jihad fi Sabil Allah.* He believed that only Islam could resurrect a force traumatized in combat with its mortal foe, India.

In 1947, Pakistani troops asserted their independent identity by daubing 786 on barrack gates and vehicles: 786 represents the numerical value of the opening line of the Quran, *Bismillah ir Rahman ir Rahim* (In the Name of Allah, the Merciful and the Compassionate). In Zia's view, such tokenism was inadequate, and even counterproductive. Pakistan had been corroded to the point of fragility by a westernized officer-class that enjoyed Scotch and ballroom dancing, and could attain its potential strength only through the values of Islam. Allah had not forsaken the Pakistan army; the army had forsaken Allah.

It did not take him very long to grasp the extraordinary opportunity created by the Soviet occupation of Afghanistan in December 1979; now, the Pak army could not only live up to its motto, it could also expand its scope from the limited theatre on the Indian front into an international cause financed and armed, ironically, by America. Zia sought to turn Afghanistan into a

regional asset that was surrogate to his principal purpose, which was to turn Pakistan into a fulcrum for the revival of the Muslim world.

Relations between Pakistan and Afghanistan were blighted by a border dispute that dates to a British decision in 1893, when a Raj civil servant, Sir Mortimer Durand, imposed a frontier between tribals who had never recognized one before. The Afghan Amir Abdur Rahman could do little about this so-called Durand Line except record his resentment. The eminent scholar Vartan Gregorian notes, '. . . caught between Russian pressure, British intransigence, and his own unwillingness and unpreparedness to start a war with the government in India . . . the Amir renounced Afghanistan's right to intervene in the tribal belt. The Durand Line divided the allegiance of many tribes, without regard to the ethnography of the region. It demarcated a no-man's land, which became a haven for Afghan tribal chieftains and sometimes even for entire clans . . . The Durand Agreement had other serious consequences for Afghanistan. It gave the British control of the border passes and thus the power to prevent Afghan nomads from entering India or re-entering Afghanistan. With this diplomatic and economic weapon, the authorities in India believed they could induce the Afghans to compose any differences they might have with the British Government.'[1]

Abdur Rehman signed the agreement, but not the official boundary maps. The snide British response was that the amir did not understand maps but was too conceited to admit it. Mixing metaphors for such rocky territory, Kabul maintained that Durand was a line drawn in water. Such was the sustained animosity that, half a century later, Afghanistan was the only country to oppose Pakistan's application for membership of the United Nations in 1947.

This tension helped buttress Pakistan's case that it had inherited British India's geo-strategic role as guardian of the Indian subcontinent against predators from an inconsistent Afghanistan and Soviet-controlled Central Asia, without possessing the size or strength of British India. There was increasing sympathy for such

logic as the Cold War intensified, and the Soviet Union became a far bigger threat to Western interests than Tsarist Russia had ever been to British India. Khyber is only the best-known of many passes that connect Afghanistan to the Indian subcontinent. Alexander and Taimur marched through Khwak, Chengiz Khan used Shibar, and Babur entered the plains via Kipchak. Once they occupied Kabul in 1979, the Russians had unimpeded access from the Oxus, through the Salang pass, to Khyber.

—✺—

Pakistan's efforts to create a powerful lobby in Kabul had begun long before the Soviets arrived. The defeat of the Pak army in 1971 and the formation of Bangladesh lent urgency to the theory of 'strategic depth'; in sum, if India managed to repeat in the west what it had achieved in the east, Pak forces would need more space at the back for their counteroffensive. This in turn required a friendly if not pliable Kabul. Islam, propped up by cash, became the instrument of choice in Pakistan's post-1971 Afghan policy.

In 1972, Burhanuddin Rabbani, a Tajik professor of theology in Kabul University, started the Jamiat-e-Islami Afghanistan. Among his young lieutenants were Ahmed Shah Massoud and Gulbuddin Hekmatyar; all three would become international stars during the jihad against the Soviet Union. Pakistan's opportunity for covert intervention expanded when Kabul lurched into political instability, from which it has not recovered four decades later. In 1973, Sardar Muhammad Daoud overthrew his cousin, King Zahir Shah, and invited local communists to join his republican Cabinet. The presence of atheists in power offered Islamists a chance for some potent propaganda. The Pakistan Jamaat-e-Islami became a conduit through which Pakistan began to supply money, arms and training to cells in Afghanistan, and, with more money available, expanded its work into Central Asia. Maududi's books were translated and distributed on Afghan campuses. Money also arrived from the Saudi Rabita al-Alam al-Islami (World League of Muslims). The Jamaat set up the Dar ul Fikr (House of Thought)

to disseminate accounts of communist repression against Muslims. (Xinjiang, however, went off its radar when Pak-China ties warmed up.)

America played a supportive, albeit marginal, role. Robert Gates, who later had the distinction of being defence secretary to both George Bush and Barack Obama, notes that Jimmy Carter signed the first authorization for secret help to Afghan mujahideen on 3 July 1979, six months before the arrival of Soviet troops in Kabul. Half a million dollars were allotted, and disappeared in six weeks, a rate donors continue to experience.[2]

During the decade of the Afghan jihad, Zia turned Pakistan into a parade ground for believers and freebooters from Mindanao to Morocco, enriched by CIA or Saudi cash. What is not common knowledge is that Zia nurtured other ambitions.

Husain Haqqani, a protégé of General Zia who was appointed ambassador to the United States in 2008, writes: 'Although Zia ul-Haq had been keen to obtain US funding and weapons for his venture in Afghanistan, he had always known that US objectives were different from those he had defined as Pakistan's goals. For Zia, Afghanistan marked an important turning point in Pakistan's quest for an Islamic identity at home and for leadership of the Islamic world ... Zia shared the full extent of what he hoped to accomplish only with a small group of confidants, one of whom, journalist Ziaul Islam Ansari, explained Zia's overarching vision.'[3] The idea was to turn Pakistan into 'a stable and strong country ... capable of providing strength to Islamic revivalist movements in adjoining countries and regions'.

How? 'Zia ul-Haq was paving the way for the day when "the lower rungs of society are mobilized in favour of greater Islamization". At the same time, the Afghan jihad would make Pakistan the instrument for the creation of an Islamic ideological regional block that would be the source of a natural Islamic revolutionary movement, replacing artificial alliances such as the Baghdad Pact. This would be the means of starting a new era of greatness for the Muslim nations of Asia and Africa.'

We can only speculate on the psychological impact that two

bitter military defeats suffered by Muslim nations – the demolition of Arabs in 1967 and the humiliating surrender of the Pakistan army to India in 1971 – must have had on Zia, but he was determined to reverse the military weakness that has been a significant factor in the modern history of Muslims. The success of the Afghan jihad was a dramatic departure from this trend; in Zia's cosmology, Muslims were victorious against a superpower like the Soviet Union because they fought the Afghan war in the name of Islam.

Zia showed extraordinary foresight in his analysis, when he placed his faith in the 'lower rungs of society' to carry forward the Islamization mission. Twenty years after Zia's death, those 'lower rungs' were still providing foot soldiers for extremist and terrorist organizations all across Pakistan. Ayesha Siddiqa, the brave Pakistani academic and author who wrote a remarkable piece in the September 2009 issue of *Newsline* titled 'Terror's Training Ground', explains this phenomenon. 'The first step,' she reports, 'is recruitment – and the methodology is straightforward. Young children, or even men, are taken to *madrassas* in nearby towns. They are fed well and kept in living conditions considerably better than what they are used to.' This was, she notes, visible evidence that militant organizations were able to provide them a better life on earth, not to mention heaven later. Indoctrinated children became virtual recruiting agents, creating 'a swelling cycle'. These 'martyrdom *madrassas*' have been expanding into Punjab, with south Punjab as their hub: the Sipah-e-Sahaba Pakistan (SSP), Lashkar-e-Jhangvi (LeJ), Jaish-e-Muhammad (JeM) and Lashkar-e-Tayyiba (LeT) operate there. Their mission included not just known enemies of Pakistan, but also traditional rivals of Wahabi Sunnism, like Shia Iran.

Discussing the collusion between such outfits and officials, Siddiqa notes, 'since all these outfits were created by the ISI [Inter-Services Intelligence] to support General Zia ul Haq's Islamisation process, in essence to fight a proxy war for Saudi Arabia against Iran by targeting the Shia community, and later the Kashmir war, the officials feel comfortable that they will

never spin out of control. Those that become uncontrollable, such as Al Furqan, are then abandoned.' (Al Furqan was involved in the second assassination attempt on Musharraf.)

Zia nurtured the 1980s as the pregnant decade for future jihad, encouraging seminaries that subscribed to the hardline Salafi ideology. South Punjab became the biggest reservoir for recruits to the Kashmir jihad, thanks partly to organizations like the Tablighi Jamaat which had seeded the area with their rabid version of religion. The LeT even began to permit women among its jihadis, giving them a twenty-one-day course in ideological and military training. The explanation was that these women would be able to defend Pakistan if their men were on jihad abroad.

It was estimated that by 2010 at least a million Pakistani children from the 'lower rungs of society' were studying in over 20,000 madrasas. The growth of jihadis from this resource seemed immune to the highs and lows of the roller-coaster ride from the Soviet defeat and Taliban rule in Kabul, to the Taliban collapse of 2001. They were sustained by the belief that faith made them invincible. As a Taliban spokesman famously told a Western journalist, 'You have a watch; we have time.'

———

If the 1980s were manipulated by General Zia, the 1990s belonged to the Taliban, a group created in Pakistan for operations in Afghanistan by Zia's successor, Benazir Bhutto, daughter of Zulfiqar Bhutto. Benazir, who once described the Taliban (literally, students) as 'my children', put the Taliban amir, Mullah Omer, into the field to halt spiralling chaos and bring Kabul into Islamabad's fold. He delivered on both counts, securing Pakistan's strategic depth and reducing Indian influence to zero.

The Taliban began its advance in November 1994, fortified by Pakistani weapons, intelligence and battlefield guidance. It took Kandahar, Lashkargarh and Helmand easily. Kabul fell on 26 September 1996. The outstanding figure of the anti-Soviet jihad,

Ahmed Shah Massoud, was defeated in Kabul and retreated north, to head what became known as the Northern Alliance. India helped this alliance during its five years of exile, both financially and as sanctuary for families. In 2001, the Northern Alliance marched with NATO troops to retake Kabul but without Massoud, who was shot dead by two suicide missionaries posing as journalists three days before 9/11.

Al-Qaeda's strike on the Twin Towers, and the consequent American-alliance victory in Afghanistan, scattered the Taliban, which took more than three years to regroup and seep into nationalist space when the Americans showed no signs of leaving. The Pakistan army took a long view of the confrontation, helping America in public and supporting the Taliban when it suited it to do so. It took care to protect its interest in case of American departure. Despite continuing evidence, Washington was forced to ignore this duplicity.

The Wikileaks of 2010 provide a mass of such evidence. One newspaper report will indicate the level of subterfuge. On 26 July 2010, Rob Crilly from Islamabad and Alex Spillus from Washington filed a story for the *Daily Telegraph* of London based on information obtained from classified documents released by Wikileaks. 'Vehicles [meant for Taliban] were allegedly filled with explosives in Pakistan before being driven across the border in Afghanistan, sometimes with ISI collusion . . .' At least 1,000 motorbikes were sent in 2007 for use in suicide attacks, according to the documents, and they named former ISI chief General Hamid Gul as a go-between who regularly met al-Qaeda and Taliban commanders to organize suicide attacks. Gul is described, in one classified 'threat report', as ordering that magnetic mines should be planted in snow on roads used by military vehicles, using the picturesque phrase 'make the snow warm in Kabul'.

General Gul, of course, denied the allegations, complaining that the Americans were looking for a scapegoat 'and this is the sign of their defeat in Afghanistan'. On 1 December 2010, the Delhi correspondent of the *Telegraph*, Dean Nelson, citing a new batch of Wikileaks, quoted the American ambassador in Islamabad,

Anne Patterson, as writing in a despatch that Pakistan was supporting four militant groups, including the Lashkar-e-Tayyiba (believed to have masterminded the three-day terrorist attack on Mumbai in 2008), and that 'no amount of money' could persuade Islamabad to abandon this support. Remarkably, there was no consternation anywhere when in November 2010 Hillary Clinton remarked that she believed Osama bin Laden was still hiding in Pakistan territory. The world had internalized this assessment, irrespective of Pakistan's denials.

Asad Munir, a former brigadier who served as chief of military intelligence and of the ISI for NWFP, FATA and the Northern Areas of Pakistan, commented in the Lahore daily, *The News*, on 17 February 2009 that 'Mullah Omer started his Taliban movement with less than 50 *madressah* students . . .' By December 1994, bolstered by the fall of Kandahar, he had a force of 12,000, with thousands from Pakistani madrasas rushing to join the new force. 'A new phenomenon had been created in Pashtun society – that of *madressah* students and mullahs, with guns in their hands, ruling the Pashtuns.' The region had a history of religious wars, but the fighters reverted to their tribal identity once conflict was over. But the latest version of Talibanization, Munir argued, was not just 'a movement for enforcement of Sharia; the mullahs want power, authority and a defined role in decision making in the social system of Pashtun society'.

The Talibanization of Swat and the tribal Frontier, a story that dominated headlincs in 2009, was not merely a cycle of fear, compromise and war, but a sustained ideological objective, the conversion of parts, and then the whole of Pakistan, into a theocracy. One epicentre was the beautiful valley of Swat.

———∘∾∘———

The wali, or ruler, of the princely state of Swat opted for Pakistan in 1947. He was permitted functional autonomy till 1969, when Swat was merged with the adjoining North West Frontier Province. Under the wali, Sharia was the official law of Swat, but in the

same perfunctory way that Sharia was the law in Afghanistan during royal rule. In 1987, the wali was downgraded to honorary ruler, and then removed from the power structure.

On 28 June 1989, Maulana Sufi Mohammad, born in Lal Qila, Lower Dir, adjacent to Swat, left the Jamaat-e-Islami to set up the Tehrik Nifaz Shariat-e-Mohammadi (TNSM). He was still in his forties. He had been elected to the district council on a Jamaat ticket but decided that democracy was incompatible with Islam. His political objectives were spelt out in the name of his organization, which says, in effect, that a Muslim can be loyal only to the law of Muhammad. His battle cry was equally unambiguous, 'Sharia or Shahadat' (God's Law or Martyrdom). His letterhead described him as a member of Tehrik rather than leader; its emblem, the Hajr-e-Aswad, was the holy rock that is kept in the Khana-e-Kaaba in Mecca. It also had a drawing of two black-and-white flags, one the main standard of the Prophet and the other his military flag. (The Prophet's standard was black-and-white. TNSM members wore black turbans.)

In October 1994, Sufi Mohammad gave an interview to the reputed journalist Rahimullah Yusufzai, which the latter recalled in a dispatch published in *The News* on 5 May 2009: 'Who else but the Maulana . . . is ready to declare at this point in modern times that democracy and Sharia are incompatible, that Pakistan's superior courts are unIslamic and that women can only come out of their houses to perform the Haj? . . . For him, the judiciary then was "English law" and, therefore, unIslamic and unacceptable. His concept of Sharia then and now is simply a judicial system in which judges, or *qazis* as he referred to them, would preside over courts and dispense quick and affordable justice. The chosen *qazis* were to match the specifications set forth by him both in terms of character and physical features, meaning they had to be pious and bearded. In Sufi Mohammad's scheme of things, the *qazis* were to enjoy a status higher than the deputy commissioner or the superintendent of police . . .'

A little after this interview, the maulana took to arms. His logic could hardly be faulted: if Islamabad was sending a Taliban army

to Afghanistan to save a neighbour with God's law, why should Pakistanis be denied the same privilege? TNSM started an insurrection to enforce Sharia within the seven tribal districts of Malakand division: Dir Upper, Dir Lower, Swat, Shangla, Buner, Malakand and Chitral. Sufi Mohammad was arrested but the government was reluctant to force a confrontation; he was released on condition he maintain peace. This truce came to an end with 9/11. Sufi Mohammad joined the new jihad in Afghanistan, alongside the Taliban. He is believed to have led a force of about 10,000.

The Americans proved far stronger. Sufi Mohammad was arrested on his return to Pakistan in 2002. His son, Maulana Fazlullah, adopted more modern techniques when he took over. Fazlullah started a string of localized FM radio stations to preach the Sharia and send instructions to people, bypassing authority. President Musharraf, under multi-pronged pressure from democracy activists, political parties and Islamists, dismissed an obscure tribal maulana as low on the priority of his problems. An influential Jamaat MP, Maulana Fazlur Rehman, brokered what is known as the Miramshah agreement between the government and militants, signed on 5 September 2006. Fazlullah now had reason to believe that his writ had official sanction.

He formed an alliance with a new organization set up by Baitullah Mehsud, the Tehrik-e-Taliban Pakistan (TTP), and together they set up a parallel administration. It is not entirely coincidental that Sufi Mohammad and Fazlullah ruled their virtual 'Islamic state' in the same 'liberated zone' from where Sayyid Ahmad Barelvi and his successor Shah Ismail established 'Tehrik-e-Mujahideen' and fought first the Sikh kingdom and then the British in the nineteenth century. In the twenty-first century, the Pak administration left them largely alone, apart from stray engagements in which the jihadis often had the better of the police and army.

The liberal Awami National Party won the February 2008 elections in the province, and thought it could arrange a peaceful compromise with the Islamists. On 20 April 2008, the government

publicly acknowledged that every Muslim had the fundamental right to struggle, peacefully, for Sharia. On 21 May 2008, details of a deal were made known. Maulana Fazlullah promised to stop attacks on government personnel and property, hand over foreign militants, end FM broadcasts, dismantle training facilities and explosive factories, stop display of illegal weapons and permit polio vaccinations. (The last is more evidence of primitive attitudes; an injection was still treated as some sort of Western conspiracy.) In return, the government agreed to withdraw the army in stages, set up an Islamic university at Imam Dherai (the site of the main TNSM madrasa), review all cases against imprisoned militants, and take action against a very revealing list of culprits: oppressors, bribe-takers, adulterers, thieves, dacoits and kidnappers. The central concession was to implement Sharia in letter and spirit across the entire Malakand Division, which was the original objective of the TNSM.

The Islamists, however, were not content. Fighting continued, and remnants of state authority began to crumble. Men of Pakistan's Frontier Corps began to desert to take up a new vocation – serving Allah. A desperate provincial government signed a fresh agreement with Sufi Mohammad on 16 February 2009 that promised to extend Sharia to Kohistan and Hazara, abolish all 'unIslamic laws', set up a Shariat court (Darul Quza) as the supreme judicial authority and halt all security operations. A triumphant Sufi Mohammad then drove in a huge convoy to Swat to meet his son Fazlullah. Among the more interesting 'concessions' that he made was attacks on barbers and music shops would cease.

Shariat courts, with qazis as judges, began functioning from 17 March 2009. The government tried to plant stories of a rift between the TNSM and Taliban, to little purpose. The regional agreement, however, had to be endorsed by the national Parliament. When President Asif Zardari dithered over what was known as the 'Nizam-e-Adl resolution', ANP threatened to withdraw support to his government. A vote was scheduled for 12 April 2009.

By this time, journalists had begun to report that Afghan and Pak Talibans, and TNSM, were working towards a coordinated objective. The *International Herald Tribune* reported (28–29 March 2009) that Mullah Muhammad Omer, former amir of Afghanistan and now 'hiding' in Quetta, had persuaded leaders of the three Taliban factions, Baitullah Mehsud, Hafiz Gul Bahadur and Maulvi Nazir, based in north and south Waziristan, to cooperate; and had also secured the sworn allegiance of Sirajuddin Haqqani, son of Jalaluddin Haqqani. They had, reportedly, formed a Council of United Mujahideen.

On 11 April 2009, Amir Izzat Khan, a TNSM spokesman, warned Pakistan's Parliament against any deviation from Nizam-e-Adl: even prophets had no authority to make or amend religious law, he argued, so how could the National Assembly do so? If members opposed the Shariat-e-Muhammadi, they would become non-Muslims and Pakistan turn into Dar al-Harb. A jihad against the state of Pakistan would, thereby, become mandatory upon believing Muslims. Fazlullah's spokesman, Muslim Khan, was more blunt: anyone who opposed the bill would be declared an apostate. He recommended that such a member should henceforth contest from a seat allotted to minorities – provided he or she remained alive. Parliament decided on an open vote rather than secret ballot.

The Karachi-based MQM, whose support came from Muslims who had migrated from India after partition, showed some spirit when it opposed the resolution, but rather than cast a 'no' vote, its members abstained by leaving the House. Only one member of the National Assembly, the journalist–politician Ayaz Amir, voted against the resolution. On the night of 13 April 2009, Zardari signed Nizam-e-Adl Regulation 2009.

Scholars have noted the irony and contradictions of classic Sunni political theory when put into practice. It conceives of a pious amir ruling on the basis of Sharia with the help of an equally

pious shura (council). The practical problem is not so much the law but piety. Since the amir is not bound by the advice of the shura, the temptation towards dictatorship is magnetic, prompted by one excuse or the other. In practice, Muslim autocrats have found it reasonably easy to 'persuade' the ulema to certify their authority as Sharia-compliant. Moreover, the law that the Tehrik was seeking to impose – its name includes the term 'Nifaz', meaning imposition – was only one of the systems of jurisprudence developed by Islamic scholars, the Hanafi law. Under the authoritarian dispensation of Tehrik and Taliban, it quickly degenerated into punitive measures, particularly against the few non-Muslims still in the region.

Abdul Saboor Khan reported from Hangu, on 16 April 2009, in *Daily Times* that following a Taliban demand of Rs 50 million as jiziya, Sikh families living in Orakzai Agency had left the agency. 'The Taliban had notified the Sikh families about the tax' a week ago on the grounds that the Sikhs 'were a minority and liable to pay the tax for living in the area in accordance with Sharia'. The families were impoverished and had left the area to avoid any Taliban action.

Muslims who had 'strayed' faced equally harsh action, particularly if they were women. In April 2009, a video clip surfaced in which two shrouded figures had pinned down a seventeen-year-old girl, Chand Bibi, while a third (his face hidden by a black wrap) whipped her thirty-seven times. Her crime was being seen in public with a man who was not her father or brother. Her piteous screams cried out for humane intervention. There was none. It was not an isolated incident, but one brought to world attention in the age of mobile-phone cameras. The initial reaction of Islamabad was to downplay the barbarism with spurious justifications: the video was 'fake', or such practices were 'traditional'. But most of media and civil society reacted in horrified anger, conscious that this was a preview of a future they must mobilize to prevent.

A young Pakistani woman, Sehar Tariq, studying for a master's degree at Princeton, described the Nizam-e-Adl resolution as

'legislated lawlessness' in a piece for *The News* (17 April 2009): 'Today we legislated that a group of criminals would be in charge of governing and dispensing justice in a part of Pakistan according to their own obscurantist views. They have declared that the rulings of their courts will be supreme and no other court in the land can challenge them. They have also declared that their men (who) killed and maimed innocent civilians, waged war against the Pakistani army and blew up girls' schools will be exempt from punishment under this law. A law that does not apply equally to all men and women is not worthy of being called a law ... The Parliament by endorsing the Nizam-e-Adl Regulation [NAR] has heralded the end of Pakistan as I knew and loved it. Today, the elected representatives of the people turned Pakistan into Talibanistan. Today, we handed over a part of the country to them. I wonder how much longer before we surrender it all.'

Emotion and faith were not the only spurs: Taliban and TNSM were able to exploit a generic fault in a nation where every serious attempt at land reforms, whether weak or well-intentioned, had been subverted. Taliban and TNSM promised an egalitarian society, an ideal of Islamic polity.

The *New York Times* published a report on 17 April 2009, filed from Peshawar by Jane Perlez and Pir Zubair Shah, which said, 'The Taliban's ability to exploit class divisions adds a new dimension to the insurgency and is raising alarm about the risks to Pakistan, which remains largely feudal.' It noted that, unlike India, Pakistan had a landed elite that kept its workers subservient, that avenues of advancement for the vast majority of rural poor did not exist, and that the Taliban had engineered a class revolt. They quoted a senior Pakistani official who said, on condition of anonymity, 'I wouldn't be surprised if it sweeps the established order of Pakistan.'

An instance will illustrate how and why Zia's 'lower rungs' began to gravitate towards the Taliban. In 2007, the Taliban announced a list of forty-three persons who, they said, were oppressors of the poor in Matta, a region famous for orchards and exploitative landlords. Each of the 'accused' was ordered to

appear before a Taliban court or face more immediate retribution.
When landlords fled, their tenants were encouraged to cut down
orchard trees and sell the wood. They worked the land on which
they had been tenants, and paid a tribute to the Taliban from
their earnings. By 2009, the Taliban had opened two dormant
emerald mines, claiming one-third of the revenues. Zia's 'under
class' had found a route to Islamic justice.

—⁓⁓—

Emboldened by Nizam-e-Adl, the Taliban announced a progressive
campaign to impose Sharia on the whole country, starting with
Punjab, where it had a network of potential allies in militias, the
best known being the chameleon LeT, with strong roots in
Punjab. The LeT was a central player in the 'war by other means'
strategy against India devised by General Zia; despite sufficient
evidence of involvement in terrorist activity, LeT finessed punitive
measures by the simplest of expedients, like changing its name. It
became, for instance, the Jamaat-ud-Dawa when the anti-terrorism
sanctions committee of the United Nation ordered action after the
LeT was implicated in the terrorist attacks on Mumbai in November
2008.

In December 2008, in a token gesture, Pakistan placed its amir,
Prof. Hafeez Mohammad Sayeed, under house arrest. Sayeed
challenged even this mild form of detention in the Lahore High
Court; in response, the Pakistan government counsel cited UN
strictures to justify the arrest. The court asked if the government
had any independent evidence. Counsel explained that there was
evidence linking LeT to al-Qaeda. The Lahore High Court asked
to see any notification under which al-Qaeda had been declared
a terrorist organization. There was no such notification. The
Pakistan government had not placed al-Qaeda on its list of
terrorist organizations. On 6 June 2009, Prof. Sayeed was released
on the court's orders.

LeT's involvement with the terrorist strike on Mumbai is well
known, even if Islamabad will not acknowledge this. Britain's

Channel 4 showed an extraordinary documentary in 2009, *Terror in Mumbai*, which contained footage of controllers sitting in Pakistan and communicating with the terrorists in Mumbai on cell phones.

They spoke in Urdu, Punjabi and bits of English. They were cool and professional. A few quotations should suffice: 'The whole world is watching your deeds ... Remember this is a fight between believers and non-believers ... Throw some grenades, my brother ... How hard can it be to throw a grenade? Just pull the pin and throw it. For your mission to succeed, you must be killed. Allah is waiting for you in heaven.' Repeatedly, the terrorists respond to their instructions with 'Inshallah'. The only terrorist who was caught alive, Ajmal Kasab, told the Indian police that his father had 'sold' him to the LeT, explaining that the money would pay for his sisters' weddings.

Dozens of such groups operate freely, the most prominent of them being the Jaish-e-Muhammad, the Harkat-ul-Jihad-al-Islami, the Harkat-ul-Mujahideen and the anti-Shia Lashkar-e-Jhangvi. There are splinter groups; the Pakistan Taliban is split three ways (so far). In addition, Pakistan has settled some 150,000 tribal ex-servicemen in the part of Kashmir under its control, who form an unofficial resource pool in case of conflict across the Line of Control. A state in permanent war needs a supply of permanent warriors.

On the evening of 7 July 2009, Pakistan's President Zardari admitted before a closed-door meeting of officials that conflict with India had bred a nexus between terrorist groups and Pakistan's intelligence agencies. He said, 'Militants and extremists emerged on the national scene and challenged the state not because the civil bureaucracy was weakened and demoralized but because they were deliberately created and nurtured as a policy to achieve short-term tactical objectives. Let's be truthful and make a candid admission of the reality. The terrorists of today were heroes of yesteryear until 9/11 occurred and they began to haunt us as well.' Surprisingly, these comments were made available to the media. Journalists could barely disguise

their surprise at such unprecedented candour. Officials tried later to deflect the 'damage', but Zardari was stating the obvious.

In March 2009, a self-professed admirer of the 'Islamic resistance', General Mirza Aslam Beg, former Chief of Army Staff, Pakistan, advised, in an article distributed by his foundation, Friends Foundation, that America and NATO should quit the region gracefully before they were defeated. It is not necessary to agree with him, but important to know what he says about the power of the Islamic 'Shadow Army': 'The Global Order of the twenty-first century is being determined by three major powers: One is led by the United States, supported by the European Union, India and Japan; the second is China and Russia and the third is the Islamic Resistance. The first and the second are not confronting each other. They are, rather, in the cold war frame of mind. It is the Islamic Resistance, which has been confronting the American power, limiting its role and its global ambitions.'

This invincible Islamic resistance, the general argued, would exist until 'occupation forces' learnt to make peace with them on their terms. The battle lines for the final round in Afghanistan had been drawn, and the CIA had named the alliance of Taliban, Mujahidden under Jalaluddin Haqqani and Hekmatyar, Iraqi veterans, Central Asian jihadis and the 005 Brigade of al-Qaeda as the Shadow Army. It was well-armed thanks to loot from NATO supply lines.

A radically different view of Islamism and Pakistan appeared in the 16 March 2009 issue of the Indian magazine *Frontline*. Pakistani academic Pervez Hoodbhoy, chairman of the physics department at Quaid-e-Azam University in Islamabad, wrote that the problem extended far beyond generally identified areas like FATA; extremism was breeding at a ferocious rate in public and private schools because the official curriculum was promoting what he described as a 'blueprint for a religious fascist state': 'Pakistan's education system demands that Islam be understood as a complete code of life, and creates in the mind of the schoolchild a sense of siege and constant embattlement by stressing that Islam is under threat everywhere.' In 1976, a law was passed compelling

all schools to follow the study programme prepared by the Curriculum Wing of the Federal Ministry of Education, promoting militarism. 'Militant Jihad became part of the culture on college and university campuses. Armed groups flourished, invited students for Jihad in Kashmir and Afghanistan, set up offices throughout the country, collected funds at Friday prayers, and declared a war without borders.'

In an interview with *Der Spiegel*, published on 7 June 2009, former President Pervez Musharraf admitted, 'The only thing I was concerned about was apprehending Osama bin Laden and putting him on trial within Pakistan. You need to understand the sensitivities within our country.' That is as close as any leader has come to admitting that Osama has a huge fan base in Pakistan. Musharraf added: 'The Americans are hated in the country today.'

When the United States walked away from Afghanistan after defeating the Soviet Union, it did not notice, in its euphoria, that Pakistanis had begun to walk away from the United States. After 2001, and over the next decade, the Pakistan army has had to face a simple but provocative question from the man on the street: 'Why are you fighting America's war against fellow Muslims?'

Very early in his term, President Obama defined Iraq as the war of choice and Afghanistan as the war of necessity. The battlefield had blurred boundaries and Richard Holbrooke, his special envoy to the region, coined a term, Af-Pak, to try and define the new fighting zone. One of Holbrooke's preliminary missions was to clear the confusion that Islamabad had injected with its local deals. He called the Taliban and TNSM in Swat 'murderous thugs' who posed a threat to Pakistan as well as the United States. On 7 May 2009, while Zardari was in Washington negotiating yet another round of largesse from the American government, Pakistan's Prime Minister Yusuf Raza Gilani ordered the armed forces to 'eliminate' terrorists. The next day, Pakistan's air force bombed targets in Swat, and a ground offensive began with a strength of 12,000 troops. Estimates vary, but by the end of May

2009 there were over a million internally displaced refugees who had fled the battle zone. According to the *Economist* (May 16–22), 'Among the charities that have set up relief camps is Jamaat-ud-Dawa, an Islamic group that is in theory banned, as a front for the terrorists of Lashkar-e-Taiba.' The LeT-Dawa and similar organizations have exploited any opportunity for humanitarian work to find recruits for their cause.

Army action in Swat restored some confidence among those who had become uneasy, or even alarmed. There were some doubts about the army's claims in the troubled summer of 2009. After the authorities put on display pictures of fifty-four Taliban dead, a former Pak ambassador, Zafar Hilaly, wrote in *The News* on 24 June 2009, under the discomforting caption, 'The dead do tell tales', that the army was faced with a credibility problem with its claims of dead, injured and captured Taliban, which it would do well to attend. '. . . there were no photos of injured Taliban and only a desultory few of those claimed to have been captured have ever been shown on TV.' In contrast, he added, the Taliban paraded their victims, allowed interviews and generally made a great show about their capture. However, it was clear by the end of 2009 that the army was the only relevant guarantor of the Pakistan state as it exists.

Even trenchant critics of the Pak army welcomed its offensive against the Taliban in the Frontier. In a column published on 26 June 2009 in *The News* (*What are our soldiers dying for?*), Ayaz Amir was typically honest: 'If the present fight against the Taliban leads to a new Pakistan, it is worth fighting and winning. But if our ways don't change, if our ruling elites remain as corrupt and self-centred as they have always been, then doubts will arise whether the blood being shed was worth anything. The Taliban are a threat to our way of life. But the Taliban, it bears remembering, were the product of our folly, the general staff and our military intelligence agencies (ISI and MI) chasing shadows and fantasies at the altar of muddled strategic theories . . . American folly and narrow self-interest was also an ingredient in this witches' brew. But there was no divine command that we had

to follow American orders . . .' If Pakistan, he concluded, wanted to become a modern republic, it would have to revisit the morality tales of that 'prince of hypocrites' General Zia ul Haq.

—∞∞—

Any crisis breeds Cassandras, and there were enough floating around on the wide world of the web in 2009, predicting the disintegration, or worse, of Pakistan. The pessimists, however, underestimated the determination of those Pakistanis who wanted to save their nation from Maududi–Zia Islamists. There were many objective factors in their favour. Urban Pakistan – what might be called Jinnah's Pakistan – proved a powerful counterweight to the fundamentalists, its will bolstered by domestic military muscle and America's dollar power.

The best-case scenario for Pakistan is that the 'Islamic-subaltern' revolt in impoverished areas is brought under control by the military, and elected governments appreciate that a real solution demands social and economic reform: land redistribution; high economic growth which can facilitate rapid redistribution of national wealth; Keynesian investments in low-skill jobs and artisan products; secular, gender-equal education; health care and infrastructure, with democracy as a non-negotiable necessity, which in turn means that the 'doctrine of necessity', the judicial cover for coups, has to be eliminated.

There might be little hope for peace with India, given the fundamental divergence on Kashmir, but a settlement with India will help excise the jihad culture ravaging Pakistan. Altaf Hussain, the self-exiled, London-based leader of Muslims who had migrated from India at the time of partition, made headlines (particularly in the Urdu press in India) when he said, in June 2009, that partition was a mistake because it had split and thereby weakened the Muslims of the subcontinent. This was a rebellious, if not revolutionary, departure from the conventional Pakistani narrative that the two-nation theory was essential to save Indian Muslims and Islam from Hindus.

It is comparatively easier for India to come to terms with Pakistan. Economic growth and dreams of becoming a part of the first world have begun to dominate the Indian mind. The Indian middle class has begun to appreciate a simple reality: social violence and economic growth cannot coexist. Liberalization has had an impact on lifestyle and attitudes. The culture of consumerism has been quickly adopted by the young, while entertainment television is a mirror of sexual liberation and the fusion of Western mores with Indian sentiment. The most remarkable aspect of this change was that even terrorism, often exported from Pakistan, and wearing an 'Islamic' label, did not feed a backlash in the form of Hindu–Muslim riots, even after the venomous terrorist attacks in Mumbai in 2008.

India is content being a status quo-ist power, determined to preserve its current geography, without serious claims even on territory it believes it has lost to China along the Himalayas and to Pakistan in Kashmir. Peace is a logical extension of this position. There is a large and growing constituency in Pakistan that understands this. But unless Pakistan achieves clarity on terrorism, with all its snake-oil justifications, the subcontinent will remain hostage to malevolent mania.

—◦◦◦—

Pakistan is burdened with its own secessionist worries, in Baluchistan, which constitutes one-third of the nation's territory and adjoins Afghanistan. The Baluch have always been fiercely independent in spirit; and Islamabad has done itself no favours by treating a quest for ethnic consolidation with a heavy hand. Baluchi grievances have emerged from poverty, fear of economic colonization by Punjabi businessmen, and the use of excessive and repressive force by Islamabad.

Nawab Nowroz (or Babu Nowroz), head of the Zarakzai tribe, led the first Baluch insurrection in 1958. When Nowroz surrendered, his sons and nephews were taken to Hyderabad jail and executed. Brutality silenced the anger, but did not eliminate

it. In 1962, Marri tribals instigated the second Baluch rebellion, known as the Parari resistance (Parari means rebel). By July 1963, the rebels, using classic guerrilla tactics of ambush, raids on military camps and sniper-fire, were operating across some 45,000 square miles, from Jhalawan to Marri and Bugti. General Tikka Khan was put in charge of Baluch operations and earned the sobriquet 'Butcher'. Eight years later, the same general would become internationally infamous as the 'Butcher of Bengal' after his crackdown on civilians in Dhaka in March 1971, but his original claim to infamy came from Baluchistan.

The Baluch movement seemed to have become the flavour of the year for young student-radicals in 1973. The 'London Group', a group of upper-class socialists, fresh from revolutionary Oxbridge, took to the Baluch hills to fight alongside the secessionists under the leadership of Mir Hazar Khan. They included Ahmed Rashid (now an internationally renowned author), Najam Sethi (now an influential editor), Rashid Rahman, son of a justice of the Supreme Court, Muhammad Ali Talpur (son of one of the most powerful Sindhi landlords) and Duleep 'Johnny' Dass, son of a senior air force officer and, as his name indicates, a non-Muslim. They wanted a Marxist Pakistan rather than a separate Baluchistan; they got neither. They were arrested, and after a suitable period of internment, released. Dass was never seen again. Zulfiqar Ali Bhutto, who was in power then, sent helicopter gunships (gifted by the Shah of Iran) in September 1974 into action in Baluchistan. In early 1975, the Baluch leader, Khair Baksh Marri, was arrested and charged with treason; the government claimed he had support from Afghanistan, Soviet Union and India. Mir Hazar Khan took refuge in Afghanistan in 1976.

The ferment resurfaced a generation later, around 2005, when a nebulous 'Baluchistan Liberation Army' began to appear in dispatches. Islamabad had a ready explanation. India had activated consulates across Afghanistan after the overthrow of the Taliban in 2001, and begun to fund and arm the 'BLA' through its missions in Kandahar and Jalalabad. Musharraf and the Pak army went into high gear, with the usual consequences. The return of

democracy in 2008 did little to change the behaviour of state forces.

In 2009, Carlotta Gall of the *New York Times* reported that the bodies of three local political leaders, riddled with bullets and badly decomposed, had been found in a date-palm grove.[4] They had been picked up five days ago in front of their lawyer and neighbouring shopkeepers, 'handcuffed, blindfolded and hustled into a waiting pickup truck'. The locals were convinced that the killings were the work of the Pakistani intelligence agencies. 'The deaths provided a new spark for revolt across Baluchistan . . . where the government faces yet another insurgency . . .'

Repression comes naturally to any government protecting a country from secession, and the story was the same whether under army or civilian rule. The discovery of these bodies set off a wave of anger, which eventually subsided. But even schoolchildren refused to sing the national anthem and pulled down the Pakistan flag and replaced it with the pale blue, red and green Baluchi nationalist standard.

———✵———

Fears of Pakistan disintegration however are highly exaggerated. Even pessimists like Pervez Hoodbhoy are more worried by the 'slow-burning fuse' of religious extremism rather than collapse.[5] He recounts the surreptitious rehabilitation of the Taliban by Musharraf after it was devastated in 2001 because 'this force would remain important for maintaining Pakistani influence in Afghanistan – and keep the low-intensity war in Kashmir going'. Hoodbhoy bemoans that 'a sterile Saudi-style Wahabism is beginning to impact upon Pakistan's once-vibrant culture and society' and indulges a horror-scenario: a 'coup by radical Islamist officers who seize control of the country's nuclear weapons, making intervention by outside forces impossible. Jihad for liberating Kashmir is subsequently declared as Pakistan's highest priority and earlier policies for crossing the Line of Control are revived; Shias are expelled into Iran, and Hindus are forced into

India; ethnic and religious minorities in the Northern Areas flee Pashtun invaders; anti-Taliban forces such as the ethnic Muttahida Qaumi Movement and the Baluch nationalists are decisively crushed by Islamists; and Sharia is declared across the country. Fortunately, this seems improbable – as long as the army stays together.'

When George Bush launched his second war in 2003, he surely missed the greatest paradox of his decision. He invaded Iraq to eliminate nuclear weapons, dictatorship and terrorists. In 2003, he would have found all three in Pakistan, including a champion proliferator in Dr A.Q. Khan, widely considered father of Pakistan's nuclear programme. America has opted for the blind eye. When Richard Barlow, a CIA agent working in the directorate of intelligence on proliferation during George Bush Senior's administration, protested that the Pentagon was manipulating intelligence to protect Pakistan's bomb project, he was sacked and denied his pension.[6] Pakistan became a nuclear power with America's tacit consent and China's assistance, because both powers accepted its argument of self-defence against nuclear India.

Juan Cole makes an interesting observation in *Napoleon's Egypt: Invading the Middle East*. There have only four instances in the Middle East, if you include Afghanistan in the term, when Muslim clerics came to power: '... under the republican French in Egypt, under Khomeini and his successors in Iran, under the Taliban in Afghanistan and, it could be argued, with the victory of the United Iraqi Alliance in the Iraq elections of 30 January 2005 (the UIA was led by the Shia cleric Abdul Aziz al-Hakim).' In other words, it is Western intervention that created the conditions for a clerical upsurge. We do not know what the American intervention in Afghanistan and Pakistan in the first decade of the twenty-first century will leave behind.

For six decades, power in Pakistan has seesawed between military dictatorship and civilian rule. What happens when both the army and political parties lose their credibility? Will it be the turn, then, of Zia's 'lower rungs'?

Driven by the compulsions of an ideological strand in its DNA, damaged by the inadequacies of those who could have kept the nation loyal to Jinnah's dream of a secular Muslim-majority nation, Pakistan is in danger of turning into a toxic 'jelly state', a quivering country that will neither collapse nor stabilize.

The challenge from Taliban and its present and future allies is not irreversible. But Pakistan cannot face this challenge unless it returns to the precepts and advice of the father of the nation, Mohammad Ali Jinnah, and decisively rejects the man who became godfather, Maulana Maududi. If Pakistanis cannot find the will to abort the possibility of theocracy, perhaps through a new Constituent Assembly, Jinnah's nation might become the inheritance of the heirs of Maududi. If Pakistan does not find modernity, it will sink into medievalism. There is no third path.

In his April 1946 interviews to Shorish Kashmiri, editor of a Lahore magazine, *Chattan*, Maulana Azad made some significant predictions about Pakistan. 'The moment the creative warmth of Pakistan cools down, the contradictions will emerge and will acquire assertive overtones. These will be fuelled by the clash of interests of international powers and consequently both wings will separate ... After the separation of East Pakistan, whenever it happens, West Pakistan will become the battleground of regional contradictions and disputes. The assertion of sub-national identities of Punjab, Sind, Frontier and Baluchistan will open doors for outside interference. It will not be long before international powers use the diverse elements of Pakistani political leadership to break the country on the lines of Balkan and Arab states.'

He then asks Indian Muslims to debate a question: '... what have we gained and what have we lost. The real issue is economic development and progress, it certainly is not religion. Muslim business leaders have doubts about their own ability and competitive spirit. They are so used to official patronage and favours that they fear new freedom and liberty. They advocate a two-nation theory to conceal their fears and want to have a Muslim state where they have the monopoly to control the economy without any competition from competent rivals. It will

be interesting to watch how long they can keep this deception alive.'

Azad listed eight potential ills that could leave the body politic of Pakistan in high fever. 'I feel right from its inception, Pakistan will face some very serious problems:

1. An incompetent political leadership will pave the way for military dictatorship as it has happened in many Muslim countries.
2. The heavy burden of foreign debt.
3. Absence of friendly relationship with neighbours and the possibility of armed conflict.
4. Internal unrest and regional conflicts.
5. Loot of national wealth by the neo-rich and industrialists of Pakistan.
6. Apprehension of class war as a result of exploitation by the neo-rich.
7. The dissatisfaction and alienation of youth from religion and collapse of the theory of Pakistan.
8. The conspiracies of international powers to control Pakistan.'

Azad continued, 'I must warn that the evil consequences of partition will not affect India alone. Pakistan will be equally haunted by them ... We must remember that an entity conceived in hatred shall last only as long as that hatred lasts. This hatred shall overwhelm relations between India and Pakistan. In this situation it will not be possible for India and Pakistan to become friends and live amicably unless some catastrophic event takes place.'

It was beyond Azad to imagine that this possible catastrophe could have a nuclear dimension, or visualize nuclear weapons in the control of those who advocate suicide as a path to heaven. Azad thought that destruction wrought by catastrophe might bring the subcontinent back to its senses. More than six decades later we are staring, transfixed, at havoc beyond repair.

15

Dark Side of the Moon

———◦◦◦———

The obituary of General James Abbott, published in the *Times*, London, voice and occasionally trumpet of the British Empire, in 1896, was too dry to do justice to one of its most colourful heroes, a swashbuckling officer in the mould of those who helped turn a fledgling British Raj into an Asian superpower. James was the third son of Henry Alexius Abbott, a merchant who made his fortune in Calcutta before settling down in Kent, where James was born in 1807. He followed his elder brother Augustus and Frederick into the army, and enlisted in the Bengal Artillery at the age of sixteen. He retired as general in 1877, outranking three brothers, including the younger Saunders, all of whom reached the rank of major-general only.

The British Empire in the nineteenth century was as much the achievement of daredevil, even romantic, young men, as the top hats in Calcutta and London who took responsibility for its preservation. In 1839, Captain James Abbott was sent to the central Asian Khanate of Khiva at a crucial moment in the Great Game between British India and the advancing Russian Empire. Abbott left Herat disguised as an Afghan with an impressive turban and a fashionable beard, carrying a message for the Khan

and a letter for Tsar Nicholas: this image, done in 1841, is preserved in an impressive watercolour in London's National Portrait Gallery.

Central Asia was the great battlefield of this nineteenth-century Cold War, with spies and political missionaries as its principal soldiers. Abbott's mission was pre-emptive – to obtain the release of slaves. It was not a humanitarian gesture. Russia under Tsar Nicholas I (1825–55) had become so aggressively expansionist that any excuse was considered good enough; in this case, the liberation of slaves. The Muslim Khans were bemused that a ruling class that thrived on serfdom should feel so conscientious about slavery outside its borders, but semantic logic did not increase the number of Khiva's battalions. Few empires have expanded as rapidly as the Russian during the 300-year rule of the Romanovs, who came to power in 1613. The principal thrust was towards the Pacific in the east and the Himalayas in the south.

Calcutta, the capital of British India, was not vastly interested in the fate of slaves either; it did not want Cossacks at Herat, the western door of Afghanistan. With the defeat of Napoleon, Russia remained the only credible European threat to Britain's Indian colony, and there was continuous debate whether the defence of British India began at the Khyber or in Herat and beyond. A Russian column under General Perovsky was already headed towards Khiva when Captain Abbott reached the Khanate, and he was first suspected of being a Russian spy in the disguise of an Englishman. The fate of spies was not pleasant. As Robert Johnson points out in *Spying for Empire: The Great Game in Central and South Asia, 1757–1847*, '. . . two men accused of spying had recently been tortured and executed, their corpses and entrails being thrown over the city walls.' Abbott's colleague, Lt Col Charles Stoddart, on a similar mission to Bukhara in 1839, spent two years in prison and had to convert to Islam to obtain a reprieve.

Khiva proved surprisingly obdurate. General Perovsky's force of 5,000 Cossacks and 2,000 Kirghiz was beaten back, and the Russians showed no appetite for returning in larger numbers. Khiva was the last Turco-Muslim state to fall, in 1873. By 1897,

according to the Russian census, 14 per cent of the empire's population was Muslim. The Tsars fell in 1917, but the communist diatribe against imperialism looked better in theory than practice. Lenin piloted a resolution through the Seventh Social Democratic Congress offering Muslim nations the right to secede, and then placed a certain Joseph Dzugadhvili, more familiar as Stalin, in charge of minorities. Stalin promised 'complete freedom' and sent the Red Army to those who took the promise seriously. On 2 September 1920, his soldiers destroyed the great treasure house of Islamic thought, the library at Bukhara, and on 20 September recaptured Khiva.

Abbott returned to India at a time of great ferment in the Punjab. Maharaja Ranjit Singh's death in 1839 had left his Sikh kingdom leaderless and vulnerable, a virtual invitation to the prowling British. Between 1845 and 1849, over two wars, the British decimated the Sikhs and extended their empire to the Khyber Pass. Abbott joined the select circle around the British general Sir Henry Lawrence, and was sent to Hazara, on the North West Frontier, in 1847. In 1853, he was redesignated deputy commissioner when Punjab was formally integrated into the Raj. He established a capital in the exquisite Orash Valley at a height of 4,000 feet, some 150 km east of Peshawar and 50 km north-east of what is today Islamabad. The town was named after him: Abbottabad. Its current pronunciation, 'Abtabad', clips off a syllable in an effort to make it sound more local.

As the calm of Pax Britannica settled over India after 1857, Abbottabad became better known as a sanatorium, a local alternative to the Alps. In 1947, Pakistan's strategists recognized that its original strategic value had doubled on the new map of the subcontinent. Abbottabad was perched between two frontlines, the Afghan border in the west and India in the east. It became the headquarters of a brigade of the Northern Army Corps and, in October 1947, the Pakistan Military Academy was established as the country's Sandhurst. On 25 January 1948, The First Pakistan Battalion was raised. It had four companies, named Khalid (after Khalid ibn Waleed, the great Arab general who raced through a

thousand miles of desert and helped defeat Byzantines, opening
the way to Jerusalem in 637); Tariq (ibn Ziyad, who defeated the
Goths at Guadalete in 711); Qasim (Muhammad bin, who brought
the first Arab army to the Indian subcontinent in 712, defeating
King Dahir of Sindh); and Salahuddin (better known as Saladin,
who re-conquered Jerusalem in 1187). The battalion's vision, if
not reach, was international.

War came in the very month the Academy was founded.
Pakistan moved to seize the valley of Kashmir, then independent,
in the third week of October 1947 through a force of irregulars,
trained in camps set up in Abbottabad. Abbottabad's true moment
in world headlines, however, would come sixty-four years later.

At 11:35 p.m. on 2 May 2011, American President Barack
Obama delivered a speech that brought closure to a decade-long
quest: he announced the death of the most wanted terrorist in
history, Osama bin Laden, alumnus of another Great Game, killed
by a special contingent of US Navy Seals in an overnight operation,
'hiding within a compound deep inside of Pakistan'. That compound
was in the immediate vicinity of the Abbottabad military academy.
The White House went on to stress that the American force had
acted alone; it was implicit, later made explicit by other American
officials, that Pakistan was not part of this operation since it could
not be trusted with intelligence about bin Laden.

The CIA, which had masterminded the strike, assumed that bin
Laden could not have survived, safely and secretly, for many
years in the sanctuary of a military cantonment without the
knowledge and protection of elements within the powerful
Pakistani military intelligence agency, ISI. The identification and
death of bin Laden could have been a triumph for America–
Pakistan military partnership, one of the success stories of the
Cold War. Instead, it marked a nadir in a relationship that
dissipated into bitter suspicion touched with outright hostility.

The Virtuous Alliance

In 1947, Mohammad Ali Jinnah convinced himself that 'Hindu
India' – he refused to believe that independent India could

become a secular nation, as that would deny the very basis of a
'Muslim Pakistan' – would put the destruction of nascent Pakistan
at the top of its priority list. This could take one of many forms:
annihilation, re-absorption, dismemberment or a state of
subservience. India's professed secularism, he argued, was a thin
disguise for 'Hindu hegemony' which in turn was determined to
eliminate the 'Islamic way of life' from the Indian subcontinent.
When Jawaharlal Nehru hosted an Asian Relations Conference in
Delhi in March 1947 to nurture the idea of non-alignment,
Dawn, the Muslim League newspaper, dismissed it as 'the
expansionist designs of Indian Hinduism' and caricatured Nehru
as 'this ambitious Hindu leader'. Jinnah set the tone at a conference
in Cairo in 1946, where he proclaimed, 'If India will be ruled by
Hindu imperialistic power, it will be as great a menace for the
future, if not greater, as the British imperialistic power has been.'
The 'if' was clearly tautological.

Jinnah prepared carefully for the security of the nation he had
sired. Pakistan, he believed, 'could not stand alone' (see Shuja
Pasha's *Crossed Swords*). It needed a powerful ally. Its neighbour
to the north, the Soviet Union, was communist, atheist and
thereby ipso facto anti-Islam; moreover, Moscow, with its Muslim
belt, was wary of secessionist demands in the name of Islam.
France had become too weak and divided. There remained only
Britain and America, and of the two 'the devil you know is better
than the devil you don't'. But Britain was clearly not the power
it had been. America seemed a far better candidate for benefactor.

In November 1946, Jinnah sent his friend, the industrialist
M.A.H. Ispahani, and Begum Shah Newaz, to tour the United
States and suss out American attitudes. Ispahani, later to become
Pakistan's first ambassador to Washington, returned with some
telling advice for Jinnah and his successors: 'I have learnt that
sweet words and first impressions count a lot with Americans.
They are inclined to quickly like an individual or organization.'[1]
On 17 February 1947, Ispahani wrote to Jinnah emphasizing the
value of a Muslim Information Centre in New York, and on 22
February asked Liaquat Ali Khan to send $1,750 to meet its
expenses, promising to reimburse the equivalent in Indian rupees.[2]

But sentiment, Jinnah knew, being thoroughly unsentimental himself, was a silly card to play in international relations. America would act in the American interest, and not as a bodyguard for Pakistan against India. He had a bold, and, as it transpired, far-sighted view that indicated sharp comprehension of the emerging contours of the Cold War much before it had become either very cold or a war. When Margaret Bourke-White, the American journalist, asked Jinnah a month after Pakistan was born whether he hoped to enlist technical or financial assistance from America, Jinnah answered, 'America needs Pakistan more than Pakistan needs America. Pakistan is the pivot of the world, as we are placed – the frontier on which the future position of the world revolves.' Then, she writes, Jinnah 'leaned toward me, dropping his voice to a confidential note. "Russia is not so far away" ... America is now awakened," he said with a satisfied smile. Since the United States was not bolstering up Greece and Turkey, she should be much more interested in pouring money and arms into Pakistan. "If Russia walks in here," he concluded, "the whole world in menaced".' The author notes, perceptively, 'Jinnah's most frequently used technique in the struggle for his new nation had been playing of opponent against opponent. Evidently this technique was now to be extended into foreign policy.'[3]

Pakistan constructed a brilliant double-play. It sought military help as part of the West's legitimate concern about the Soviet Union, and used most of the arsenal in its confrontation with India. Pakistan developed a narrative in which it became a Western base for 'Middle Eastern defence' against the southward pressure of Soviet communism. Pakistan's Islam would also serve as an ideological counterweight to godless communism in a way amorphous Hinduism could never be trusted to become.

On 11 September 1947, Jinnah told a Cabinet meeting that communism does not 'flourish on the soil of Islam' and pointed out that Russia alone of all the great powers had not sent a congratulatory message on the birth of Pakistan. Pakistan positioned itself as the inheritor of British India's role as bulwark against the Soviet Union without either the bulk or the wealth of

the British Raj. The conundrum would evolve into arguments like the need for strategic depth, and therefore 'influence' over Afghanistan, particularly after 1971, when the Bengali war of liberation broke up Pakistan. Pakistan wanted both arms and money, cash grants, generally disguised as loans.

The first request for aid was not long in coming. As Dennis Kux notes in his definitive study, *The United States and Pakistan 1947–2000: Disenchanted Allies*, in September 1947, Pakistan sent a formal request to Charles Lewis, the American chargé d'affaires in Karachi, for two billion dollars in aid over five years. Adjusted for inflation, this would be higher than even contemporary demands. Pakistan never undersold itself as a military ally. The request was rejected. America was taking a cool look at the strategic map of the region, and would take time to make up its mind.

During the Second World War, the idealist American President Roosevelt had, to the great discomfiture of Churchill, supported decolonization, and India, as leader of the world struggle against British imperialism, inherited great goodwill in Washington when she became free. But Nehru's first visit to America in the summer of 1949 cooled this warmth beyond immediate recovery. Nehru expounded on the virtues of neutrality, stepping aside of the conventional dialectics of a bilateral dialogue, oblivious of the fact that American hospitality never extended to lectures. His host Harry Truman was unimpressed. Talk of aid to India vanished, and Indo-US relations never rose above the necessary levels of cordiality.

The atmospherics of Pakistan Prime Minister Liaquat Ali Khan's first visit in 1950, by contrast, were electric. Truman sent his personal plane to pick up Liaquat from London, and was present at the airport, along with his Cabinet, on 3 May when the Pakistani delegation landed. Neutrality did not exist in Liaquat's vocabulary. He pledged full support to America against communism, and Pakistan voted with America at the UN over North Korea. In return he sought military aid to defend the Khyber. Both sides held their hand at that point. America did not

offer military aid, although it let Pakistan buy arms on commercial terms from manufacturers subject to concurrence by Washington; and Pakistan refused to send troops to Korea despite an American offer to equip one brigade for the purpose. Pakistan's explanation then is a refrain now; it had its own frontiers to worry about, particularly the eastern one against India.

There was one important takeaway, however. Pakistan realized that US military aid would be measured by the sincerity of its commitment against communism. This harmonized well with the personal convictions of the new Army chief Ayub Khan who, quite apart from American sensibilities, was also worried by the domestic threat from socialists in Lahore and Karachi. By August 1952, the State Department was beginning to fret about another problem, the rising power of mullahs. It argued that the 'enlightened western-oriented leaders' currently in power in Pakistan needed the benefits of American aid. A request for $200 million military aid had been rejected; a plea for 200,000 tonnes of wheat was pending. The Pentagon reinforced this view from its own perspective: Pakistan offered excellent airbase sites that would put industrial centres in Soviet Central Asia and China within range of its medium- and heavy-range bombers.

On 5 January 1954, President Eisenhower 'agreed in principle' that Pakistan should get military aid. In February, the National Security Council documented the expectation that Pakistan would provide manpower and strategic facilities in case of a general war with communism, adding the caveat that Washington would not support either side in case of an Indo-Pak conflict. In March, a conference of American ambassadors to Iran, Afghanistan, Pakistan, India, Burma and Ceylon at Nuwara Eliya in Ceylon (as Sri Lanka was then called) endorsed the decision as part of a 'regional defence arrangement in the Middle East [that] will probably be politically beneficial to the United States and the free world'.

By the mid-1950s, power in Karachi was effectively gravitating towards Defence Secretary Iskander Mirza and the Army chief Ayub Khan, as politicians were unable to deliver on either a Constitution or on the formation of a stable government. The US

ambassador to Karachi, Horace Hildreth, proved to be a great friend of Pakistan and Pakistanis; his daughter married Humayun, Mirza's son. Mirza, Ayub Khan and Hildreth effectively persuaded the various echelons of American bureaucracy, not least within the Pentagon, to bend towards Pakistan's needs. Mirza and Ayub used advice from American allies like Saudi Arabia and Turkey on how to befriend Washington. Discretion, however, was not one of Mirza's strengths. According to Shuja Nawaz, Mirza once startled American officials at a dinner in Turkey by mentioning that Pakistan had an army of 250,000 when they thought it was only 80,000. Mirza blandly blamed the faux pas on an excessive quantity of liquid refreshments.

All, however, was well that ended well. On 19 May 1954, the United States and Pakistan signed the Mutual Defense Agreement in Karachi. They had factored in the risk of Indian hostility, and judged that the strategic benefits far outweighed the downside. Pakistan loyally supported the Anglo-French-Israel invasion of Egypt during the Suez crisis in 1956, prompting Abdul Gamal Nasser to say that Suez was as dear to Egypt as Kashmir was to India. Comments by other Egyptian leaders were more tart, including the wry observation that Pakistan seemed to believe that Islam had been born on 14 August 1947.

Pakistan's description of 'communism', however, was more nuanced than Eisenhower's America might have expected. In October 1949, Pakistan was the first Muslim country to recognize Mao's China, and its foreign minister, Zafrulla Khan, supported China's membership in the Security Council in a speech at the UN in 1950. Diplomatic ties were established in January 1950, and in the same year China said thank you in terms that mattered. India and Pakistan had their first trade war in September 1949, when India devalued her rupee and Pakistan refused to do so. India, in turn, rejected the higher value of the Pak rupee and stopped barter supplies of coal, in return for jute and cotton. China stepped in, giving coal in exchange for Pak cotton. China was just the powerful neighbourhood hedge Pakistan needed against India.

Pakistan's China policy has been a sophisticated manoeuvre that kept America onside without disturbing a parallel, if initially quiet, rapprochement with Beijing. This trans-Himalayan equation began on the geometric principle that the sum of two sides in any triangle is greater than the third, before it was upgraded to a strategic alliance against India when events provided the opportune moment in the 1960s. Pakistan was quick to comprehend that Chinese communism was more nationalist than internationalist, and that Mao Zedong had no desire to export his revolution to Pakistan or in fact anywhere else. More to the point, the Chinese definition of nationalism included territorial claims that impinged upon India. When Mao seized Tibet in 1949, China extended Tibet's suzerainty claims to Bhutan, Sikkim and Arunachal Pradesh, the largest province in India's North-East, as well.

Pakistan never allowed its military partnership with the US, or indeed the phase of India–China 'bhai-bhai' brotherhood during the mid-1950s, to interfere with its long-term goal of using China as an insurance policy against India. Four days after Pakistan became a member of SEATO in Manila in August 1954, its ambassador to Beijing, General Agha Muhammad Raza, told Premier Chou en Lai that Pakistan wanted to further develop harmonious relations between the two nations. In 1956, Prime Minister Mohammad Ali Bogra told Chou during the Afro-Asian conference in Bandung that Pakistan would not become a frontline participant if America launched a global war, citing as an example its non-intervention in the Korean War. When Hassan Shaheed Suhrawardy became Pak prime minister later that year, he went on a twelve-day visit to China. The joint communiqué was candid enough to say that divergence of views should not prevent strengthening of relations, since 'there is no real conflict of interest between the two countries'. Beijing, in turn, saw Pakistan as its bridge to the Muslim Middle East at a time of isolation. Suhrawardy reported to his Parliament that he was 'certain that when the crucial time comes, China will come to our assistance'. The 'crucial time' referred to any military confrontation with India.

There was one potential hitch. China claimed a part of Kashmir

under Pakistani control after the ceasefire of 1949. In 1953, Pakistan protested when Chinese maps showed areas in the Shaksgam region of Kashmir, which stretched into the northern boundary of the Siachen glacier, as part of China. In 1956, Pakistan watched with private satisfaction as China built a highway linking Xinkiang to Tibet through adjoining Aksai Chin, which was claimed by India. India was in no position to interfere, and Pakistan had no desire to.

In 1960, Ayub Khan floated the idea of a joint India–Pakistan defence against the 'north', arguing that this unspecified 'north' had always desired access to the warm waters of the Indian Ocean. It was a nineteenth-century theory that seemed a bit passé in the twentieth; moreover, it was never clarified whether 'north' meant the whole of the Soviet-Chinese communist phalanx or just the Soviet Union. Nehru, always suspicious of defence treaties, particularly when produced by American allies, rejected the idea. It did not cross Nehru's mind that India and China could soon be engaged in a territorial war, or that Pakistan could be part of some future triangulation. Although Nehru repeated the formulaic proposition that India wished Pakistan well, he could barely conceal his contempt for a nation that he believed had been conceived in archaic folly. He did not treat Pakistan as an adult power.

India's abject collapse in the October 1962 Sino-Indian war upturned the strategic balance of the region. Defeat shattered the various myths Indian leaders, principally Nehru, had fed the people with for fifteen years. Nehru had gulled himself into believing that ideology was a substitute for defence capability. Nehru's adversary Mao Zedong took a more empirical view. Henry Kissinger says, in *On China*, that in October 1962 Mao summoned his top military and political commanders to Beijing and ordered them to break the border stalemate, explaining, 'China and India were not doomed to perpetual enmity. They could enjoy a long period of peace again, but to do so, China had to use force to "knock" India back "to the negotiating table".'

Ayub Khan drew a more self-serving inference. He thought Pakistan's military would be able to knock a demoralized India

out of Kashmir if he provoked a war. Moreover, Pakistan had extracted an important pledge from America at the height of the India–China crisis. On 14 November 1962, with Chinese forces staring down the Assam plains, Nehru wrote a desperate letter to John Kennedy asking for two squadrons of B-47 bombers and twelve of supersonic fighters with American crews. Kennedy was eager to help India against Chinese designs, and mollified Pakistan with the assurance that America would stand by her in case of Indian aggression.

Ayub Khan had seized power through a coup in 1958 – one of eight across the developing world that year – with tacit American support. Reckless economics, uncontrolled inflation, bizarre politics and the threat of a secessionist movement in the old princely state of Kalat on the Iranian border persuaded Ayub Khan to act. According to his aide and ghost writer Altaf Gauhar, Ayub Khan spiced up his explanatory messages to Washington with the fear that socialists of dubious antecedents would get themselves elected by rigging the polls in the elections scheduled for February 1959. Ayub Khan had been dropping hints about such a contingency since 1954; by 1958 he was convinced that the 'country [was] going to the dogs'.[4]

As far as Washington was concerned, most of the Middle East was headed in that direction. In July 1958, the pro-West regime in Iraq, a prime mover behind the Baghdad Pact, was overthrown and massacred. No one could be certain in which direction a restive Pakistan would shift. The State Department advised caution in May 1958 when Iskander Mirza, now president and in cahoots with Ayub, hinted that he might need to dismiss his own civilian government, but when on 4 October Mirza informed US ambassador James Langley that martial law would be imposed within a week, there were no serious American objections. Washington merely hoped that the 'interval of restricted rule would be as short as necessary to preserve democracy'.

Mirza abrogated the 1956 Constitution and declared martial law on 7 October 1958. But martial law does not encourage dual authority. Mirza lasted only twenty days; on 27 October, Ayub

Khan forced him to resign. Mirza was detained in Quetta. When he left for exile in London, Langley was the only diplomat at the airport to see him off. Dennis Kux notes: 'Four days after the ouster of Mirza, Pakistan's new president received best wishes from US chargé d'affaires Ridgway Knight ... Ayub assured Knight, "Recent developments have, if anything, strengthened Pakistan's faithfulness to its alliances. Pakistan is more than ever on the side of the free people of the West."' Neither side saw much irony in the fact that Pakistan's own people had just lost their freedom. On 5 March 1959, America and Pakistan signed a bilateral security arrangement, which committed the US to take appropriate action, 'including the use of armed forces, as may be mutually agreed upon' in case Pakistan faced aggression.

The flaw was noted by Pakistani foreign minister, Manzur Qadir, who commented that the agreement added nothing new since it did not commit US support in case of an attack by India. Ayub Khan did not make this an issue. The public bonhomie between America and Pakistan added to a misconception that this was an all-weather commitment. In December 1959, Eisenhower became the first American president to visit Pakistan. (This was the first occasion on which Air Force One was used.) An estimated 750,000 people cheered as Eisenhower and Ayub drove fifteen miles from Karachi airport; they then shifted to a horse-drawn state carriage, in grand British Raj style, for the final mile through the capital's packed streets. The exotic highlight of Eisenhower's itinerary was a visit to the stadium to see Pakistan play Australia at cricket. Eisenhower did not stay long at the stadium. He left Pakistan with a very positive impression of Ayub Khan, describing him in his memoirs as agreeable, intelligent, persuasive, pleasant, modest, incisive – and a gentleman. Eisenhower even believed that Ayub believed in democracy.

During their talks, Ayub mentioned that Soviet influence over Afghanistan was on the rise and that the Chinese were building air bases near the Pak border; he also worried, a bit facetiously, that India might collapse. He urged America to enable a settlement on Kashmir, if not through a plebiscite then through other means.

(In 1955, Nehru had offered a settlement based on a partition along the ceasefire line, but this was rejected by Pakistan.) Eisenhower rejected the role of an intermediary, not least because he was headed for a four-day visit to Delhi after Karachi and Kabul. Perhaps Pakistan expected that its ally would display the solidarity in the event of war that it was not ready to display in the less demanding environment of peace.

Ayub Khan was careful; he played his China card calmly. In December 1962, within weeks of India's humiliation along the Himalayas, Pakistan and China came to a 'provisional agreement' on their disputed Kashmir border, the provision being that the final demarcation would be sealed after a resolution of Kashmir's status. The text was finalized in February 1963, and signed in March. India objected, to little avail. China pointed out that it had never accepted, unreservedly, Kashmir's accession to India. In June 1963, *Dawn*, Pakistan's premier English newspaper, quoted Chou en Lai as telling a Pakistani journalists' delegation that China 'would defend Pakistan throughout the world'. In August 1963, China signed an agreement for commercial flights with Pakistan, the first with any non-communist country. In July 1964, China gave Pakistan its first loan, of $60 million, to finance the purchase of Chinese goods.

When Ayub Khan invaded Kashmir in the autumn of 1965, China sent a three-day ultimatum to India to dismantle military works on the 'Chinese side' of the Sikkim border and described India as the aggressor, raising Pak expectations. But Pakistan had to deal with a triple shock. America halted arms supplies to Pakistan; the war tilted in India's favour; and Beijing did nothing to follow up on its bluster. Beijing did not confuse its own interests with Pakistan's. After 1965, with American supplies frozen, China helped Pakistan re-arm, providing, in May 1967, weapons worth $120 million, including hundred T-59 tanks and eighty MiGs. By early 1971, a quarter of Pakistan's tanks and one-third of its air force were from China, but Beijing once again did nothing when Pakistan lost half its country in the December war of 1971, treating the conflict, as Chou informed President Yahya Khan, as a purely internal matter of Pakistan.

The Chinese view of its neighbourhood has been explained succinctly by Henry Kissinger. '[Imperial] China,' writes Kissinger in *On China*, '. . . never engaged in sustained contact with another country on the basis of equality for the simple reason that it never encountered societies of comparable culture or magnitude. That the Chinese Empire should tower over its geographical sphere was taken virtually as a law of nature, an expression of the Mandate of Heaven . . . Neighbouring peoples, the Chinese believed, benefited from contact with China and civilization so long as they acknowledged the suzerainty of the Chinese government. Those who did not were barbarian . . . In its imperial role, China offered surrounding foreign peoples impartiality, not equality.' A proper relationship demanded the ritual of 'kowtow' to acknowledge the Chinese emperor's superiority.

As Kissinger points out, Mao saw himself as heir to these classical precepts; and China's resurgence under communism was a modern and liberal manifestation of eternal imperial truths. The Mongols, Uighurs and Tibetans were people of the periphery; individually, they constituted a potential threat, collectively, they could overwhelm a superior civilization. If we remove Mongolia, Muslim-Uighur Xinkiang and Buddhist Tibet from the Chinese map, it begins to look like a very different place – and also explains why the Great Wall is situated where it is. The answer, therefore, was to divide the 'barbarians' so that they could be held in subjection more easily. Independence for Xinkiang or Tibet, therefore, would endanger the security of the mainland. A Ming dynasty official put the matter pithily: 'Wars between the "barbarians" are auspicious for China.' Extending that principle south of the Himalayas, wars between India and Pakistan are auspicious for China. Pakistan has cemented its ties with China with deferential 'kowtows'; India shows no intention of similar consideration.

In material terms, the 1965 American ban on arms supplies hurt Pakistan far more since America was its principal supplier. Under relentless Pak pressure, Lyndon Johnson amended this to a sale of 'non-lethal' arms and spare parts in April 1967. Kissinger,

who chooses his words carefully, detected a 'somewhat warmer tone' towards Pakistan after Richard Nixon became president, but it was not until 8 October 1970 that America announced a one-time $50 million sale of replacement aircraft and 300 armoured personnel carriers. Nixon and Kissinger were softening Pakistan for a radically different initiative. On 25 October 1970, President Yahya Khan met Nixon over dinner at the White House. Yahya was due to visit Beijing in November. He was asked to carry a message: that Washington regarded rapprochement with China as essential; that America would not join a 'condominium' against China; and was ready to send a high-level envoy for secret discussions. That envoy, of course, was Kissinger. Nixon and Kissinger stood by Pakistan during the 1971 war, but only to the extent of protecting the territorial integrity of West Pakistan. As Kissinger has written, the aircraft carrier *Enterprise* was ordered towards the war zone to warn India against any dismemberment of West Pakistan.

Pakistan under Yahya's successor Zulfiqar Ali Bhutto once again showed the unique capacity of maximizing the advantages of adversity. It projected the 1971 war as a triumph of 'Hindu imperialism' and sought, and got, both immediate and long-term aid from Arab countries. During the 1965 war, Pakistan received $20 million from Saudis, ten F-104s from Jordan, three F-5s from Libya, loans from Kuwait and Abu Dhabi and an offer from the Shah of Iran to intervene militarily on Pakistan's behalf. But this was only an appetizer. The 'destruction' of an 'Islamic bastion' by 'Hindu India' was an easy if simplistic narrative for an eager Arab audience. Implicit was the assumption that Bengali Muslims, who had formed their independent Bangladesh, were not 'proper' Muslims for reasons foreshadowed by Shah Waliullah in the eighteenth century – they had been contaminated by 'Hindu culture'. Images of puja celebrations in Dhaka by Bangladeshi Hindus fed into this narrative. In strategic terms, the division made Pakistan more defensible, while the need for recovery opened up the purse of allies and friends. By 1975, Bhutto had achieved two great objectives.

On 24 February 1975, Washington announced an end of the arms embargo on India and Pakistan. The second was immensely more valuable. With oil revenues heading into stratosphere after 1973, Bhutto sought aid from Islamic states like Saudi Arabia and Libya for the ultimate security blanket of the faith-fortress, an 'Islamic bomb'. The term was fluid enough to mean more than just a weapon against 'Hindu India', which had tested its first nuclear device in 1974. Pakistan was already, by the 1970s, an exporter of infantry and air force pilots to the Arab world, through military protocols with Saudi Arabia, Libya, Jordan, Iraq, Kuwait, UAE and Oman. Payment came both directly and indirectly, as for instance in 1981 when Saudi Arabia provided $800 million for the purchase of forty F-16s. Faith became an argument in the nuclear game: Christians had more than one bomb; Jews had got theirs through Israel; Hindus of course had India and the godless communists had two. It was time for Islam to enter the nuclear bomb age, with or without permission from America.

The superpowers paid the usual lip service to non-proliferation, while privately enabling Pakistan to go nuclear. In 1975, France was negotiating the sale of a nuclear fuel reprocessing plant which had far greater capacity than needed by the nuclear reactor at Karachi, and could provide the plutonium needed for nuclear weapons. Dennis Kux reports that Kissinger's briefing memorandum to President Gerald Ford for Bhutto's visit to Washington in 1975 included this paragraph: 'There is now considerable evidence that Pakistan is embarked on a programme that could in time give it the option to duplicate India's nuclear explosion of last May.' Ford and Kissinger did not raise the nuclear topic with Bhutto, but a very polite demarche was sent to Iqbal Riza, chargé d'affaires at the Pak embassy, hoping that Pakistan would not pursue 'the politically risky and costly development of nuclear explosives'. Pakistan ignored this pro forma hint and signed the contract with France. Washington stared hard the other way. The Soviet invasion of Afghanistan in 1979 was sufficient to persuade American presidents to continue staring in the opposite direction.

When they met in 1975, neither Ford nor Bhutto knew they would be out of office by 1977. The first went into retirement after being defeated by Jimmy Carter; the second went to his grave after being deposed and then hanged by General Zia ul Haq. On 18 December 1978, a pale and haggard Zulfiqar Bhutto appeared in the Supreme Court to argue his own appeal against the death sentence passed by the Lahore High Court on 18 March. General Zia rejected pleas for clemency towards Bhutto by Pakistan's closest allies, including America and Saudi Arabia. On 2 February 1979, the Pakistan Supreme Court rejected Bhutto's appeal by a single vote, and Zia ignored Carter's final appeal for clemency. Bhutto was hanged on the morning of 4 April. On 6 April 1979, Carter suspended aid to Pakistan, using its nuclear programme as the excuse; Pakistan continued to insist that its programme was peaceful. Well, it was as peaceful as India's.

Carter abandoned all thoughts of human rights, and the Saudi king his much professed affection for 'brother Bhutto' when, on Christmas day 1979, Moscow ordered troops into Kabul. It was as if the age of James Abbott had suddenly been resurrected. Carter phoned Zia that very day and reaffirmed his commitment to the 1959 bilateral security pact against communist aggression. Zia did not need any persuasion. He was clear and courageous on the Soviet threat. Dennis Kux quotes the then Pak foreign minister, Agha Shahi's story of the meeting between Zia and the Soviet ambassador to Islamabad. Zia, angry at this violation of a fellow Muslim nation's sovereignty, asked a simple question of the Soviets: 'Which government, Mr Ambassador, invited you in?'

Zia's strategy to counter the Soviets was simple and unwavering: no compromise, even if the threat extended to Pakistan; clandestine support for the Afghan military resistance; and shelter for Afghan refugees. His fresh wish-list to Washington included the latest tanks and F16s. It suited Zia perfectly when India became the only non-communist country not to vote against the Soviet invasion at the United Nations. Carter was not yet ready to sell F16s but offered $400 million in aid. On 18 January 1980, Zia, while talking to journalists, dismissed this offer as 'Peanuts!', which did not go down too well with the peanut farmer in Washington.

When Zia met Carter in the White House on 3 October 1980, he did not even bother to raise the issue of security assistance. It was Carter who, on his own volition, offered state-of-the-art, nuclear-capable F16s. Zia snubbed his host, telling Carter that he must be very busy with the elections, and the matter could wait. Pakistan had calculated that Ronald Reagan would win, and it would get a far better deal from Reagan. Zia was right.

He set the terms in April 1981 when Agha Shahi, along with General K.M. Arif, went to Washington to talk to General Alexander Haig, the new Secretary of State. Pakistan told the United States, unambiguously, that it would not compromise on its nuclear programme. Haig replied that the dispute should not become the centrepiece of relations between the two countries. America said, in other words, that it could live with a Pak bomb as long as Pakistan did not test one. Haig also agreed that his administration would not raise either human rights or democracy in Pakistan. Haig also agreed that while CIA would serve as supplier of arms for the Afghan mujahideen, the weapons would be funnelled through ISI, giving ISI effective control of the battlefield and decisive influence over its various players. This arrangement had been put into effect in 1979; Reagan reaffirmed the Carter deal. And the money was anything but peanuts: $3.2 billion, divided equally between military and economic aid. On 13 May 1981, the Senate Foreign Relations Committee approved a six-year waiver for the sanctions against aid to Pakistan.

This was the moment when Pakistan won the Afghan jihad and America lost control over its sequence and consequence. Zia kept Washington, and particularly CIA director William Casey (who had, unusually, full Cabinet membership), happy with briefings on the Soviet ambitions in the Gulf, and military aid escalated from $30 million a year to $600 million by 1982. The Saudi funding was less transparent, but is believed to be equal. By 1984, Lieutenant General Sahibzada Yaqub, who had replaced Shahi as foreign minister, could tell George Schultz, who had replaced Haig, that 'The Soviet war effort in Afghanistan is marked by ineptitude, incompetence and erosion of morale. After

four and a half years, they have not learnt how to fight in Afghanistan, and they have not won over the Afghans to their side.' Yakub, who had been Zia's senior officer, had the dexterity of a diplomat and the knowledge of a general.

The Reagan administration gave Pakistan a total pass on the bomb. Reagan raised the topic of the nuclear programme when he met Zia privately for twenty minutes on 7 December 1982, before joining their advisers for formal talks in the Cabinet room of the White House. Zia blandly assured Reagan that Pakistan's nuclear programme was peaceful, and Reagan equally blandly accepted the assurance. Later in the day, the White House spokesperson said, 'We accept that the President of Pakistan is telling the truth.' A number of tell-all books have revealed, most tellingly in Adrian Levy and Catherine Scott-Clark's *Deception: Pakistan, the United States and the Global Nuclear Weapons Conspiracy*, how deliberate American indifference, Arab money and Pakistani initiative combined to make Pakistan a nuclear power.

A second instance reveals more. On 4 April 1984, the Pakistani Urdu newspaper *Nawa-e Waqt* quoted Abdul Qadeer Khan, father of the Pakistani bomb, as claiming that Pakistan had enriched uranium to weapons grade. On 12 September that year, Reagan shot off a stern letter; Zia sent a non-reply, and life went on. Whenever pushed, by politician or journalist, Zia simply denied that Pakistan was making a bomb. Reagan helped water down sanctions against Pakistan – embodied in Senator John Glenn's proposal for action against nuclear proliferation – to the Larry Pressler amendment, which required only an annual certificate of good behaviour. Zia was confident enough about the Reagan administration to be flippant. According to Kux, when General Vernon Walters showed Zia a satellite photograph of the Kahuta facility in 1984, Zia replied, 'This can't be a nuclear installation. Maybe it is a goat shed.'

The war was fought in Afghanistan, but the massive war industry was operated from Pakistan. Zia's war objectives were significantly different from Reagan's. America wanted the

humiliation of the Soviet Union, to revenge Vietnam and Angola
and the Horn of Africa. For Zia, the Afghan jihad was also an
embryo of a new regional, and perhaps world, order that would
emerge out of the Islamic resistance.

The Soviet invasion gave Zia and his ISI director general,
General Akhtar Abdul Rahman, the opportunity to expand both
Islam and resistance. Soon, there were volunteers and groups
from Morocco to Mindanao, financed by the Saudi-sponsored
Rabita al-Alam al-Islami. Pakistan invigorated the Motamar al-
Alam Islami (Muslim World Congress), founded in 1949 with the
blessings of the controversial grand mufti of Palestine, Al-Haj
Amin al-Husseini, with American money and turned over a
mosque in Islamabad to serve as its headquarters to announce
Pakistan's support for Islamic causes all over the world. In 1984,
Pakistan welcomed a Palestinian scholar, Abdullah Azam, who set
up base and an institution, Maktab al-Khidmaat (Bureau of
Service), to mobilize recruits, particularly from the Arab world,
for the jihad. One of his most motivated disciples was the son of
a great Arab business tycoon, Osama bin Laden.

By 1986, Pakistan was training, going merely by official figures,
at least 20,000 mujahideen every year. This did not include the
Islamist parties and organizations in Pakistan that used this
windfall environment to give their cadre both arms and an
education on how to use them, even as they stocked up their
private arsenals. There was money to be made from various
sources: siphoning off aid in the name of jihad, or through the
high-revenue drugs smuggling (alcohol-light Pakistan became a
principal market for drugs). The Afghan jihad wound down with
a negotiated settlement in April 1988. General Zia died suddenly
that year, on 17 August, in a plane crash whose mysteries have
never been unravelled. In *Pakistan: Between Mosque and Military*,
Husain Haqqani quotes an ISI official: 'With the Soviets leaving
Afghanistan, the last thing the US wanted was for Communist
rule in Kabul to be replaced by an Islamic fundamentalist one. US
officials were convinced that this was Zia's aim. According to
them his dream was an Islamic power block [sic] stretching from

Iran through Afghanistan to Pakistan with, eventually, the Uzbek, Turkoman and Tajik provinces of the USSR included. To the State Department such a huge area shaded green on the map would be worse than Afghanistan painted red.' It is tempting to speculate how Zia would have responded to the collapse of the Soviet Union which occurred just four years after he died.

Zia's seeds flowered under the care of non-state protagonists, most of whom continued to receive the patronage of the state as its tactics shifted with emerging objectives. Pakistan's new, elected leader, the young Benazir Bhutto, plunged into Afghan power-plays with inherited instruments. The Soviet protégé Najeebullah, widely expected to keel over without the presence of Russian troops, displayed surprising resilience in Kabul; Bhutto, along with her ISI chief Hamid Gul, tried to finesse him by setting up an alternative Afghan interim government based in Jalalabad, a key town between Peshawar and Kabul. Mujahideens were grouped into a patchwork force for a conventional assault on Jalalabad. They failed miserably.

Among those involved in the battle for Jalalabad was Osama bin Laden. Osama, contrary to popular impression, played only a marginal role in the anti-Soviet jihad. Al-Qaeda came into its own with the rise of Taliban in 1994. The Taliban leader, Mullah Omar, a member of the Ghilzai tribe, had, in contrast, fought vigorously against the Russians and lost an eye. He had gone back to the quiet life in his home city of Kandahar. Order crumbled under fractious mujahideen governments after Najeebullah was defeated in 1992. Mullah Omar was incensed when a group of Herati boys and girls were raped and murdered at a roadside extortion post controlled by a warlord 90 km north of Kandahar. He began a march that climaxed, on 27 September 1996, with the capture of Kabul, helped along the way by ISI and Prince Turki Al Faisal through Saudi Arabia's General Intelligence Directorate. Osama, who had been evicted from semi-retirement in Saudi Arabia after the first Gulf war, found eventual sanctuary under the Taliban.

America began applying pressure, through Pakistan and Saudi

Arabia, to get bin Laden after the Al-Qaeda attack on American embassies in East Africa in 1998. By this time, Qaeda had an estimated 20,000 actual and potential terrorists in its ranks. Mullah Omar admitted that Osama had become a bone stuck in his throat, which he could neither swallow nor spit out. He, however, finally decided in Osama's favour, and that is where matters stood until 9/11. There will be as many variations as there are books about where and how Osama survived in the decade till his death in May 2011, but this much is evident: he lived in the border regions of Afghanistan and Pakistan before settling down in Abbottabad. The ISI kept track, but chose to keep its information to itself.

This decade saw an explosion of jihadi groups operating out of Pakistan, each with its own agenda, claiming a more or less common cause without common leadership. Arabs continued to arrive for training in Pakistan for a never-ending jihad that sought targets where it could find them. Some war zones were obvious, like Tajikistan or Bosnia–Herzegovina, as teachers like bin Laden's mentor Abdullah Azzam insisted that jihad expel occupiers of all Muslim lands as part of compulsory duty. This was extended by 'classicists' to all regions once ruled by Muslims, placing Spain and India neatly into the jihad matrix. Among Azzam's disciples was a Pakistani teacher at the University of Engineering and Technology in Lahore, Hafiz Mohammad Saeed, who had studied at the Islamic University of Medina and emerged as both scholar and militant. In 1985, Saeed, along with a colleague, Zafar Iqbal, started the Jamaat-ud-Dawa (Organization of Preaching; JuD) to promote the cleansing of society through Islamic principles. Jihad was essential to this purification; Saeed argued that the decline of Muslim power began when they abandoned jihad. In 1990, the JuD launched its military wing, the Lashkar-e-Tayyiba.

Lashkar had eight declared objectives, among them: to end persecution of Muslims, avenge the killing of any Muslim, defend Muslim states, recapture Muslim land and, curiously, impose jizya, or the poll tax, on non-Muslims under Muslim suzerainty.

This suited the ISI, which hoped to use Lashkar and others of the same ilk to repeat in Kashmir what they had achieved in Afghanistan. It was believed that the Indian Army would be a pushover compared to the mighty Soviet phalanx. The ISI began to invest heavily in Lashkar in the belief that it would be more amenable to its aims in Kashmir. For Lashkar, Kashmir was not just another territorial war between nations but an epic confrontation between idolaters and iconoclasts that had begun from the time of Prophet Muhammad. A particularly blissful paradise, therefore, would be a martyr's reward for killing Hindus. Moreover, Kashmir once taken would serve as the base for the reconquest of India.

Pak Army and ISI personnel helped train the Lashkar fidayeen or young men ready to die in the line of duty. When on 22 December 2000, two of his fidayeen managed to reach the Red Fort in Delhi, once the seat of Mughal power, killing two soldiers and a guard before escaping, Saeed boasted that he had extended jihad to the heart of India. That same month, his men attacked the Srinagar airport. The spectacular assault on India's Parliament on 13 December 2001 was, however, by a fellow jihadi outfit, Jaish-e-Muhammad. But Hafiz Saeed began to plan something even more dangerous.

On 21 November 2008, ten young Lashkar fidayeen left the Pakistani coastline by sea for Mumbai. Nearly a week later nine of them were dead, but not before they had stunned India with a display of mass butchery of innocents at selected targets, which included two premier hotels, the main railway station and an obscure Jewish establishment, in which 166 innocent civilians and security personnel died. Among the dead were six Americans, including a Hasidic Jewish couple, Rabbi Gavriel Holtzberg and his wife Rivka at their residence, Chabad House; their child was saved by a brave maid (both are now in Israel). The world heard a Lashkar handler in Pakistan telling, over their phone link, the two Lashkar terrorists, Nasir (from Faisalabad) and Imran Babar (from Multan), assigned to Chabad House, that killing a Jew would fetch fifty times the reward in heaven as compared to

killing any other infidel. The Lashkar has proclaimed often
enough that its world war is against the alliance of 'America,
Zionists and Hindu India'.

When the havoc ended, one fidayeen, Ajmal Kasab, was caught
alive and is still in a Mumbai jail. This was the one thing Lashkar
did not want, because Kasab was living proof of the connection
to Pakistan, making deniability that much more implausible.
Indian intelligence agencies recorded nearly a thousand minutes
of phone conversation between the assailants and their
manipulators in Pakistan. Islamabad's attempts to delink Pakistan
from this outrage collapsed completely on 7 December 2008
when Pakistani media exposed Kasab's origins to a village in
Faridkot and revealed that his parents had been taken away by
Pakistani security forces who in turn were feeding misinformation
to the media. The United Nations named Lashkar and its
'missionary' wing Jamaat-ud-Dawa as terrorist organizations.

Under international pressure, Pak authorities raided a Lashkar
camp on 7 December, but for cosmetic purposes. The Lashkar
merely reverted to its parent name of Dawa, and this thin
camouflage was considered sufficient. At the moment of writing,
Hafiz Saeed is under a benevolent form of house arrest, while
Lahore courts cannot get their act together to begin any effective
prosecution. Jamaat-ud-Dawa continues to get grants from the
Punjab government.

America had its own reasons to worry about Dawa/Lashkar. Its
'martyrs' spread their engagement to Afghanistan, fighting
alongside Taliban even as it carried out its own special operations,
as for instance the attack on the Indian embassy in October 2010.
Pakistan has, in the meantime, made clear, if clarity was required,
that it will not be able to restrain Lashkar as long as the conflict
over Kashmir is not resolved.

In October 2009, American authorities arrested a Lashkar
operative, a Pakistani-American called David Headley. He had
been arrested in a different context, but when he began to talk,
details of ISI and Lashkar involvement in the Mumbai outrage
began to unravel. Headley did not sing for free; he escaped a
death penalty charge in America or repatriation to India.

David Headley was born in 1960, and named Daood Gilani; he took the nom de plume only in 2006 when he began reconnaissance work for Lashkar on trips to India. (Daood is the Arabic version of David.) His Pakistani father sent him to the elite Hasan Abdal Cadet College, a boarding institution in Pakistan that provides officers for the Army. His American mother took David back to her country when he was seventeen, but it was a mistake: he turned into a drug addict and small-time drug smuggler, a familiar journey. But the rest is unfamiliar enough to deserve a chapter in esoteric spy fiction. He was first arrested in 1988 for smuggling heroin from Pakistan to the US, and gave enough information to obtain a reduced sentence of four years. He was back in handcuffs in 1997 for a similar offence. This time he did a deal and became a double agent for the US Drug Enforcement Agency (DEA), promising to infiltrate the Pakistani narcotics gangs in New York.

As reward, he was released within a year, and allowed to travel to Pakistan in 1999 for an arranged marriage. (Duplicity, or its multiple, came easily to David. He had four wives, none of whom was aware of the others; he divorced once. When they learnt the truth they took their revenge.) David established contact with Lashkar on this trip, in Lahore, and met Hafiz Saeed several times. In February 2002, he participated in a three-week Lashkar camp at Muridke and another in August in Muzaffarabad. He offered to join the jihad in Kashmir, but was told he was too old. Instead, he was directed towards the Daura-e-Ribat, a unit which concentrates on India. In December 2003, Headley was given a four-month course in unarmed combat and battle techniques by an officer of the Pakistani Army.

His American passport made him ideal for surveillance work in India; to avoid suspicion he decided to change his name. In September 2005, he returned to America and on 15 February 2006, he changed his name, at a government office in Philadelphia, to David Coleman Headley. American authorities came to know about his terrorist connections only in August 2005 when one of his wives, enraged after a fight, tipped off the Joint Terrorism

Task Force, a unit under FBI. In 2007, another wife, based in Pakistan, told the American embassy about his trips to India, although she had no idea that a Mumbai operation was being planned.

The ISI, or at least a group within it, was certainly in the know. Headley had an ISI handler, known to us as Major Iqbal. ISI's relations with terrorist outfits like Lashkar were full of shadowy characters, some in uniform and others who had retired, as for instance Headley's friend Major Abdur Rehman Syed, who joined Lashkar in 2003. Headley was detained once in the Khyber area and interrogated by a certain Major Samir Ali. He was let off after he explained that he had come to activate his old drug smuggling contacts in order to send arms to India, where he would be deployed. A 'Major Iqbal' contacted Headley after this brief interrogation at Khyber, and gave him $25,000.

Headley used this money to open an immigration office in Pakistan, as a front. During his visits to India, he worked for both the Lashkar and the ISI, bringing videos of army installations in Delhi and Pune for Major Iqbal. Headley has also told American interrogators that when several architects of the Mumbai attack met in Muzaffarabad in March 2008, a clean-shaven, crew-cut man joined them, who, he believed, was from the Pakistan Navy. Chabad House was among the sites surveyed by Headley.

When America put Headley on trial in Chicago, it was not because he was on India's most wanted list. The Lashkar is as much America's enemy as India's. America has long recognized the double game played by elements within the Pak establishment in the Afpak wars, but has been forced by the larger need for an alliance with Pakistan to calibrate its reaction. It required the traumatic discovery of Osama bin Laden in Abbottabad for the full shock of betrayal to be felt not only in Washington but also across American streets.

Geronimo is the name of an Apache nationalist who fought Mexican and American invasions of his territory – not the most appropriate nomenclature for the last phase of a long hunt for Osama bin Laden. But someone in CIA considered the analogy relevant, since Geronimo had also eluded capture for years.

In August 2010, the CIA briefed President Obama on a possible intelligence lead to bin Laden. As the President said, while announcing the death of bin Laden, 'It was far from certain, and it took many months to run this thread to ground. I met repeatedly with my national security team as we developed more information about the possibility that we had located bin Laden hiding within a compound deep inside of Pakistan.'

It was not only deep inside Pakistan, but it was also literally next-door to Pakistan's vaunted military academy, in Abbottabad, a command base for the Army. American intelligence had intercepted a phone call from the mobile of a trusted bin Laden courier, Abu Ahmed al-Kuwaiti, a name high on America's wanted list. Bin Laden had always taken careful precautions; he allowed his men to make calls only after they had driven for at least ninety minutes from his residence. Once the CIA was confident that they had al-Kuwaiti's number, they tracked it down to the compound. But the CIA could not be certain that the principal resident was bin Laden.

Satellite surveillance began immediately. The CIA also used the 'stealth Drone', a bat-winged craft capable of taking photographs from high-altitude angles. A man who looked like bin Laden was spotted walking up and down. The CIA nicknamed him 'the pacer', but that did not amount to confirmation. In the *Washington Post*, Karin Bruilliard and Karen De Young have described the house where bin Laden was eventually found: 'Even in a neighborhood of roomy residences, the three-story white house stood out. The home, down the street from an elite Pakistan military academy, was eight times as large as others nearby. Its razor-wire-topped walls were higher. Its occupants acted mysteriously, neighbors said, burning trash rather than placing it outside.'

The CIA rented a house nearby for intense scrutiny as well as a series of imaginative exercises. It sent people in plain clothes to the door of the bin Laden house, ostensibly to check whether it was on sale, which was an excuse to ask for architectural plans. The most imaginative plan was surely setting up a phoney

vaccination programme to try and get DNA evidence from inmates through inoculations. It was run by a Pakistani doctor, Shakil Afridi, who recruited nurses to give hepatitis B vaccinations throughout the city, starting with the impoverished fringe.

Dr Afridi did manage to get access but neither saw bin Laden nor could he obtain samples of the others. After bin Laden's death, in July 2011, Dr Afridi was picked up by the ISI, which has shown more enthusiasm for harassing and arresting Pakistanis who helped the CIA than it has ever done in finding bin Laden. The Pak foreign ministry claimed, after Geronimo, that the ISI had kept this compound 'under sharp focus' since construction began in 2003, but then, mysteriously, scrutiny was abandoned. The Associated Press checked property records and found that the compound was purchased by a Mohammad Arshad for $48,000 in four stages between 2004 and 2005.

There is no further information so far in the public domain about Mohammad Arshad. But common sense, if not CIA information, suggests that Osama bin Laden could not have been hiding in plain sight without some level of support from military intelligence officials. In the immediate aftermath of bin Laden's death, Husain Haqqani, Pak ambassador to Washington, said flatly that Islamabad did not know bin Laden was living in Abbottabad. But John Brennan, Obama's top counter-terrorism adviser, who went public on the subject, had this to say: 'I think it's inconceivable that bin Laden did not have a support system that allowed him to remain there for an extended period of time. I am not going to speculate about what type of support he might have had on an official basis inside Pakistan.' There will be many theories about who knew what, and when, but there is enough to surmise that mistrust between Washington and Islamabad was total over Geronimo.

What we do know is the American version of what happened. On the morning of Friday, 29 April, Obama gave the nod. By this time too many officials were in the know, and a leak would have destroyed one of the most meticulous hunts mounted by the CIA. An option to bomb the site with B2 stealth bombers was rejected

as there would inevitably be civilian casualties, and bin Laden's body might get buried beyond easy recovery in the rubble. The helicopter option was assigned to Seal Team 6 from the Naval Special Warfare Development Group, or DEVGRU in military-speak, based in Dam Neck, Virginia. They are known as 'black' operatives since their action-remit is outside military protocol. The night chosen was Saturday, since it was moonless. Weather delayed the forty-minute operation to Sunday night.

Two specially adapted Black Hawks, with twenty-three Seals, a translator and a tracking dog called Cairo, left a base in Jalalabad, flying low to avoid radar. The plan was to hover over the bin Laden house while two teams clambered down ropes, one to the roof and the other to the compound. One Black Hawk malfunctioned over destination; its pilot ditched, and its tail and rotor got caught in one of the high walls. The other landed safely outside the compound. The surprise was gone, but no one was hurt, and the Seals began blasting their way through. Bin Laden and his family lived beyond the main building in a single-storeyed structure. Back in the White House – where a tense group around Obama, Vice President Joe Biden and Secretary of State Hillary Clinton waited in the Situation Room for live information – no one knew for about twenty to twenty-five minutes what was going on.

Three Seals found bin Laden in the hall on the top floor; he saw them and ducked into his room. Two women were screaming and trying to protect bin Laden when the Seals entered. A Seal pushed them aside and killed bin Laden with two bullets, one to the head and a second to the chest. His companion radioed back: Geronimo EKIA. The message was relayed instantly to the White House. Obama had a simple reaction that could not possibly have fully conveyed the relief he must have felt: 'We got him.' An AK-47 and a Russian Makarov pistol were found in the room. Bin Laden had not touched them. A Chinook helicopter picked up the team from the damaged Black Hawk, which was blown up to prevent its technology from reaching Pakistani – and from there, probably Chinese – authorities. They took with them bin Laden's body and

a library full of information on discs. Osama bin Laden was buried at an undisclosed location in the northern Arabian Sea.

On 11 May 2011, Maulvi Asmatullah of the Jamaat e Ulema Islam (Fazl group) stood up from his seat in Pakistan's Parliament and offered prayers for the soul of Osama bin Laden, despite protests by deputy speaker Faisal Karim Kundi that this was no forum for religion. Pakistan was enveloped with questions: about its porous airspace, about the impotence of its government, about the silent groundswell of sympathy for bin Laden, and about whether the Americans had come to some private understanding with their Army chief Ashfaq Kayani before invading their airspace – what else could explain the fact that Pakistani Air Force had not stirred?

There are questions in America, too, where few are now willing to give Pakistan the benefit of any doubt. The administration is still wary of a total breach in the military alliance with Pakistan, not least because Pakistan's cooperation is essential for any American withdrawal from Afghanistan. But enough has been said and done to drag relations to a nadir. As Major General (Retired) James R. Helmly, who was the top US officer in Pakistan from mid-2006 to 2008, told the *International Herald Tribune* on 4 May 2011, 'Someone knew. Whether it's in the top echelons of the ISI is anyone's guess.'

General Zahir Azimi, spokesman for the Afghan defence ministry, who had less reason to be circumspect, put it more pithily, as reported in the *Times of India* of 7 May 2011: 'If the Pakistan intelligence agency does not know about a home located 10 m or 100 m away from its national military academy, where for the last six years the biggest terrorist is living, how can this country take care of its strategic weapons?' Afghanistan has been saying for years that Osama bin Laden was in a safe haven in Pakistan. No one could quite believe it was this safe.

The eminent Pakistani author and commentator Ahmad Rashid has astutely described the Pakistani Army's shopping list for Americans as money at the top and money at the bottom and arms in the middle. For a long while all three arrived without too

many questions. That trust is gone. Adam Entous and Siobhan Gorman reported in the *Wall Street Journal* on 15 August 2011: 'The White House has started conditioning the award of billions of dollars in security assistance to Pakistan on whether Islamabad shows progress on a secret scorecard of US objectives to combat Al-Qaeda and its militant allies. The US is also asking Pakistan to take specific steps to ease bilateral tensions. The classified system, put in place after the US raid that killed Al-Qaeda leader Osama bin Laden at his Pakistani hideout, signals a shift by the White House towards a pay-for-performance relationship with Pakistan, as doubts grow that the two countries can now forge a broader alliance based on shared interests. A senior official called the unusual new approach "a hard-knuckled reflection of where we are right now" in relations.'

The Pakistani armed forces, in other words, had been reduced to an unreliable mercenary contractor. There is corrosive uncertainty in Washington about the imperatives that drive Pak armed forces policy towards those terrorists who consider America their principal enemy. The daily diet of mayhem feeds many forms of sectarian hunger in Pakistan: Shias, for instance, are regularly gunned down by Sunni fanatics, while Karachi is riven by a continual civil war between those who came as refugees in 1947 and newer immigrants from the Frontier and Baluchistan. America, understandably, is concerned primarily about the sanctuary that anti-American militias get in Pakistan, like the one operating under the command of Jalaluddin and his son Serajuddin Haqqani. On 22 September 2011 Admiral Mike Mullen, chairman of joint chiefs of staff, told the Senate Armed Services Committee that the Haqqanis 'operate from Pakistan with impunity'. His indictment was severe: 'Extremist organizations serving as proxies of the government of Pakistan are attacking Afghan troops and civilians as well as US soldiers. For example, we believe the Haqqani Network – which has long enjoyed the support and protection of the Pakistani government and is, in many wars, a strategic arm of Pakistan's Inter-Services Intelligence Agency – is responsible for the September 13th attacks against the US Embassy

in Kabul. There is ample evidence confirming that the Haqqanis were behind the June 28th attack against the Inter-Continental Hotel in Kabul and the September 10th truck bomb attack that killed five Afghans and injured another 96 individuals, 77 of whom were US soldiers. History teaches us that it is difficult to defeat an insurgency when fighters enjoy a sanctuary outside national boundaries, and we are seeing this again today.' Mullen went full frontal in his own attack: 'The actions by the Pakistani government to support them – actively and passively – represent a growing problem that is undermining US interest and may violate international norms, potentially warranting sanction. In supporting these groups, the government of Pakistan, particularly the Pakistani Army, continues to jeopardize Pakistan's opportunity to be a respected and prosperous nation with genuine regional and international influence.'

This is hardly the ideal way forward in what Washington believes is an existential conflict. The war on terror is America's fourth world war in eleven decades. Europe was the central battlefield in three, including the Cold War. The Afpak region claims that position in the fourth. Why has America been repeatedly checked, suborned, and at enormous cost in human and treasury terms? It is perhaps a matter of time before American strategists accept that their problem is, to use an analogy from the Second World War, that their strategic partnership this time has been forged with a Vichy government rather than a Britain – a government that keeps one hand in the glove of the enemy. Perhaps the true strategic partner in the war against terror, the Britain of this conflict, is India. And that Pakistan needs, urgently, to find its own Charles de Gaulle.

Notes

—⟨⟨⟨⟨⟩⟩⟩⟩—

Introduction

1. *Collected Works*, Volume 95, Publications Division, Government of India.
2. *Transforming Pakistan: Ways out of Instability*, published by Routledge for the International Institute of Strategic Studies.

1. The Age of Defeat

1. Arabic, Uthman; hence Uthmani, whence the Anglicized Ottoman.
2. Francois Bernier, the French traveller, estimated that the revenues of Jahangir's grandson Aurangzeb probably exceeded the joint revenues of the Ottoman sultan and the king of Persia.
3. Maya Jasanoff, *Edge of Empire: Lives, Culture, and Conquest in the East 1750-1850.*
4. Robert Harvey, *Clive: The Life and Death of a British Emperor.*
5. A 'Black Hole' was a cell reserved for drunken soldiers and the term remained in use in the British Army till 1868.
6. Peter Hardy, *The Muslims of British India.*

2. A Scimitar at Somanath

1. *Selected Works of Jawaharlal Nehru, Vol XVI,* edited by Sarvepalli Gopal.
2. *Alberuni's India,* translated by Dr Edward Sachau, Rupa, 2002.
3. *Somanatha: The Many Voices of History.*

4. Pakistan was shocked when on the evening of 1 July 2010 two suicide bombers belonging to the Sunni extremist militant organization, Sipah-e-Sahaba, attacked his shrine, killing forty-two.

5. John Keay, *India: A History.*

6. *Demolishing Myths or Mosques and Temples?*, edited by Sunil Kumar.

7. *Authority and Kingship under the Sultans of Delhi, 13th-14th Centuries.*

8. *Hazardinari* means 'worth a thousand dinars' and may have referred to the price paid for him.

9. *The Indian Muslims,* George Allen and Unwin, London, 1967.

10. *A Comprehensive History of India,* edited by Muhammad Habib.

11. *Travels in Asia and Africa 1325-1354,* Routledge & Kegan Paul, 1929.

12. *Islamic Contestations: Essays on Muslims in India and Pakistan,* Oxford University Press, 2004.

13. *Sources of Indian Tradition, Volume 1,* Columbia University Press.

14. *The Corporation that Changed the World: How the East India Company Shaped the Modern Multinational.*

15. *Journey through the Kingdom of Oude in 1849-50,* London, 1858.

16. *After Tamerlane: The Global History of Empire,* Allen Lane.

3. A Theory of Distance

1. *The Wahabi Movement in India.*

2. As late as in 2010, the pre-Islamic kite-flying festival of Basant, a great traditional joy of Lahore, was abolished on the rather spurious excuse that it caused accidents.

3. *Abul Kalam Azad: An Intellectual and Religious Biography,* Oxford University Press, 1988.

4. Translated by M. Mujeeb.

5. 'The Indian Mussalmans: Are They Bound in Conscience to Rebel Against the Queen?'

6. Among the more interesting converts to Wahabism was Momin, the famous contemporary Urdu poet; and while the great Ghalib had little use for Wahabism, he could not but express his admiration for Barelvi's heroism.

7. Proceedings of the Board of Revenue, 12 May 1851.
8. *Ideologies of the Raj.*

4. An English Finesse

1. Quoted in *Ghalib: Life and Letters* by Ralph Russell and Khurshidul Islam; the authors do not provide the name of Ghalib's friend.
2. *The British Conquest and Dominion of India.*
3. This is among the select hundred letters from 1847 to 1947, published by HarperCollins in 2000.
4. Bishop Heber, who visited Lucknow in 1825, thought its Rumi Darwaza and Asaf ad-Daula Imambarah better than the Kremlin. *Narrative of a Journey through the Upper Provinces of India from Calcutta to Bombay, 1824-1825*, by Reginald Heber, published in London in 1828.
5. *Hayat-e Javed*, by Hali, translated by K.H. Qadri and David Matthews.
6. Quoted in *The Life and Work of Syed Ahmed Khan*, by G.F.I. Graham.
7. Report of the Indian Education Commission, Calcutta, Government of India, 1883.
8. Quoted in *Sources of Indian Tradition*, Volume Two, Columbia University Press, 1958.
9. Jawaharlal Nehru once reminded them that Chingiz Khan might have been a Khan, but he was not a Muslim.
10. See *Writings and Speeches of Sir Syed Ahmed Khan*, edited by Shan Muhammad.
11. *Pakistan: A Modern History*, Hurst and Company, 1998.

5. Grey Wolf

1. An Ismaili descended from Hindu converts, rather than an immigrant. Ismailis are a Shia sect who recognized the eldest son of Imam al Sadiq, Ismail, as their imam; hence the name.
2. A phonetic variation of Mohammad Ali.
3. In fact, Naoroji, a Persia-origin Parsi, was fair-skinned.
4. *Jinnah, Creator of Pakistan.*
5. Quoted in Stanley Wolpert's admiring biography, *Jinnah of Pakistan.*
6. Our Rule, Our Religion, Our Identity.

7. Jinnah appeared for Tilak a second time, in 1916, again on a charge of sedition, and won.
8. *The Memoirs of Aga Khan,* Simon and Schuster, New York, 1954.
9. The British-owned and edited *Times* did not print the letter; it was later printed in a Gujarati newspaper.
10. This was read out by Gokhale, since Dadabhai was too ill.
11. See *Mohammad Ali Jinnah: His Speeches and Writings, 1912-1917,* edited by Sarojini Naidu.
12. Urdu became the national language of Pakistan in 1947, despite the fact that more than half the population spoke Bengali, and Jinnah did not know a word of Urdu.
13. The surname had an interesting history. Sir Dinshaw's great-grandfather, a shipping clerk and *dubash* (one who knew two languages) for the East India Company, had been affectionately nicknamed 'Le petit Parsi' by French merchants; the Petit stuck.
14. He was indignant when an infatuated biographer bloated the dower to Rs 33,00,000 in 1944.
15. *Ruttie Jinnah: The Story, Told and Untold,* Pakistan Study Centre, University of Karachi, 2004.

6. Gandhi's Maulanas

1. In *The British Conquest and Dominion of India.*
2. As quoted in *The Khilafat Movement: Religious Symbolism and Political Mobilization in India,* Columbia University Press, 1982.
3. 'Allah forbids you not, with regard to those who fight you not ... nor drive you out of your homes, from dealing kindly and justly with them, for Allah loveth those who are just', Surah 60, verse 8.
4. *Al Hilal,* 29 May 1913.
5. *The Collected Works of Mahatma Gandhi, Volume 14.*
6. Turkey was in touch with another Indian revolutionary movement, Ghadr, founded by a Punjabi Hindu, Har Dyal, a graduate of Oxford and lecturer at Stanford University – from where he was discharged because of his politics. He was arrested in the United States as an undesirable alien, but jumped bail and escaped to Geneva. Ghadr established a network from Kabul to Rangoon and Singapore. Here too there was more hope than fulfilment.
7. Unofficial estimates put the figure at 16 million; census figures indicate that the population increased by only 2.5 million in the

decade of 1911–21 as compared to 19 million in 1901–1911 and 32 million in 1921–31.

8. Reproduced in Matlubul Hasan Saiyid's *Mohammad Ali Jinnah.*
9. Quoted by Wolpert, from M.H. Saiyid's *Mohammad Ali Jinnah.*
10. *Collected Works, Volume 17.*
11. Translated from the original Gujarati by Mahadev Desai, Navajivan Publishing House, 1927 and 1929.
12. *Young India,* 28 July 1920.
13. Rudyard Kipling contributed ten pounds.

7. The Non-violent Jihad

1. Congregation of the Clergy of India.
2. The full text was published in the Calcutta newspaper *Amrita Bazar Patrika* on 24 January 1920.
3. Mohandas Karamchand Gandhi, *Collected Works, Volume 23.*
4. Jawaharlal Nehru, *The Discovery of India,* Penguin Books India, 2006.
5. Quoted by Gail Minault in *The Khilafat Movement: Religious Symbolism and Political Mobilization in India.*
6. These non-violent munitions were spinning wheels: as Muhammad Ali put it, a shot fired from Madras would kill the textile industry in Manchester. The famous bonfires of foreign cloth took place on 31 July and 9 October.
7. Quoted in *Independent,* 6 July 1921.
8. This would cause bitterness when Gandhi aborted the movement; there were accusations that valuable Muslim careers had been sacrificed in vain.
9. Mohandas Karamchand Gandhi, *Collected Works, Volume 25.*
10. Quoted at length by D.G. Tendulkar, *Mahatma: Life of Mohandas Karamchand Gandhi.*
11. The full letter is quoted in *Regional Pan-Islamism: Documents of the Khilafat Movement,* edited by Mushirul Hasan and Margrit Pernau
12. *Gandhi's Truth: On the Origins of Militant Nonviolence.*

8. The Muslim Drift from Gandhi

1. Gopal Krishna Gokhale had formed the Servants of India Society in 1905 as a forum to promote social and human development.

2. *India from Curzon to Nehru and After.*
3. *Young India*, 28 November 1921.
4. Quoted in Francis Robinson's *The Ulama of Farangi Mahall and Islamic Culture in South Asia*. Though Gandhi was sympathetic to the reasons for Bari's depression, and rushed to Ajmer from Ahmedabad, calming the maulana temporarily, Robinson notes, 'This speech marked the end of Abd al-Bari's presence at the summit of national politics.'
5. *Islamic Contestations: Essays on Muslims in India and Pakistan.*
6. *India's Maulana Abul Kalam Azad: Selected Speeches & Writings.*
7. *The British Conquest and Dominion of India.*
8. *India's Maulana Abul Kalam Azad.*
9. *Mahatma Gandhi: The Man Who Became One with the Universal Being.*
10. *The Brotherhood in Saffron: The Rashtriya Swayamsevak Sangh and Hindu Revivalism.*
11. *Jinnah, Creator of Pakistan.*
12. *Modern India 1885-1947.*
13. The great Hakim, a genius in traditional medicine, charged an astonishing Rs 1000 a day as consultation from princes. When the British leaned on the nawab of Rampur, and the rajas of Kashmir and Patiala to spurn Khan's services, they rejected the advice.
14. *Islam in the Subcontinent: Muslims in a Plural Society.*
15. *Continent of Circe.*
16. *Islam and Muslim History in South Asia.*
17. *Gandhi: Prisoner of Hope.*
18. In 1927, the League's membership was just 1,330. Its 1930 session did not even have a quorum. In 1933, it declared an income of only Rs 1,318.
19. Punjab, which had a 56 per cent Muslim population, provided 62 per cent of the contingent of the British Indian Army, if Gurkhas were excluded.

9. Breaking Point

1. He would describe this first round as Hamlet without the prince, since the Congress was not at the table.
2. Sir Malcolm Hailey, governor of the United Provinces, was so incensed that he later described Jinnah, in a letter to Irwin, as 'the

perfect little bounder and as slippery as the eels which his forefathers purveyed in Bombay'.

3. *Bengal Divided: Hindu Communalism and Partition 1932-1947.*
4. By the 1937 elections, the electorate had expanded to thirty-six million, as compared to seven million in 1920.
5. *Recent Essays and Writings*, published in Allahabad in 1934.
6. William Metz, *The Political Career of Mohammad Ali Jinnah*, edited by Roger Long.
7. *Jinnah of Pakistan*, Oxford University Press, 1984.
8. *Collected Works, Volume LXV.*
9. *Jawaharlal Nehru: Rebel and Statesman.*
10. Barbara Metcalf, *Islamic Contestations: Essays on Muslims in India and Pakistan.*
11. *India's Maulana, Selected Speeches & Writings, Volume 2.*
12. *The Political Career of Mohammad Ali Jinnah.*
13. Dennis Dalton, *Nonviolence in Action: Gandhi's Power.*
14. Quoted in *Pakistan Resolution to Pakistan, 1940-47*, edited by Latif Ahmed Sherwani.
15. *The Last Days of the British Raj.*

10. Faith in Faith

1. *Pakistan: The Formative Phase.*
2. *Pakistan: Between Mosque and Military.*
3. *In Quest of Jinnah: Diary, Notes, and Correspondence of Hector Bolitho*, edited by Sharif al Mujahid. Bolitho also records that Jinnah teased a fellow Muslim League leader, from Bengal, Khwaja Nazimuddin, because the latter's wife wore a veil.
4. The architect was an Englishman, Claude Bentley; Italian masons fitted the marble on the terrace; the clerk of works was a Muslim; and a Hindu was in charge of the plumbing. Jinnah was a true cosmopolitan in temperament: a favourite recreation before 1947 was spending an afternoon at the Bombay racecourse.
5. Mirza Ghulam Ahmad (1835–1908) was born to a family of landlords in Qadian, in the Gurdaspur district of Punjab. He claimed to receive revelations from Allah, and upgraded himself to the Messiah who represented the second coming of Christ. Christ, he said, had not died on the crucifix but been taken down alive by his disciples, headed east out of Roman territory, and died in Kashmir. Ahmad adopted the normative behaviour of Islam,

but claimed the mantle of a Prophet, challenging a basic tenet of the faith, Khatam-e-Nubuwat, or the conviction that Muhammad is the last Prophet sent by Allah. Muslims were scandalized, but powerless to do much about their anger under British rule. Ahmad created the Jamaat-e-Ahmadiyas in 1889 and received recognition from the British government as a separate sect within Islam, in 1901.

6. The Jamaat-e-Islami was checked, not defeated. Its next opportune moment came in 1974 when a desperate Zulfiqar Ali Bhutto was seeking support from any direction for his re-election. Bhutto accepted the Jamaat demand. In 1984, the Ahmadiyas shifted their headquarters to Tilbury, near Guildford in England. They had rejected India in 1947 and lost Pakistan in 1974.

11. The Godfather of Pakistan

1. In *Islam and Muslim History in South Asia*.
2. *Islamism and Democracy in India: The Transformation of Jamaat-e-Islami*.
3. *Husain Ahmad Madani: The Jihad for Islam and India's Freedom*.
4. *Diaries of Field Marshal Mohammad Ayub Khan 1966-1972*, edited and annotated by Craig Baxter.
5. *We've Learnt Nothing from History*.
6. *Pakistan: A Modern History*.
7. *Friends Not Masters: A Political Autobiography*.
8. Entry for 4 September 1966, *Diaries of Field Marshal Mohammad Ayub Khan 1966-1972*.
9. *Political Order in Changing Societies*.

12. God's General

1. This is the third month of the Muslim calendar; in India, it has been conflated with spring, and *rabi* lives in the term for the spring harvest, as the *rabi* crop.
2. The government thought this important enough to publish the text in a compilation of interviews.
3. *Muslim Khwateen ke Liye Bees Sabaq*.
4. It is relevant to note that practices like the stoning of adulterous men and women are not Quranic, but emerge from sources whose validity has been questioned by scholars.

5. One reason why Maududi called Jinnah's Muslim League another form of Congress was because it allowed women among its cadres and leadership.

6. Masih is the term for Prophet generally used in conjunction with Jesus, and hence widely used by Pakistani Christians.

7. Out of the 2.5 million Hindus left in Pakistan in 2009, 51 per cent lived in Tharpakar and 43 per cent in Umarkot district.

8. The Quran has not prescribed any punishment for alcohol. Paradoxically, the disappearance of alcohol might have led to an unintended consequence. Till 1979, heroin addiction was rare in Pakistan. Within five years, the country had the second largest population of addicts in the world.

9. *Islamisation of Pakistani Social Studies Textbooks.*

10. *Shaping a Nation: An Examination of Education in Pakistan.*

11. *Social Studies for Class VI,* Sindh Textbooks Board, July 1997.

12. *Our World, for Class IV,* Directorate of Education, Punjab, New Curriculum, published by Malik Din Mohammad.

13. One of the first decisions taken by the Pakistan Taliban when they established temporary control over Swat in 2009 was to introduce jiziya upon the few Sikhs still living there.

14. *Shaping a Nation: An Examination of Education in Pakistan.*

13. The Long Jihad

1. *The Transfer of Power,* Volume 10, edited by Nicholas Mansergh and Penderel Moon.

2. *Raiders in Kashmir: Story of the Kashmir War 1947-48.*

3. *Crossed Swords: Pakistan, Its Army, and the Wars Within.*

4. Quoted in Brian Cloughley's *A History of the Pakistan Army.*

5. For a detailed account of the quadrilateral India-Pak-Britain-United Nations diplomacy, see Joseph Korbel's *Danger in Kashmir.*

6. *Shadow War: The Untold Story of Jihad in Kashmir,* Jamal interviewed Maulana Bari on 16 April 2002 in Muzaffarabad.

14. Pakistan: The Siege Within

1. *The Emergence of Modern Afghanistan: Politics of Reform and Modernization 1880-1946.*

2. *From the Shadows: The Ultimate Insider's Story of Five Presidents and How They Won the Cold War.*

3. *Pakistan: Between Mosque and Military.*
4. See the *International Herald Tribune*, 13 July 2009.
5. *Whither Pakistan? A five-year forecast:* Bulletin of the Atomic Scientists, 3 June 2009.
6. According to *The Nuclear Jihadist: The True Story of the Man Who Sold the World's Most Dangerous Secrets . . . and How We Could Have Stopped Him* by Douglas Frantz and Catherine Collins.

15. Dark Side of the Moon

1. *Jinnah-Ispahani Correspondence*, edited by Z.H. Zaidi.
2. Jinnah Papers, editor-in-chief Z.H. Zaidi, published by government of Pakistan.
3. Margaret Bourke-White, *Halfway to Freedom: A Report on the New India in the Words and Photographs of Margaret Bourke-White.*
4. *Ayub Khan: Pakistan's First Military Ruler.*

Index

Books Cited

Ahmad, Irfan, *Islamism and Democracy in India: The Transformation of Jamaat-e-Islami,* New Delhi: Permanent Black, 2010

Ahmad, Qeyamuddin, *The Wahabi Movement in India,* New Delhi: Manohar, 1994

Andersen, Walter, and Shridhar Damle, *The Brotherhood in Saffron: The Rashtriya Swayamsevak Sangh and Hindu Revivalism,* New Delhi: Vistaar Publications, 1987

Azad, Maulana Abul Kalam, *India's Maulana Abul Kalam Azad: Selected Speeches & Writings,* New Delhi: Indian Council for Cultural Relations, 1990

Battuta, Abu Abdullah ibn, *Travels in Asia and Africa 1325-1354,* London: Routledge & Kegan Paul, 1929

Baxter, Craig (edited and annotated), *Diaries of Field Marshal Mohammad Ayub Khan 1966-1972,* Karachi: Oxford University Press, 2007

Bolitho, Hector, *Jinnah, Creator of Pakistan,* London: John Murray, 1954

Bourke-White, Margaret, *Halfway to Freedom: A Report on the New India in the Words and Photographs of Margaret Bourke-White,* New York: Simon and Schuster, 1949

Brown, Judith, *Gandhi: Prisoner of Hope,* New Haven: Yale University Press, 1989

Chatterji Joya, *Bengal Divided: Hindu Communalism and Partition 1932-1947,* Cambridge: Cambridge University Press, 1995

Chaudhuri, Nirad, *Continent of Circe,* New Delhi: Jaico, 1962

Cloughley, Brian, *A History of the Pakistan Army,* Karachi: Oxford University Press, 1999

Cole, Juan, *Napoleon's Egypt: Invading the Middle East*, New York: Palgrave Macmillan, 2007

Dalton, Dennis, *Nonviolence in Action: Gandhi's Power*, Cape Town: Oxford University Press, 1999

Darwin, John, *After Tamerlane: The Global History of Empire*, London: Allen Lane, 2007

Douglas, Ian Henderson, *Abul Kalam Azad: An Intellectual and Religious Biography*, New Delhi: Oxford University Press, 1988

Erikson, Erik, *Gandhi's Truth: On the Origins of Militant Nonviolence*, New York: W.W. Norton, 1969

Frantz, Douglas, and Catherine Collins, *The Nuclear Jihadist: The True Story of the Man Who Sold the World's Most Dangerous Secrets . . . and How We Could Have Stopped Him*, New York: Twelve, 2007

Gandhi, Mohandas Karamchand, *The Collected Works, Volume 14*, New Delhi: Publications Division, Government of India

————, *The Collected Works, Volume 23*, New Delhi: Publications Division, Government of India

————, *The Collected Works, Volume 25*, New Delhi: Publications Division, Government of India

Gates, Robert, *From the Shadows: The Ultimate Insider's Story of Five Presidents and How They Won the Cold War*, New York: Simon and Schuster, 1996

Gauhar, Altaf, *Ayub Khan: Pakistan's First Military Ruler*, Lahore: Sang-e-Meel Publications, 1993

Gopal, Sarvepalli (ed.), *Selected Works of Jawaharlal Nehru, Vol XVI*, New Delhi: Jawaharlal Nehru Memorial Fund

Graham, G.F.I., *The Life and Work of Syed Ahmed Khan*, Karachi: Oxford University Press, 1974

Gregorian, Vartan, *The Emergence of Modern Afghanistan: Politics of Reform and Modernization 1880-1946*, Stanford: Stanford University Press, 1969

Habib, Muhammad (ed.), *A Comprehensive History of India*, New Delhi: People's Publishing House, 1970

Haider, Khwaja Razi, *Ruttie Jinnah: The Story, Told and Untold*, Karachi: Pakistan Study Centre, University of Karachi, 2004

Haqqani, Husain, *Pakistan: Between Mosque and Military*, Washington DC: Carnegie, 2005

Hardy, Peter, *The Muslims of British India*, Cambridge: Cambridge University Press, 1971

Harvey, Robert, *Clive: The Life and Death of a British Emperor*, London: Hodder & Stoughton, 1998

Hasan, Mushirul, *Islam in the Subcontinent: Muslims in a Plural Society*, New Delhi: Manohar, 2002

Hasan, Mushirul, and Margrit Pernau (eds), *Regional Pan-Islamism: Documents of the Khilafat Movement*, New Delhi: Manohar, 2005

Heber, Reginald, *Narrative of Journey through the Upper Provinces of India from Calcutta to Bombay, 1824–25*, London: Pickering and Chatto, 1828

Huntington, Samuel, *Political Order in Changing Societies*, New Haven: Yale University Press, 1968

Jamal, Arif, *Shadow War: The Untold Story of Jihad in Kashmir*, New York: MelvilleHouse, 2009

Jasanoff, Maya, *Edge of Empire: Lives, Culture, and Conquest in the East 1750-1850*, New York: Vintage, 2006

Jinnah Papers, Editor-in-chief Z.H. Zaidi, Islamabad: Quaid-e-Azam Papers Project, National Archives of Pakistan, Ministry of Culture, Government of Pakistan, 1993

Jinnah-Ispahani Correspondence, edited by Z.H. Zaidi, Karachi: Forward Publications Trust, 1976

Johnson, Robert, *Spying for Empire: The Great Game in Central and South Asia, 1757-1847*, London: Greenhill Books, 2006

Keay, John, *India: A History*, London: HarperCollins, 2000

Khan, Akbar, *Raiders in Kashmir: Story of the Kashmir War 1947-48*, Lahore: Jang Publishers, 1970

Khan, Ayub, *Friends Not Masters: A Political Autobiography*, New York: Oxford University Press, 1967

Khan, Gul Hassan Lt. Gen., *Memoirs*, Karachi: Oxford University Press, 1993

Khan, M. Asghar Air Marshal, *We've Learnt Nothing from History*, Karachi: Oxford University Press, 2005

Kissinger, Henry, *White House Years*, Washington DC: Little Brown, 1979

———, *On China*, Ontario, Canada: Allen Lane, 2011

Korbel, Joseph, *Danger in Kashmir*, Karachi: Oxford University Press, 2002

Kumar, Sunil (ed.), *Demolishing Myths or Mosques and Temples?*, New Delhi: Three Essays Collective, 2008

Kux, Dennis, *The United States and Pakistan 1947-2000: Disenchanted Allies*, Woodrow Wilson Center Press, 2001

Levy, Adrian, and Catherine Scott-Clarik, *Deception: Pakistan, the United States and the Global Nuclear Weapons Conspiracy*, New York: Walker Publishing Company, 2007

Lyon, Stephen, and Iain R. Edgar (eds), series editor: Ali Khan, *Shaping a Nation: An Examination of Education in Pakistan*, Karachi: Oxford University Press, 2010

Mansergh, Nicholas, and Penderel Moon (eds), *The Transfer of Power, Volume 10*, London: HMSO, 1981

Maududi, Maulana Sayyid Abul Ala, *Purdah and the Status of Woman in Islam*, Lahore: Islamic Publications Ltd, 1972; first published in 1939

——, *Islamic Law and Constitution*, Lahore: Pakistan Herald Press, 1955

Metcalf, Barbara, *Islamic Contestations: Essays on Muslims in India and Pakistan*, New Delhi: Oxford University Press, 2004

——, *Husain Ahmad Madani: The Jihad for Islam and India's Freedom*, Oxford: Oneworld Publications, 2009

Metcalf, Thomas, *Ideologies of the Raj*, Cambridge: Cambridge University Press, 1995

Metz, William, *The Political Career of Mohammad Ali Jinnah*, edited by Roger Long, New York: Oxford University Press, 2010

Minault, Gail, *The Khilafat Movement: Religious Symbolism and Political Mobilization in India*, New York: Columbia University Press, 1982

Moon, Penderel, *The British Conquest and Dominion of India*, London: Duckworth, 1979

Mosley, Leonard, *The Last Days of the British Raj*, London: Weidenfeld and Nicolson, 1961

Muhammad, Shan (ed.), *Writings and Speeches of Sir Syed Ahmed Khan*, Bombay: Nachiketa, 1972

Mujahid, Sharif al (ed.), *In Quest of Jinnah: Diary, Notes, and Correspondence of Hector Bolitho*, Karachi: Oxford University Press, 2007

Mujeeb, M., *The Indian Muslims*, London: George Allen and Unwin, 1967

Munshi, K.M., *Somanath: The Shrine Eternal*, Bombay, 1951

Naidu, Sarojini (ed.), *Mohammad Ali Jinnah: His Speeches and Writings, 1912–1917*, Madras: Ganesh, 1918

Nanda, B.R., *Jawaharlal Nehru: Rebel and Statesman*, New Delhi: Oxford University Press, 1995

Nawaz, Shuja, *Crossed Swords: Pakistan, Its Army, and the Wars Within*, Karachi: Oxford University Press, 2008

Robinson, Francis, *Islam and Muslim History in South Asia*, New Delhi: Oxford University Press, 2000

————, *The Ulama of Farangi Mahall and Islamic Culture in South Asia*, New Delhi: Permanent Black, 2001

Rolland, Romain, *Mahatma Gandhi: The Man Who Became One with the Universal Being*, London: Allen and Unwin, 1924

Rosser, Yvette Claire, *Islamisation of Pakistani Social Studies Textbooks*, New Delhi: Rupa, 2003

Russell, Ralph, and Khurshidul Islam, *Ghalib: Life and Letters*, New Delhi: Oxford University Press, 1994

Sachau, Edward Dr (trans.), *Alberuni's India*, New Delhi: Rupa, 2002

Saiyid, Matlubul Hasan, *Mohammad Ali Jinnah: A Political Study*, Lahore: S.M. Ashraf, 1945

Sarkar, Sumit, *Modern India 1885–1947*, New Delhi: Macmillan, 1983

Sayeed, Khalid bin, *Pakistan: The Formative Phase*, London: Oxford University Press, 1968

Shah, Sultan Mahomed, Aga Khan III, *The Memoirs of Aga Khan*, New York: Simon and Schuster, 1954

Sherwani, Latif Ahmed (ed.), *Pakistan Resolution to Pakistan, 1940-47*, Karachi: National Publishing House, 1969

Siddiqui, Iqtidar Hussain, *Authority and Kingship under the Sultans of Delhi, 13th–14th Centuries*, New Delhi: Manohar, 2006

Sleeman, Colonel W.H., *Journey through the Kingdom of Oude in 1849-50*, London, 1858

Talbot, Ian, *Pakistan: A Modern History*, New York: Hurst and Company, 1998

Tendulkar, D.G., *Mahatma: Life of Mohandas Karamchand Gandhi*, New Delhi: Publications Division, Government of India, 1951

Thapar, Romila, *Somanatha: The Many Voices of History*, New Delhi: Penguin/Viking, 2004

Wolpert, Stanley, *Jinnah of Pakistan*, New York: Oxford University Press, 1984

Acknowledgements

⸻ ∾∾ ⸻

This book is a culmination of a long journey that began much before the first word was written, and a true list of those who have helped shape my thoughts and brought me back from tempting bylanes towards a relevant horizon would be a long one. I am particularly grateful to my friends Strobe Talbott, president of the Brookings Institution, and Martin Indyk, head of its Saban Center, for giving me the opportunity to take a break from the mad schedules of journalism, and spend time on study and reflection at one of the great think-tanks of the world. I was involved in a different project there, but, happily, clarity can be contagious. I miss the friendship of Strobe's wife, Brooke, a wonderful woman of gossamer appearance and sharp intellect, who left our world too suddenly and too early. My colleagues in journalism were kind enough to permit me time and mental space for work in Delhi. A very special thank you to friends in Pakistan, who offered the warmth of affection as well as access to documents and discussion. Now that P.G. Wodehouse has established the template for references to family, it seems perfectly in order to thank my adult children, Mukulika and Prayaag, for being away from home while most of this book was written: they were involved in their education, their jobs and the new homes they set up. The truth is, I wish they had not left, but that is the typical foolishness of a father. The big bonus for us has been the addition into our family of a second son, Carl Nordenberg, a

wonderful husband for Mukulika. My brother-in-law Lokesh
Sharma and my sister Ghazala have always been a source of
undemonstrative help and affection. As with all my books the
quiet, calm love of Mallika, my wife, has been an invaluable and
immeasurable anchor during the turbulence of writing and,
worse, rewriting. Which brings me to Krishan Chopra, my editor
at HarperCollins, whose persistence, perseverance and sharp eye
for detail helped polish the chapters. Krishan is an asset to any
author. Shantanu Ray Chaudhuri has been wonderful in tweaking
out the repetitions, overlaps and niggles that are par for the
course in any manuscript. Lipika Bhushan's executive skills are
evident in her marketing plans. Sapna Kapoor designed a fabulous
cover, and Rajesh Sharma, librarian of the India Today Group,
was a marvel at getting us the pictures.

About the Author

M. J. Akbar is one of India's most distinguished journalists. He has worked with and launched some of the most well-known newspapers and magazines in India over the last forty years. These include the *Times of India*, the *Illustrated Weekly of India*, *Onlooker*, *Sunday*, *The Telegraph*, the *Asian Age*, *Deccan Chronicle*, *Covert*, and the *Sunday Guardian*. In September 2010, he joined *India Today* and *Headlines Today* as editorial director.

He has also been a member of the Indian Parliament, contesting and winning the Kishanganj seat in Bihar on a Congress ticket in the general elections held in 1989. Simultaneous with a full-time career in journalism, he has been a prolific and bestselling author of major political works, which include *India: The Siege Within, Challenges to a Nation's Unity*; *Riot after Riot*; *Nehru: The Making of India*; *Kashmir: Behind the Vale*; *The Shade of Swords: Jihad and the Conflict between Islam and Christianity*; and *Blood Brothers*, a novel.